Ana Alan

Gronley

The Met 1991

The Lotus Transcendent

*Indian and Southeast Asian Art from
the Samuel Eilenberg Collection*

The Lotus Transcendent

Indian and Southeast Asian Art from
the Samuel Eilenberg Collection

Martin Lerner and Steven Kossak

The Metropolitan Museum of Art, New York

Distributed by Harry N. Abrams, Inc., New York

This book has been generously supported by the Samuel I. Newhouse Foundation.

This publication is issued in connection with the exhibition *The Lotus Transcendent: Indian and Southeast Asian Art from the Samuel Eilenberg Collection*, held at The Metropolitan Museum of Art from October 2, 1991, to June 28, 1992.

Published by The Metropolitan Museum of Art

John P. O'Neill, *Editor in Chief*
Carol Fuerstein, *Editor*
Barbara Cavaliere, *Production Editor*
Abby Goldstein, *Designer*
Susan Chun, *Production*

Library of Congress Cataloging-in-Publication Data

Metropolitan Museum of Art (New York, N.Y.)
 The lotus transcendent : Indian and Southeast Asian art from
the Samuel Eilenberg collection / Martin Lerner and Steven Kossak.
 p. cm.
 Includes bibliographical references and index.
 ISBN 0-87099-613-4. — ISBN 0-8109-6407-4 (Abrams)
 1. Art, South Asian—Exhibitions. 2. Art, Southeast Asian—
Exhibitions. 3. Eilenberg, Samuel—Art collections—Exhibitions.
4. Art—Private collections—New York (N.Y.)—Exhibitions.
5. Metropolitan Museum of Art (New York, N.Y.)—Exhibitions.
I. Lerner, Martin. II. Kossak, Steven. III. Title.
N7300.M47 1991
730'.0954'0747471—dc20 91-15177
 CIP

Type set in Sabon by U.S. Lithograph, typographers, New York
Printed by Mercantile Printing, Worcester, Massachusetts
Bound by Acme Bookbinding Company, Inc., Charlestown,
Massachusetts

All photographs by Maggie Nimkin except
cover by Lynton Gardiner
rollout photograph, No. 72, by Justin Kerr
Maps by Wilhelmina T. Reyinga-Amrhein

Cover:
No. 139 *Seated Transcendental Buddha Vairochana*
Indonesia, Java, Central Javanese period, ca. late 9th century

Table of Contents

Acknowledgments

The authors gratefully acknowledge their indebtedness to Carol Fuerstein, the editor of this catalogue. The text would certainly have been less coherent without her judicious guidance through problems of syntax, proper word-usage, and organization. Maggie Nimkin, the photographer, has done a splendid job overcoming the problems presented by working with so many small objects. Nina Sweet of the Asian Art Department patiently typed Martin Lerner's contributions.

Steven Kossak would also like to expresses his appreciation for the helpfulness of Prudence Harper, Curator of the Ancient Near Eastern Art Department, Marilyn Jenkins, Curator of the Islamic Art Department, and Carlos A. Picón, Curator in Charge of the Greek and Roman Art Department, with whom he consulted.

Finally, we both extend our particular thanks to a few special supporters of Indian and Southeast Asian art who, when first informed of the possibility that the Eilenberg collection might come to the Metropolitan, responded with unusual enthusiasm and were extremely encouraging. Their personal generosity served as the catalyst that brought us from the initial phase of hopeful intention to our successfully realized conclusion. They are credited individually in the appropriate catalogue entries.

Martin Lerner and Steven Kossak

Director's Foreword

The Eilenberg collection represents the fruit of a lifetime's passionate and informed connoisseurship. The gift of more than four hundred works of art from Samuel Eilenberg in 1987, combined with our purchase from Columbia University of an additional twenty-four sculptures formerly in his collection, marked a turning point in the growth of the Museum's collections of Indian and Southeast Asian art. It has completely transformed the Metropolitan's holdings in two important areas, the early arts of India and Pakistan and the bronzes of Indonesia. Our collections have been enriched as well by numerous splendid objects dating from the fifth through the fourteenth century from other cultures of Southeast Asia. It is a tribute to Professor Eilenberg's undiminished collecting impulse and pertinacity, as well as to his continuing generosity to the Metropolitan, that, even after the transfer of the majority of his holdings to the Museum, he has continued to acquire rare works of art and has promised many of them to this institution.

Professor Eilenberg's gifts have come at the auspicious moment when we are preparing for the reinstallation of the Museum's much expanded collections of Indian and Southeast Asian art, which have not been on permanent view since the early 1950s. When Samuel Eilenberg made his generous intentions known, planning for the Florence and Herbert Irving Galleries was already underway. It was clear that the accommodation of the extensive Eilenberg holdings would require many modifications to the design of these galleries, and happily these could be realized. The present exhibition affords a preview of a selection of the objects that will be housed in our new galleries.

We extend our thanks to Martin Lerner, Curator of Indian and Southeast Asian Art, and Steven Kossak, Assistant Curator of Indian and Southeast Asian Art, for their invaluable role in the organization of the exhibition and the redaction of the catalogue that accompanies it. Appreciation is due as well to the many donors who helped us acquire the Columbia University Eilenberg works.

Philippe de Montebello
Director
The Metropolitan Museum of Art

Introduction

The byways of institutional and private collecting sometimes cross; more often than not, however, because they are bounded by different parameters and propelled by different motivations, they meander along separate routes. Although the methods of institutions and private individuals may vary, each has the potential for notable accomplishments. Given this, when a distinguished private collection is joined to a strong museum collection, the result is a symbiotic mutual enrichment that, by definition, neither could achieve independent of the other. This enrichment extends considerably beyond the adding of objects to objects; rather, it becomes a merging of separate visions, with one intelligence complementing the other.

Private collections are almost always personal and idiosyncratic. Nevertheless, relative to each individual, certain constants exist. It is a truism that, subject to practicalities, serious collectors acquire the objects whose aesthetic qualities they most admire and to which they respond both intellectually and emotionally —thus, they honor and pay respect to the cultures and artists responsible for producing the works of art. In this, Samuel Eilenberg is no exception. And, rather than admiring these cultures from afar, Eilenberg has made innumerable trips to India, Pakistan, Indonesia, and Thailand to carefully study their museums and monuments. More about the collector and his collection follows.

The works of art included in this catalogue, most of which are bronzes, range from images of deep religious significance to secular objects intended for domestic use. Although most of them are small, they collectively provide some sense of the enormous scope of artistic productivity evident in the cultures of the Indian subcontinent and Southeast Asia and of their impressive aesthetic achievements. While the provenance of most of these works of art can be deduced from formal characteristics and other evidence, a few are so unusual that their places of origin remain somewhat speculative. Some are well known,

having appeared in earlier books and catalogues; many, however, have not been published previously.

The great religions of India, which were exported north and to both mainland and insular Southeast Asia, are well represented by depictions of the most popular deities as well as of rare and esoteric gods, either Hindu or Buddhist, with a single representative of the Jain faith. All are members of an elaborate and extensive family of gods. Each is assigned a specific purpose and is usually supported by a body of textual information that cites the function of the deity, the proper form of worship, and the merit that accrues to the believer when the deity is invoked, and also includes other didactic and exegetic material. Most have a long tradition of veneration, and some trace their origins to the very dawn of civilization in India. Whatever their religious affiliation, gods and goddesses are usually identifiable through a complex but somewhat standardized vocabulary of hand gestures and attributes, the latter either held or set in their hairdos. The evolution of the needs and expectations of the religious faithful is reflected in the changing popularity of individual deities over a long period of time and the introduction of new ones when required.

The formal properties of the sculptures are as varied as those found in Western art. One encounters deities depicted in iconic frontal and symmetrical poses, some that are animated through subtle shifts of the body, and a few that display aggressive, contorted postures. These characteristics correspond to a certain extent to the natures of the gods and goddesses themselves, who range from comforting, easily accessible presences to others who are forceful and aggressive. Some express the specific nature of their divinity through their multiarmed and multiheaded aspects; the forms of others adhere to different sets of iconographic prescriptions. The Buddha, for example, displays suprahuman external physical attributes (*lakshanas*), usually considered to be thirty-two major and eighty minor auspicious marks. The facial expressions of most of the deities are impersonal and

devoid of emotion, reflecting the deep inner calm and spiritual serenity of beings who have overcome personal concerns and reached a higher plane of cosmic consciousness.

The exploration of the various possibilities inherent in three-dimensional figural representation interested artists in Asia as much as those in the West. While it may not be readily apparent, we are confronted here with figures that, within their own idioms, reflect sculptural innovations worked out on the large monuments of their respective cultures. Changes in figural proportions are usually symptomatic of changes in style and redefinitions of concepts of ideal beauty that have taken place over a period of time. Some things, however, remain constant. Musculature is rarely depicted except in the sculpture of Gandhara, which was heavily influenced by the styles of the classical world. Instead, the body is conceived of as a container for the vital inner breath (*prana*), which, pulsing outward, expands its surface into swelling volumes. In general, there is a preference for organic naturalism rather than abstracted geometricized forms.

In addition to the figural sculpture in the exhibition, there are many decorative objects. These objects all display a high level of craftsmanship, and those of the most superb quality reflect the consummate skill of master artisans. Some were created for domestic use, but most had a ritual function. The purposes of a rare few remain unknown. Many of the figures and objects are small yet through their scale and the interrelationship of their individual forms, and in some instances a deep sense of religious intensity, convey a sculptural presence and radiate a grandeur far in excess of their physical dimensions.

Exhibition catalogues have their own idiosyncrasies, and this one, reflecting a collection that is very rich in some areas while excluding others, makes no attempt to survey the history of Indian and Southeast Asian art. The entries have been arranged geographically and approximately chronologically. Since some of the works of art are classic representatives of familiar types and others are decidedly rare examples of categories about which little is known, the lengths of the entries vary dramatically.

In the attempt to make this catalogue useful for both layman and scholar, compromises have been made that will be unsatisfactory to both. Nevertheless, it is hoped that this publication, the only one to date that deals specifically with the Eilenberg collection, will provide some new insight into what is a most extraordinary assemblage of Indian and Southeast Asian art. The task of selecting these 187 works of art from the more than 400 now in the Museum's collection has not been easy. Many more will be on view when the Metropolitan's Florence and Herbert Irving Galleries dedicated to Indian and Southeast Asian art open in the not too distant future.

Martin Lerner
Curator of Indian and Southeast Asian Art

The Man and His Collection

Since I have known Samuel Eilenberg and his collection for over thirty years, it seems appropriate to share here some personal observations about them. My first encounter with Professor Eilenberg was not face-to-face, but rather through an exhibition and its catalogue. The show, a wonderful one called *Masterpieces of Asian Art in American Collections*, was held at the old Asia Society galleries more than thirty years ago—in 1960 to be exact. In that exhibition there were eleven Indian and Southeast Asian sculptures. Six of the eleven came from major museums —none, by the way, from the Metropolitan—and the other five were borrowed from Samuel Eilenberg. In 1958 or 1959, when the selection for that exhibition was made, one would have been hard pressed to think of another private collection in this country that could have yielded sculptures of the quality and importance of those lent by Eilenberg. From that first Asia Society exhibition until today, there have been very few significant exhibitions of Indian and Southeast Asian art in which the Eilenberg collection was not represented.

Eventually I met the collector, and, while my initial encounters were not disappointing, I later realized they were incomplete. Not until one visited his Riverside Drive apartment and spent time with him and his collection could one get a measure of the man. Without that visit, one could not get a sense of the vast scope of his holdings, nor experience the delight of seeing Samuel Eilenberg within the environment of the works of art he had assembled. To listen to him discoursing with contagious enthusiasm was not only a great treat but also a reminder that one was in the presence of a formidable connoisseur-collector, with an obvious command of his subject. And, when he pointed out some interesting features of a new acquisition, one might perceive a rare synthesis of the former rabbinic student's appreciation of the seriousness of acquiring knowledge, the mathematician and educator's devotion to a logical clarity that can be explained to others, and the committed art-collector's concern for beauty and for man's mastery over base materials. For him, collecting art is clearly a compulsion—it is as if his soul requires the romance of a very different kind of aesthetic satisfaction to balance that of his mathematics. The collections at Riverside Drive were available to be seen and studied, and as Eilenberg opened one drawer after the other, it became clear that more could be seen and more learned about Indonesian bronzes and early Gandharan and Kashmiri *kleinkunst* here than at any museum in this country.

If one had to isolate the major strength of the collection, one would choose its extensive holdings of Southeast Asian bronzes, particularly those of Indonesia. The latter incorporate what is widely regarded as the finest private collection in the world of Javanese bronze sculpture: It is unrivaled in both its quality and comprehensiveness. The holdings also include a fine selection of Gandharan minor arts—small objects from Pakistan and Afghanistan dating from the first through the fifth century—as well as some very rare and remarkable examples of early Indian art, and sculpture from Thailand, Cambodia, Sri Lanka, Nepal, and Tibet.

Thirty-five years ago, Eilenberg, with prescience and conviction, was a pioneer in areas that only today are beginning to be appreciated. But from the very outset, his method of collecting was distinguished from that of many others by the simple fact that he knew precisely what he was doing. Eilenberg established himself as a primal force, constantly on the prowl, blanketing vast areas of South Asian art. He was the will-o'-the-wisp who seemed to be everywhere, often one step ahead of everyone else—buying either at public auction or in some relatively remote part of the world those small, exquisite, sometimes esoteric objects that are the heart of his collection.

Eilenberg's style of collecting is very elegant and to the point—I have been told he writes mathematics in just the same way. He bought in areas of special interest to him—often acquiring pieces that helped explain features of other objects he owned. He created study collections of the highest order—comprehensive enough to provide an overview of complete classifications of objects, but of such high quality that they delight the eye of the nonspecialist as well as the initiate.

Samuel Eilenberg, it seems to me, has always possessed a particularly acute appreciation of the appropriate. I cannot imagine a more fitting testament to that rare quality than the arrangements he initiated to have his collection integrated into the Indian and Southeast Asian collections of the Metropolitan Museum. The combining of his somewhat idiosyncratic holdings with the Museum's collection will enable us to present to the public a rich, and now synoptic, overview of the artistic accomplishments and contributions of these great cultures.

Martin Lerner

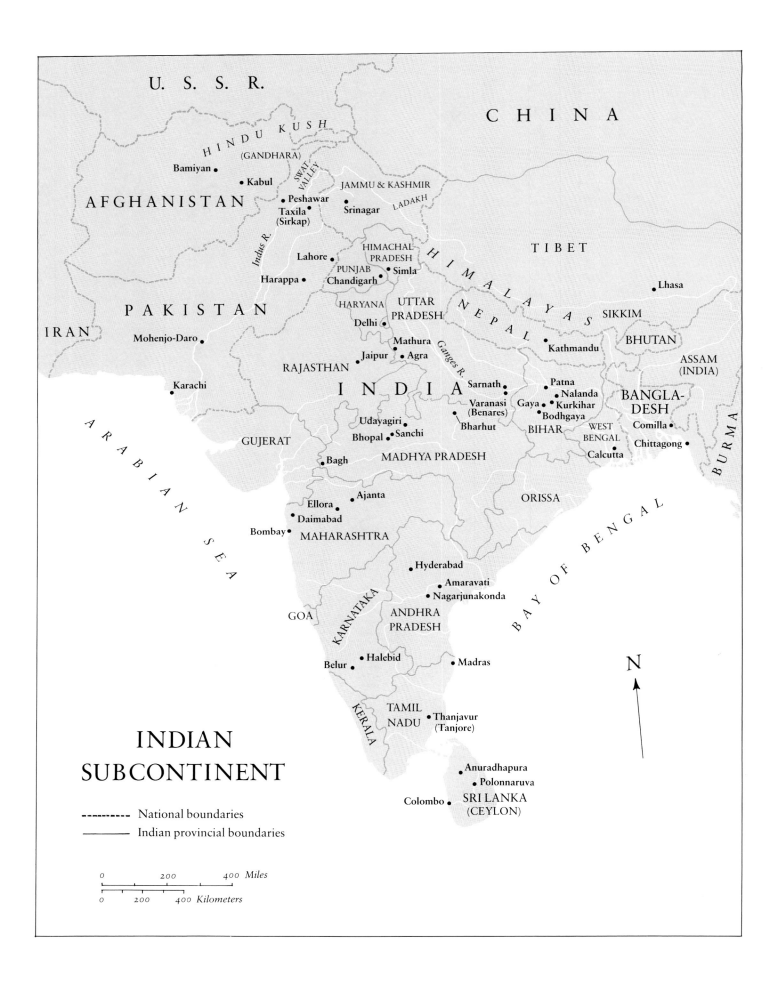

U. S. S. R.

CHINA

HINDU KUSH
(GANDHARA)

Bamiyan
• Kabul

AFGHANISTAN

SWAT VALLEY

JAMMU & KASHMIR

Peshawar
Taxila
(Sirkap)
Srinagar
LADAKH

TIBET

Lhasa

Indus R.

Lahore
HIMACHAL
PRADESH
Simla

HIMALAYAS

SIKKIM

IRAN

PAKISTAN

Harappa
PUNJAB
Chandigarh

HARYANA
Delhi

UTTAR
PRADESH

NEPAL

BHUTAN

Kathmandu

ASSAM
(INDIA)

Mohenjo-Daro

Mathura
Jaipur
Agra

RAJASTHAN

INDIA

Ganges R.

Sarnath
Varanasi
(Benares)

Patna
Nalanda
Kurkihar
Gaya
Bodhgaya

BANGLA-
DESH

Comilla

Karachi

Udayagiri
Bhopal
Sanchi

Bharhut

BIHAR

WEST
BENGAL

Chittagong

ARABIAN
SEA

GUJERAT

Bagh

MADHYA PRADESH

Calcutta

BURMA

ORISSA

Ajanta

Ellora
Daimabad

Bombay

MAHARASHTRA

BAY OF BENGAL

Hyderabad

Amaravati
Nagarjunakonda

N

GOA

KARNATAKA

ANDHRA
PRADESH

Belur
Halebid

Madras

INDIAN
SUBCONTINENT

KERALA

TAMIL
NADU

Thanjavur
(Tanjore)

- - - - - - - - National boundaries

——————— Indian provincial boundaries

Anuradhapura
Polonnaruva

Colombo
SRI LANKA
(CEYLON)

0 200 400 Miles

0 200 400 Kilometers

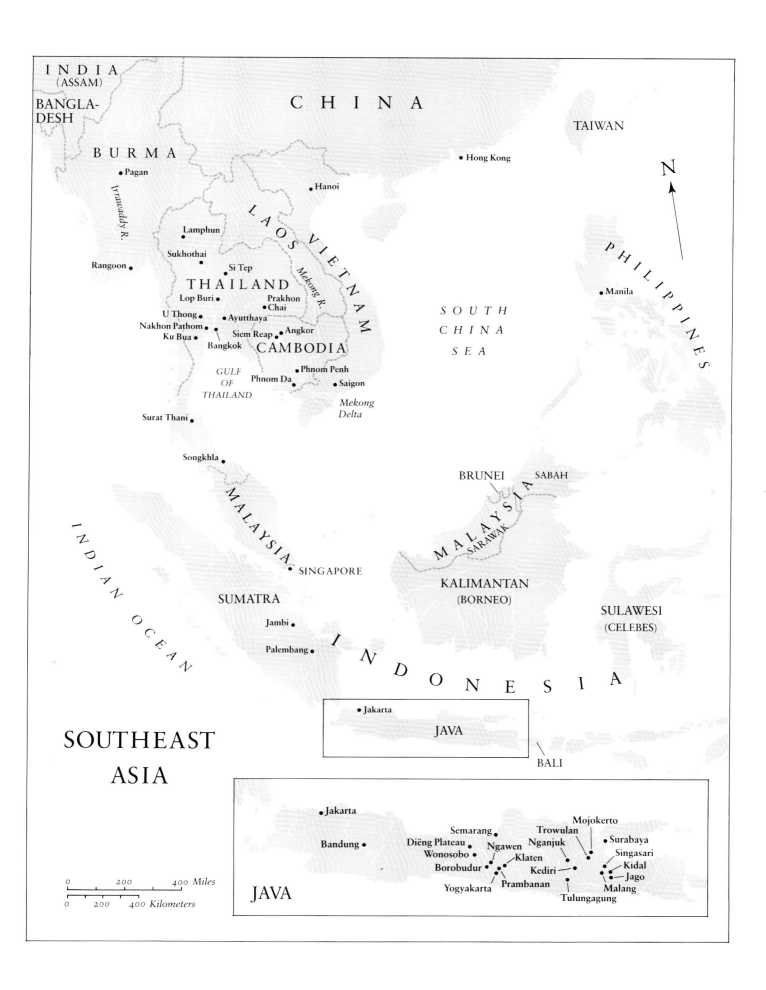

INDIA
(ASSAM)

BANGLA-
DESH

CHINA

TAIWAN

BURMA

• Hong Kong

• Pagan

• Hanoi

LAOS

Irrawaddy R.

• Lamphun

VIETNAM

• Sukhothai

• Si Tep

N

PHILIPPINES

Rangoon •

THAILAND

Mekong R.

• Lop Buri

SOUTH
CHINA
SEA

• Manila

Prakhon
• Chai

U Thong •

• Ayutthaya

Nakhon Pathom •

Siem Reap • • Angkor

Ku Bua •

Bangkok

CAMBODIA

GULF
OF
THAILAND

• Phnom Penh

Phnom Da •

• Saigon

*Mekong
Delta*

Surat Thani •

Songkhla •

BRUNEI

SABAH

MALAYSIA

SARAWAK

INDIAN OCEAN

MALAYSIA

• SINGAPORE

KALIMANTAN
(BORNEO)

SULAWESI
(CELEBES)

SUMATRA

Jambi •

INDONESIA

Palembang •

SOUTHEAST
ASIA

• Jakarta

JAVA

BALI

0 200 400 *Miles*

0 200 400 *Kilometers*

JAVA

• Jakarta

Mojokerto

Bandung •

Semarang •

Diëng Plateau •

Ngawen

Trowulan

Nganjuk

• Surabaya

Wonosobo •

Klaten

Singasari

Borobudur •

Kediri

• Kidal

Yogyakarta

Prambanan

• Jago

Tulungagung

Malang

Colorplates

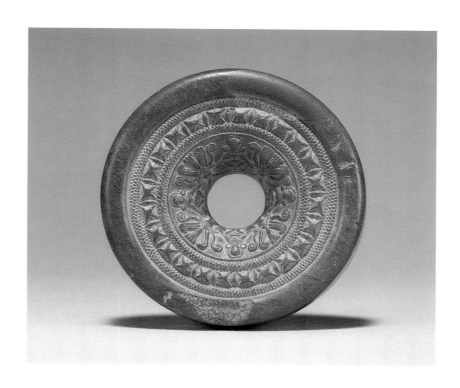

2 **Ringstone with Four Goddesses and Four Date Palms.**
India, Mauryan period, 3rd–2nd century B.C. Stone, diam. 2 5/16 in. (5.9 cm).
Lent by Samuel Eilenberg

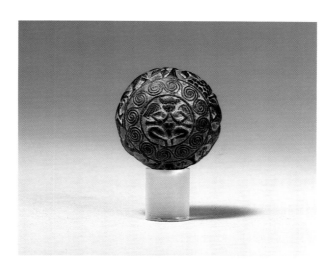

9 **Spherical Object with Scenes of Rites at a *Yaksha* Shrine** (top view).
India, 1st century B.C. Stone, diam. 1 3/16 in. (3 cm).
Purchase, Evelyn Kranes Kossak Gift, in memory of John Kossak, 1987 1987.218.22

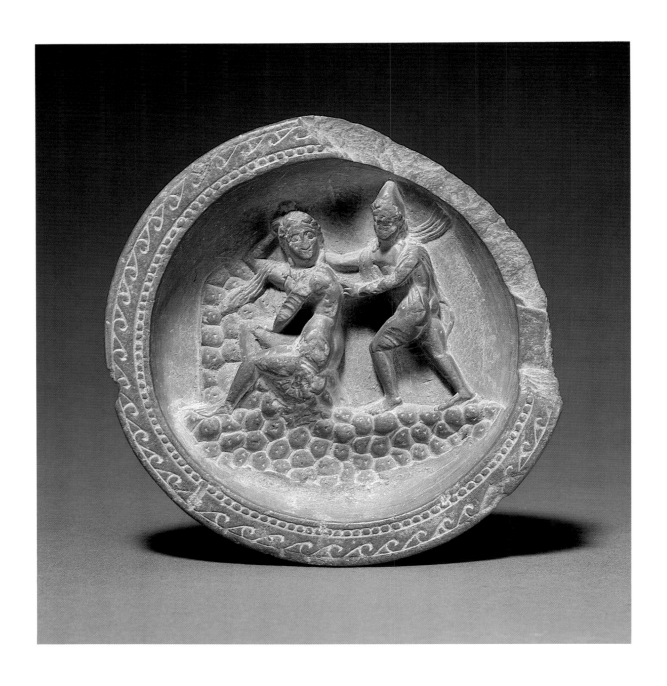

17 **Dish with Apollo and Daphne.** Pakistan, Gandhara, Sirkap(?),
Greco-Bactrian period(?), ca. 2nd century B.C. Schist, diam. 4 ³⁄₁₆ in. (10.6 cm).
Gift of Samuel Eilenberg, 1987 1987.142.307

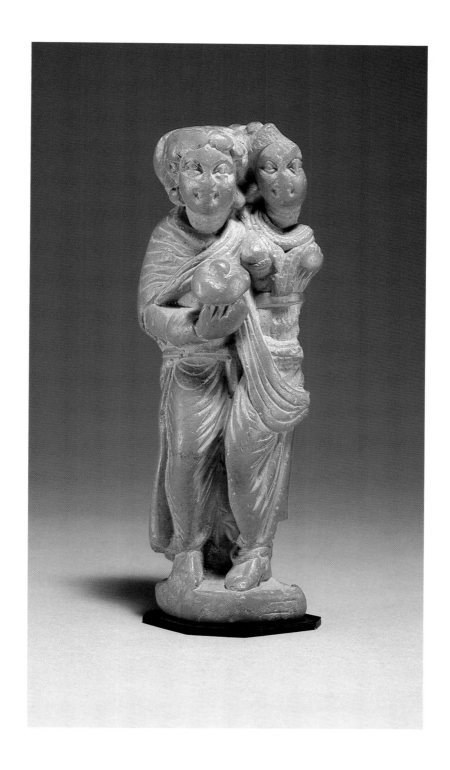

30 **Mirror Handle with a Pair of Women.** India or Pakistan,
early 1st century B.C.–1st three-quarters of 1st century A.D. Stone, h. 4⅜ in. (11.2 cm).
Gift of Samuel Eilenberg, 1987 1987.142.38

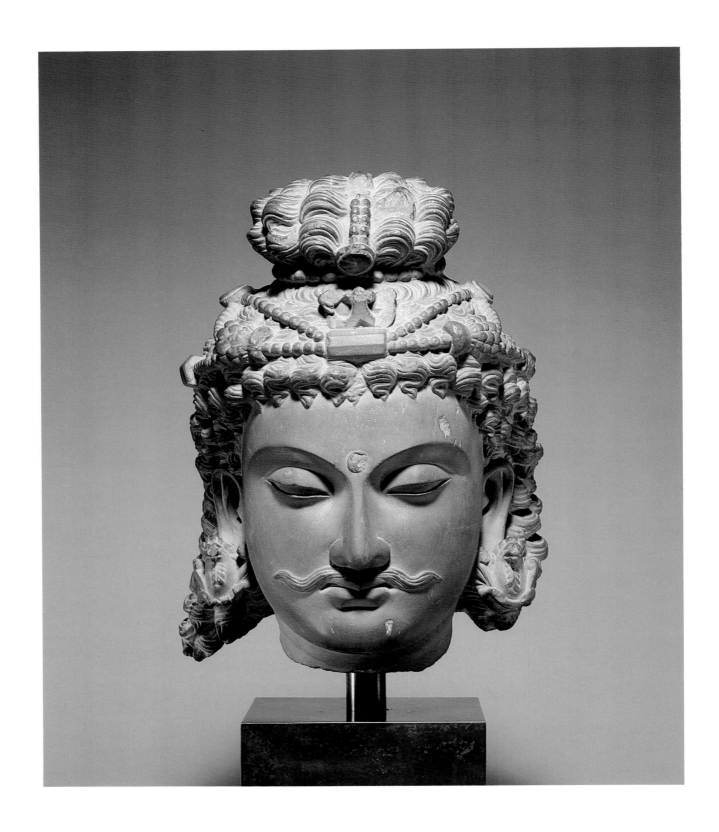

49 **Head of a Bodhisattva.** Pakistan, Gandhara,
Sahri Bahlol, Kushan period, late 2nd century. Schist, h. 10¹¹/₁₆ in. (27.2 cm).
Purchase, Anonymous Gift, 1987 1987.218.11

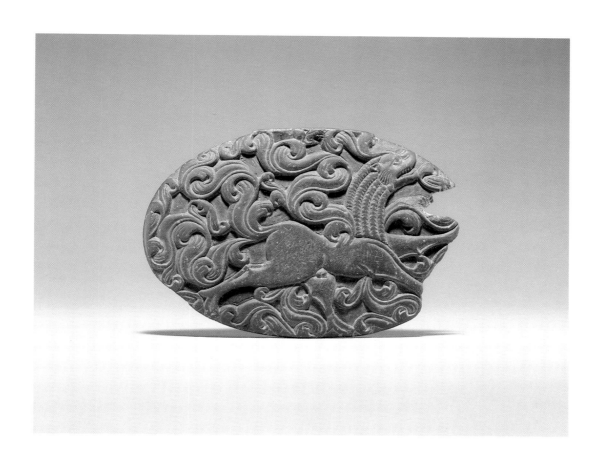

58 **Box Lid with a Winged Lion.** Pakistan, Gandhara, ca. 5th century.
Schist with remnant of iron hinge, w. 4 ⅜ in. (11.1 cm).
Lent by Samuel Eilenberg

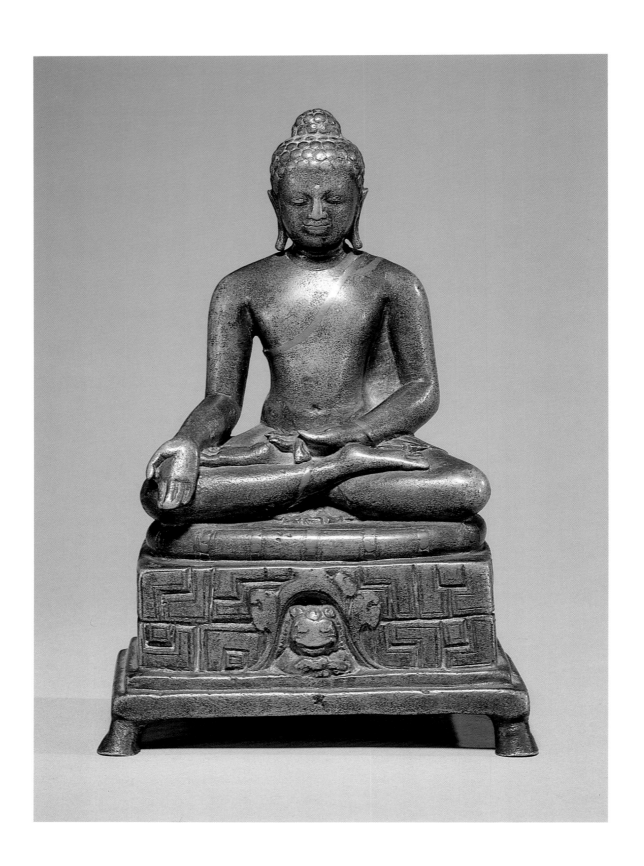

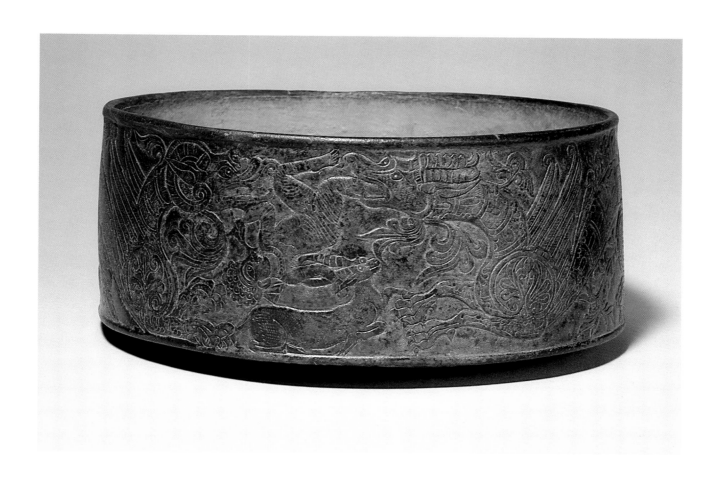

67 **Seated Buddha.** India, Post-Gupta period,
later Sarnath style, late 6th–1st half of 7th century.
Bronze inlaid with silver and copper, h. 7 in. (17.8 cm).
Purchase, Rogers Fund, 1987 1987.218.2

72 **Ritual Basin.** Pakistan, Gandhara, or Central Asia(?),
7th–9th century. Bronze, diam. 7¹¹⁄₁₆ in. (19.5 cm).
Purchase, The Dillon Fund Gift, 1987 1987.218.6

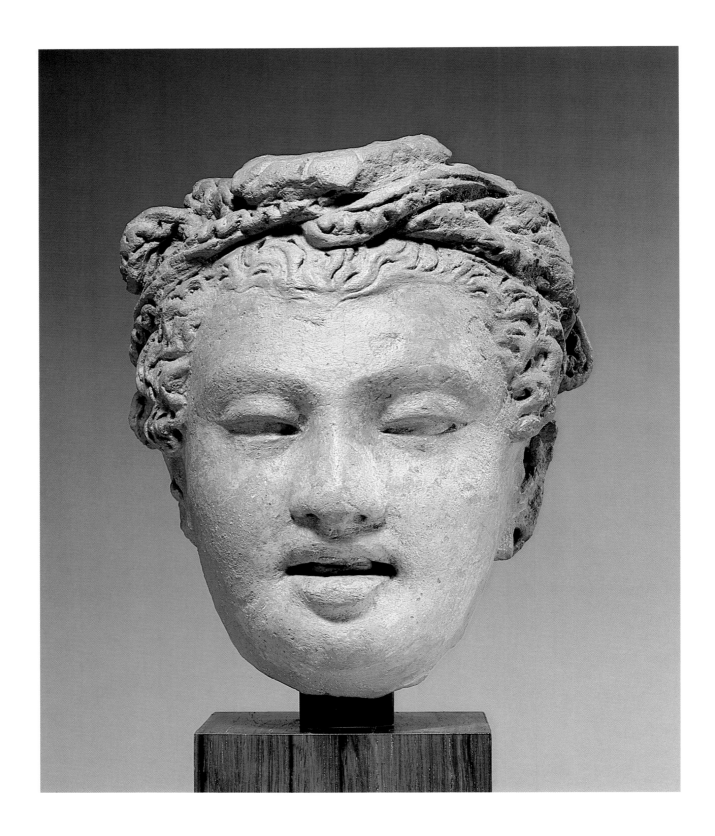

73 **Male Head.** Pakistan, Gandhara region,
4th century. Terracotta, h. 8⁹⁄₁₆ in. (21.9 cm).
Gift of Samuel Eilenberg, 1987 1987.218.13

78 **Section of a Portable Shrine with Two Scenes from the Life of Buddha.**
Pakistan, Gandhara region, ca. 5th century. Stone, h. 3⁷⁄₁₆ in. (8.7 cm).
Gift of Samuel Eilenberg, 1987 1987.142.53

82 **Section of a Portable Linga with Shiva and Parvati.**
India, Kashmir, 7th century. Chlorite, h. 3 in. (7.6 cm).
Gift of Samuel Eilenberg, 1987 1987.142.66

88 **Seated Buddha.** Pakistan, Swat Valley,
8th century or earlier. Bronze, h. 8⅜ in. (21.3 cm).
Purchase, Lita Annenberg Hazen Charitable Trust Gift, 1987 1987.218.3

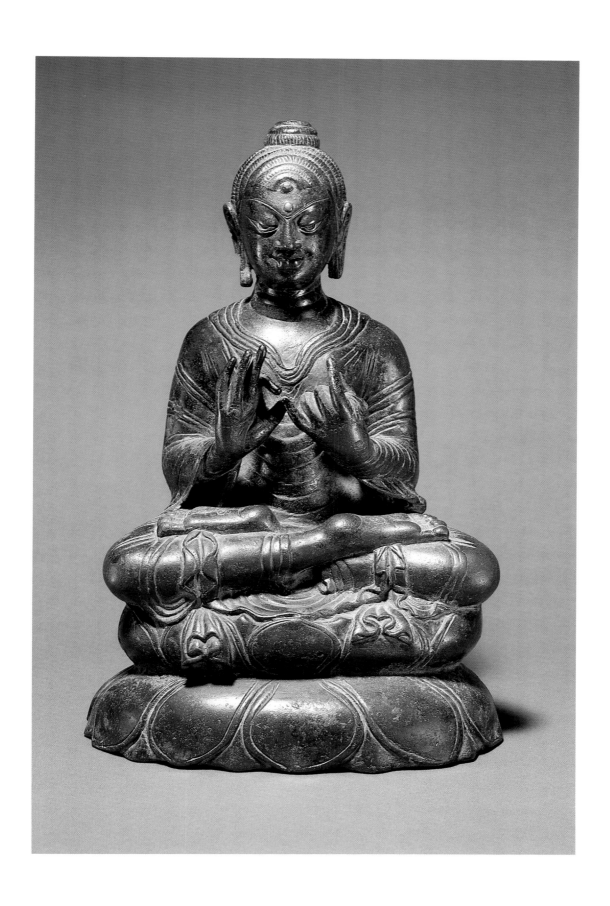

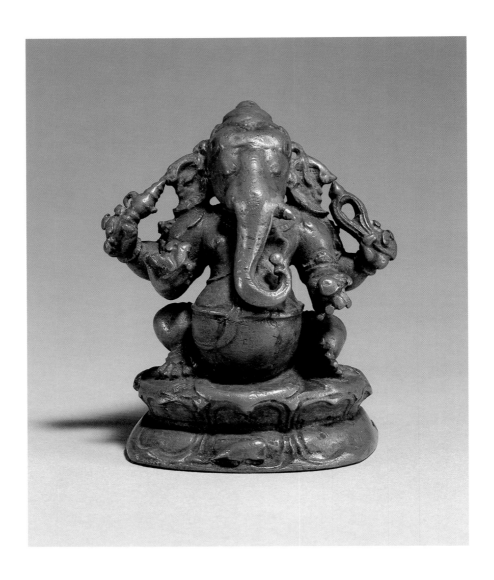

103 **Seated Four-Armed Ganesha.** India, Tamilnadu,
Chola period, late 12th–13th century. Copper, h. 2⅞ in. (7.3 cm).
Gift of Samuel Eilenberg, 1987 1987.142.325

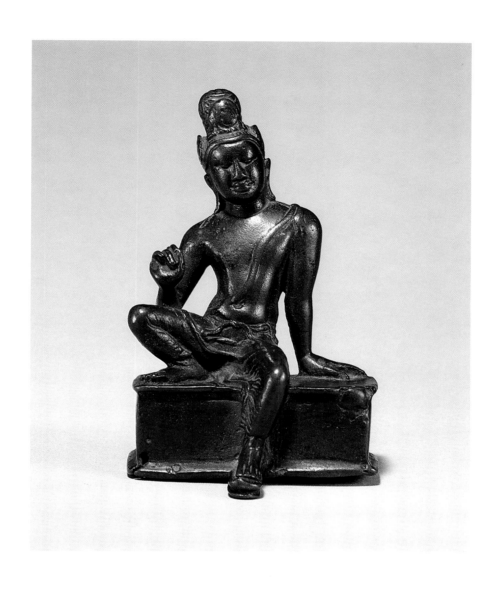

108 **Seated Avalokiteshvara.** Sri Lanka,
Anuradhapura period, ca. late 7th–1st half of 8th century. Bronze, h. 3 5/16 in. (8.4 cm).
Gift of Samuel Eilenberg in memory of Carneg Kevorkian, 1987 1987.142.65

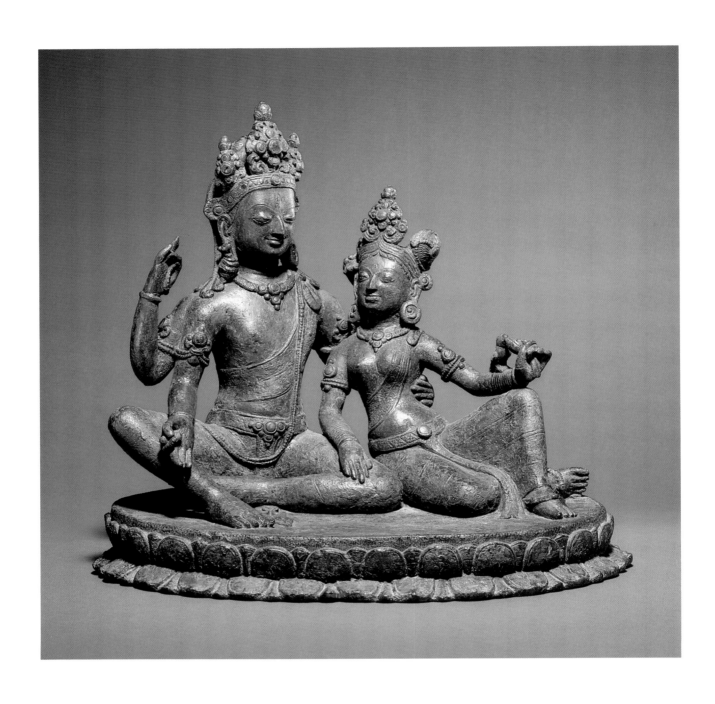

113 **Shiva Seated with Uma (Umamaheshvara).** Nepal,
Thakuri dynasty, 11th century. Copper, h. 11⅛ in. (28.3 cm).
Purchase, Rogers Fund, 1987 1987.218.1

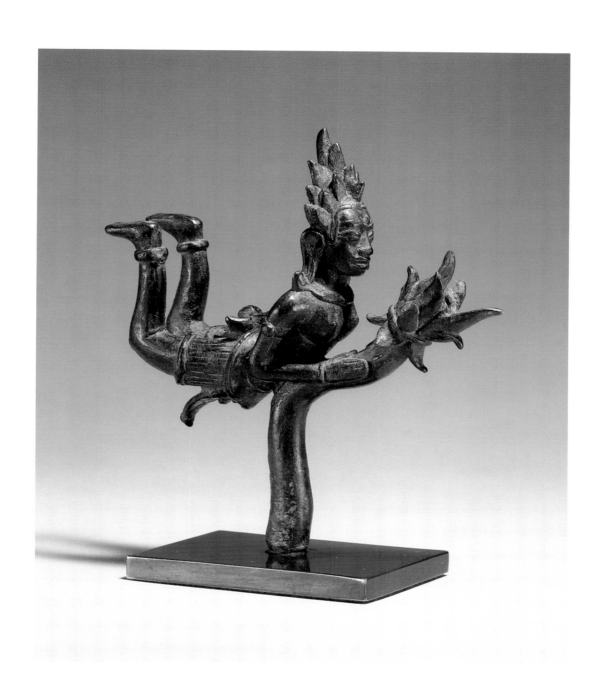

126 **Finial in the Form of an *Apsaras*.** Thailand,
Haripunjaya, Mon style, ca. 12th century. Bronze, h. 4 ¹⁵⁄₁₆ in. (12.5 cm).
Purchase, Mr. and Mrs. Uzi Zucker Gift and Rogers Fund, 1987 1987.218.23

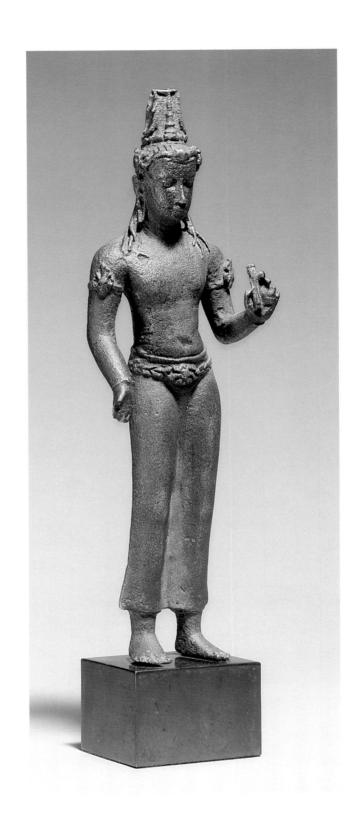

130 **Standing Maitreya (or Manjushri?)**. Indonesia,
Shrivijaya style, late 7th–early 9th century. Bronze, h. 9 ¼ in. (23.5 cm).
Purchase, Pfeiffer Fund, 1987 1987.218.15

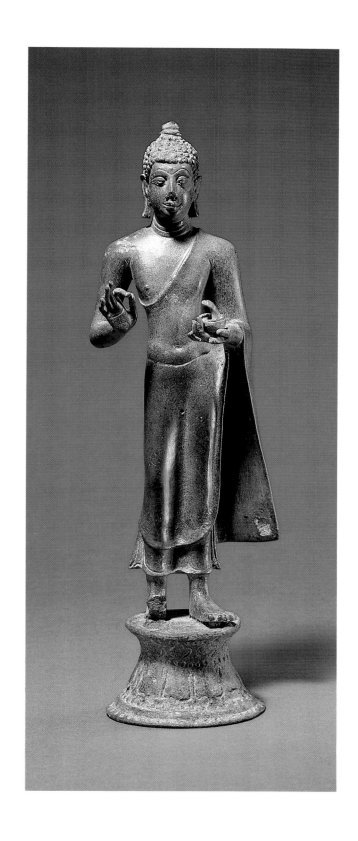

137 **Standing Buddha Shakyamuni.** Indonesia, Java,
Central Javanese period, 9th century. Bronze, h. 7¹¹⁄₁₆ in. (19.5 cm).
Gift of Samuel Eilenberg, 1987 1987.142.19

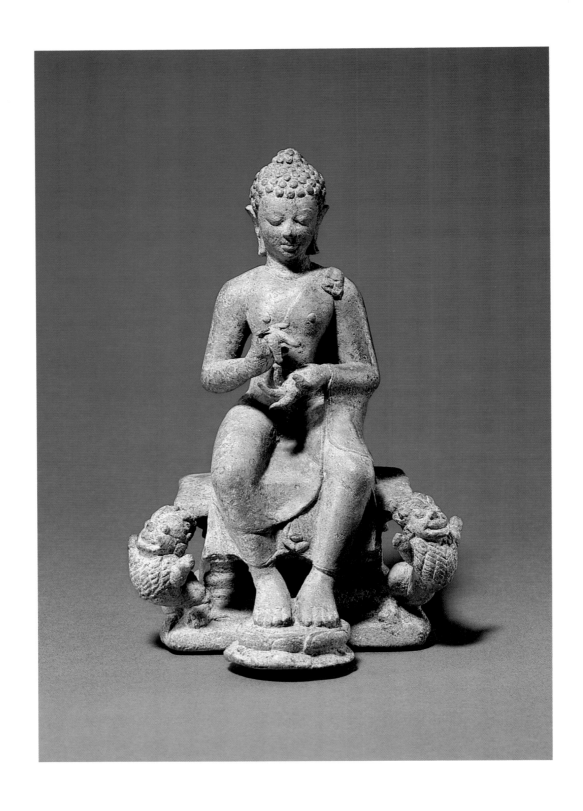

138 **The Transcendental Buddha Vairochana(?) Seated in Western Fashion.**
Indonesia, Java, Central Javanese period, ca. mid-9th century. Bronze, h. 5 ⅛ in. (13.1 cm).
Gift of Samuel Eilenberg, 1987 1987.142.14

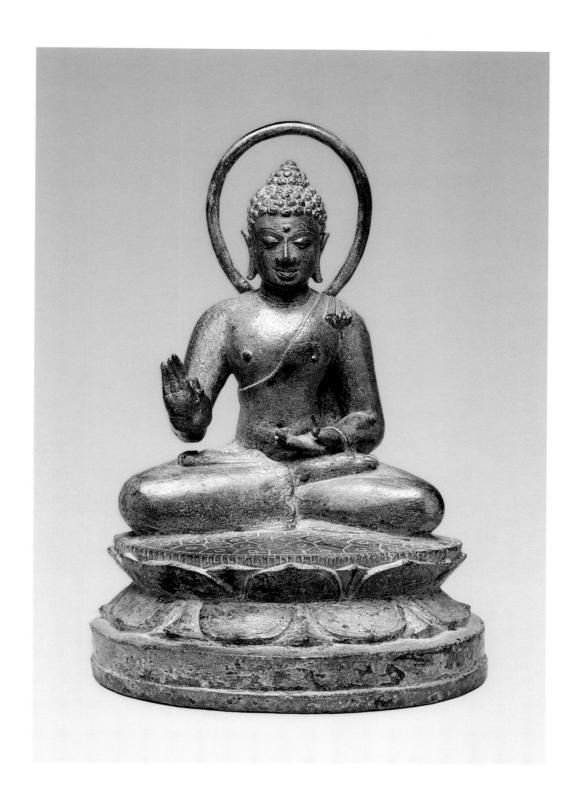

139 **Seated Transcendental Buddha Vairochana.** Indonesia, Java,
Central Javanese period, ca. late 9th century. Bronze, h. 7⅝ in. (19.3 cm).
Gift of Samuel Eilenberg, 1987 1987.142.23

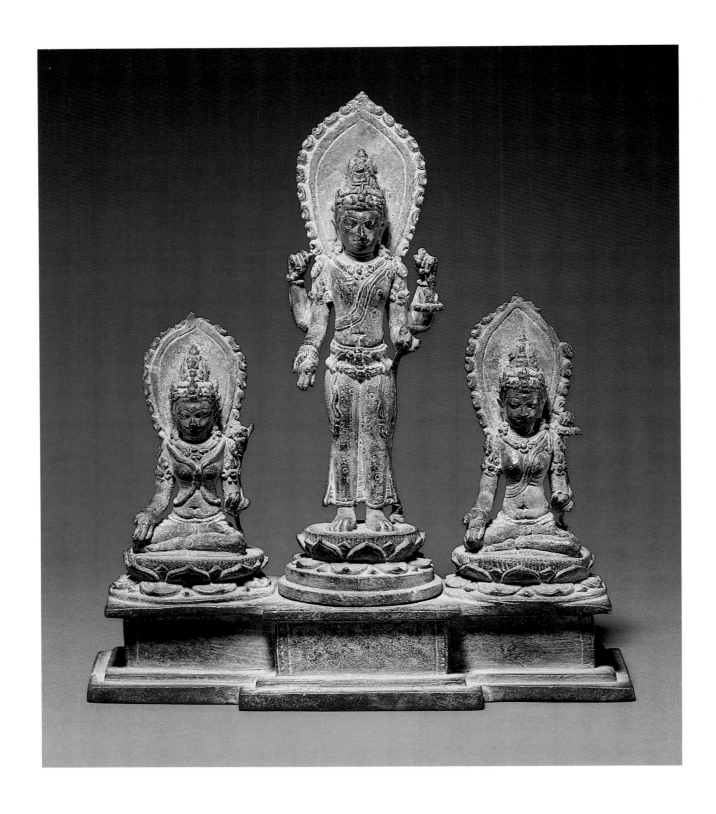

140　**Standing Four-Armed Avalokiteshvara Flanked by Tara and Bhrikuti(?).**
Indonesia, Java, Central Javanese period, 2nd half of 9th–early 10th century.
Bronze inlaid with silver, 7 9/16 x 6 7/8 in. (19.2 x 17.5 cm).
Gift of Samuel Eilenberg, 1987 1987.142.22

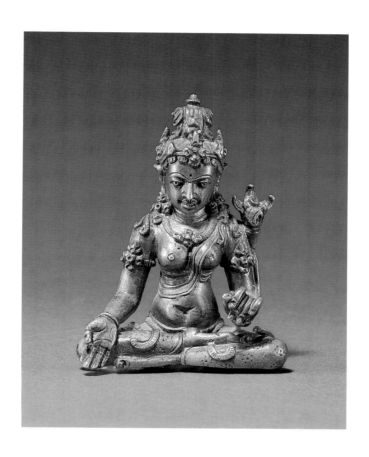

141 **Seated Tara.** Indonesia, Java,
Central Javanese period, 2nd half of 9th–early 10th century. Silver, h. 2⅛ in. (6 cm).
Gift of Samuel Eilenberg, 1987 1987.142.12

149 **Hanging Lamp in the Form of a *Kinnari*.** Indonesia, Java,
Central Javanese period, ca. 2nd half of 9th–early 10th century. Bronze, w. 7⁷⁄₁₆ in. (18.9 cm).
Gift of Samuel Eilenberg, 1987 1987.142.24

150 *Kinnara* **Playing the** *Vina.* Indonesia, Java,
Central Javanese period, ca. 1st quarter of 10th century. Bronze, h. 6 1/16 in. (15.4 cm).
Gift of Samuel Eilenberg, 1987 1987.142.16

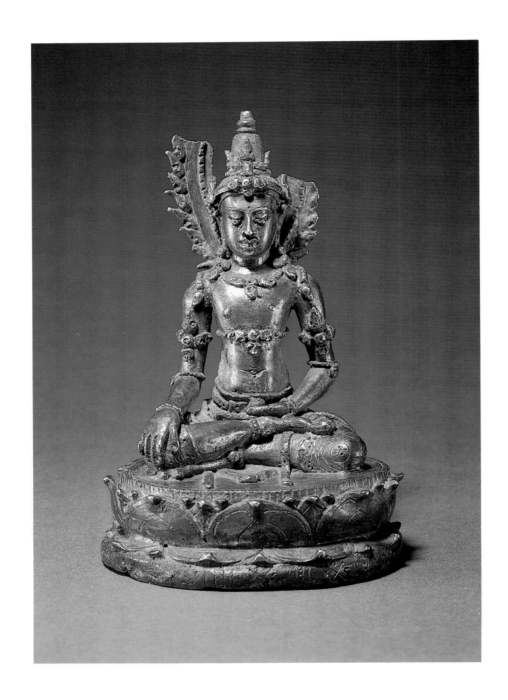

156 **Seated Dhyani Buddha Akshobhya(?)**. Indonesia, Java,
Eastern Javanese period, 2nd half of 10th century. Silver, h. 3 ⅝ in. (9.3 cm).
Gift of Samuel Eilenberg, 1987 1987.142.11

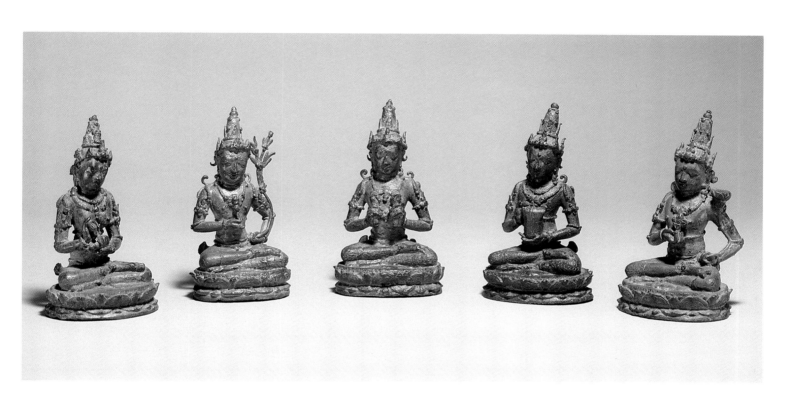

158 a–e **Five of Six Sculptures from a *Vajradhatu* Mandala.**
Indonesia, Java, Nganjuk, Eastern Javanese period,
last quarter of 10th–1st half of 11th century. Bronze, h. 3 9/16–3 5/8 in. (9–9.2 cm).
Gift of Samuel Eilenberg, 1987 1987.142.5–9

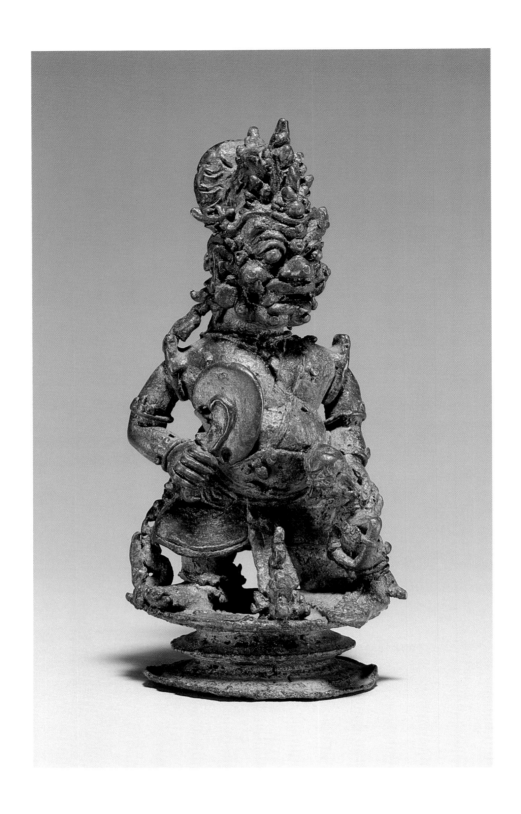

171 **Bell Finial in the Form of a *Rakshasa*.** Indonesia, Java, Eastern Javanese period,
ca. 2nd half of 12th–early 13th century. Bronze, h. 4 15/16 in. (12.5 cm).
Gift of Samuel Eilenberg, 1987 1987.142.17

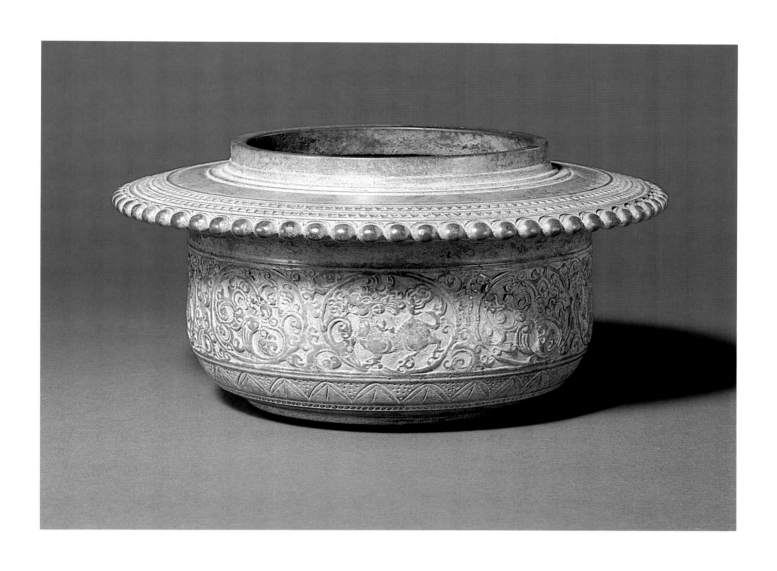

175 **Holy-Water Vessel.** Indonesia, Java,
Eastern Javanese period, 11th–12th century. Bronze, diam. 7⁵/₁₆ in. (18.6 cm).
Gift of Samuel Eilenberg, 1987 1987.142.193

Catalogue

All works are Samuel Eilenberg Collection. Height (h.) precedes width (w.), d. signifies depth, diam. stands for diameter. The abbreviation B.C. is used for dates before Christ, and B.C. and A.D. are used for inclusive dates ranging over both eras. For dates after Christ, no such designation is used. Diacritical marks are omitted, and phonetic spellings are used. Information in published references and notes is abbreviated. For full listings, see the Bibliography, pp. 229-34.

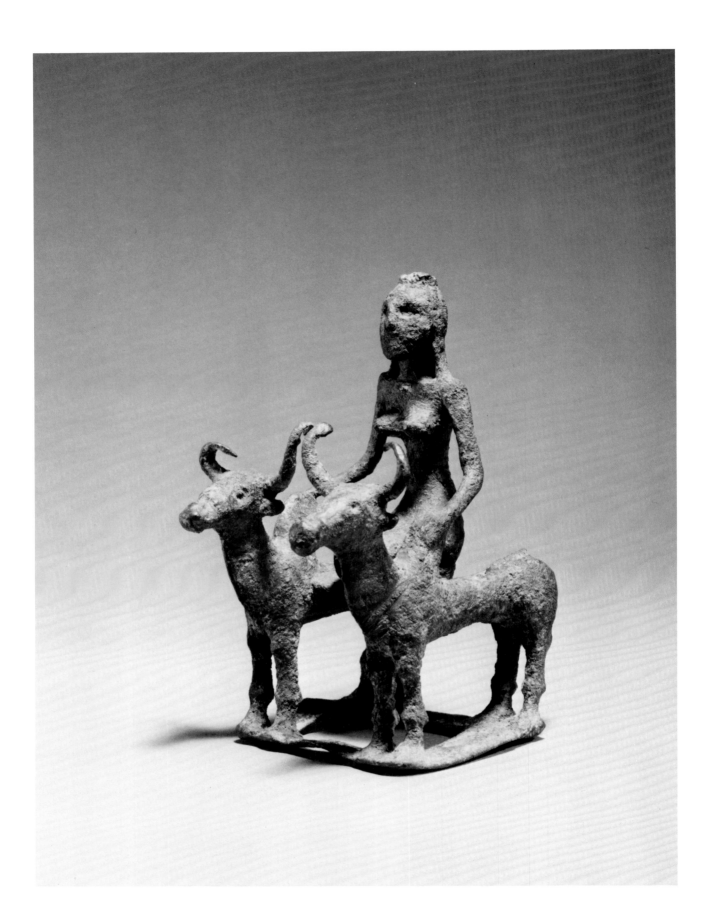

Early India and Pakistan

Ringstones, Discstones, Stone Dishes, Mirror Handles, and Other Objects

1 **Woman Borne by Two Brahman Bulls**

India, Kaushambi, late Harrapan period,
ca. 2000–1750 B.C.
Bronze, h. 5 1/8 in. (13 cm)
Lent by Samuel Eilenberg

This unique sculpture portrays a woman kneeling on a platform supported between two Brahman bulls on whose humps her hands rest. The animals stand on a small square ledge that was cast separately. The bulls' bodies are rather lean, with prominent joints, and they have long muzzles, incised eyes and nostrils, and small, triangular ears. Their outer horns curve inward, toward their foreheads, and their inner horns curve up and back, toward the woman. Curiously, their tails rest flat on top of their backs. The rider has a large head with summarily rendered features: deep eye-sockets, a jutting nose, and an incised slash of a mouth. Her hair falls to her shoulders, and she appears to be wearing a crownlike ornament on top of her head. She has a lithe upper body with broad shoulders, long, spindly arms, and prominent, upturned breasts. Her lower body is full in comparison with her torso, yet not so voluptuous as the wasp-waisted goddesses who later come to epitomize the ideal female form in early Indian sculpture.

In terms of subject and general form, this sculpture seems to be directly related to the Daimabad bronzes, which are dated to the late Harrapan period (about 2000–1750 B.C.). However, a close comparison reveals a number of differences. The animals of the Daimabad group are much larger than our bulls, with fuller volumes and more reduced, naturalistic forms.[1] The only human figure in the Daimabad group, a standing male charioteer, has a more elongated body, more prominent hips, and fuller arms than our rider. Although their heads are similar in shape, the Daimabad man's is proportionately much smaller than the Eilenberg woman's. These contrasts notwithstanding, the Daimabad group offers the closest known parallel to our sculpture. The Daimabad sculpture and the present bronze are among the few existing links between the artistic products of the Indus Valley cultures and those of the Mauryan period.

SK

1 Sali, pls. CXXIV–CXXX; P. Chandra 1985, no. 3.

Ringstones

Ringstones are an important and enigmatic category of early Indian art. They are small, doughnut-shaped objects whose top surfaces, richly decorated with raised carvings, are contoured in the form of gentle parabolas that curve down and in to constitute the walls of their central voids. The perimeters and bottom surfaces of ringstones are flat and smoothly finished but are never decorated. Typically, a register of frontal nude goddesses alternating with plants appears on the inner wall of the void and can be conceived of as being in the process of emerging from it. The remaining portion of the surface is carved with concentric bands of decoration. Often the cross-and-reel design appears in several bands, and occasionally the largest, outer band is filled with either plant motifs or animals.

Ringstones are dated to the Mauryan period, the third to second century B.C. Their bravura miniaturized carving, whose individual elements look more like repeated stamped impressions than integrated bas-relief carvings, seems to have closer affinities with the aesthetics of Near Eastern seals and early Greek mold-made ceramics than with later Indian sculpture. Although neither the precise format of the ringstones nor the style of their carving survived much later than the Mauryan period, in their iconography and general form they appear to be related to another mysterious group of objects, which may have evolved from them, called discstones (see Nos. 5–8).

The function and iconography of ringstones have been much discussed. Their connection with a fertility cult has always seemed likely, given the nudity and splayed attitude of the ubiquitous goddesses, the plant imagery (palmettes, lotuses, and fruiting trees), and the obvious analogy of the rings' form with the female genitalia. The birthing metaphor, expressed by an amalgam of flower and female genitalia, is crucial to an understanding of these objects. The ringstones give metaphoric birth to female goddesses, animals, and plants from their central voids. Perhaps they are carved only on their convex surfaces because this artistic solution allows the stone object to suggest both the thinness of a flower's petals and a fragment of human anatomy. That the floral analogy is important to the meaning of ringstones is supported by the

fact that many of the related discstones take on actual floral form.[1]

It has been suggested that the iconography of ringstones derives from the Vedic tradition. However, considering the rather limited role of goddesses in early Hinduism, there is little justification for the assumption. Similarly, there is no evidence to indicate that this iconography should be directly related to the worship of the local genies of the earth, *yakshas*, or their female counterparts, *yakshis*. The imagery must be understood as a generic part of the religious systems of early India rather than as related to any specific cult. An association with the cult of any particular goddess or class of female deities, therefore, must remain conjectural.[2]

The function of ringstones is uncertain. Several scholars have suggested that both ringstones and discstones were either earplugs or molds for the manufacture of repoussé metal discs (which were later strengthened with a resin or shellac filling) for use as earplugs.[3] However, this theory has been substantiated neither through portrayals of figures wearing such jewelry, nor by the wear patterns on some ringstones, nor by the total lack of such patterns on others. Also, jewelry molds are generally made as intaglios, which allow for a maximum of detail to be transferred. Another common conjecture, that they are in some way related to *chakras* (wheel-shaped objects) or yantras (geometric diagrams) used in later rituals as focuses for meditation, seems more likely, given their symmetry and the repetitiveness of the designs.[4]

SK

1 For example, see S. P. Gupta 1980, pl. 33.
2 V. S. Agrawala has made an argument for their identification with the cult of Shri, a Vedic goddess of abundance and fertility who is associated with the lotus and is described as being encircled by and emergent from one such flower (pp. 80–82). This has been refuted by S. P. Gupta (1980, pp. 69–72). The generic nature of this description is illustrated, for example, by the fact that in the garden of Kubera, king of the *yakshas*, the "trees have jewels for leaves and girls as their fruit" (Coomaraswamy 1928, p. 6).
3 See Postel, p. 131; Coomaraswamy 1965, p. 20; Lohuizen-de Leeuw 1972, p. 29.
4 For references, see P. Chandra 1971, p. 147.

2 Ringstone with Four Goddesses and Four Date Palms

India, Mauryan period, 3rd–2nd century B.C.
Stone, diam. 2 5/16 in. (5.9 cm)
Lent by Samuel Eilenberg

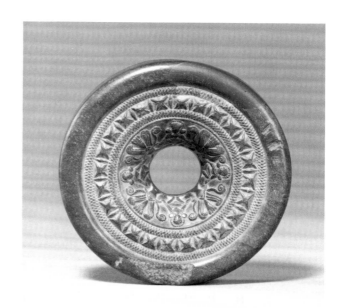

2

3 Fragment of a Ringstone with Goddesses and Palm Trees

India, Mauryan period, 3rd–2nd century B.C.
Stone, diam. 3 3/16 in. (8.1 cm)
Gift of Samuel Eilenberg, 1987
1987.142.391

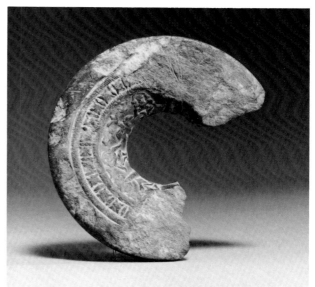

3

4 Fragment of a Ringstone with a Goddess and Two Birds

India, Mauryan period, 3rd–2nd century B.C.
Stone, w. 2 3/16 in. (5.6 cm)
Gift of Samuel Eilenberg, 1987
1987.142.374

The convex surface of the first complete ringstone shows four nude goddesses alternating with four trees framed by a quadripartite border. The goddesses wear a characteristic wiglike coiffure and are adorned with large circular earrings, tripartite collar-necklaces, bangles, and girdles. Each hourglass-shaped tree trunk supporting a palmette (*nagapushpa*) may represent an Oriental date-palm.[1] The central band is carved with the cross-and-reel motif and is surrounded by two borders with demilune profiles carved with a plaited pattern. These are in turn set within a wide, raised, undecorated border with a demilune profile. The perimeter and bottom surface are typically smooth and undecorated.

The second, fragmentary ringstone once measured about three inches in diameter and showed five goddesses alternating with five palm trees, each apparently of a slightly different configuration. Crescent-shaped motifs appear irregularly in the spaces between the goddesses' heads and the tops of the palms. A floral motif is substituted for one crescent. The goddesses are dressed much like those in the first example. A band of cross-and-reel motif, flanked on either side by a ropelike border, appears above the band of goddesses and palms.

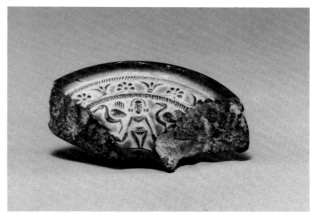

4

Originally, the last, fragmentary ringstone with a goddess and two birds had a diameter of approximately 2¼ inches and was carved with six goddesses and six *hamsas* (ganders) emerging from the central void. A band of floral decoration closely related to the early Achaemenid anthemion motif is set within ropelike borders above the figures. The wiglike coiffure and large earrings of the single goddess whose head and body remain are typical; however, she wears a girdlelike belt around her hips and a garment (necklace?) across her breast that are unusual. Her face is particularly well preserved and sensitively

carved, and its features are very similar to those of the Mauryan black terracottas of mother goddesses.[2] Uncharacteristically, the goddesses seem to be holding ovoid pointed objects in their outstretched hands; these objects may be lotus buds—not an improbable identification in view of the importance of floral imagery in ringstones.

SK

1 S. P. Gupta 1980, pp. 33, 109. The curving leaves of the palmettes in the Indian version of the motif resemble snake hoods, hence the prefix *naga* (snake).
2 See Poster, nos. 18–20.

Discstones

Discstones are closely related to ringstones in iconography, size, and general shape but have no central void. This void is replaced by a circular element, which is usually left undecorated. Often, the top edge is articulated by a single step, and the bottom is smoothly finished but undecorated. In some discstones, such as those in the Eilenberg collection, the top surface is flat rather than parabolic, and most of it has been carved away, leaving only a tracery design in shallow relief of uniform height. The carving, although sometimes extremely fine, usually does not possess either the jewel-like miniaturization or the high level of technical proficiency exhibited in the ringstones.

The way the discstones are carved, as well as their more simplified form and more varied imagery, suggests that they evolved from the ringstones.[1] Although the discstones' motifs are more diverse, the use of certain elements that appear consistently in the ringstones, for example, frontal goddesses, palmettes, and palm trees, indicates a clear iconographic ancestry in the earlier objects.[2] A functional continuity between the two categories is also likely. The iconographic and stylistic variation within the genre is so great that its dating must remain provisional. Our discstones are tentatively being assigned to the first century B.C.

SK

1 P. Chandra 1985, p. 142; S. P. Gupta 1980, pls. 17–36.
2 For example, see S. P. Gupta 1980, pl. 19A.

5 **Discstone with Quadripartite Design of Palmettes and Lotus Buds**

Pakistan, Taxila, 1st century B.C.
Stone, diam. 1¹³/₁₆ in. (4.6 cm)
Gift of Samuel Eilenberg, 1987
1987.142.55

6 **Discstone with Quadripartite Design of Palmettes and Branches**

Pakistan, 1st century B.C.
Stone, diam. 2⁵/₁₆ in. (5.9 cm)
Gift of Samuel Eilenberg, 1987
1987.142.56

7 **Discstone with Quadripartite Design of Tracery Palmettes**

India, 1st century B.C.
Stone, diam. 2⁹/₁₆ in. (6.5 cm)
Lent by Samuel Eilenberg

8 **Discstone with Tripartite Design of Palmettes and Birds**

India, 1st century B.C.
Stone, diam. 2⅛ in. (5.4 cm)
Lent by Samuel Eilenberg

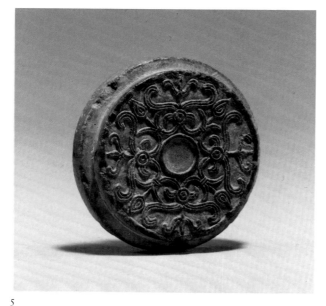

5

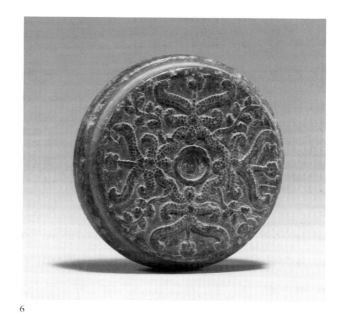

6

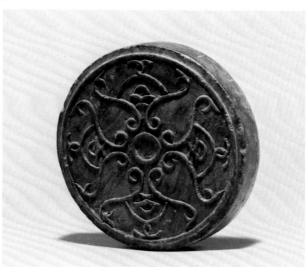

7

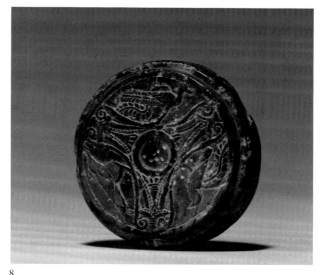

8

Four palmettes from whose interlaced lower leaves lotus buds sprout appear on our first discstone. The leaves and buds are articulated with shallow-relief lines, which give the whole the look of a fine-pen drawing.

Our second discstone shows four palmettes, each surmounted by a flower on a long stalk, with lower interlaced leaves from whose junctures curving leafy branches spring forth. The surfaces of the leaves and flowers are covered with a plethora of small dots that resemble granulation.[1]

The extraordinary tracery palmettes of the next discstone have been reduced almost to the point of abstraction. However, the bifurcating and intertwin-

ing ends of the design elements, as well as their overall configuration, reveal their vegetative ancestry.

The last discstone is ornamented with a tripartite design of three birds and stylized palmettes. Atypically, the palmettes emerge from the outer edge of the disc rather than from its center. Their outer, tendril-like elements do not issue from the palmettes but instead float free, forming large arcs whose curled ends rest against the bases of the palmettes. From the center of each of these arcs sprouts a single shoot on which is superimposed a bird. Two of the sprouts terminate in leaves and one in what may be a seed-pod. The relationship of the birds to the sprouts is ambiguous. They do not seem to be perching, since

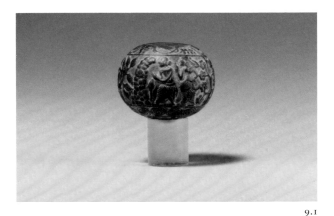

9.1

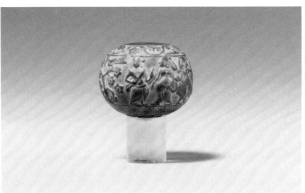

9.2

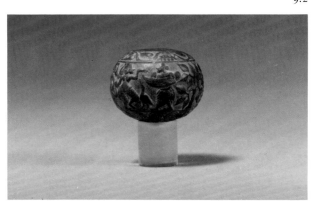

9.3

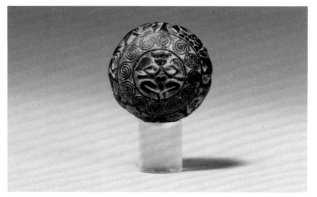

9.4

no legs or feet are shown. It is possible that they are meant to be seen as emerging metaphorically as a kind of fruit of the vine, the whole design being a symbol of nature's procreative bounty.[2] At some time, one side of the disc was pierced to allow it to be suspended.

SK

1 This discstone is almost identical to S. P. Gupta 1980, pl. 32A.
2 For a fragmentary ringstone with perching birds, see ibid.

Ex coll. D. H. Gordon, Hingham, Norfolk (No. 5).

PUBLISHED
Ashton, no. 150 (No. 5).

Postel, no. VI.16 (Nos. 7, 8).

9 Spherical Object with Scenes of Rites at a *Yaksha* Shrine

India, 1st century B.C.
Stone, diam. 1³/₁₆ in. (3 cm)
Purchase, Evelyn Kranes Kossak Gift, in memory of John Kossak, 1987
1987.218.22

Only one other object comparable to this extraordinary miniature work is known.[1] Although the function of each is enigmatic, it is clear that the basic imagery of our object is derived from that of early Indian *yaksha* cults. Early Indian cosmology divided the world into three realms—one for earth spirits, one for humankind, and the last for gods. The *yakshas* ruled over the first realm and were considered to be the guardians of the earth's bounty. Particular *yakshas* held sovereignty over specific regions within which they were believed to reside, often inside rocks or mountains.

Around the middle of our compressed sphere is a frieze partitioned into two scenes by trees, one in leaf, the other, on which a peacock is perched, covered with blooms. In the first scene, a man and woman raise their hands in a gesture of adoration toward a rock outcropping before which a lotus flower has budded. In the center of the rocks, facing the adorants, can be discerned the profile of a male head, presumably that of a *yaksha*. In the other scene, a woman accompanied by a craning goose dances to the strains of a *vina* (harp) played by a man, and a couple stands to one side, the man holding in his raised left hand a

small, pointed ovoid object, perhaps a lotus bud, at which the woman gazes.[2] The frieze is bordered above by a register of meandering grapevines—complete with bunches of grapes, curling tendrils, and leaves—and below by a scrolling device arranged in a wave pattern. The top of the sphere is unadorned, but the bottom is carved with an image of an imaginary creature in a splayed attitude playing long double pipes. This figure has the face of an animal, a human body, and large wings.

In antiquity, cults and shrines dedicated to local *yakshas* were common throughout northern India. The propitiation of these deities was deemed essential to the success of human endeavors as well as to ensure the fecundity of the earth. Wine, music, and dance all seem to have been elements in *yaksha* cult rituals. Along with water, sap, and soma (the nectar of the gods), wine may have been considered a substance that was analogous to the universal natural growth–essence.[3] A tankard or flask is, therefore, often held by a *yaksha* as an attribute.

Although a first appraisal of our object, with its superb miniaturized decoration, would seem to indicate a formal relationship with both ringstones and discstones, neither their iconography, style, nor method of carving is comparable. The *yaksha*, Dionysiac-grape iconography of the sphere is distinct from the fertility imagery of the ringstones and discstones. Also, the sphere's subtle low-relief and lithe, comparatively naturalistic depictions differ markedly from the emblematic, stamplike carving of the ringstones and discstones. Our object probably should be dated later than the majority of ringstones and discstones, a premise that is supported by details of costume and hairstyle and by the narrative format. Despite its diminutive size, the fullness of iconography, which provides an encompassing vision of one aspect of early Indian religious life, and the superb quality of execution make this work one of the most remarkable small early Indian sculptures to have survived.

SK

1 The sculpture is decorated with a procession of animals. It is unpublished.
2 Coomaraswamy 1930, pp. 244–45.
3 For a discussion of *yaksha* cults, see Carter.

10 Goddess with Weapons in Her Hair (Durga)

India, early Shunga period(?), ca. 2nd century B.C.
Bronze, h. 2 13/16 in. (7.1 cm)
Gift of Samuel Eilenberg, in honor of Steven Kossak, 1987
1987.142.289

Goddesses with weapons emerging from their coiffures are among the most commonly found iconographic types in the terracotta plaques of the Shunga period (the second century B.C. through the first century B.C.). This sculpture of the subject, however, is unique in that it is bronze and modeled in the round. The goddess stands in a frontal posture, her left hand resting on her left hip, her right arm bent with forearm held out perpendicular to her body at waist level. Her right hand is broken off, as are both feet, just above the ankles. She wears a short dhoti and a blouselike upper garment that falls over her hips. It is unclear whether the upper garment covers her breasts or supports them. The goddess is adorned with a large necklace slung low, resting just above her bosom, a tubular earring in her left ear, a large hoop-style earring in her right, and bangles on each forearm. Two open lotus flowers, joined by a band of smaller blooms(?), appear just above her ears. The two undecorated, swaglike ends of the floral wreath are visible on the back of the goddess's head. From her hair, which is parted in the center and arranged in two shallow buns, emerge six weapons, three on each side of her head. A lotus flower crowns the center of her coiffure.

The identity of this goddess has been much discussed yet has not been definitively established, despite her very frequent appearance in early terracottas.[1] This is largely because the inscriptional and literary remains of the Vedic and Buddhist traditions constitute the main sources for iconographic identification at this early date, and early Indian terracottas do not commonly portray either the principal gods of the Vedic pantheon or deities that can be associated with Buddhism in more than a general way.

By the middle of the Kushan period, the second to third century A.D., however, a whole new pantheon of gods, largely drawn from sources outside the Vedic

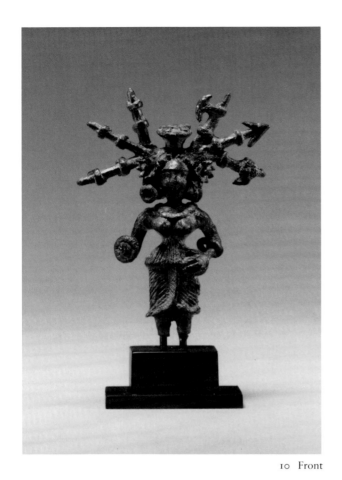

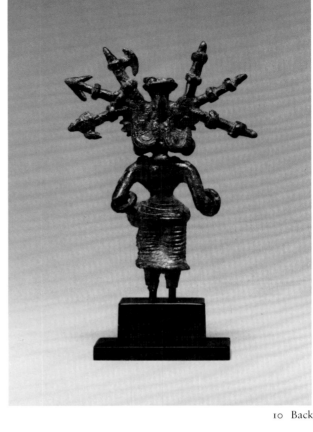

10 Front

10 Back

tradition, began to emerge as the dominant figures in Hindu thought, literature, and the visual arts. Goddesses, who served only auxiliary roles in the male-dominated Vedic literature, became primary deities. The first images of one of the most important of these, the Great Goddess Durga, are characterized by multiple arms, the majority of which carry weapons, by the figure of the Demon Buffalo, which she has subdued, and by a crown of a garland of lotuses with two looplike ends, which she is victoriously placing on her head with her two upper hands.[2]

Pratapaditya Pal has noted that in the context of their martial aspect, the terracotta goddesses may be the conceptual prototype of the later Durgas.[3] Details of our sculpture, however, would seem to indicate that the early terracottas and our bronze—bristling with weapons and crowned with a garland—are probably not prototypes but instead are the earliest representations of Durga herself. The three-dimensional nature of the Eilenberg sculpture is particularly important in the context of this identification. The long, ropelike terminals of the lotus garland that

appear on the back of the bronze but are not depicted on the terracotta plaques explain the looped ends of the wreaths held by the Durgas in the Kushan- and early Gupta-period portrayals.[4] The *Devi-mahatmya* also mentions that Durga was given a lotus flower by the earth goddess to hold in her hand along with the garland. This perhaps explains the atypical gesture that our figure makes with her outstretched arm.[5]

Coomaraswamy notes that Durga was originally a tribal goddess, that is, from outside the early Hindu tradition.[6] If my analysis of these sculptures is correct, in pre-Kushan depictions, Durga was most commonly shown in an iconic form. On the other hand, thereafter she was almost always portrayed in a narrative format—subduing the Demon Buffalo. The change probably occurred because it is precisely this incident, wherein the assembled Hindu gods implored her to come to their aid against the unconquerable Demon Buffalo, armed with weapons they had given her, that signifies her acceptance by, entry into, and importance within the post-Vedic Hindu pantheon.

SK

1 Kramrisch relates her to the *apsara panchachuda* (five-crested celestial deity) because the weapons in her hair usually appear in groups of five (1983, p. 75).
2 Harle was the first to identify this object correctly as a wreath and to connect it with the garland described in the *Devi-mahatmya* as the gift of the primordial ocean to Durga, bestowed at the moment the assembled gods relinquish to her their divine weapons (1970, p. 151). The wreath disappears as a major attribute of Durga by the end of the Gupta period.
3 Pal 1987, p. 39.
4 Harle 1970, pl. 4. This element is most clearly shown on the Durga in Cave VI at Udayagiri.
5 Ibid., p. 151.
6 Coomaraswamy 1928, p. 9.

11 Female Adorant Before a Column Support

India, late Shunga–early Kushan period, 1st century B.C.–1st three-quarters of 1st century A.D.
Bronze, h. 4⅝ in. (11.8 cm)
Gift of Samuel Eilenberg, 1987
1987.142.316

This small votive sculpture was most likely designed as the support for a Buddhist emblem, probably a *chakra* (spoked wheel), here symbolizing the unfolding of Buddhist law. The only other similar object in the literature is a nonfigural *chakra* with base found at Brahmapuri and now lost. It is known today only through drawings.[1] Our sculpture is in the form of a standing female adorant leaning against a pillar, her hands raised to her breast in *anjalimudra*, the gesture of adoration. The figure is nude except for elaborate jewelry and a long diaphanous dhoti, which falls in pleats between her legs and ends, uncharacteristically, above her ankles. The pillar is ringed with raised bands at its top and behind the figure's head and hips, and is set on a low double plinth.

SK

1 Khandalavala, figs. 63, 64.

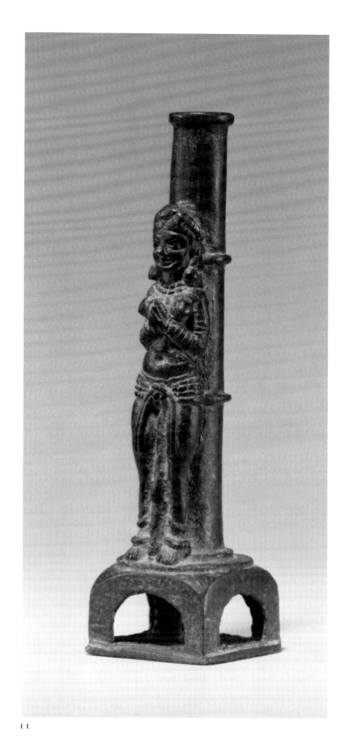

11

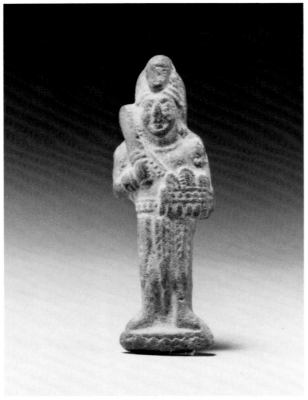

12

12 Amulet in the Form of a Warrior

India, Shunga period, 2nd–1st century B.C.
Terracotta, h. 2 1/8 in. (5.4 cm)
Gift of Samuel Eilenberg, 1987
1987.142.389

This amulet is a slightly smaller, more finely modeled version of one already in the Metropolitan Museum's collection.[1] It is in the form of an armed standing male figure wearing a tall turban with a bunlike cockade secured to its front. A rectangular piece of armor, which is attached with straps, covers the back of his neck. The man grasps his drawn sword with his right hand, resting it against his right shoulder. His left forearm, obscured by a shield(?), is held across his body. The shield has a central band with pearling, a tripartite element at its top, and a row of hanging elements at its bottom. He wears a necklace, bangles, and a peculiar skirt composed of long leaves, hung points downward from a waistband decorated with pearling. A similarly embellished band crisscrossing the figure's chest supports a scabbard, which hangs behind him at his waist.

The sculpture was probably mold made, and the raised ridge on the left side of the turban was most likely left by the juncture of the two halves of the mold. As the figure is pierced through the shoulders, it was probably meant to be worn as a pendant. The turban is similar to those seen on many of the male figures on the Barhut and Sanchi stupas and therefore indicates an early date for the amulet.

SK

1 Acq. no. 28.159.14.

13 Plaque with a Dancer and a *Vina* Player

India, Kaushambi(?), late Shunga period,
1st century B.C.
Terracotta, h. 5 in. (12.7 cm)
Gift of Samuel Eilenberg, 1987
1987.142.376

Mold-made plaques such as this example, often pierced with two holes, presumably for suspension, are the most common form of Shunga-period terracottas. Whether they functioned as votive offerings, as objects of personal devotion, or purely as decoration

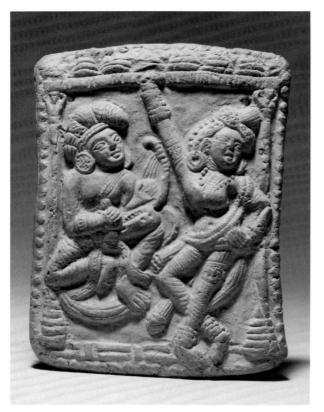

13

is unknown. Usually, they depict deities, but a number show amorous episodes and other secular scenes. It is possible that, like the Shunga-period pull toy in the following entry, some drew their subject matter from contemporary literature.

This plaque portrays a man playing a *vina* (harp), accompanying a female dancer. He is seated on a low cushion in a small pavilion with a raised floor, two wooden columns with cone-shaped bases and small lotus(?) capitals, and a roof surmounted by stepped merlons. The musician wears a long dhoti secured by a belt whose ends fall between his legs, a strap slung diagonally across his chest, bangles(?) on his right forearm, large circular earplugs, and a floppy turban. In his right hand, he holds a plectrum with two spherical ends that resembles a small dumbbell, and his other hand is positioned behind the strings of the *vina*, perhaps to dampen them. The woman, who is dancing outside the pavilion, wears a long dhoti, several scarves, anklets with bells(?), bangles on her forearms, armlets, a necklace of beads, and large circular earplugs, and her hair is richly adorned with pearls and flowers. The rapt attention of the musician is focused on the animated dancer, whose open mouth suggests that she may be adding a vocal accent to the performance. A band of rosettes encircles the scene.

In India, dance accompanied by music is often an integral part of religious ritual. It is unclear, therefore, whether the scene on our terracotta has religious or secular overtones. The unusual subject, the skill of the artist's rendering, the quality of the impression, and the excellent state of preservation of this plaque distinguish it as a particularly fine example.

SK

PUBLISHED
Poster, no. 36.

14 Pull Toy with Udayana and Vasadatta's Elopement

India, Uttar Pradesh, Kaushambi, late Shunga period, ca. 1st century B.C.
Terracotta, h. 4 1/2 in. (11.4 cm)
Gift of Samuel Eilenberg, 1987
1987.142.378

This terracotta sculpture was produced from a two-part mold and was probably a pull toy.[1] The lower portion is broken off, and the axle holes are therefore no longer present. There are many such toys in the

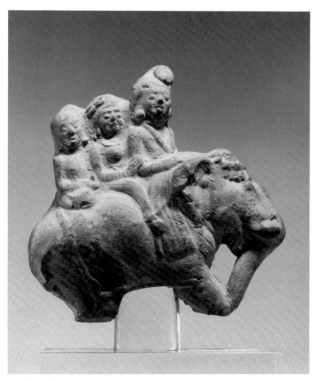

14 Front

14 Back

corpus of Shunga terracottas; in fact, together with votive plaques they account for the majority of extant terracottas of the period. In this example, three figures are shown sitting on a large saddlecloth atop a striding elephant. The first, a man wearing a turban with a prominent knot in front (see No. 12), holds an elephant goad in his right hand. The female figure behind him clutches his right arm with her right hand, and with her left she holds a *vina* (harp). The diminutive third figure, who kneels behind the others, holds a bag of coins at his right side.

The conjunction of these details suggests that the subject is the well-known early Indian story of the elopement of Udayana and Vasadatta. In the story, the Vatsa king Udayana was captured by his neighbor, King Mahasena of Avanti. During Udayana's captivity, King Mahasena took Udayana's favorite harp and presented it to his daughter, Vasadatta. Udayana and Vasadatta subsequently fell in love. When Udayana was ultimately freed in gratitude for his miraculous taming of the king's favorite she-elephant, Bhadravati,

who had become intoxicated and was running amok in the city, Udayana and Vasadatta eloped. They rode on Bhadravati and took with them the court jester, Vasantaka, who threw coins at the pursuing soldiers, assuring their escape.[2] The precise identification of a genre subject from current literature as the subject for a toy is unique and may indicate that other pull toys with elaborate iconography derive from similar sources.

SK

1 There exists in the Los Angeles County Museum of Art a similar, complete pull toy with an elephant and four riders (see Czuma 1985, no. 46).
2 Kala, cat. no. 298 and fig. 146.

PUBLISHED
Poster, no. 45.

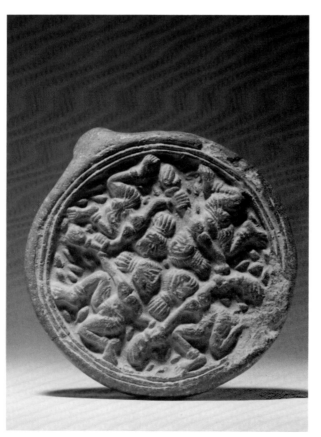

15

15 Rattle with Four Dancing Figures

India, Uttar Pradesh, Kaushambi, late Shunga period, ca. 1st three-quarters of 1st century
Terracotta, diam. 4%/16 in. (11.6 cm)
Gift of Samuel Eilenberg, 1987
1987.142.379

Mold-made terracottas in the form of plaques, figures, and toys were common in early India from at least the first century B.C. This terracotta belongs to a category of objects designated as rattles because their hollow bodies often contain loose pellets that make noise when disturbed. All such rattles have a pierced protrusion on one side through which a cord can be passed that allows them to be held and shaken without dampening the sound. All are decorated on their fronts with figurative reliefs and on their obverses with shallower abstract designs.

The round front surface of this rattle bears a design of four nearly identical intertwined dancing women whose feet touch the incised double rim and whose profile heads surround a small raised boss at the center. Their legs are seen from the side, the left foot and leg bent back in a kneeling position, and the right leg bent up, facing ahead, with the foot barely touching the ground, so that the figures seem to be proceeding

clockwise around the face of the rattle. The hands of each dancer clasp her neighbors' outstretched hands and arms, forming a configuration of an almost perfect square that frames the heads, which are turned back, in the opposite direction from the legs. The upper bodies are frontal. Each woman's hair is drawn back in a large bun behind the head, and all are nude except for their jewelry—bangles, anklets, and a short girdle composed of strings of beads worn across the hips. The spaces between the figures are filled with a pattern of long raised ovoid shapes. The obverse of the rattle is covered with low-relief concentric circles, the innermost molded with a rope-twist pattern, all disposed around a central swirl. At the center of the swirl is a dot surrounded by a single circle.

No other rattle with a design as masterful as this is known. The composition expresses the movement and energy of the dance it portrays. The tension of the opposed heads and bodies is held in balance by the undulating square of joined arms that links the dancers. A rattle with a similar, albeit less accomplished, composition was found at Basarh.[1]

SK

1 Spooner 1917, pl. XLIII, F.827.

PUBLISHED
Poster, no. 52.

16 Intaglio Ring with Two Figures

Pakistan, Gandhara, 1st century B.C.
Bronze, w. 1 1/8 in. (2.9 cm)
Lent by Samuel Eilenberg

Although a few Indo-Bactrian hard-stone intaglios are known, this inscribed bronze ring with three intaglio images is unique. The large flat oval top shows a woman carrying a sizable ewer. She is approaching a man on a low seat set upon a raised dais. An object, perhaps a brazier, is placed before the man. The woman wears a long skirt and tunic, both pleated, the man only a long dhoti whose presence is indicated by its hem, which lies across his feet. Her hair is short in back; his is arranged behind

his head in a small bun like those of the men on the spherical object (see No. 9). The details of the man's torso—nipples, stomach, and navel—are clearly indicated. His right hand is lowered and cupped, and in his left hand he holds a stalk with a lotus bud(?) whose torpedolike form appears to his right. There is an inscription in Kharoshti behind the woman, and a small mark, perhaps a letter, which resembles an upside-down bird, appears beneath the dais.

Each tapering shank of the ring is decorated with an intaglio depicting a figure, probably representing the same man and woman shown on the top. Their costumes are identical, except that the man wears a long scarf across his body, with ends streaming at his left side. Both are standing; she holds a mirror to her face, and he carries a lotus flower in full bloom.

The inscription is in a form of Kharoshti used during the Indo-Bactrian period and most likely is a name prefaced by the honorific *bhata* (warrior). The ring was probably a personal seal.

SK

16

Stone Dishes

Stone "dishes" of the type discussed in the following entries are mainly indigenous to the Gandharan region.[1] They are concave, with shallowly carved rims surrounding deeply excavated figurative reliefs. The backs are usually decorated only cursorily, but sometimes are more elaborately adorned (see Nos. 18, 19, 25). Their iconography, unlike that of the overwhelming majority of Gandharan art, which is based on Buddhist tradition, draws heavily on the imagery of the classical world, possibly filtered through Alexandria and Palmyra. Such stone dishes have not been excavated at Buddhist sites. They therefore are most likely secular, or else perhaps they were used in non-Buddhist rituals.

The dating of these dishes is problematic. The largest number were found at the city of Sirkap in the Shaka and Indo-Parthian strata, although some were unearthed in the Greco-Bactrian level.[2] Sirkap was destroyed in the first century A.D., and few stone dishes have been discovered at the sites of the Great Kushans, the rulers who followed the Indo-Parthians and the first two Kushan kings. It is probable, therefore, that the majority of such dishes antedate the era of Kanishka (before about A.D. 78) and were made in the time of the many kingdoms that had flourished previously in the Gandharan region—under the successive reigns of the Bactrians, Scythians, Parthians, and early Kushans. Because little Indian art remains from this early period, it is difficult to test this hypothesis except through stylistic analogies with non-Indian objects. The problem is further complicated by the fact that many of the classical motifs encountered in the dishes were used continuously from the Hellenistic through the Roman period, and therefore it is impossible to know whether one is looking at an inaccurate provincial copy of a Hellenistic motif or a more faithful version of a Roman one.[3] However, as the archaeology seems to point to an appearance earlier than the era of the Great Kushans, such stone dishes will be assigned an entirely provisional dating based on those analogies.

When the dishes are sorted according to decoration, size, profile, and material, they seem to present a picture of evolution over time.[4] The Indo-Bactrian examples are small, made of very fine-grained olive-green schist, and have rather flat, convex backs. Their fronts are decorated with allover scenes (see Nos. 17, 18). The Scytho-Parthian dishes are larger, made of coarser brown or gray schist, and generally have flat backs with articulated rims. Although the entire fronts of these dishes are often carved, the high pictorial relief is usually restricted to their upper halves (see Nos. 20–22). The early Kushan dishes are about the same size as the latter group, are generally of gray schist, and revert to a flattened, convex form. They are the only examples with specifically delineated compartments (see Nos. 23–25).

The function of these objects, like their dating, is somewhat uncertain. Although they have been repeatedly referred to in the literature as cosmetic palettes, this identification is problematic for various reasons. First, their imagery seldom refers to self-adornment of any kind.[5] If they were related to cosmetic use, one would expect to see depictions of women grooming themselves, as in certain mirror handles (see Nos. 28, 69). Instead, mythological subjects and drinking scenes, which may or may not be mythological, prevail. Second, it is difficult to understand how they could have been used as toilet trays. The earliest dishes either provide spaces with relief carving that would interfere with the processes of mixing or cleaning (see No. 17) or have cavities that are very small and obviously pictorial rather than functional elements (see No. 18). The compartments in the Scytho-Parthian dishes also have relief carving. Moreover, the cavities in question rarely show any signs of wear. Only in the early Kushan-period dishes are definite compartments delineated, and even these rarely show the evidence of use that mixing or grinding of cosmetics would probably leave.

The closest parallel to these Gandharan dishes in the classical world are phiales, larger, shallow vessels, often with raised carvings in their interiors, which were used for offering wine to the spirits of the dead. Given the predominance of classical imagery and the frequent appearance of drinking themes in the Gandharan dishes, phiales may well have served as their prototypes.

It is possible that both a chronology and a change in function are implied by this series—wherein the earliest examples were either purely decorative or had

a votive purpose, and, like the phiales, were used for the offering of wine. This would explain why they provide no delineated cavities, as the liquid would fill up the entire carved-out surface of the dish. Perhaps only much later, when dishes with discrete recesses were made, was the type adapted to function for a new purpose: to contain or mix small amounts of preparations, such as toiletries or offerings other than wine.

SK

1 A few related objects with imagery that associates them with Greco-Roman Egypt exist—for example, see Francfort, pl. LI.B., and *A Shallow Bowl with Isis Riding on a Goat(?)*, which is in the collection of The Metropolitan Museum of Art (acq. no. 74.51.5027).
2 Marshall, vol. 1, p. 128.
3 In her review of Francfort's book *Les Palettes du Gandhāra*, Rekha Morris does not acknowledge this. Also, her categorization of the dishes as Roman-influenced products of the Kushan period does not account for the fact that many of the motifs found on the dishes do not appear in the art of Kushan Gandhara (pp. 488–94).
4 The overall evolution described is simplified; individual, transitional(?) examples may depart somewhat from the progressive development outlined here.
5 A fragmentary dish in the Eilenberg collection (not exhibited) does have a scene with a woman arising from her bath (acq. no. 1987.142.109), and No. 23 shows a woman looking in a mirror.

17 Dish with Apollo and Daphne

Pakistan, Gandhara, Sirkap(?), Greco-Bactrian period(?), ca. 2nd century B.C.
Schist, diam. 4³/₁₆ in. (10.6 cm)
Gift of Samuel Eilenberg, 1987
1987.142.307

18 Dish with a Mythological Amorous Couple (Apollo and Daphne[?])

Pakistan, Gandhara, Sirkap(?), Greco-Bactrian period(?), ca. 2nd century B.C.
Schist, diam. 3¹⁵/₁₆ in. (10 cm)
Gift of Samuel Eilenberg, 1987
1987.142.108

These two dishes are similar in form, size, iconography, and stone type. In terms of style and iconography they are related to the Oriental Hellenism of Alexandria, and they are, therefore, provisionally being dated to the Greco-Bactrian period, about 200 to 90 B.C. This dating is supported by the fact that stone dishes of this type are the rarest known, probably because the Greco-Bactrian stratum of Sirkap was the least excavated.

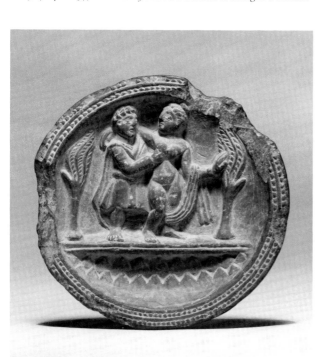

17

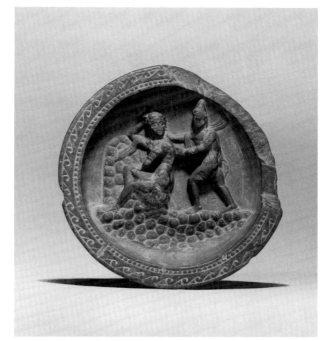

18

The scene portrayed in the first dish may depict the moment just before the nymph Daphne is transformed into a tree to escape the advances of the god Apollo. Although the basic costume of the male figure is classical, he wears a cap unknown in the classical world. The form of this cap is similar to several Indo-Scythian helmets worn by Kushan rulers on certain coins and also in some fragmentary portrait heads in the Government Museum, Mathura.[1] This does not rule out my dating but points up the complications involved in almost any attempt to assign these early works to a particular period.

The second dish also portrays an amorous subject, perhaps again the myth of Apollo and Daphne. Here, a male figure crowned with a wreath fondles his companion's breast, while she, with right arm resting on his shoulder, reaches back and touches a tree beside her with her left hand. Below the ground plane is a two-tiered, serrated motif that perhaps indicates water. The back of this dish is uncharacteristically adorned with a carving of a tied wreath. Not all dishes of this general type are decorated with subjects related to love. At least one other in the Eilenberg collection, a fragmentary example, is carved with a representation of Hercules wrestling with the Nemean lion.

SK

1 For coins, see Czuma 1985, nos. 62A–D; for portrait heads, see Rosenfield, figs. 3, 4, 14–16; for examples of the headdress, see Rosenfield, figs. 4, 14–16; for a relief with a typical complete Indo-Scythian costume, see Rosenfield, fig. 22.

19 Dish with Eros on a Swan

Pakistan, Gandhara, late Greco-Bactrian period(?), late 2nd century B.C.
Schist, diam. 3 1/16 in. (7.8 cm)
Gift of Samuel Eilenberg, 1987
1987.142.212

20 Dish with a Nereid Riding on a Sea Monster

Pakistan, Gandhara, Scytho-Parthian period(?), 1st century B.C.
Schist, diam. 5 5/16 in. (13.5 cm)
Gift of Samuel Eilenberg, 1987
1987.142.107

21 Dish with Eros Borne by a Lion-Headed Sea Monster

Pakistan, Gandhara, Scytho-Parthian period(?), 1st century B.C.
Schist, diam. 6 1/16 in. (15.4 cm)
Gift of Samuel Eilenberg, 1987
1987.142.42

22 Dish with a Triton Bearing a Woman

Pakistan, Scytho-Parthian period(?), 1st century B.C.
Schist, diam. 4 1/2 in. (11.4 cm)
Gift of Samuel Eilenberg, 1987
1987.142.41

Sea monsters bearing riders are among the most common subjects for the decoration of these stone dishes. This motif comes directly out of the classical world, where nymphs and *aurai* are typically portrayed riding fantastic mounts, thus combining water and sky imagery. The first dish shows Eros riding on a swan, holding aloft in his raised right hand a wreath from which two ribbons stream. Like the first two examples (Nos. 17, 18), it is small. However, the profile and stone color are different and the iconography is closer to that of the next three dishes. The perimeter of the back is decorated with a row of stylized flowers, and, very uncharacteristically, the center of the back, which is also carved with a floral design, is concave. This unusual aspect may derive from phiales, many of which have a similar feature.

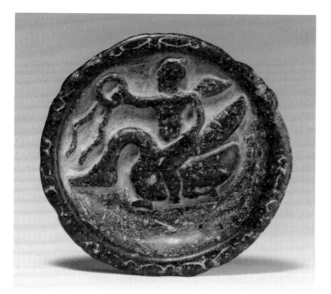

19 Front

19 Back

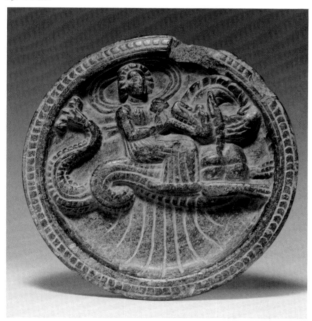

20

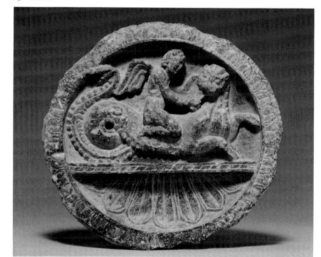

21

In the next example, a young woman, perhaps a
Nereid, one of the fifty daughters of Poseidon's
attendants Nereus and Doris, is shown riding on the
back of an aquatic dragon. She holds a lotus(?) in her
hand, and her head and shoulders are framed by a
scarf. This dish is very close to one in the Alsdorf
collection, except that in the latter the Nereid holds
a large cup.[1] The present dish is the only one in the
Eilenberg collection that displays striated decoration
below the figures and a wiglike hairstyle, both of
which are related by Henri-Paul Francfort to Palmyran
styles.[2] The billowing scarf is a motif drawn from the

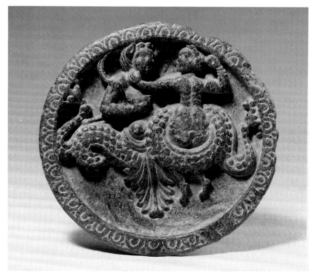

22

classical repertory that probably became popular in Gandhara as well as in Rome during the Augustan period (30 B.C.–A.D. 14). In Gandharan art, it is also found in the early Buner stair risers.[3]

The third example of this iconographic type presents Eros astride the back of a lion-headed sea monster. The winged god proffers a wine cup, from which his mount, tongue extended, is lapping. The demi-lune space below the figures is decorated with a section of a floral rosette. The surround of the vessel, like that of the preceding dish, is engraved with a border of lotus petals.

In the last dish, a Triton, one of the half-human, half-fish sons of Poseidon, carries a female figure in the coils of one of his two tails. He holds a wine cup in one hand, and she caresses his cheek with her left hand. Amorous drinking scenes are another common leitmotif of the dishes and may also be related to ideas of transcendence, here achieved through intoxication and love. Triton-like figures with bifurcated tails continue to be an occasional subject in the Buddhist art of Gandhara into the Kushan period.[4]

SK

1 Czuma 1985, no. 70; for another, similar example, see Francfort, no. 41.
2 For other examples with Palmyran motifs, see Francfort, nos. 23, 27, 28, 33, 44.
3 Czuma 1985, no. 88A. Czuma associates the manner in which the shawl is worn with early Mathura styles, but the prototype of both the Gandharan and Mathura examples is clearly of classical origin.
4 For example, see Ingholt, no. 390.

23 Dish with Male and Female Busts

Pakistan, Gandhara, early Kushan period(?), 1st three-quarters of 1st century
Schist, diam. 5 5/8 in. (14.3 cm)
Gift of Samuel Eilenberg, 1987
1987.142.106

24 Dish with Hercules Embracing Two Women

Pakistan, Gandhara, early Kushan period(?), 1st three-quarters of 1st century
Schist, diam. 4 7/8 in. (12.4 cm)
Gift of Samuel Eilenberg, 1987
1987.142.105

25 Dish with a Man Embracing Two Women

Pakistan, Gandhara, Swat Valley(?), early Kushan period, 1st three-quarters of 1st century
Schist, diam. 6 1/8 in. (15.6 cm)
Gift of Samuel Eilenberg, 1987
1987.142.40

These three dishes differ from the others studied in that they were almost certainly designed with recesses specifically meant for mixing or containment. Unlike the areas in some of the earlier examples, for which a similar function has been argued, in two of the three dishes these depressions are discrete and undecorated, allowing for easy mixing and cleaning. The first is divided into five sections, four inner and one outer, by four semicircular ridges that join at their ends. Two adjoining compartments are filled, respectively, by a relief of a male bust and a relief of a female bust. The woman is peering into a mirror, which she holds up in her left hand; the man looks toward her and points upward with his left index finger. The border of the dish is decorated with a band of pearling, and the divides are filled with a scrolling device. The vessel's internal configuration is similar to that of two other known dishes.[1]

The next dish is one of three in the Eilenberg collection that probably illustrate episodes from the life of Hercules. Here, Hercules is shown naked, except for a large cape, which is tied across his chest and flares out broadly behind him. His outstretched arms are placed on the shoulders of two women who stand at either side and look toward him. To his right is a large but pacific seated lion shown in profile,

facing the central figures. The right side of the dish is broken off. Below the ground plane of the figures, set into the demilune lower half of the dish, are two circular cavities. Foliation fills the interstices between the cavities and the ground plane.

The last example is the only one in the group whose imagery relates specifically to the greater Indian rather than the classical world. In the top demilune are carved the busts of three figures—a man and two women whom he embraces—and the lower half is divided into two equal compartments. A low-relief lotus flower decorates the entire inner surface of the dish and forms a backdrop for the figures. Each of the women faces inward toward the man and holds a wine cup before her chest. The women seem to be wearing tunics with pleats running down the sleeves, and their long hair is pulled back and tied into loops on one side of their heads(?). The man is dressed in a turban and a shawl, which is thrown over his left shoulder. All have elaborate jewelry, including bangles, necklaces, torques with large hanging elements, and earplugs. The man's costume—particularly the way in which the shawl forms a pendant loop over the shoulder, and the turban with a central vertical cockade— resembles that of early Kushan sculpture from the Swat Valley. Some features of the women's adornment, notably the unusual tubular earplugs, are also found in the Swat sculptures.[2] These similarities indicate a Swat origin and a pre-Kanishka date during the first three-quarters of the first century A.D. for the vessel. This is one of the rare cases in which a dish can be attributed with some confidence to a particular period. The assignment reinforces the proposed early dating of the group of Gandharan dishes as a whole, as our vessel, with its clearly delineated compartments, appears to be one of the latest examples in the sequence I have suggested.

SK

1 Francfort, nos. 80, 89.
2 For shawl style and torques, see Faccenna, vol. 2.2, pl. CXXXVII; for the unusual long earplugs worn by the women and an asymmetrical hairstyle(?), see ibid., pl. CLXVI.

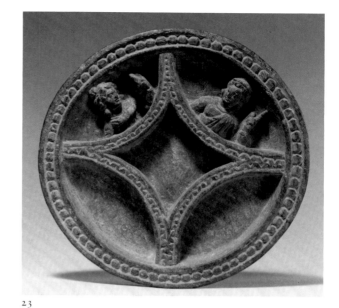
23

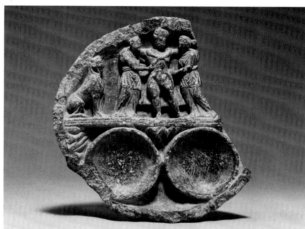
24

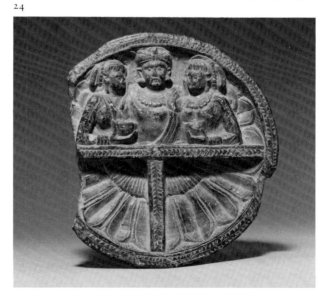
25

26 Rondel with a Hunting Scene

Pakistan, Gandhara, late 1st century(?)
Schist, diam. 5 ¾ in. (14.6 cm)
Gift of Samuel Eilenberg, 1987
1987.142.308

On the front of this large rondel is portrayed a young hunter dressed in classical style (in a long-sleeved tunic [*chaiton*], pants[?], and boots[?]) on a rearing horse, poised to shoot a lion, which rears up before him. Below the feet of his horse, a dog(?) lunges toward the prey.[1] A lotus flower is carved on the back. Kushan-period hunting scenes are unusual, the only ones known to me being a series of ivory panels from a box found at Begram showing hunters, mounted and on foot, in combat with animals.[2] The iconography of our rondel shows affinities with royal hunting scenes on Sasanian silver plates, the earliest of which date to the fourth century, and with fifth-century box lids from Gandhara, some of which portray equestrian hunters (see Nos. 57–61).[3] The rearing pose of the lion is certainly a Middle Eastern convention. However, there is a marked difference between the posture of the steed in this rondel, rearing with its hind hooves planted firmly on the ground, and the stance of the horses on the silver vessels and box lids, which seem suspended in midair. In fact, the disposition of the rider and hound derives directly from classical prototypes. Additionally, the

horse trappings do not have the large pompons that are usually seen in Sasanian depictions.

This rondel has formerly been classified as a Gandharan palette.[4] The allover format of the design would seem to relate it to the earliest of such dishes (see Nos. 17, 18). However, any similarities of design are overshadowed by the larger size of the rondel, the coarse gray schist from which it is made, and the fact that its profile is like those of some of the Scytho-Parthian dishes. These anomalies relate it to later dishes; however, its very different iconography and lack of compartments argue that it may belong to a separate class of objects. Provisionally, it is being assigned to the late first century.

SK

1 If the animal below the horseman is a dog, this may indicate Roman influence.
2 Hackin, figs. 117–25, 183.
3 Harper, p. 25.
4 Czuma 1985, no. 71.

27 Fragment of a Large Vessel

Pakistan, Gandhara, Scytho-Parthian period,
1st century B.C.
Schist, h. 5 in. (12.7 cm)
Lent by Samuel Eilenberg

This extraordinary fragment of a large schist vessel is beautifully decorated with a frieze of figures enclosed within two ornamental borders, the whole set above a pattern of large lotus petals. The decorative motifs, the figurative imagery, and the style in which they are executed are directly related to classical prototypes. The carving is extremely subtle and is unusual in the degree to which its depth is varied in the different sections. Below the rim there is a border of shallowly carved, stylized lotus petals enclosed within two raised bands. Beneath this border is a wide figurative frieze atop a raised band with a tripartite stepped profile from which hangs a row of deeply modeled marquise-shaped pendants. The frieze is shallower than the borders that define the space within which it exists. On the left side of the frieze, all that remains is the animated leg of a figure; on the right, two women flank a young man. The young man's left arm is placed around the neck of the woman to his left, who

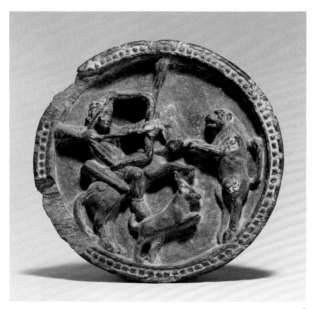

26

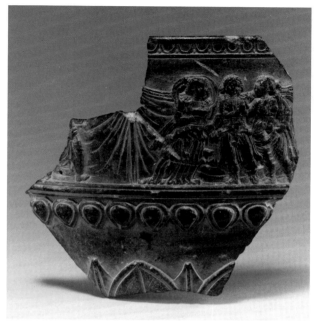

27

and in some of the female figures on early Buner stair risers. This motif derives from the classical vocabulary, as does the rare curtain backdrop. The interior of our fragment indicates that the vessel was wheel turned before it was carved. However, the complexity and subtlety of carving and iconography and its debt to the classical world set this example apart from early Kushan-period wheel-turned, simply decorated schist reliquaries (see Nos. 40–43).

SK

28 Seated Woman Holding a Mirror(?)

Pakistan(?), Gandhara, early 1st century B.C.–1st three-quarters of 1st century A.D.
Bronze, h. 3 13/16 in. (9.7 cm)
Gift of Samuel Eilenberg, 1987
1987.142.326ab

This mirror handle is in the form of a woman seated on an openwork wicker stool. Her left arm is akimbo with hand placed on her hip; her right hand is raised to chin level and holds the handle of a round object,

embraces him around his waist. She is nude except for a shawl that encircles her body and covers her left shoulder, back, and legs. With his right hand, the young man clasps the lowered left wrist of the other woman. In her left hand, this woman holds the handle of a ladle, and in her right, which is drawn up before her chest, there is a large cup. She wears a tunic over a long skirt, and a long shawl that surrounds her head as if it were blown by the wind. The young man is dressed in boots and a long-sleeved tunic that opens down the front. Both the man and the woman to his right wear animal skins around their waists. The entire scene is disposed against a curtain backdrop.

Our male figure is probably Dionysus, as he is the only character in the classical repertory who wears an animal skin in such a manner. The rest of his costume seems to reinforce this identification. Most likely his two companions are his consort Ariadne, shown partially nude, and one of the maenads, who are also commonly portrayed girt with animal pelts. Dionysus, with his off-balance posture, may be slightly drunk. He appears to be refusing the wine offered by the maenad but not necessarily the advances of his wife, which are suggested by her loosened garment.

Several pictorial devices point to an early date for the fragment. The unusual "windblown" depiction of the shawl of the woman at the left is found in Parthian-period Gandharan stone dishes (see No. 20)

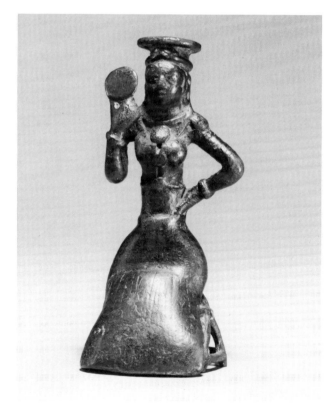

28

presumably a mirror. She wears a long skirt, which falls to the ground, concealing her feet, and a short-sleeved blouse(?). Over the blouse is an elaborate halterlike bodice made up of a series of rondels connected by cords suspended from the neck by a circlet and tied around the waist. Her hair falls down her back in one long braid, which bifurcates at the end and spills over the edge of her seat. Atop her head is an articulated, stepped hatlike device into which a removable mirror could be set. A squared-off ring just above the braid no doubt allowed the mirror to be fastened to its base.

Mirrors were probably introduced into South Asia about the beginning of the first century A.D. via the extensive Gandharan trade that existed with Rome. The prototypes of Gandharan examples appear to be metal mirrors with ivory handles in the form of standing nude women, such as those found at Taxila.[1] Stone handles discovered at the same site are of similar form. Such handles differ from those depicted in reliefs from India proper, where the mirrors are shown with back straps or nonfigurative handles of much greater size.[2] No examples comparable to the Eilenberg figure are known. Several of its elements —the seated posture, elongated torso, halterlike bodice, hairstyle without curls framing the face, and long skirt that does not reveal the legs or feet—are without precedent in Gandharan art. The long braid in particular points to a pre-Kushan date.

SK

1 Marshall, vol. 2, p. 658; vol. 3, pls. 203.43–46.
2 For example, see S. P. Gupta *Kushana* 1985, pls. 1, 8.

29 Mirror Handle with a Standing Woman

India or Pakistan, early 1st century B.C.–
1st three-quarters of 1st century A.D.
Stone, h. 4³/₄ in. (12.1 cm)
Gift of Samuel Eilenberg, 1987
1987.142.37

30 Mirror Handle with a Pair of Women

India or Pakistan, early 1st century B.C.–
1st three-quarters of 1st century A.D.
Stone, h. 4³/₈ in. (11.2 cm)
Gift of Samuel Eilenberg, 1987
1987.142.38

These two sculptures have sockets drilled into their tops, probably to accept the tangs of metal mirrors. The first is in the form of a standing woman holding a wine cup to her bosom. She is richly dressed in a long tunic, dhoti, and shawl. The tunic is draped from her right shoulder, cinched below her breasts with a strap, drawn up twice in front, and tucked into a large girdle to form a tripartite swag. The dhoti emerges from beneath the tunic and is crisscrossed so that it falls in diagonal pleats in front. The shawl is wrapped around the woman's arms, and one portion is held across her body in her lowered left hand, the end trailing to the ground by her left side. She wears elaborate jewelry consisting of an unusual torque with drops, a long necklace with a squared-off bottom, earplugs, armlets, bangles, and anklets. The dhoti may be tied to the anklets, in the style typically adopted by Indian women in the Kushan period. The figure's hair is plaited into two long, looped braids, each of which hangs below her shoulder blades and whose splayed, fanlike ends are secured to the sides of her head by long, similarly doubled ribbons with ends trailing down her back. The face has been recut.

The second mirror handle is of almost identical size, of a like stone, and is carved in the form of two women standing side by side in an embrace. The figure at the left holds a large lotus blossom to her breast and is pressed close to her friend. The other woman cradles her companion's head with her right hand. It is probable that the left-hand figure's arm encircled her friend's waist; however, the right side of the sculpture into which the mirror tang was affixed has broken off and is lost, leaving an exposed socket.

The woman to the right is dressed in much the same fashion as the figure in the first handle, with a

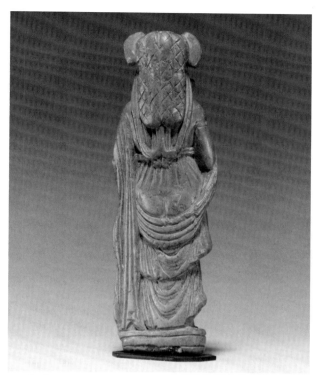

29 Front

29 Back

long tunic cinched below the breasts, a long dhoti similarly worn, a thick girdle, long shawl, torque, and long necklace with squared-off bottom. The other woman's shawl is wrapped around her torso, but she is otherwise similarly attired. The faces of both are more plastic than that of the first example, with deeper-set eyes and lips, and more rounded cheeks. The wavy hair of the woman at the left is parted in the center and swept toward the back of her head.

Similar mirror handles in the form of standing women are known from the classical world. A large ivory example from India found at Pompeii is evidence of the trade contacts that existed between Asia and the West and supports the presumption of a classical prototype and an early date for the production of the genre in the Indian subcontinent.[1] Several characteristics of the present mirror handles—the unusual stone from which they are carved, the long braided hair of the single figure, the combination of torque and long necklace with a squared-off bottom, and the style of dress in each example—also suggest an early date.

SK

1 Czuma 1985, chart III, no. 2.

Ex coll. Frederick Mayer, New York (no. 29).

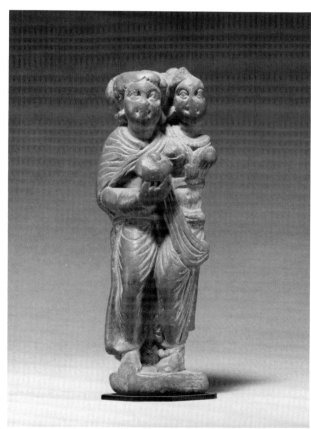

30

31 Standing Female Donor

Pakistan, Gandhara, Sirkap, early Kushan period, 1st three-quarters of 1st century
Gold, h. 3 1/16 in. (7.8 cm)
Gift of Samuel Eilenberg, 1987
1987.142.309

One of the few early Indian gold reliefs that survive, this small repoussé plaque shows a standing female figure. The subject's legs cross at the ankles, her left hand is placed on her left hip, and her right hand grasps to her breast the stalk of a flower(?) whose blooms (composed of small granules of gold) rest on her right shoulder. She wears a long diaphanous skirt with a central pleat and an unusual sleeveless tunic top, short in front and longer in back. She is adorned with simple jewelry—anklets, bracelets, a torque, a single earring, and a small brooch pinned above her left breast. Her long hair is smoothed tightly over her head, parted in the center, ornamented with a small flower, and arranged in a large bun behind her left ear. As in most of the other extant objects of this kind, the shape of the plaque closely follows the figure depicted. In this example, undecorated rectangular strips of the gold sheet are pierced with a small hole and project above and below the figure.

In terms of style and iconography, this object has little in common with either the *Winged Deity with Consort* in the Bharat Kala Bhavan in Varanasi[1] or the representation of a *yaksha* (genie of the earth) discovered in Vaishali and now in the Patna Museum,[2] plaques that form a coherent pair iconographically and stylistically. The closest parallel is perhaps represented by another plaque of a standing female in the Patna Museum: Although the modeling of the Patna example is more refined, it shares with our work not only subject matter but also similar treatment of the hands and physiognomy and the use of granulation.[3] Our plaque is reported to have been found at Sirkap. If this is the case, an early first-century date must be presumed, as the city was destroyed by the time of Kanishka, before about A.D. 78.

It has been suggested that this plaque was used as a brooch, since a hook for attachment could pass through the two small holes at top and bottom.[4] However, the thinness of the metal as well as the prominence of the holes would tend to make this supposition improbable. The plaque was broken into three pieces and has been restored.

SK

1 Morley, p. 110 and pl. 7.
2 Czuma 1985, no. 78.
3 P. L. Gupta, pl. LVIII.Arch.11071, as Kushāna, and p. 350, as Gupta, Sultanganj.
4 Czuma 1985, pp. 160–61.

PUBLISHED
Czuma 1985, no. 78.

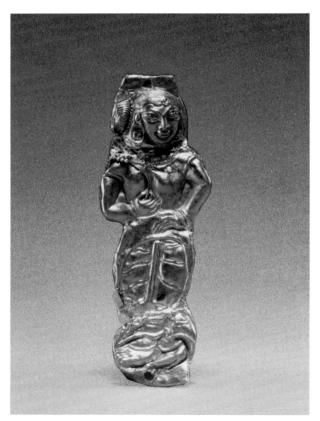

31

32 Hinged Armlet

Pakistan, Gandhara, Sirkap, early Kushan period, 1st three-quarters of 1st century
Gold with remains of lac or mastic core, diam. 3 in. (7.6 cm)
Gift of Samuel Eilenberg, 1987
1987.142.291

This armlet of elegant form is composed of two mirror-image, blunted, horn-shaped elements. The locking mechanism indicates that the two flaring ends

were originally meshed so that they could be twisted to allow the armlet to be slipped on. The armlet is made of fused sheets of gold, with a visible seam along the inner contour of each section. The horn-shaped elements were filled with a core of lac or mastic to strengthen them, and the ends were reinforced with additional gold sheet. The hinge tongue is made of a piece of much thicker gold. The form of this example is identical to that of a group of armlets discovered by John Marshall at Taxila and dated by him through stratigraphy to the first century A.D.[1]

SK

1 Marshall, vol. 2, p. 634; vol. 3, pls. 195C, D, G.

32

33 Pair of Earplugs with *Hamsas*

Pakistan, Gandhara, Taxila, 1st century
Gold, each diam. 1 3/16 in. (3 cm)
Gift of Samuel Eilenberg, 1987
1987.142.290ab

These rare gold earplugs are nearly mirror images of each other. The front surfaces are ornamented with repoussé *hamsas* (ganders) surrounded by bands of incised and pierced decoration, which in turn are enclosed by a wide plain band. The fronts were hammered out of one sheet of gold and joined to a second, from which the indented cylindrical sides and back rims were fashioned. *Hamsas* were used frequently in early India as symbols of transcendence because their extraordinary migratory pattern—they fly beyond the Himalayas for the summer and return to India each winter—is associated with rebirth.

SK

PUBLISHED
Postel, no. 1.45.

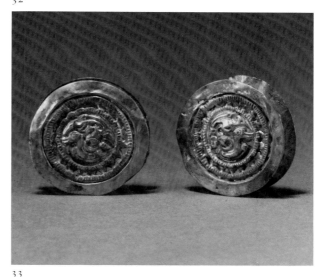

33

34 Two Rondels with Heads

Pakistan, Gandhara, Charsadda, ca. 1st century
Bronze, each diam. 1 5/8 in. (4.1 cm)
Gift of Samuel Eilenberg, 1987
1987.142.280ab

These two almost identical medallions may have been jewelry ornaments. At Taxila, Marshall found a rondel of similar size strung on a simple copper-wire

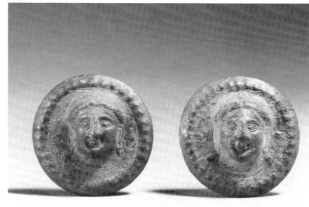

34

bracelet.[1] One of our medallions still retains a stirrup for attachment on its reverse, and the other has remnants of the rivets that held a similar device.

Each rondel bears the same male portrait head in high relief surrounded by a band of large pearling, whose interior edge is bordered with a row of small punch marks. The physiognomy is highly particularized, with a large nose jutting out from the prominent brow-line, a heavy jaw, large eyes, and a small, deeply sunken mouth. The man's hair is parted in the center and broadly plaited, and two hanks with pointed ends are tied in a knot on top of his head. He wears large earrings composed of rings from which vase-shaped elements hang—a type commonly found in Gandhara.[2] A collar (necklace?) of pendant, leaflike forms encircles his broad neck.

The identity of the person depicted is unknown.

SK

1 Marshall, vol. 3, pl. 181A, no. 18.
2 For example, see ibid., pls. 190G, H.

35 Volute with a Winged Celestial

Pakistan, Gandhara, Swat Valley(?), early Kushan period, 1st three-quarters of 1st century
Schist, h. 9 13/16 in. (24.9 cm)
Gift of Samuel Eilenberg, 1987
1987.142.213

A number of "false brackets" are published in the literature, but there has been no speculation regarding their use.[1] They usually are in the form of a winged celestial emerging from a foliate volute. A tang perpendicular to each volute allowed it to be attached to a building. Many were excavated in the Swat Valley around the Great Stupa at Butkara and around the stupa at Sirkap, but none still attached to the structures were found.[2] Their association with these two sites points to a first-century date prior to Kanishka. Several examples discovered at Butkara are particularly close stylistically and iconographically to our false bracket and are carved out of the same green schist.[3]

Our beautifully modeled sculpture portrays a winged female celestial emerging from an acanthus leaf set against a large volute that scrolls above the figure's head. The celestial's hands are raised to the level of her breasts—the right presents a rolled garland in the palm, the left gestures with palm extended outward. She wears a long, pleated tunic that exposes her breasts and is cinched at her waist, and wrapped around her arms is a shawl whose ends stream down on either side of her body. She is bedecked with elaborate jewelry that includes a tripartite belt of beads, and her hair is swept back and adorned with three flowers. The radiant face has large staring eyes showing no iris or pupil, an aquiline nose, a small mouth, and a circular chin. There is an indication on the back of the sculpture that there was once a tang.

One of the chief occupations of winged celestials in early Buddhist iconography is the bearing of offerings of flower garlands to holy places. Shrines are frequently pictured festooned with such offerings, which are often shown being presented by human as well as celestial devotees. Volutes may have been used as hooks on stupas on which wreaths of flowers could be hung. At least one stupa shown in a relief carving on the north gate of the Great Stupa at Sanchi seems to have projecting from its dome a series of large hooks from which a long garland hangs; adorants, both celestial and human, are depicted converging toward the stupa with floral offerings in their hands.[4]

SK

1 For example, see Ingholt, nos. 473–75; Hallade, pl. 54; Marshall, vol. 3, pls. 212.8, 213.11, 18, 19.
2 Faccenna, vol. 2.3, pls. DXLVII–DLIV; Marshall, vol. 3, pls. 213.11, 16, 18, 19.
3 For example, see Faccenna, vol. 2.3, pls. DXLVII, DLXXV.
4 Zimmer, vol. 2, pl. 10.

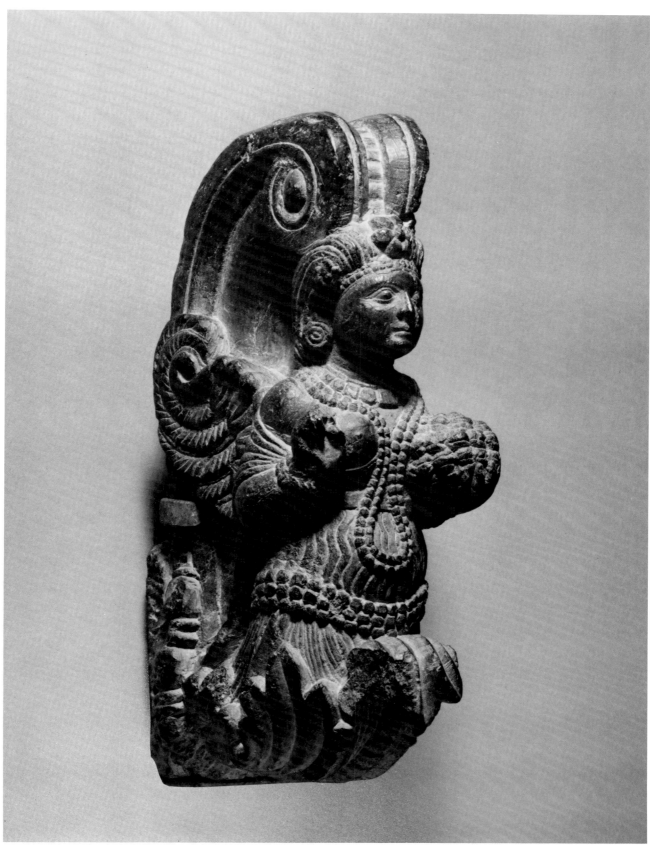

36 Reliquary in the Form of a Miniature Stupa

Pakistan, Gandhara, Kushan period,
1st three-quarters of 1st century
Schist, h. 4¹¹/₁₆ in. (11.9 cm)
Gift of Samuel Eilenberg, 1987
1987.142.96

37 Reliquary in the Form of a Miniature Stupa

Pakistan, Gandhara, Kushan period,
2nd–3rd century
Schist, h. 7⁹/₁₆ in. (19.2 cm)
Gift of Samuel Eilenberg, 1987
1987.142.43a–c

When the historical Buddha died, he was cremated and his ashes were divided into eight parts. These were distributed to his disciples and enshrined by them in reliquaries that were placed inside stupas, structures whose form was based on that of earlier burial mounds.[1] For the early Buddhists, the stupa became a symbol both of the Buddha and of his *parinirvana* (extinction) and, therefore, the most important focus of worship. The early Indian stupa is a hemispheric mound surmounted by a *harmika* (a square structure derived from the fenced enclosures of early shrines) and crowned by a many-tiered umbrella whose shaft rises through the central axis of the monument. The stupa was frequently separated from its surroundings by a high railing, which delineated a processional path accessed by four entrance-gateways oriented to the cardinal points. At one level, the ensemble can be understood as a cosmogram, with the world tree/umbrella enshrined within the protective fence/wall of the *harmika* and rising through the axis of the world/hemisphere, the whole at once separated from and oriented within the sensory world by the surrounding railing. At another level, the monument can be considered a metaphor for the Buddha's passage from the constraints of the

36

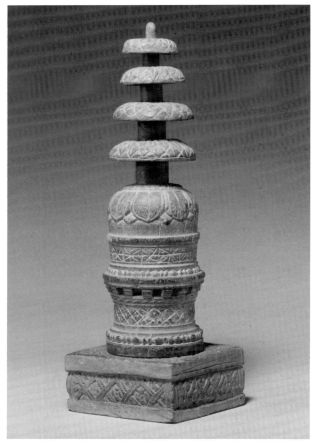

37

world of samsara, or illusionary experience (represented by the space beyond the processional path), to nirvana, his merging with the ultimately formless state of the universe (represented by the stupa itself with its central ascendant axis).

Although stupas in Gandhara usually retained the basic structure of their Indian predecessors, their decoration and forms became more elaborate. Whereas the carved ornamentation of the Indian Hinayana stupa was chiefly confined to the exterior railing, in the Gandharan Mahayana stupa, the dome was frequently raised on a multitiered platform, and much of the structure was covered with decoration.

These two reliquaries are in the form of miniature stupas. The first was made in three parts: base, dome, and *harmika* with umbrellas. The circular base has wheel-turned moldings at its top and bottom and is hollow, providing a space in which relics can be placed. The dome is decorated with similar moldings on its lower, cylindrical portion and is crowned by a band with a chevron motif. Like the base, it is hollow. The *harmika* and the four tiers of umbrellas are carved from another piece of stone and key into a small socket in the top of the dome. The form of our reliquary is very close to that of one excavated by Marshall at Sirkap.[2] A first-century date for it is therefore likely.

The second reliquary is larger and more elaborate. It rests on a hollow, square base whose sides are inscribed with crisscross bands containing rosettes and whose top surface shows low-relief palmettes in the corners. The bottom of its circular interior cavity is carved in the form of a lotus flower. Each of the two drumlike sections of the stupa is ornamented just above its base with a carved bead-and-reel motif and around its center with a band of incised decoration. The top of the dome is embellished with a design of two layers of lotus petals. The top and bottom surfaces of each of the four umbrellas are decorated with radiating arcs that resemble petals. The shaft is a replacement.

SK

1 For an account by Hsüan-tsang (Xuanzang) of two stupas built according to the Buddha's instructions during his lifetime, see Tucci, vol. 1, p. XXVI.
2 Marshall, vol. 3, pl. 35.

38 The Indravarman Casket

Pakistan, Gandhara, Bajaur region, A.D. 5–6
Schist, diam. 2¹/₈ in. (5.4 cm)
Gift of Samuel Eilenberg, 1987
1987.142.71

This wheel-turned reliquary casket has a long Kharoshti inscription around its body and cover that has proved to be of enormous historical interest. The vessel is of bulbous shape with a small foot and is surmounted by a knob with a conical top. Incised bands delineate the registers into which the letters have been incised. The inscription reads:

In the sixty-third (63) year of the late Great King Aya [Azes], on the sixteenth day of the month Kartia [Kārttika]; at this auspicious(?) time, Prince Idravarma [Indravarman], son of the King of Apraca, establishes these bodily relics of Lord Śākyamuni in a secure,

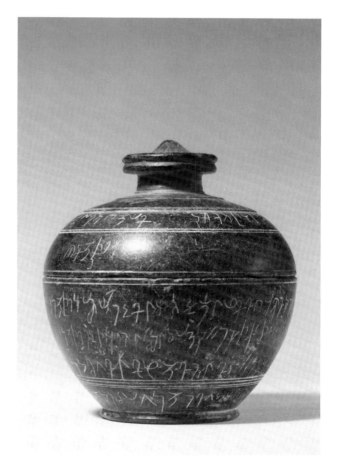

38

deep, previously unestablished place; he produces brahma-merit together with his mother Rukhuṇaka̧, daughter of Ăjĭ (and) wife of the King of Apraca, with (his) maternal uncle Ramaka, with (his) maternal uncle's wife Dạsaka̧, with (his) sisters and wife— Vasavadata (Vāsavadattā), Mahaveda (?; = Mahā-vedā?), and Ṇika̧, and (his) wife Utarā (Uttarā). And (this is done) in honor of (his) father Viṣṇuvarma. The King of Avaca (=Apraca)'s brother, the Commander Vaga is honored, and Viyayamitra (Vijayamitra), [former] King of Avaca. (His) mother's sister, Bhaïdata (Bhagĭdattā?) is honored. And these bodily relics, having been brought in procession from the Muryaka cave stūpa, were established in a secure(?), safe, deep(?) depository, (in) the year twenty-five.[1]

This inscription is important for several reasons. First, it greatly broadens knowledge of the poorly understood genealogy of the rulers of Avaca, a small kingdom to the west of the Swat Valley, situated near Bajaur. In addition, it conclusively establishes the Indo-Scythian king Azes I as the founder of the Vikrama era, which began in 58–57 B.C. There was no single, unified system for dating in Gandhara, and some kings restarted their own calendric calculations at year one, to commemorate their accessions or some momentous historical event in their reigns. Unless these individual systems can be coordinated with a known calendar, the exact dates involved are unclear. It has been possible to determine when the Vikrama era occurred because the Apostle Thomas referred to King Gudnaphar (the Parthian king Gondophares) in his description of his journey to India; scholars agree that this king's inscriptions belong within the Vikrama sequence of dates.[2] The Indravarman casket inscription is also significant because the unusual wording, grammar, and syntax of parts of it suggest that a standard Buddhist text is being paraphrased, most probably some redaction of the *Ekottaragamma.* This would be the earliest example of a Buddhist inscription from the Gandharan region that uses the Buddhist canon as a source. Indeed, the language of the paraphrases seems to demonstrate that a canon in Prakrit (local vernacular) existed in the area at this time. Last, the inscription shows that there was a direct relationship between doctrine and practice. Indravarman seems to be literally following canonical instructions to place relics of the Buddha Shakyamuni in a "secure, deep, previously

unestablished place" in order to accrue for himself and his family brahma-merit (equivalent to a *kalpa*— 4,320 million years or a day in the life of Brahma—of happiness in heaven).[3]

SK

1 This translation, which takes into account the variations of all the earlier ones, is by Salomon and Schopen (pp. 108–9). Variations occur because Kharoshti originated as an Aramaic script and was not well suited to capture the phonetics of the Indian language, as some of Aramaic's vowels and consonants were different (Bailey, pp. 3–4). Some extrapolation is, therefore, necessary in any Kharoshti translation, but especially in that of names, for which standard forms may not exist.
2 Salomon, p. 67.
3 Salomon and Schopen, pp. 116–21.

PUBLISHED
Mukherjee, pp. 93–114 (inscription only).
Bailey, pp. 3–13 and pl. IV, p. 8.
Fussman 1980, pp. 1–43 and pl. I.
Bivar "Azes Era," pp. 360–76.
Bivar "Vikrama Era," pp. 47–58.
Salomon, pp. 59–68.
Fussman 1984, pp. 31–46.
Salomon and Schopen, pp. 107–23.

39 Inscribed Reliquary

*Pakistan, Gandhara, Kushan period,
1st quarter of 1st century
Schist, diam. 3 5/8 in. (9.2 cm)
Gift of Samuel Eilenberg, 1987
1987.142.70*

The form of this wheel-turned inscribed reliquary is similar to that of the Indravarman Casket, but the Kharoshti inscription around the lower part of its body and on the inner surface of its cover is carved rather than incised. The inscription reads:

Donation of Ramaka, son of Mahasrava. (Donation) of Ramaka, son of Mahasrava, inhabitant of the village of Kamti. From him (come) the relics. The relics are abundantly deposited. All those who are worthy to be honored are honored.[1]

It is probable that this is the same Ramaka who is identified in the Indravarman Casket inscription (see No. 38) as Indravarman's maternal uncle. Thus, the

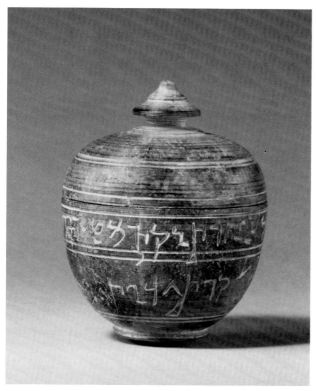

39

present inscription adds to our knowledge of the genealogy of the royal house of Avaca by giving us the name of Ramaka's father, a bit of information about yet one more generation.

SK

1 English translation by the author from the French by Fussman (1980, p. 5). The use of the word abundantly (*avec abondance*) makes little sense, and the Kharoshti is translated by Bailey as "reverently(?)" (p. 4).

PUBLISHED
Bailey, pp. 3–13 and pl. v, p. 9.
Fussman 1980, pl. 2.

40 Reliquary with Contents

*Pakistan, Gandhara, early Kushan period,
2nd or 3rd quarter of 1st century
Schist with gold, copper, crystal, pearl, and
turquoise objects, diam. 2 ½ in. (6.4 cm)
Gift of Samuel Eilenberg, 1987
1987.142.44a–m*

41 Reliquary

*Pakistan, Gandhara, early Kushan period,
1st three-quarters of 1st century(?)
Schist, diam. ⅞ in. (2.3 cm)
Gift of Samuel Eilenberg, 1987
1987.142.48ab*

42 Reliquary

*Pakistan, Gandhara, early Kushan period,
1st three-quarters of 1st century(?)
Schist, diam. 2 in. (5.1 cm)
Gift of Samuel Eilenberg, 1987
1987.142.46ab*

43 Reliquary

*Pakistan, Gandhara, early Kushan period,
1st three-quarters of 1st century
Schist, diam. 2 ¼ in. (5.7 cm)
Gift of Samuel Eilenberg, 1987
1987.142.47ab*

44 Reliquary

*Pakistan, Gandhara, Kushan period,
2nd–3rd century
Schist, diam. 2 1/16 in. (5.2 cm)
Gift of Samuel Eilenberg, 1987
1987.142.45ab*

These examples were selected from the large group of Gandharan reliquaries in the Eilenberg collection. They illustrate some of the many types of decoration and forms used in the genre. All but No. 44 were made by turning schist on a wheel and then adding incised or carved decoration.

The first (No. 40) is a low, lidded vessel with a small foot. It is embellished with incised lines and a large band of incised leaves that form a wreath around the shoulder of the lid. The lid is surmounted

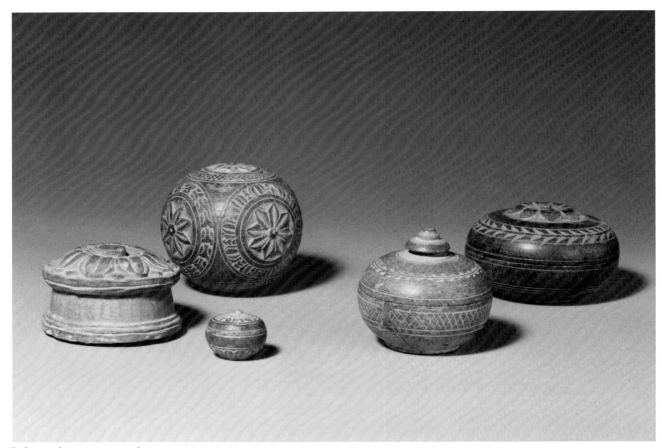

Left to right: rear, 41, 40; front, 44, 43, 42

by an upside-down lotus bud whose stalk forms a raised button in its center. A number of relics and offerings—a small gold box, four copper coins, a crystal bead, a pearl, and a piece of turquoise—were found inside the box. The coins were minted by one of the last of the Indo-Parthian rulers, Gondophares. The fact that there are four coins from the same reign makes it likely that the reliquary is contemporaneous with them, and therefore it is being dated to the second or third quarter of the first century.[1] The second example (No. 41) is a tiny reliquary of similar configuration but without the lotus finial. The body above the foot is carved with a design of petals, and the top of the cover shows palmettes that radiate from a central boss. There are also several incised lines around the lid and body. The next (No. 42) has a more bulbous body and is surmounted by an articulated knob. There is a wide band of incised crisscross decoration below the rim of the pot and a small wreath of leaves encircling the middle of the lid. Several incised linear bands are also used as

decoration. The fourth (No. 43) is of spherical form with six contiguous medallions decorating its surface. The medallions have carved floral centers surrounded by a wide band of carved petals, leaves, or cross-hatching enclosed in incised linear borders. One of the floral centers is removable and permits access to the excavated interior. A reliquary of similar form and design was excavated by Marshall at Sirkap.[2] The last reliquary (No. 44) was carved rather than turned, and the quality of finish is less refined than in the previous examples. It is squat and circular with a tripartite stepped bottom. The sides slope inward. The top is decorated with a high-relief lotus flower, and its interior, uncharacteristically, has a lip that allows it to be secured to the rim of the box.

SK

1 Rosenfield, pp. 129–30. The coin is similar to Rosenfield, pl. xv, no. 281.
2 Marshall, vol. 3, pl. 36G. The cover shown with this reliquary may not belong to it. (For other reliquaries of the type, see ibid., pls. 104A–E, 141.103.)

45 Reliquary

*Pakistan, Gandhara, early Kushan period,
1st three-quarters of 1st century
Schist, diam. 5 1/8 in. (13 cm)
Gift of Samuel Eilenberg, 1987
1987.142.137a–c*

The form of this large, squat, wheel-turned reliquary with cover and flaring base is unusual. The body and cover are decorated with wheel-turned incised and raised bands, and the top has a knoblike finial with a concave depression in its center. In antiquity, the body was broken in two and mended in the typical classical manner by securing the halves with metal pins with cross braces. Almost all traces of these cross elements have broken off. The top is pierced with a hole, the discoloration around which indicates that it too once held some sort of metal attachment. The reliquary has been preliminarily assigned to the early Kushan period, although an earlier date is also possible.

SK

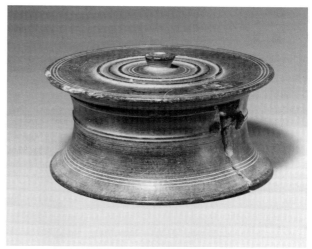

45

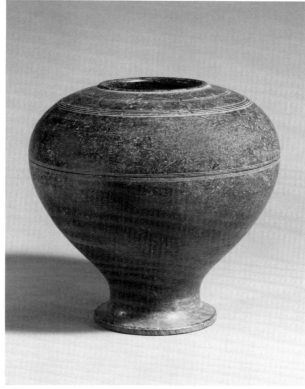

46

46 Reliquary Urn

*Pakistan, Gandhara, Kushan period, 1st century
Schist, diam. 8 5/16 in. (21.1 cm)
Gift of Samuel Eilenberg, 1987
1987.142.208ab*

Although numerous utilitarian objects made of stone and metal have been discovered in Gandhara, both the large size and the unusual shape of this schist urn make it unique. Like many of the other stone vessels, this example may be based on either a metal or pottery prototype. The two pieces that make up the body of the container fit together at its widest point, but there is no sign that any attempt was ever made to bond them permanently. Both sections were produced by wheel turning, a technique often used to make Gandharan stone vessels. In contrast to the body, the lid is rather crudely manufactured. This would seem to indicate that it was a hasty addition, made to adapt an existing object to a new, funerary context. The only related object in the literature is a

first-century schist vase excavated by Marshall at Sirkap.[1] It is possible that our urn is also from the first century.

SK

1 Marshall, vol. 3, pl. 52A. This vase also seems to have been manufactured in two pieces.

PUBLISHED
Czuma 1985, no. 83.

India and Pakistan
Kushan-Period Sculpture

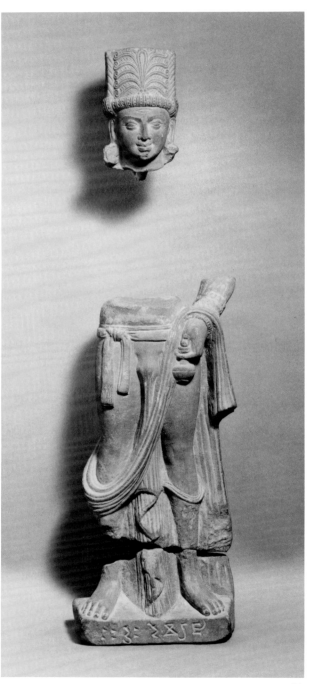

47

47 Standing Indra

India, Uttar Pradesh, Mathura or Ahicchatra(?),
Kushan period, 2nd century
Sandstone, lower body h. 11½ in. (29 cm);
head h. 3¾ in. (9.4 cm)
Purchase, Rogers Fund, 1987
1987.218.12

This fine small sculpture in the round is an important
recent addition to the corpus of Mathura-style
sculptures of the Kushan period, even though it is
incomplete. The deity is identified through the in-
scription on the pedestal as "Indra, King of the Gods,"
and has the horizontal third eye and elaborately
decorated crown usually associated with this god.

At Mathura, by the time this sculpture was created,
a well-established tradition existed for depicting stand-
ing male deities and their costumes. Most often, the
figures stand in a frontal position, legs apart, feet
placed sideways, the weight of the body distributed
evenly on the two rigid legs. The positioning of the
arms is less varied than one might expect, it being
usual to find the right arm raised with the hand
making the fear-allaying gesture (*abhayamudra*) or a
close approximation of it, *vyavrttamudra*,[1] and the
lowered left hand holding, as here, a *kundika* (sacred-
water vessel) in the area of the left thigh.

The transparent dhoti falls from the hips to below
the knees, adhering tightly to the body, and is
partially secured by a knotted belt whose ends hang
down the right thigh. The garment accumulates
between the legs and drops from the clearly defined
genitals in an expanding mass of folds until it reaches
the pedestal. A long, heavy scarf comes from behind
the figure, crosses below the right knee, and is then
looped over the left wrist, falling downward in a
bulky swag. Had the upper part of the figure sur-
vived, most likely it would have displayed a broad
circular torque below the neck and a longer necklace
descending to about the level of the nipples.

Writers who have previously discussed this sculpture have properly pointed out its stylistic resemblance to the well-known Maitreya from Ahicchatra[2] but have neglected what probably is the most compelling point of comparison—their size. Despite arguments to the contrary, it is clear, on the basis of style, that the Eilenberg Indra and the Maitreya from Ahicchatra cannot be the work of the same artist, and that the obviously similar features are part of a well-developed formal vocabulary of the second-century Mathura school. Therefore, the first thing that should prompt one familiar with the Kushan-period Mathura-school corpus to connect the two figures is that within the enormous wealth of sculpture of this school, these two deities stand out conspicuously as miniatures. Clearly, since the Ahicchatra Maitreya is about twenty-six inches tall and our Indra probably was originally about eighteen inches high, miniature is a relative term. However, in the context of Kushan sculpture in the round of the Mathura school, one is immediately taken by the small size and corresponding sense of delicacy of these figures, despite their powerful volumes and strong presence.

ML

1 Härtel, pp. 667–68.
2 Pal 1979, p. 212; Czuma 1985, p. 131.

PUBLISHED
Pal 1979, pp. 212–26.
Czuma 1985, pp. 130–31.

48 Bust of a Bodhisattva

Pakistan, Gandhara, Kushan period,
late 2nd century
Schist, h. 18¼ in. (46.1 cm)
Purchase, Anonymous Gift and
Rogers Fund, 1987
1987.218.10

During the Kushan period, the new Mahayana sect of Buddhism gained currency in the Gandharan region.

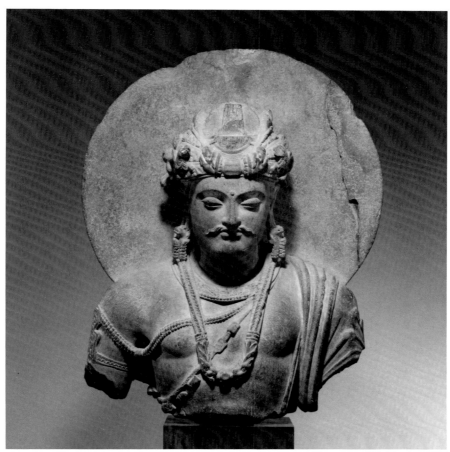

48

Bodhisattvas, individuals who renounced Buddhahood in order to devote themselves to bringing salvation to mankind, were central figures in the creed. Together with Buddhas, they came to be the most commonly represented divinities in Gandhara in Kushan times. The great number of extant large-scale sculptures of bodhisattvas of this period indicates that the Gandharan workshops were extremely prolific and also that such statues must have been stock products.

In its physiognomy, body type, and ornamentation, this unusually fine bust of a bodhisattva is typical. A debt to classical sculptural traditions is revealed in the idealized facial features and the naturalism of the torso—the musculature in particular is sensitively rendered. The jewelry, which includes a torque, a necklace with two heads of *makaras* (fantastic aquatic beasts) supporting a faceted jewel, a necklace with amulets, a *yajnopavita* or *upavita* (sacred Brahmanical thread), armband, and large earrings with winged lions and tassels, is standard. The turban is especially handsome, with its headband showing two mythological winged beasts with lion bodies and beaks, and its central faceted jewel held by two *makara* clasps. The central element of the turban, which was probably the usual cockade set in front of a pleated fan of fabric, is missing. This element was sculpted from a separate piece of stone and slotted into a tenon that is visible above the jewel of the headband. Typically, a large aureole forms a backdrop for the head and shoulders.

SK

49 Head of a Bodhisattva

Pakistan, Gandhara, Sahri Bahlol,
Kushan period, late 2nd century
Schist, h. 10 11/16 in. (27.2 cm)
Purchase, Anonymous Gift, 1987
1987.218.11

Gandharan artists evolved an idealized physiognomy for both the Buddha and the bodhisattvas in which a debt to the Greco-Roman sculptural tradition is apparent. This fragment of a lifesize sculpture of a bodhisattva is one of the finest Gandharan stone heads known. It is distinguished by the subtle beauty of carving as well as by uncharacteristically idiosyncratic facial features. The aquiline, pinched bridge and fleshy wings of the nose, slanting eyes, complexity of planes at the juncture of nose and eye socket, horizontality of the moustache, clear geometry of the lips, and the row of downward-pointing curls over the forehead all depart somewhat from the stock formulaic elements typically used by Gandharan artists to portray divine beings. They lend our sculpture a sense of individuality rarely encountered in the genre.

The bodhisattva's wavy hair is pulled up into a large chignon, which is held in place by a band of beads (pearls?). His multistranded headband, composed of beads of various types, is of a kind characteristically worn by bodhisattvas. Here its central faceted bead is surmounted by a *shrivatsa* symbol, an emblem of Shri Lakshmi, the goddess of prosperity and good fortune. Our head is the only Gandharan image known in which this element appears. The bodhisattva's earrings, which are in the form of winged lions, are of a type common in the Kushan art of both Gandhara and Mathura. Whether they simply represent some sort of auspicious symbol or refer to the historical Buddha's birth in the Shakya clan is unclear.[1]

SK

1 Czuma 1985, p. 208.

PUBLISHED
Czuma 1985, no. 116.

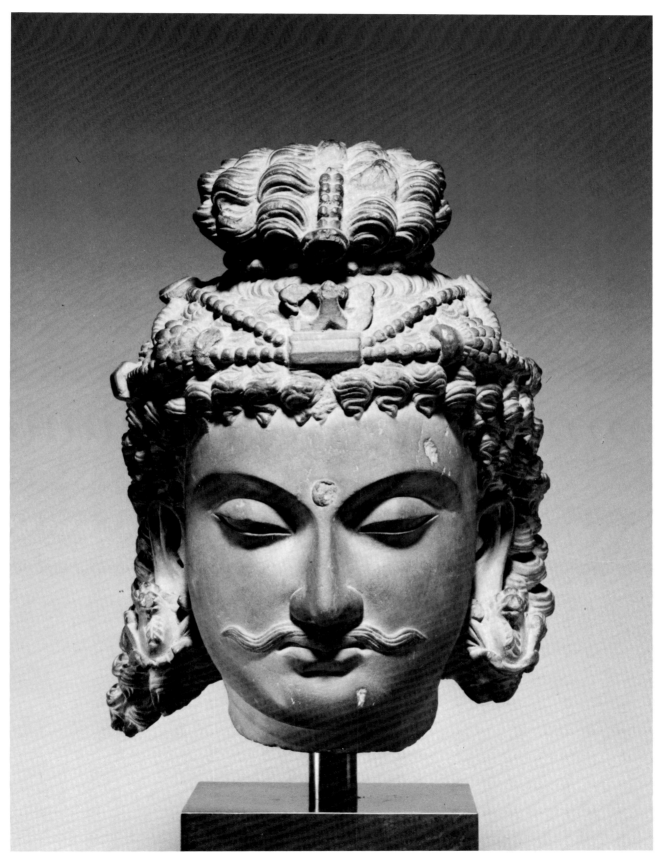

49

50 Head of the Fasting Siddhartha

Pakistan, Gandhara, Kushan period,
ca. 3rd century
Schist, h. 5 3/8 in. (13.7 cm)
Gift of Samuel Eilenberg, 1987
1987.142.73

51 Fasting Siddhartha

Pakistan, Gandhara, Kushan period,
ca. 3rd century
Schist, h. 10 15/16 in. (27.8 cm)
Purchase, Rogers, Dodge, Harris Brisbane Dick,
and Fletcher Funds, Joseph Pulitzer Bequest,
and Lila Acheson Wallace Gift, 1987
1987.218.5

As soon as the future Buddha, Prince Siddhartha, managed to escape the confines of his sheltered palace life, he realized that there existed in the world an inherent cycle of suffering made up of desire, pain, decay, death, and rebirth. He therefore renounced his temporal pleasures in favor of a quest for spiritual emancipation. The prince attempted several then-current techniques, including meditation undertaken together with the imposition of extreme austerities, in order to reach his goal. All ultimately proved inadequate. Siddhartha fasted until he was near death before finally abandoning this path as fruitless.

Representations of the Fasting Siddhartha do not exist in the art of Kushan India and are rare in that of Gandhara. The few that occur are remarkable for their emotive power and hyperrealism, characteristics

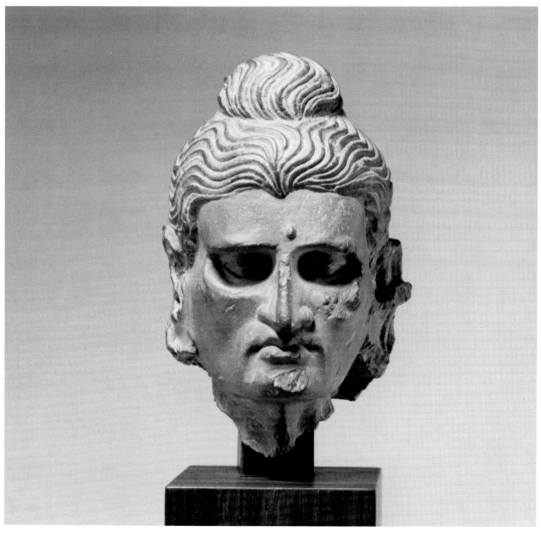

50

that at first seem at odds with the nature of the main corpus of idealized, classically inspired Gandharan sculpture. Yet the Gandharan artists' concern with the description of corporeal substance—which sets their work apart from the conceptualized depictions of Indian sculpture—is in fact present in their Fasting Siddharthas. However, it has been carried to an extreme in terms of closely observed detail and has been applied to a subject that falls outside the classical tradition. In so doing, the Gandharan artists have produced their most original image. In these Fasting Siddharthas, the flesh has almost entirely disappeared from the emaciated body, leaving only skin, sinews, and veins tightly stretched upon the now-visible skeleton. At the same time, an inner-searching, living presence informs these spectral images.

There are two fragmentary Fasting Siddharthas in the Eilenberg collection, a head and a headless torso. A comparison of the two fragments to the two finest extant representations of the subject, the greatest one in the Lahore Museum and the other in the Peshawar Museum, is rewarding. Our sculptures are most closely related to the figure in the Lahore Museum. The arrangement of the drapery in the larger fragment is similar, except that our Siddhartha's shawl covers his shoulders rather than falling down about his elbows as it does in the Lahore sculpture. The hairstyles are comparable, as is the way in which the rib cage is articulated. However, the relief decorating the front of the pedestal of the torso is an abbreviated version of the scene on the front of the Siddhartha from Peshawar, which depicts the seated deity

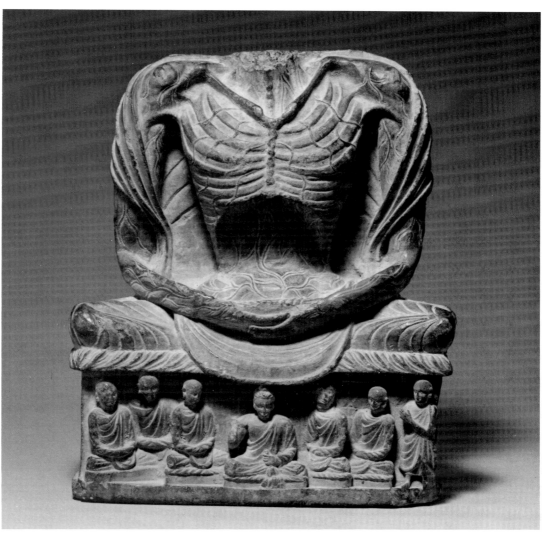

51

preaching to an assembly, holding up his right hand in *abhayamudra*, the gesture signifying the allaying of fear. Several elements in the Eilenberg sculptures do not derive from either classical or Indian prototypes: the clean-shaven physiognomy, with heavy-lidded eyes, down-turned mouth, and full-winged nose, and the patterning of veins covering the concave depression of the now-shrunken stomach. Of the two fragments, the head is both the most expressive and the more beautifully modeled.

SK

PUBLISHED
Pal 1984, no. 39B (No. 51).

52 Relief Panel: Presentation of a Statue

Pakistan, Gandhara, Kushan period,
2nd–3rd century
Schist, 11⁷/₈ x 6 in. (30.2 x 15.2 cm)
Purchase, The Christian Humann Foundation
Gift, 1987
1987.218.9

Toward the end of his life, the Buddha disappeared from among his disciples and rose to the Trayastrimsha Heaven (the second of six levels of heaven, the heaven of Brahmanism) in order to instruct his mother and the devas (gods) in doctrine. In his absence, King Udayana of Kaushambi commissioned a sandalwood statue of the Buddha to worship. When the Buddha returned to earth with a retinue of devas, he was greeted by the king and presented with the image, whose veneration he condoned.[1]

The bottom portion of the present two-register relief may illustrate this episode, although the king is not portrayed, and the statue being held is atypical as a representation of the Buddha. Shakyamuni Buddha is at the right, holding a small statue set on a lotus base. The god Indra, thunderbolt in hand, stands to his left, and at his right two monks—one standing, the other kneeling—raise their hands in *anjalimudra* as a sign of adoration toward the Buddha. Behind them, another figure, perhaps Brahma, holds aloft a bunch of flowers. Like many Gandharan reliefs, the scene is enclosed in an architectural setting. In the upper register, a bodhisattva, enclosed in an elaborate arch, is seated in meditation. He holds a

small water bottle, identifying him as Maitreya, the future Buddha. Two devas, one with a wreath of flowers, the other with hands raised in *anjalimudra*, stand on lotus pedestals flanking the bodhisattva.

Iconic representations of the Buddha and of bodhisattvas first gained prominence in the Kushan period. The story depicted in our relief may have originated to help legitimize the worship of such images. Portrayals of the scene are rare.

SK

1 For another example of a relief depicting this subject, see Ingholt, no. 125.

PUBLISHED
Pal 1984, no. 55.

53 Relief Panel: The Gift of Anathapindada(?)

Pakistan, Gandhara, Kushan period,
ca. 2nd century
Schist with traces of gilt, 9⁵/₈ x 9 in.
(24.5 x 22.9 cm)
Gift of Samuel Eilenberg, 1987
1987.142.1

The identification of the subject of this relief as the Gift of Anathapindada is by no means certain. The presence at the far left of the figure holding a water bottle suggests that a gift is about to be made, as a donor traditionally poured water over the hands of a recipient to seal a gift.[1] However, what the scene as a whole specifically represents rests on the identification of the objects in the bowl being proffered to the Buddha. Sudatta, called Anathapindada (the Incomparable Almsgiver), was the richest merchant of the town of Shravasti (in Koshala). He met the Buddha at Rajagriha and proposed to donate money in order to buy land for him for a Buddhist vihara in Shravasti. The amount of the payment exacted from Anathapindada was calculated by covering the grounds of the park to be purchased with gold coins. The identification of the objects in the bowl as coins is speculative, and the precise scene in the life of the Buddha that is represented is therefore unclear.

The presence of original gilt on this relief and on the panel discussed in the next entry is extraordinarily unusual and of great interest. How prevalent the use of gilt was in Gandhara is unknown, but its

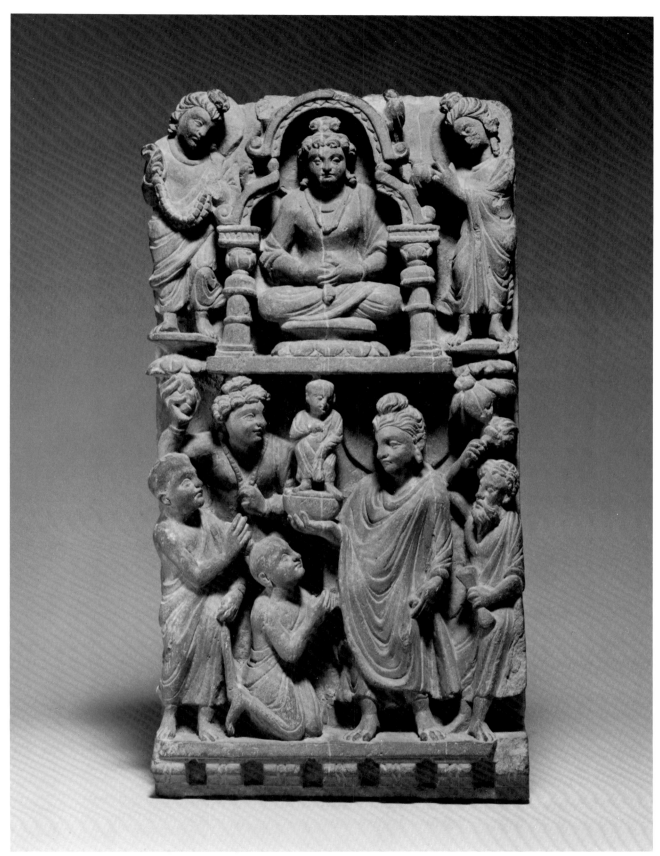

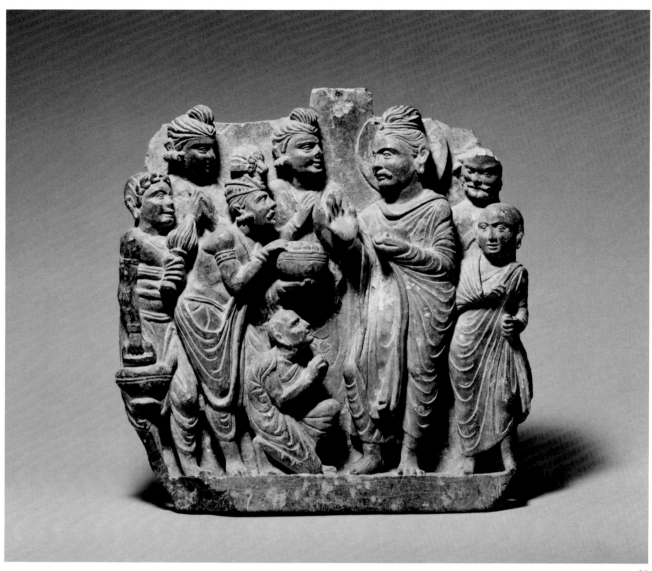

appearance in these examples suggests that at least some bands of reliefs encircling Gandharan stupas were originally entirely gilt.

SK

1 Pal 1984, p. 115.

PUBLISHED
Pal 1984, no. 57.

54 Relief Panel: Procession of Five Figures

Pakistan, Gandhara, Kushan period,
ca. 2nd century
Schist with traces of gilt, 9 ⁵/₈ x 12 ³/₁₆ in.
(24.5 x 31 cm)
Gift of Samuel Eilenberg, 1987
1987.142.2

Friezes with stories from the life of the Buddha commonly adorned Gandharan stupas. Many of these stories can be considered parables of proper living as well as historical accounts of the Buddha's life, and a number carry a specific religious message.

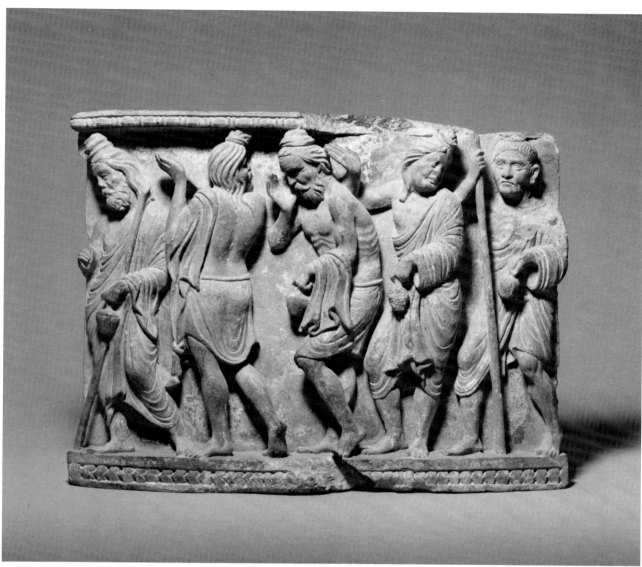

54

In one frequently depicted episode, sixteen disciples of a Brahman pundit are shown on their way to seek counsel from the Buddha.[1] This relief of a procession of five ascetics is probably a portion of a larger scene illustrating this story. The ascetic nature of the characters is evidenced by their hair, which has been allowed to grow long and is piled atop their heads, by the beards worn by two of them, their long staffs, and the water bottles they carry. Almost all show signs of emaciation—sunken cheeks and, in the case of the central figure, a visible rib cage as well.

The modeling of the relief is particularly fine. The artist has skillfully arranged the interrelated poses of the figures so that they appear to proceed from right to left in a subtle curve that reinforces the slight convexity of the panel, which was probably contoured to conform to the stupa drum it was set in. The relief is bordered on the bottom by a row of overlapping pipal leaves and on top by a classical bead-and-reel motif. The rare remnants of gold would seem to indicate that this sculpture was originally entirely gilt.

SK

1 Ingholt, p. 71 and pls. 82, 106–8.

Pakistan and India
Gupta-Period Box Lids and Other Objects

55 Intaglio Seal with *Buddhapada*

Pakistan, Gandhara, 4th century(?)
Lapis lazuli, w. 1 in. (2.5 cm)
Lent by Samuel Eilenberg

Undoubtedly, this oval intaglio lapis-lazuli seal was carved as a talisman. At the center of the seal is a representation of the footprints of the Buddha, *buddhapada*, and on either side there are Brahmi characters. Images of the Buddha were not worshiped prior to the early first century A.D., and the *buddhapada*, along with relics of the historical Buddha, formed the focus of early cults. Even after the image of the Buddha evolved, depictions of his footprints were carved as objects of devotion. This seal can be dated only by means of its letters, which seem to be of the Gupta period. The inscription is a name prefaced by the honorific *shri* (blessed).

SK

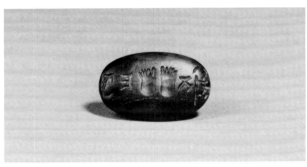

55

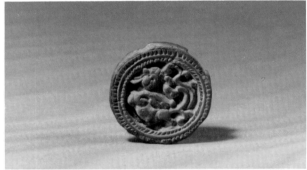

56

56 Earplug with a *Kinnari*

India, Gupta period, ca. 5th century
Terracotta, diam. ⅞ in. (2.3 cm)
Gift of Samuel Eilenberg, 1987
1987.142.390

Despite its frequent depiction in sculpture, very little early Indian jewelry has survived. Earplugs, often of extremely large size, appear to have been a popular adornment for both men and women. A small number of them, made in a variety of materials such as stone, crystal, and gold, are extant. This example is unusual in terms of its material—terracotta—and diminutive size, and because it is decorated on both the front and back surfaces (backs of earplugs are usually left plain). The front of our earplug is carved in deep relief with a depiction of a *kinnari*, a mythological half-bird, half-woman inhabitant of the celestial sphere (see No. 149), enclosed in a surround of two narrow borders. Her large tail of swirling feathers is the most prominent feature of the design. The back is more shallowly carved with a shieldlike motif of two beaded, crossed bars and four abstract chevrons, all contained within a large border of pearling. The swirling feathers of the *kinnari* are related to the decorative elaborations seen on fifth-century box lids (see Nos. 57–61), and I am therefore dating this earplug to about the same time.

SK

PUBLISHED
Postel, no. 1.20.

90

57 Box Lid with a Phoenix

Pakistan, Gandhara, ca. 5th century
Schist, w. 4³/₁₆ in. (10.6 cm)
Lent by Samuel Eilenberg

58 Box Lid with a Winged Lion

Pakistan, Gandhara, ca. 5th century
Schist with remnant of iron hinge,
w. 4³/₈ in. (11.1 cm)
Lent by Samuel Eilenberg

59 Box Lid with a Brahman Bull

Pakistan, Gandhara, ca. 5th century
Schist, w. 3⁹/₁₆ in. (9.1 cm)
Gift of Samuel Eilenberg, 1987
1987.142.120

60 Box Lid with a Lion Attacking an Elephant

Pakistan, Gandhara, ca. 5th century
Schist, w. 3¹/₂ in. (8.9 cm)
Gift of Samuel Eilenberg, 1987
1987.142.49

61 Box Lid with a Floral Bud

Pakistan, Gandhara, ca. 5th century
Schist, w. 3⁵/₈ in. (9.2 cm)
Gift of Samuel Eilenberg, 1987
1987.142.50

These five box lids are all closely related in style and imagery and seem to be secular productions. Their imagery is almost exclusively animals, either fantastic or realistic, shown alone or in combat.[1] Some lids depict hunting scenes.[2] For instance, a fragmentary example in the Eilenberg collection (not exhibited) portrays a hunter on horseback pursuing game, aiming his bow in the Parthian manner (with body turned at the waist to enable him to shoot behind himself). In his garb, hunting paraphernalia, and riding posture, he resembles the nobles of the northwestern kingdoms as they are commonly portrayed on silver court vessels. It is to these sumptuary objects that the animal-hunting imagery of the Eilenberg box lids is most closely related.

The imagery of most of the Eilenberg lids is elaborated with an unusual decorative motif of twisted ribbonlike curls, which is derived from Gupta-period foliate scrolls. In Gupta-period art, this device is

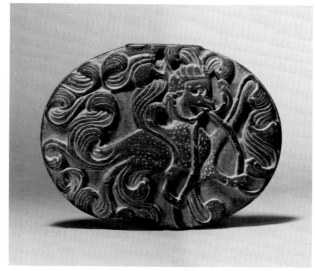

57

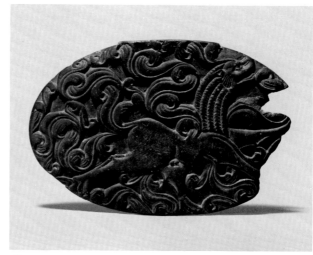

58

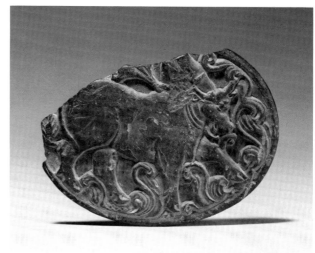

59

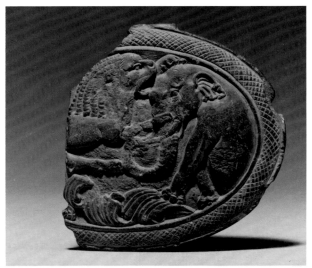

60

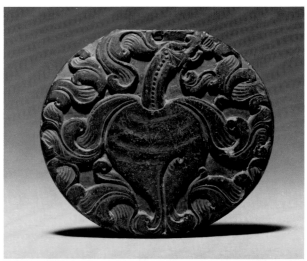

61

to have survived, was reportedly found on the banks of the Swat River and is dated by scholars to the third quarter of the fifth century.[4]

The round form and almost exclusively floral decoration of the box lid with a floral bud (No. 61) set this example somewhat apart from others in the group. The meaning of its imagery of abundance, with foliate scrolling emerging from both the base and tip of the bud, is made more explicit by the small head of a *makara* (fantastic aquatic animal), itself a progenitor of nature's bounty, which terminates the bud's stem. Although in its largely vegetal character the decoration of this lid is closer than that of the others to Gupta prototypes, the form of the foliate scrolling and the way it elaborates the images are consistent with the usage in most of the other examples. For instance, the scrolling that signifies the beard and crest of the *makara* head is identical to that on the head of the phoenix (No. 57).

The close similarity of the imagery, style, and shape of our box lids suggests that they may have been the product of a single workshop. The stylization of the animals generally follows Iranian prototypes, although some elements, such as the consistent rendering of the lion manes as parallel braided(?) rows, are distinctive. Stylistic parallels would seem to indicate that these box lids should be dated to the fifth century and that a northwestern Indian provenance, like that of the Oxus bowl, is probable. Ovoid silver dishes are part of the Sasanian repertory, but they are not lidded, nor are they segmented like the two ovoid schist boxes in the Eilenberg collection.[5] Nevertheless, both the general form and the medium of our boxes make it likely that they were less costly copies of silver ones made for court use. Given the preponderance of animal and hunting imagery in these objects, it is possible that hunting paraphernalia was stored in them. These boxes and box lids are among the rare examples of the secular art of the period, little of which has survived.

SK

found in the bands of the halos of some Mathura-style Buddhas as well as in a number of architectural reliefs, where they are sometimes developed into overall patterns.[3] In the Eilenberg box lids, the generic Gupta scroll is used not only to describe vegetation but also to signify animal parts such as the plumage of the phoenix or the tail and wings of the winged lion (Nos. 57, 58). The scrolling becomes as well a decorative device independent of the object it describes, as if its original function as a symbol of nature's bounty had imbued it with a life of its own. The same device is present on the base of a bowl from the Oxus Treasure, where it functions with a similar decorative invention and independence in the elaboration of the plumage of four phoenixes. This bowl, one of the rare secular objects from the Gupta period

1 Two box lids with couples drinking, one in the British Museum, London (1920.5–17.1), the other in a private collection, are known.
2 For a lid with a hunter spearing a lion, see Czuma 1985, no. 72.
3 For example, see the *Standing Buddha* in the collection of The Metropolitan Museum of Art (acq. no. 1979.6) (*Notable Acquisitions*, p. 87), and Williams, pls. 83, 89.
4 Dalton, no. 201 and pl. XXIX; Marschak, p. 32 and fig. 14. The phoenixes on the Oxus bowl are in fact identical to our fantastic crested bird.
5 For an Iranian example of approximately the same size dated to the seventh century, see Harper, no. 29.

India

Gupta, Post-Gupta, and Chalyuka Sculpture

62 Bodybuilder's Weight

India, Uttar Pradesh, Mathura,
Gupta period, 4th century
Sandstone, 10 x 19⁹/₁₆ in. (25.4 x 49.6 cm)
Gift of Samuel Eilenberg, 1987
1987.142.286

Over the years, a few examples of a rare category of object have been discovered whose form strongly suggests that they are weights for bodybuilding. They all have handgrips at the sides, and those known to me, both from Gandhara and Mathura, have as their main decoration a depiction of Krishna battling the Demon Horse, Kesi.

The account of this episode in the life of Krishna is given in book ten of the great Hindu epic the *Bhagavata Purana*,[1] where the evil king Kamsa, whose death at the hands of Krishna had been foretold by the gods, dispatches Kesi to kill Krishna and his brother Balarama. At the same time, should Kesi fail, Kamsa arranges for the brothers to be killed by his champion wrestlers in a match. Krishna kills Kesi by plunging his arm in the Demon Horse's mouth and expanding it until Kesi is choked to death. Later, at the wrestling match, the heroes again prevail and eventually King Kamsa is slain. The association of these two episodes may account for their being depicted together on either side of a rare Gandharan weight.[2]

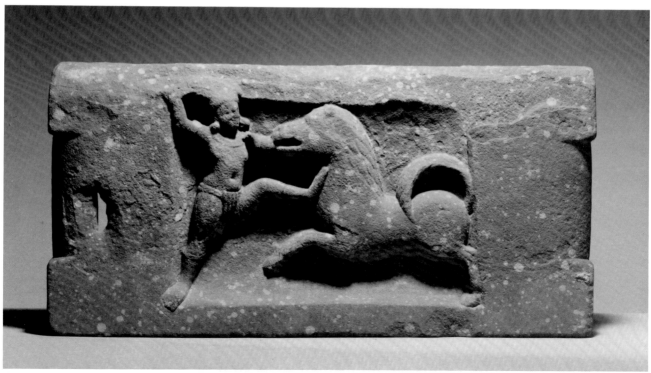

62

93

There are only two other red sandstone weights known to me; like the Eilenberg example, they depict the Krishna and Kesi theme on one side and leave the other side undecorated. A complete example, formerly in the Gai collection, Peshawar,[3] shows Krishna with his left arm in Kesi's mouth and his raised left foot against the horse's chest, as he appears on the Eilenberg weight, and a fragment, now in the Government Museum, Mathura,[4] has Kesi and part of Krishna.

Krishna's martial skills, including proficiency in wrestling, were well known, and he may have been taken by wrestlers and bodybuilders as their patron deity. It is difficult, however, to explain why the Kesi episode, among all Krishna's many victorious exploits, was the favorite subject for depiction on such weights, even if one hypothesizes that they were used primarily by wrestlers.

Although these weights have always been assigned to the Kushan period, an early Gupta-period dating to the fourth century seems more likely.

ML

1 Goswami 1971, part 2, p. 1204.
2 Czuma 1985, pp. 163–64.
3 Lohuizen-de Leeuw 1972, pl. XI.
4 Joshi, fig. 64.

63 Linga with One Face (*Ekamukhalinga*)

India, Madhya Pradesh, Gupta period,
1st half of 5th century
Sandstone, h. 6⅞ in. (17.5 cm)
Gift of Samuel Eilenberg, 1987
1987.142.323

In India, worship of the linga (phallic emblem of Shiva) goes back to remote antiquity. There and in other countries influenced by Hindu theology, worship of the linga is understood to be worship of the generative principle of the universe, the source of universal energy, conceptualized as one great aspect of Lord Shiva. The linga is the most sacrosanct object in a Shiva temple and is housed in the innermost sanctum.

The phallic emblem can be plain or have on it one to four faces (see Nos. 109, 112). This sculpture is an *ekamukhalinga*, a linga with a single face of Shiva. Carved in high relief, the full and rounded volumes of the face and head echo the configuration of the linga. The hair is separated into individual strands (*jatas*) that are pulled back and arranged on top into a small bun, with a few long strands falling to both sides of the head.

The earrings worn by Shiva are of a type that are restricted to the first half of the fifth century, according to J. C. Harle.[1]

ML

1 Harle 1978, pp. 78–80.

PUBLISHED
Kramrisch 1981, p. 4.

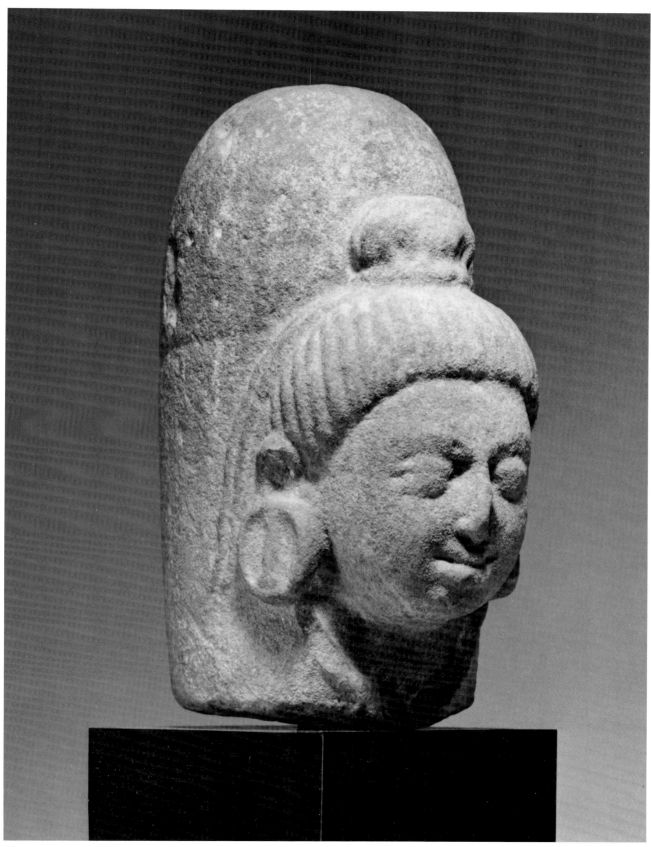

63

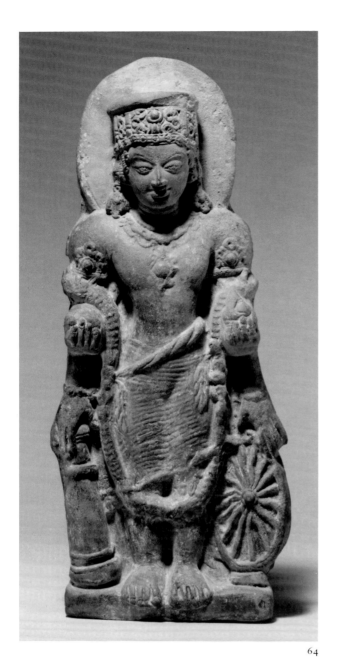

symmetrical *samabhanga* posture, the deity stands proudly, displaying his specific attributes, seemingly mindful of his special role as preserver and protector of the universe. In his raised left hand he holds the conch (*shankha*), a kind of battle trumpet, and in his raised right hand what appears to be a lotus bud (*padma*), a generic emblem of divinity. His lowered left hand is placed on either a wheel or an enlarged war-discus (*chakra*), and his lowered right hand rests on the top of a battle club or mace (*gada*). Since Vishnu is periodically called upon to save the universe from some impending calamity, most of his attributes are martial.

The deity is dressed in the usual manner of the Gupta period, wearing a broad decorated miter, a dhoti, a twisted sash slung diagonally from waist to right hip, elaborate jewelry, and a long floral garland (*vanamala*) descending below the knees. Since easily portable sculptures of this sort must have been mass-produced, one wonders how many may have found their way out of India to influence the sculptural styles and iconography of other nations.

ML

PUBLISHED
Poster, frontispiece and p. 152.

64

64 Standing Four-Armed Vishnu

India, Uttar Pradesh, Gupta period,
5th century
Terracotta, h. 10 1/4 in. (26 cm)
Gift of Samuel Eilenberg, 1987
1987.142.293

This molded Vishnu is one of the finest examples known of its type and has survived in unusually sound and crisp condition. Depicted in the frontal,

65 Standing Chakrapurusha(?)

India, Uttar Pradesh(?), Gupta period,
6th century
Bronze, h. 4 3/4 in. (12.1 cm)
Purchase, Mr. and Mrs. Donald Bruckmann
Gift, 1987
1987.218.24

According to the evidence of its size, stance, and arm position, this lively figure was both an attendant to a larger deity and the personification of one of that deity's attributes. In Indian sculpture, the attendant most often depicted with arms crossed in front of his chest in a gesture of submission or humility is Vishnu's personified discus, Chakrapurusha. Normally, Chakrapurusha is placed to the left of Vishnu and is paired with Gadadevi, the female personification of Vishnu's battle mace. There are quite a few surviving Gupta-period stone representations of Vishnu with his two personified weapons showing Chakra-

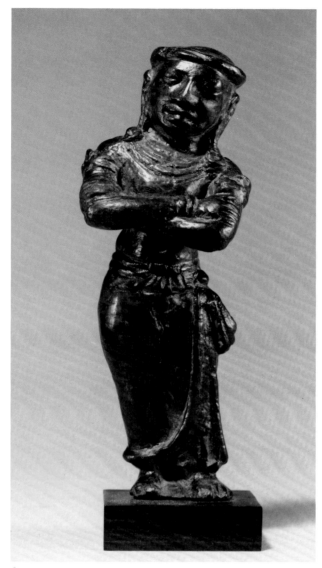

65

1 For example, see Begley 1973, figs. 5, 18; Pal 1978, nos. 3, 52.
2 The broad face and physiognomic type is somewhat related to the famous Dhanesar Khera bronze seated Buddha in the British Museum, London (Schroeder 1981, no. 43D).

PUBLISHED
Pal 1978, pp. 92–93.

66 Standing Tara

India, Gupta period, ca. 2nd half of 6th century
Bronze, h. 12 in. (30.5 cm)
Purchase, Friends of Asian Art Gifts, 1987
1987.218.4

Tara, the Buddhist deity who serves as the feminine counterpart of the Bodhisattva Avalokiteshvara, is identifiable through the blue lotus (*utpala*) held in her left hand and the citron (or pomegranate) in her right. Occupying a pivotal position in the transition from Gupta to Pala styles, this remarkable, perhaps unique sculpture has prompted speculation as to both its date and place of origin. It has previously been published as Nepali[1] as well as Indian[2] and has been assigned a seventh-century date. To my eye, this figure must be Indian, and a seventh-century date is probably a bit too late.

The sculpture seems to derive, stylistically and iconographically, from late fifth-century Sarnath-school images such as the two stone standing Taras, respectively, in the Sarnath Museum[3] and the Indian Museum, Calcutta.[4] The first prototype provides the general kind of jeweled girdle with round central clasp from which is suspended the short, flaring cloth-end, as well as some other jewelry correspondences. The second standing Tara is also a useful comparison, providing a prior example of the frontal, symmetrical stance of the Eilenberg Tara and of a scarf worn behind the figure that crosses in front at the elbows and then hangs down each side. It is clear, however, that the Eilenberg goddess stands at some chronological remove from these Sarnath images.

The full, round face, swelling hips, and organic modeling seem closer to the aesthetic spirit of the Gupta-period idiom than to that of the Pala period and, along with the details of jewelry, garments, and hairstyle, suggest a date not later than the second half of the sixth century.[5] The eroded surface calls attention

purusha's arms crossed over his chest,[1] but examples in metal other than this sculpture are unknown to me.

The figure wears a long dhoti, and, recalling earlier Kushan-period styles, a long scarf extends upward from the right ankle to the left hip, where it is gathered in a loop with the surplus material extending down the left side of the body. The attendant wears armbands, bracelets, earrings, necklaces, and an unusual flat, beretlike head-covering. If this is indeed Chakrapurusha, then the *chakra* would probably have been shown behind him. His broad face and unusual head-covering make this jaunty attendant a somewhat exotic addition to the cast of Gupta-period figural types.[2]

ML

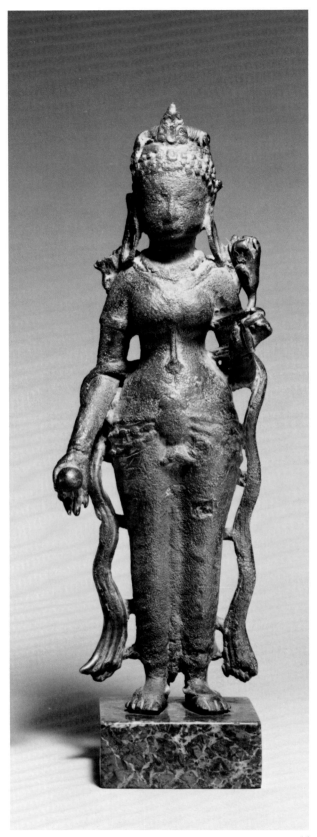

to the excellence of form and proportions of this sculpture.

<div align="right">M L</div>

1 Pal *Nepal* 1975, no. 36.
2 Schroeder 1981, no. 49E.
3 P. Chandra 1985, pp. 88–89.
4 Williams, pl. 98.
5 See Schroeder 1981, where a frontal illustration would have made clear how dissimilar the Eilenberg Tara is from the figures illustrated in nos. 49A–D, H.

Ex coll. Hagop Kevorkian, New York.

PUBLISHED
Pal *Nepal* 1975, no. 36.
Schroeder 1981, no. 49E.

67 Seated Buddha

India, Post-Gupta period, later Sarnath style,
late 6th–1st half of 7th century
Bronze inlaid with silver and copper,
h. 7 in. (17.8 cm)
Purchase, Rogers Fund, 1987
1987.218.2

Like the figure discussed in the preceding entry, this extraordinary seated Buddha is an example of a sculpture from the Eilenberg collection that, so far as I am aware, has no close cognate. Introduced into the scholarly literature in 1963 as Gupta period, fifth century,[1] and subsequently published twice as seventh century,[2] it remains unique within the corpus of Indian sculpture.

The Buddha is seated on a decorated cushion placed on a pedestal of stylized rocks; his lowered right hand makes the boon-bestowing gesture of *varadamudra*, and his left rests on his lap holding part of the outer robe in the meditative *dhyanamudra* or *samadhimudra*. This undecorated garment adheres so tightly to the body that one is aware of its presence mainly through the copper inlays indicating its borders.

The style of this sculpture relies to a great extent on the canons of the sixth-century schools of Sarnath but here is no longer so consciously geometricized; instead, the classical Gupta forms of the fifth and early sixth centuries have become a bit heavier, the proportions squatter than those encountered previously. As one might expect in a northern Indian

<div align="center">66</div>

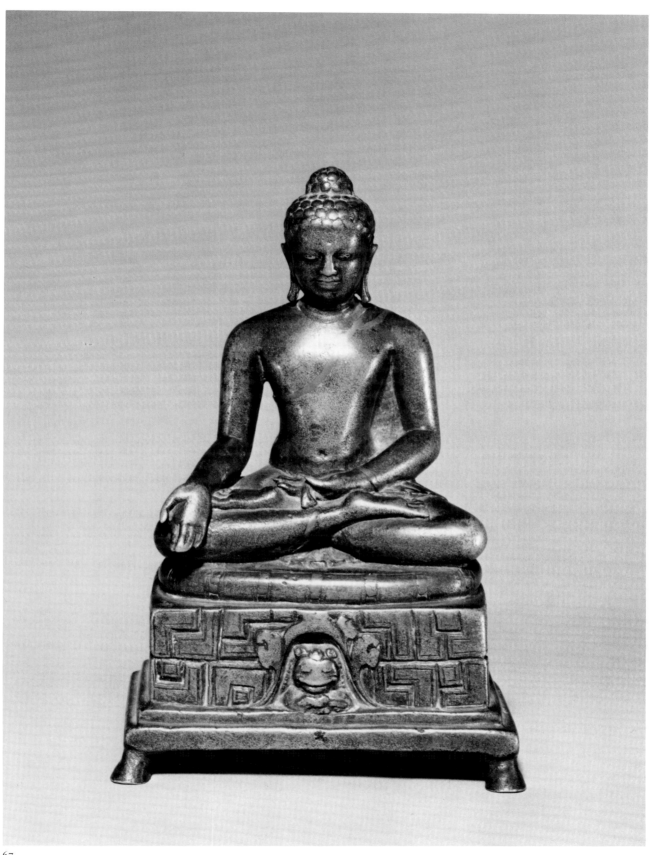

67

bronze of this date, the Buddha has certain stylistic affinities to Kashmiri metal sculpture. The curious iconography of a lion's head peering out from a cave in the center of the rocks again associates the piece with Sarnath. There are at least two rather close comparisons to be made with Sarnath stone pedestals for seated Buddhas that incorporate a lion's head resting on crossed paws.[3] This motif, rather than deriving from traditional lion thrones, seems traceable to Kushan reductions of elaborate representations of the Buddha in the Indrashala Cave,[4] as well as to some Kushan-period preaching scenes.[5]

The use of silver and copper inlays to enrich the surfaces of metal sculptures became fairly common after the fifth century. Inscribed on the back of the pedestal is the standard Buddhist creed.

ML

1 Rowland 1963, no. 13.
2 Lerner 1975, no. 2; Schroeder 1981, no. 43F.
3 Sahni, pl. IX; *Archaeological Survey of India,* p. 91, fig. 9.
4 For three examples, see Ashton, fig. 59; Ingholt, pl. 129; Nara National Museum, pl. 51.
5 Zwalf, no. 23.

PUBLISHED
Rowland 1963, no. 13.
Lerner 1975, no. 2.
Schroeder 1981, no. 43F.

68

68 The Jain Saint Bahubali

India, Western Chalukyan period, ca. 6th century
Bronze, h. 4⅜ in. (11.1 cm)
Gift of Samuel Eilenberg, 1987
1987.142.339

Bahubali (or Gommateshvara) is the son of the first Jain *tirthankara* (savior), Rsabhanatha. It is believed that he once stood so long in unmoving meditation that vines grew up and wrapped themselves around his naked body. Bahubali's posture is a very specific standing meditational pose of the Jain ascetic known as *kayotsarga*, erect and symmetrical, with the feet firmly positioned on the ground and the weight of the body evenly distributed on unbent legs. The arms hang down, and the hands do not touch the sides.

Bahubali is depicted here as a short, sturdy youth, with creeping vines wrapping around his legs, body, and arms, standing on a double-lotus pedestal. As is usual for Jain saviors and saints, he is "sky-clad," that is, naked.

U. P. Shah, the great scholar of Jain art, has isolated some sculptures at the cave sites of Aihole and Badami in Bijapur, northern Karnataka, as the best stylistic comparisons for this small figure and has dated it to the early Western Chalukyan style of approximately the sixth century.[1] Of particular importance is his claim that the Eilenberg sculpture is "the earliest figure of Bahubali as yet discovered in India."[2]

ML

1 Shah, vol. 1, p. 397.
2 Ibid., p. 398.

PUBLISHED
Shah, vol. 1, pp. 395–405; vol. 2, pls. 163, 164.

Gandhara, Swat, Kashmir, and Central Asia
Minor Arts, Terracotta and Stucco Heads, Portable Shrines, and Metal Sculpture

69 Mirror Handle with a Preening Woman

India, Kashmir, 6th–8th century
Schist, h. 2¾ in. (7 cm)
Gift of Samuel Eilenberg, 1987
1987.142.39

70 Mirror Handle with a Woman Playing the *Vina*

India, Kashmir, 6th–8th century
Schist, h. 3¾ in. (9.5 cm)
Gift of Samuel Eilenberg, 1987
1987.142.35

Like two other stone sculptures already discussed (Nos. 29, 30), these two figures have sockets drilled into their tops and probably functioned as mirror handles. This supposition is strengthened by the fact that, like the woman in the example studied in entry No. 28, one of these figures holds a small mirror. The present two handles are made of the same material and are closely related in style and iconography and probably also in date. The first depicts a woman, with lower body turned to the left, seated on a wicker stool. She is affixing a flower to her hair with her right hand while observing the effect in a paddle-shaped mirror in her lowered left hand. Except for a long shawl, which is draped across her shoulders and falls to the ground, and her jewelry, she is nude. Her hair is pulled up into a high chignon that is tied around its middle, and a row of curls rings her forehead. Her full face frames characteristic Kashmiri features: small, deeply set mouth and slanted eyes, jutting chin, and strong nose that lacks a bridge. The

69

70

reverse of the handle, which backs the figure's head and shoulders, is flat and decorated with a spray of leaves and flowers.

The second handle is also carved in the form of a female figure who sits on a wicker stool with her legs to the side. The woman is dressed in a long dhoti(?), and a bunched-up shawl is wrapped around her arms and streams down on either side of her body. She wears simple jewelry. The front portion of her hair is set into a series of large waves around her forehead, and the rest is gathered up into a huge bun(?) that frames her head. As in the first example, the head is encircled by foliate decoration, here visible both on the front and back of the handle. A parrot, often a symbol of passion, is perched on the armband of the woman's upper left arm, and she rests her left forearm on a *vina* (harp), whose strings she touches with the fingers of both hands. The neck of the *vina* extends up to the top left of the sculpture. Some small losses have obliterated the finial of the instrument.

The inclusion of vegetative backdrops for each of these women, as well as on another mirror handle in the Eilenberg collection (not exhibited), may indicate that some form of female nature spirit is being portrayed, perhaps as paradigms of female beauty. In earlier Indian sculpture such spirits were often shown preening and admiring themselves in mirrors, playing with parrots, and touching the boughs of trees, which they thereby bring to flower.

SK

PUBLISHED
Klimburg-Salter, pl. 26 (No. 70).

71 Censer with Cast Decoration

Pakistan, Gandhara, 4th–5th century
Bronze, w. 17 3/8 in. (44.1 cm)
Purchase, Mrs. Arthur Hays Sulzberger Gift,
1987
1987.218.8a–c

Very few early Indian ritual objects are still extant. There are only five bronze censers of this type known to me: this example; a smaller, undecorated one that has been in the Eilenberg collection for some time;[1] another decorated one recently purchased by Eilenberg; one published in the literature;[2] and one with cast decoration that has recently been on the market. All are of like design, having been cast in three sections— bowl, lid, and handle—with the handle serving as a locking mechanism for the lid and bowl. However, the large size and superior quality of the decoration of the present censer make it unique and mark it as one of the finest ritual objects from Gandhara to have survived.

Circling its foot and body, the bowl of this censer has several thin raised bands, which articulate three decorated bands. The two lower, wider bands are filled with a design of incised lotus petals. The upper one bears an incised crisscross motif, which is repeated around the base of the cover. A relief of scrolling flowers set against a plain ground dominates the cover. Above this area, enclosed by two herringbone-patterned double bands is a register of petal forms from whose pierced interstices the smoke rose. The

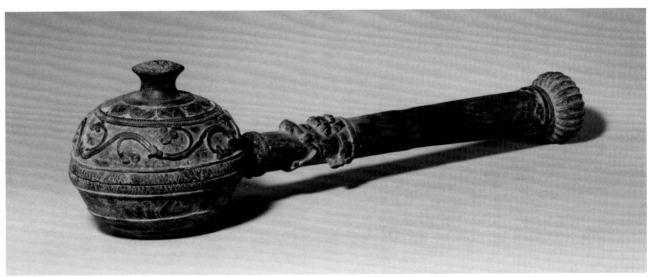

71

censer is crowned by a knoblike finial with concave sides and a small hole at its summit. The handle is complex in form; its macelike terminus, which is separated from the shaft by a raised band, is shaped like a stylized lotus bud capped by a circular element with a projecting point. The faceted shaft gently tapers and is adorned three quarters of the way down with the head of a *makara* (a fantastic aquatic beast). Typically, this ritual object presents an imagery of water (*makara*), watery birth, and transcendence of the earthly realm (the lotus flower, which roots in the mud, grows through the water and blossoms in the pure air). The smoke that rose through the lotus petals was a further, physical manifestation of transcendence.

SK

1 Acq. no. 1987.142.145a–c.
2 This bronze censer of tripartite design similar to that of our own but of far simpler form was discovered at the monastery of Kasia and is dated to the Gupta period (Vogel, pl. XXVIIIA). Marshall illustrates a broken terracotta censer without its top (vol. 3, pl. 65B).

72 Ritual Basin

Pakistan, Gandhara, or Central Asia(?),
7th–9th century
Bronze, diam. 7 11/16 in. (19.5 cm)
Purchase, The Dillon Fund Gift, 1987
1987.218.6

This unique basin has a flat bottom decorated with a lotus flower and perpendicular sides with a frieze of two dragons attacking a boy. The youth, whose lower right leg is gripped in the mouth of one of the dragons, is falling backward. In one hand, he clutches the horn of an antelope who lies below him, and with the other, he holds a lotus stalk whose flower is pressed to his nostrils. He wears a diaphanous pleated garment with a heavy collar, and his hair is tied back with a ribbon whose ends fall behind his neck. The

dragons are composite animals with horns, wings, and lithe, segmented anatomies. Their bodies sprout vegetation, and their haunches are emblazoned with palmettes.

The dragons are most closely comparable to images of mythological animals on post-Sasanian metal vessels, particularly one on a ewer in the State Hermitage Museum, Leningrad.[1] With the beast on the Hermitage ewer they share horns, wings, elongated body, haunches with palmettes, and foliate elaboration of tails, beards, cockades, and genitals. The scrolling vegetal motifs seem to be related to those on Gupta-period box lids (see Nos. 57–61), in which, however, the palmette is never depicted. The appearance of the palmette and the particular shape of the basin, which is related to early Islamic vessels, suggest a seventh- to ninth-century date, contemporaneous with the Islamic examples.[2]

SK

1 Tokyo National Museum, no. 155.
2 For an example of an Islamic vessel of this form in the collection of the Metropolitan Museum (acq. no. 1987.438), see *MMA Annual Report*, p. 29.

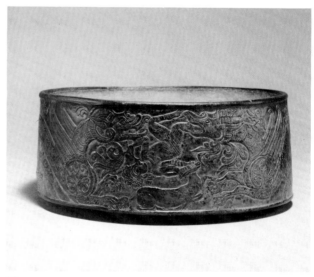

72

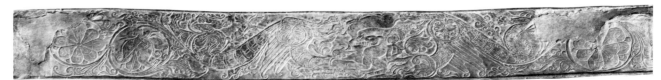

72 Exterior: continuous photograph

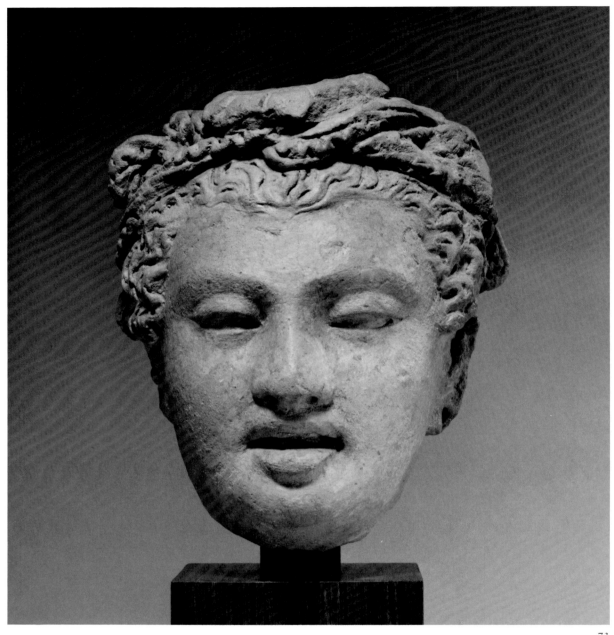

73

73 Male Head

Pakistan, Gandhara region, 4th century
Terracotta, h. 8⁹⁄₁₆ in. (21.9 cm)
Purchase, Anonymous Gift, 1987
1987.218.13

In its provocative psychological intensity, heightened
by the rich red-orange color of the material, this
unusually expressive head, perhaps of a deity, is
somewhat atypical. The sculptural freedom afforded
by the directness of technique—hand modeling—is
readily apparent. The parted full lips, partially closed
eyes, and rounded volumes suggest a sensuality not
often encountered in the art of this area. The ambiguity of the expression imparts a sense both mysterious
and dramatic.

ML

PUBLISHED
Poster, p. 134.

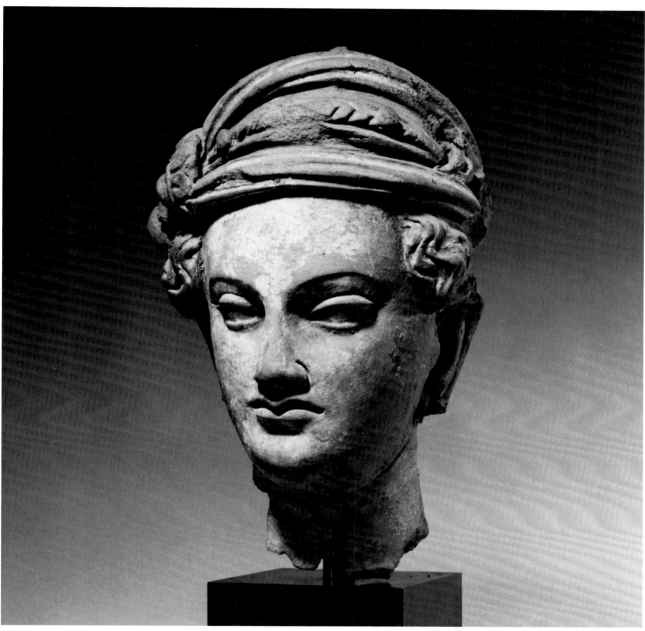

74

74 Youthful Male Head

Pakistan, Gandhara region, 4th–5th century
Terracotta with traces of gesso and polychrome,
h. 12⅞ in. (32.7 cm)
Gift of Samuel Eilenberg, 1987
1987.142.380

This large, noble head of a youthful male, proud and
aloof, is a reminder of the rich variety of physiognomic
possibilities found in Gandharan art. Not only do
facial proportions and expressions vary significantly,
but the many kinds of head coverings and their
methods of arrangement also provide an extensive
vocabulary of the costume of the period. Here, part
of an elaborate turban is pulled to the right side,
passes through a jeweled clasp, and continues around
the head.

ML

PUBLISHED
Poster, pp. 132–33.

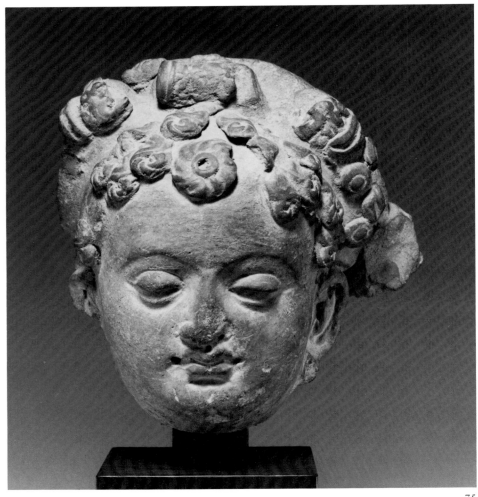

75 Head of a Female Deity

India, Jammu and Kashmir, Akhnur, 6th century
Clay or terracotta, h. 6 ⅛ in. (15.6 cm)
Purchase, Marie-Hélène and Guy Weill Gift,
1987
1987.218.14

Among the outstanding schools of northern Indian sculpture in terracotta[1] and stucco, one of the most interesting and aesthetically satisfying is that of Akhnur, situated about nineteen miles northwest of Jammu City. The original research into the so-called Akhnur terracottas in 1938 led Charles Fabri, formerly curator of the Lahore Museum, to their hitherto unknown find-spot, the cultivated fields of a small village near Akhnur, named Pambarvan. Fabri described what he found: "It was a sad and desolate view. Plowed for centuries, a once magnificent old

monument is now nothing but a large cemetery of sculptures. Broken legs, arms, fingers, heads, pieces of drapery and jewelry, a mutilated nose, a severed toe: as far as the eye can see, from hedge to hedge, these fields are brick red with the morsels of great art."[2] What Fabri had discovered had once been a great brick Buddhist monument covered with terracotta sculptures.

The surviving Akhnur terracottas are almost all heads, now primarily preserved in the museums of Lahore, Karachi, Bombay, and New Delhi, with some examples to be found in other museums and private collections. These heads have, over the years, been dated from the fourth to the eighth century, most recently settling between a "fifth/sixth century"[3] and an "early seventh century"[4] date. On the basis of comparison to securely datable fifth-century sculptures, I do not think they are earlier than the sixth century.

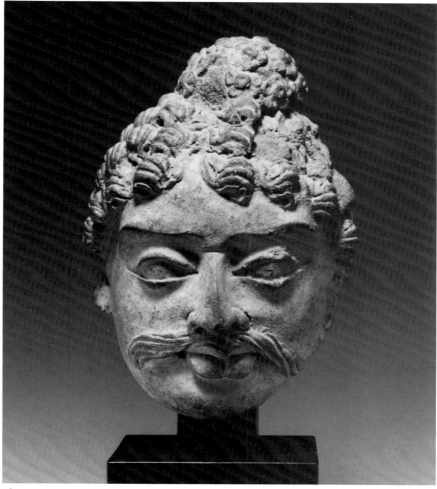

76

The Akhnur heads, which display stylistic allegiance to both late Gandharan and Gupta terracotta sculptures, are all carefully modeled, very lively and expressionistic, and represent an extremely successful resolution of the plastic potential of the medium. This charming head from the Eilenberg collection is a classic example of the style, comparing favorably to many of the finest sculptures known from the school.

ML

1 It is uncertain whether the Akhnur clay sculptures were fired purposely or accidentally (see Klimburg-Salter, p. 110).
2 Fabri 1939, p. 594.
3 Siudmak, pp. 54–55.
4 Klimburg-Salter, p. 110.

PUBLISHED
Poster, p. 136.

76 Head of a Male Figure

India, Jammu and Kashmir, late 6th–7th century
Clay, h. 6⅜ in. (16.2 cm)
Gift of Samuel Eilenberg, 1987
1987.142.4

This male head, recently published as belonging to the Akhnur group,[1] is either an atypical example or, more likely, from another site. Although it resembles some Akhnur heads,[2] it is stylistically closer to another group of terracotta sculptures that may come from Ushkur,[3] the second major site in the state of Jammu and Kashmir that has yielded fine heads in this medium. In particular, the shape of the eyes and mouth and the horizontal striations of the moustache are closer to a head in the British Museum from the Ushkur group than to Akhnur examples.

Our finely modeled head, which is slightly later in

date than the Akhnur female of the previous entry, is in some ways more similar to late Gandharan terracottas of Pakistan than to the classic sculptures of fifth- and sixth-century Gupta India.

ML

1 Poster, pp. 136–37.
2 Fabri 1955, fig. 3, "A Gentleman-in-Waiting."
3 Barrett 1957, fig. 8.

PUBLISHED
Poster, pp. 136–37.

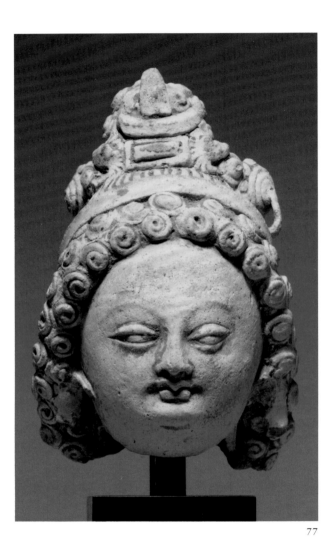

77

77 Head of a *Devata*

Central Asia (China, Sinkiang Uighur autonomous region), Tumshuk(?), 6th–7th century
Stucco with traces of gold foil and paint, h. 6 in. (15.2 cm)
Gift of Samuel Eilenberg, 1987
1987.142.72

A *devata*, one of the divine beings who cannot be identified specifically, is represented in this outstanding, rare stucco head, which originally came from a full figure in one of the cave-temples along the northern silk routes of central Asia above India and Tibet, perhaps from the site of Tumshuk. The round face with high forehead and small features is characteristic of the central Asian styles of the sixth and seventh centuries. The finely articulated hairdo with curling locks extending from forehead to behind the nape of the neck, sometimes referred to as the "Persian bob," appears earlier in ancient Near Eastern sculpture, as well as periodically in Afghanistan and Kashmir (see No. 84, where it occurs without the locks in front). In addition to the plain band around the hair, an elaborate jeweled diadem with two lion heads is worn in front of the piled-up coiffure. Traces of gold foil and red paint hint at the original rich splendor of the surface of this head, and indeed of most central Asian sculpture.

ML

Gandharan and Kashmiri Portable Shrines

The Eilenberg collection is probably unsurpassed in the scope and richness of its holdings in the area of portable miniature stone shrines. The small size of these devotional objects is totally disproportionate to their art-historical significance. The mechanics of the dissemination of Buddhist doctrine, iconography, and styles throughout south Asia and the Far East were largely implemented through the travels of Indian missionary monks, merchants, and foreigners who carried texts and portable icons of all sorts from India to lands far distant from those where the Buddha lived out his life.

These small "pocket shrines" seem to be a local invention of the ancient Gandhara region—I know of no examples from the major Buddhist centers of Mathura or Sarnath. They are almost always diptychs,[1] a format that suggests they may derive from earlier Western prototypes, perhaps Roman ivory diptychs, rather than being a continuation of earlier Indian-style miniature carving of the sort associated with the well-known Begram ivory panels.

Of the Buddhist portable shrines known to me, none seem to be earlier than the fourth or fifth century, even though they follow the well-established iconographic and stylistic traditions of narrative friezes of the third and fourth centuries, abbreviated to accommodate the miniature format. As Romanesque and Gothic ivory diptychs illustrate scenes from the life of Christ in small-scale, so many of the stone examples depict important events in the life of Buddha in miniature. In addition to Buddhist portable shrines, there are Hindu examples, most of which seem to be associated with the styles of Kashmir of the fifth through the seventh century.

Indicative of the rarity of what once must have been a relatively common type of object is the fact that, to my knowledge, only one complete portable shrine has survived.[2]

ML

1 There are a few very rare portable triptych shrines and at least one polyptych (Allchin, pl. IX; Lerner 1984, pp. 40–41; Stein, vol. 2, pl. XLVIII, B.D.001.A).
2 Allchin, pl. IX.

78 Section of a Portable Shrine with Two Scenes from the Life of Buddha

Pakistan, Gandhara region, ca. 5th century
Stone, h. 3 7/16 in. (8.7 cm)
Gift of Samuel Eilenberg, 1987
1987.142.53

The interior of this portable shrine is divided into two registers; the upper one depicts the miraculous birth of Prince Siddhartha in the Lumbini Grove. In orthodox fashion, the baby is shown emerging from the right side of his mother, Queen Maya, who grasps a branch of the *ashoka* tree. Her sister stands behind her, and the Vedic god Indra holds a cloth to receive the baby. Between Indra and Maya is another depiction of the infant, now standing, which refers to the episode of the seven steps. The holy baby is said to have taken seven steps in the direction of each of the cardinal points, proclaiming that he had been born to become the Buddha—the enlightened one—and that this birth was his final one, since in previous existences he had attained the merit necessary to escape the cycle of rebirths. The lower panel illustrates the *mahaparinirvana*, the passing away of the Buddha at age eighty in Kushinagara. The Buddha, his head facing north under a *shala* tree, reclines on a couch surrounded by figures representing his disciples and the Malla nobles of Kushinagara.

While the scenes on the interior of the shrine are easily recognizable and somewhat standardized, the exterior is problematic. Finely carved on the outer surface is a squatting bearded man with one arm positioned as if to steady the large basket strapped to his back. A small headless figure sits astride his shoulder. The man wears a boot of common Kushan design and a head covering with a decorated band. A search through the rich repertory of Gandharan sculpture will not reveal a close parallel. I know of only three other examples of this theme, all sections of portable shrines. One is an unpublished complete panel in a Japanese private collection with the same interior scenes as the Eilenberg panel but without the small figure on the basket carrier's back. This may suggest either that the small figure is not essential to the theme or that a similar figure, perhaps a child, is

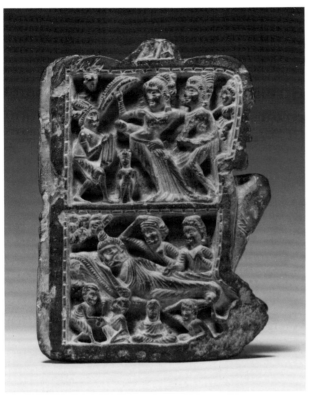

78 Interior

shown on the other half of the diptych, which is missing. A small figure of this kind that is held to the chest of a headless basket carrier appears on a fragment of a panel found by Aurel Stein in central Asia.[1] Through the Eilenberg panel, I was able to identify for the first time the subject of the third basket-bearer fragment, now in the Museum für Indische Kunst, Berlin.[2]

The identity and significance of the basket bearer or, for that matter, what the basket holds, escape me. Perhaps the basket bearer is related somehow to the other subject on the exterior of some portable shrines—a nobleman riding an elephant that supports a relic casket on its head—which refers to the transportation and distribution of the Buddha's remains after he was cremated.

ML

1 Stein, vol. 2, pl. XLVIII, Kh.003.G.
2 Lerner in MMA 1982, pp. 61–62.

PUBLISHED
Lerner in MMA 1982, pp. 61–62.
Pal 1984, no. 2.
Rowan, pl. 4.
Kurita, pls. 874, 875.

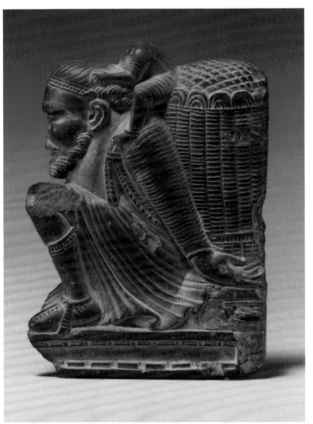

78 Exterior

79 Section of a Portable Shrine with Two Scenes from the Life of Buddha

Pakistan, Gandhara region, 5th–6th century
Stone, h. 6 in. (15.2 cm)
Gift of Samuel Eilenberg, 1987
1987.142.51

Unlike the preceding example, this relatively large panel from a portable diptych has a plain exterior, and its interior scenes do not follow established formulas. The upper register shows an expanded, rather atypical gathering of deities and monks attending the Buddha's first sermon in the Deer Park at Sarnath. The subject is identifiable through the deer flanking the wheel of the law set on a pedestal in front of the Buddha. In a somewhat uncommon pairing, Vajrapani, the Thunderbolt Bearer, stands to the Buddha's right and the goddess Hariti, of the Hellenistic Tyche type, stands to his left.

The scene below is a most unusual one, and I am unsure what it may represent. A seated Buddha

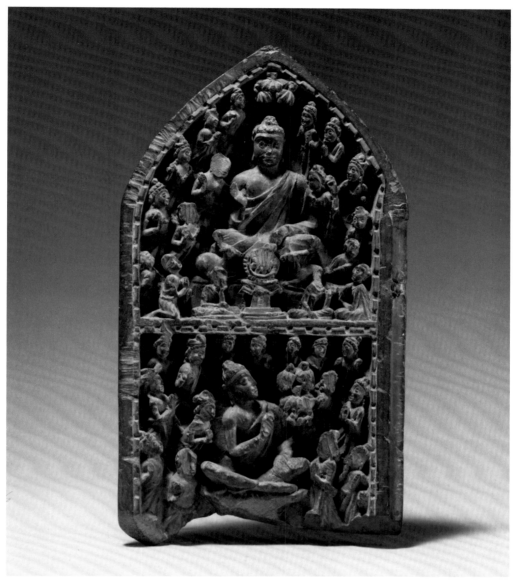

79

surrounded by many figures turns to what appears to
be an *ashoka* tree. Perhaps this alludes to the gift of a
park, an occasional occurrence in the Buddha's life—
Amrapali's gift of a mango grove is one such incident.
A likelier explanation, more worthy of such an
elaborate depiction, would be Siddhartha contem-
plating or saluting the *bodhi* tree before taking his
seat beneath it and attaining enlightenment.[1] There is
another, less probable but interesting possibility if,
indeed, a mango tree is represented. This scene
may refer to the miracle at Shravasti, where a mango
seed planted by the Buddha instantly grew into a
mature tree.[2]

ML

1 A frieze with a more elaborate depiction of Siddhartha approach-
ing the *bodhi* tree and containing the essential ingredients of the
story—including a proper pipal tree and Kalika, king of the *nagas*,
with his wife (Namikawa and Miyaji, pl. 46)—along with a
fragment of the same story showing Siddhartha with one hand
raised and the other holding a part of his robe, as he does in our
diptych wing (M. Chandra, pl. 26), may provide the justification
for this identification.

2 Brown 1984, pp. 79–82.

EXHIBITED
New York, MMA, *Along the Ancient Silk Route: Central Asian Art
from the West Berlin State Museums*, Apr. 3–June 20, 1982 (not in
cat.).

PUBLISHED
Pal 1984, no. 52.
Kurita, pl. 877.

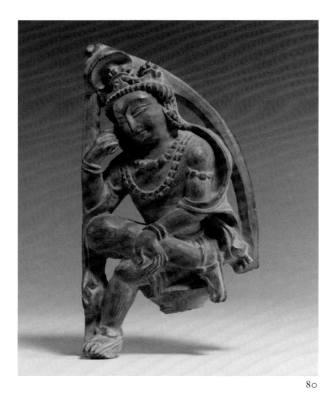

80

On the basis of the large number of individual sculptures of the Contemplative Bodhisattva from the Swat Valley area of Pakistan and from Kashmir, it would seem that by the seventh century this figure had become an important cult deity whose identity as Avalokiteshvara is confirmed through the presence of a miniature Amitahba Buddha in his hairdo.

ML

1 Czuma 1989, figs. 1, 5.
2 Lerner 1986, pp. 12–16.
3 Kurita, pls. 146–56.
4 Lerner 1984, pp. 30–35.

80 Bodhisattva Seated in a Contemplative Pose

India, Kashmir, or Pakistan, Gandhara region, 5th–6th century
Stone, h. 3 5/8 in. (9.2 cm)
Gift of Samuel Eilenberg, 1987
1987.142.92

Judging from the shape of this fine sculpture and the absence of any suggestion of metal pins, it was probably set together with other figures into a wood frame, perhaps similar to those containing the well-known, slightly later Kashmiri ivories.[1] The complete ensemble is likely to have had a central seated Buddha flanked by our figure and another bodhisattva.

Although I have discussed the evolution and iconography of the Contemplative Bodhisattva elsewhere,[2] some comments on the subject may be useful here. The seated bodhisattva, whose right leg crosses the pendant left leg and whose right elbow rests on the right knee with one or more fingers of the right hand touching his cheek, is a particularly enigmatic and important figure in the Buddhist pantheon. He appears in the earlier Kushan sculptural repertory of both Gandhara[3] and Mathura[4] and later in the sculpture of the Far East.

81 Section of a Portable Shrine with Shiva and Parvati

India, Kashmir, 7th century
Chlorite, h. 3 1/4 in. (8.2 cm)
Gift of Samuel Eilenberg, 1987
1987.142.54

This group depicting Shiva, Parvati, and Shiva's mount, the bull Nandin, is not only a gem of miniature carving but is also most interesting iconographically.

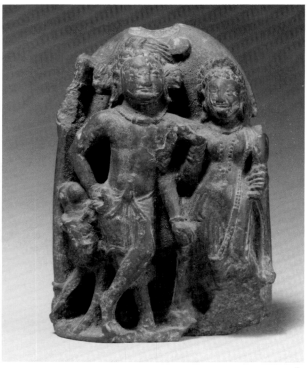

81

The four-armed Shiva, standing in a relaxed manner with his left leg crossed over his right and penis erect, is depicted in his form of Mahadeva, the Great God. Two subsidiary heads flank his primary one; the head on his right is male and grimacing, representing the destructive force of the deity, and that on his left is female and represents the female energies of Shiva, which are an essential component of the Great Deity. His hairdo is an elaborate arrangement of long strands (*jatas*), and he wears the crescent moon at his right side and the sun (partially damaged) on his left. Shiva holds a trident (*trishula*) in his raised right hand and a rosary (*akshamala* or *akshasutra*) in his lowered right hand. His lowered left hand rests on a club, a relatively rare attribute for the deity, assigned to him primarily in the sixth and seventh centuries.[1] His raised left elbow rests on Parvati's shoulder (a detail more clearly shown in the sculpture discussed in the next entry), and the missing left hand would have held a water vessel (*kundika*). Parvati holds a mirror in her left hand and the remains of a lotus in her right hand.

The artist has with considerable skill and sensitivity rendered the two deities in relaxed, intimate poses in contrast to the frontal and hieratic postures adopted for them at a later date.[2] A very similar small sculpture published by Douglas Barrett shows Shiva and Parvati seated on Nandin.[3]

ML

1 Barrett 1957, figs. 10, 12; Pal *Addorsed Saiva* 1981, fig. 2 and p. 27.
2 Pal 1977, p. 55.
3 Barrett 1957, fig. 12.

PUBLISHED
Klimburg-Salter, pl. 41.

82 Section of a Portable Linga with Shiva and Parvati

India, Kashmir, 7th century
Chlorite, h. 3 in. (7.6 cm)
Gift of Samuel Eilenberg, 1987
1987.142.66

When the existence of this section of a diptych in the form of a linga, the phallic emblem of Shiva, first became known to scholars, it prompted two articles, one based on a modern metal cast,[1] the other on the original.[2] It is indeed a fine and important object.

The composition of the scene on the interior is very similar to that of the preceding entry, except for the addition of Shiva's son Skanda, placed to Parvati's left. Carved on the exterior is a linga with a single head of Shiva (*ekamukhalinga*) similar in style to

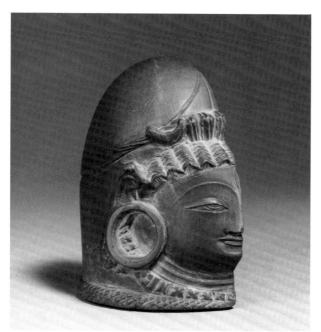

82 Exterior

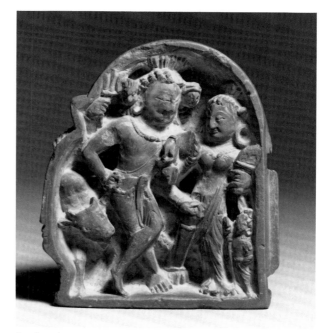

82 Interior

Shahi sculpture of Pakistan and Afghanistan of about the seventh century.

One wonders what subject was carved on the lost half of the sculpture.

ML

1 Taddei 1964–65, figs. 1–3.
2 Goetz, pp. 275–79.

PUBLISHED
Taddei 1964–65, pp. 24–25.
Goetz, pp. 275–79.
Rowan, pl. 39.

83 Section of a Portable Linga with Parvati

India, Kashmir, 6th–7th century
Stone, h. 3 in. (7.6 cm)
Gift of Samuel Eilenberg, 1987
1987.142.52

Although similar in type to the preceding example, this linga section is earlier in date and in a pure Kashmiri style, free of Shahi influence. The proportions of the *ekamukhalinga* carved on the exterior and the physiognomic type of Shiva reflect earlier models. The interior has in its upper section a

representation of Parvati holding a mirror; in its lower portion only the head of a deity, probably Shiva but perhaps Skanda, has survived.

ML

84 Seated Prajnaparamita

Pakistan, Swat Valley, or India, Kashmir,
7th century
Brass inlaid with silver and copper,
h. 4⅝ in. (11.8 cm)
Gift of Samuel Eilenberg, 1987
1987.142.62

Prajnaparamita is the Buddhist Goddess of Transcendent Wisdom and the personification of one of the most important Mahayana Buddhist texts, the *Ashtasahasrika Prajnaparamita Sutra* (*The Perfection of Wisdom in Eight Thousand Verses*). The usual hand gesture for this deity is the one symbolizing the first sermon of Buddha Shakyamuni, setting the wheel of law into motion (*dharmachakrapravartanamudra*); another sometimes employed is the wisdom fist (*bodhyagrimudra*). Although the hands of this Prajnaparamita were once described as "placed . . . in what appears to be a rather clumsy version of the

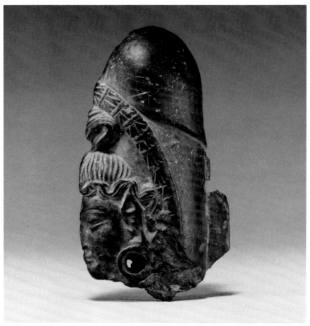

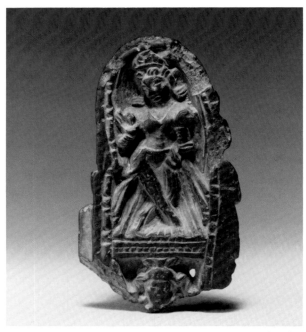

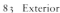

83 Exterior

83 Interior

gesture of turning the wheel of the law,"[1] the mudra is most certainly a different one, formed by pressing the palms of the hands together with the fingers extended. There is nothing tentative about the representation of this gesture; however, I confess to being both ignorant of its meaning and unable to recall another instance of its use. Perhaps it refers to the sutra associated with the deity and is a form of *shravakamudra* (Sanskrit manuscript mudra).[2]

Prajnaparamita sits cross-legged on a double-lotus pedestal of unusually large proportions, which visually helps to support the sculpture's pyramidal composition. She is dressed in a long garment that covers her feet and in a pointed tunic (visible from the back) of the sort often worn by females in Kashmiri sculpture and associated with the Shahi dynasty of Pakistan and Afghanistan. In the back her hair is arranged in the so-called Persian bob—a relatively rare hairstyle that appears periodically on other Swat Valley and Kashmiri representations of both males and females as well as in sculpture from central Asia (see No. 77). Set into the distended lobes of her ears are unusually large hoops, recalling those worn by some of the figures on the tiles from Harwan.[3]

To my knowledge, this is the earliest representation of Prajnaparamita from the Swat Valley–Kashmir area.

ML

1 Pal *Bronzes* 1975, p. 178.
2 Chandra and Sharada, nos. 3.94, 4.52: while these are not the same gesture made by the Prajnaparamita, they might be of the family to which her mudra belongs.
3 Kak, pl. XXIII.4.

PUBLISHED
Pal *Bronzes* 1975, pp. 178–79.
Schroeder 1981, no. 7C.

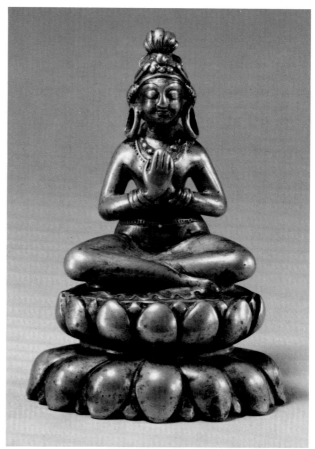

84

85 Standing Bodhisattva

Pakistan, Swat Valley, 6th–7th century
Bronze inlaid with silver, h. 3 ¼ in. (8.2 cm)
Gift of Samuel Eilenberg, 1987
1987.142.312

This bodhisattva, one of a pair of attendants from a lost halo, stands on a lotus with his hip inclined toward the left, where the larger central image he once flanked stood. He holds a bowl in his raised left

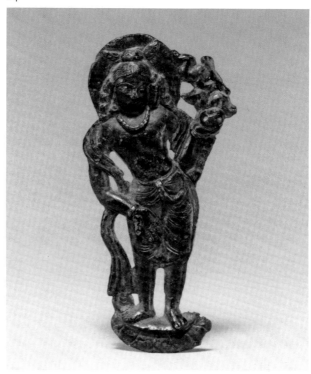

85

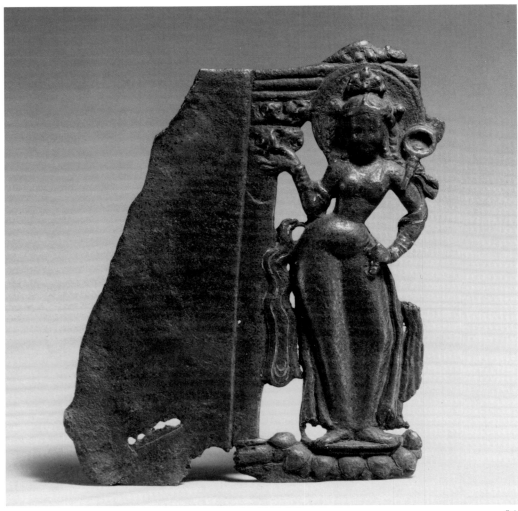

hand, perhaps suggesting an affiliation with the Buddha Bhaishajyaguru (see No. 156), and his lowered right hand makes the boon-granting gesture of *varada-mudra*. He wears a short dhoti, a long scarf around his shoulders, and feathers in his chignon. In its fluidity of contours, the modeling of the figure is reminiscent of Gupta prototypes, as are the hairstyle and earrings. This fine fragment, with silver-inlaid eyes and necklace, exhibits on a small scale the high level of metalworking techniques characteristic of the Swat Valley region.

ML

PUBLISHED
Lerner 1975, no. 7.

86 Standing Female Deity

Pakistan, Swat Valley, 7th century
Bronze inlaid with gold, h. 6 ⅝ in. (16.9 cm)
Gift of Samuel Eilenberg, 1987
1987.142.313

To judge from the large size and outstanding quality of the female deity represented, this fragment from a halo once belonged to a most extraordinary sculpture. I am uncertain as to the identity of the figure, who stands in a pronounced hipshot posture on a lotus, has been provided with a halo, and holds what might be a lotus bud in her raised right hand. She holds in her left hand an unusual stafflike object—which is missing most of its shaft and terminates in a circular element. She is probably a Tara, but I can provide no conclusive evidence for this identification.

ML

87 Standing Bodhisattva

Pakistan, Swat Valley, 8th–9th century
Bronze, h. 5 ⅝ in. (14.3 cm)
Gift of Samuel Eilenberg, 1987
1987.142.311

Like the figures in the two preceding fragments, this male deity is part of a halo belonging to a larger image. The halo was probably detachable and cast separately, and there would have been another figure standing to the left of the central deity. The missing left hand of the bodhisattva would have held an identifying attribute, probably the stalk of a lotus, since what appears to be a lotus bud and part of its stalk rests on his left shoulder. If the device emanating from the lotus on the crossbar above the bodhisattva is a sword, then the original main icon probably was Manjushri.

ML

88 Seated Buddha

Pakistan, Swat Valley, 8th century or earlier
Bronze, h. 8 ⅜ in. (21.3 cm)
Purchase, Lita Annenberg Hazen Charitable Trust Gift, 1987
1987.218.3

When this superb sculpture was first published in 1975, I wrote: "The full and rounded forms, the sense of corpulent volumes, the elongated fingers, the rich variety of drapery motifs with unusual variations such as the dip of the upper hem of the robe on the chest, and the fall of the drapery pleats over the pedestal, all are characteristic of a late eighth- or ninth-century dating."[1]

What I had interpreted as later mannerisms, others have read as early features, and this sculpture has subsequently been published twice as seventh century[2] and once dated as early as the sixth century.[3] I confess to having no great confidence in any of the dates advanced so far, including my own. What seems certain is that many different sources, including some not previously used, can be cited as stylistic comparisons.

The sculpture that others have used as the most rewarding comparison, a standing Padmapani,[4] does indeed share with our Buddha certain stylistic features,

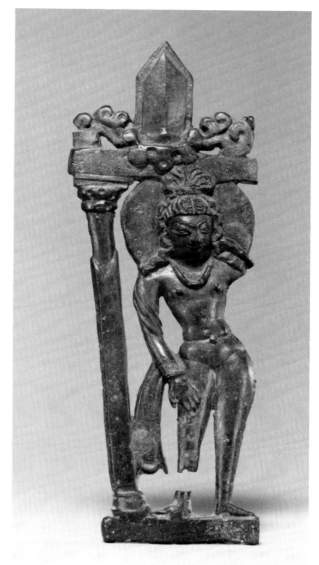

87

namely, an incised double-lotus pedestal whose petals are of approximately the same proportions, a similar color of metal, and a physiognomy that includes slanted eyes, full lips, and somewhat high cheekbones. However, the bodily proportions of the Eilenberg Buddha are full and fleshy, whereas the standing Padmapani is very thin and elongated. Moreover, this Padmapani itself has not elicited a unanimity of opinion regarding its date, having been published twice as sixth century,[5] once as about 600,[6] and again as seventh–eighth century.[7]

A better comparison is to be made with a consistently overlooked northern Pakistani sculpture of a standing Maitreya(?), published in 1901 as coming from a monastery in Beijing(!),[8] which is stylistically

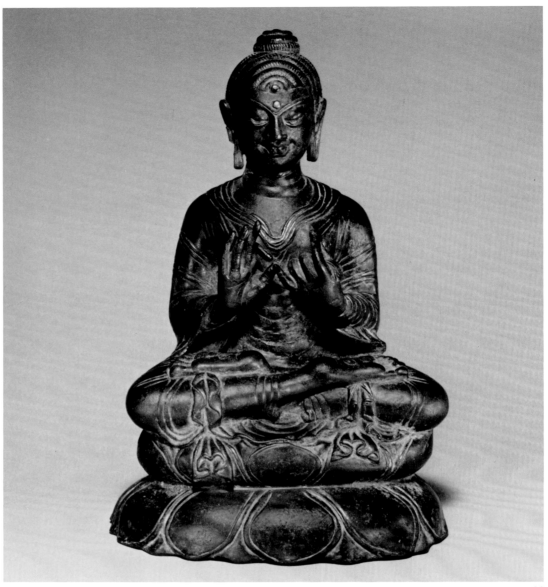

much closer to the Eilenberg Buddha and seems to me to belong to the eighth century. In addition, if one reads the emphasis on rich linear decoration of drapery folds on the Eilenberg Buddha as perhaps derivative of painterly concerns, and the full, round face as reflecting later Afghani and northern Pakistani facial types, can one not see a connection to eighth-century wall paintings from Fondukistan[9] or the ninth-century painted wood manuscript covers from Gilgit?[10]

ML

1 Lerner 1975, no. 6.
2 Pal *Bronzes* 1975, p. 212; Klimburg-Salter, p. 93.
3 Schroeder 1981, no. 5F.
4 Pal 1977, no. 21.
5 Ibid. and Schroeder 1981, no. 5C.
6 Pal *Bronzes* 1975, p. 210.
7 Klimburg-Salter, p. 98.
8 Grünwedel, p. 187.
9 Rowland 1971, pl. 148.
10 Klimburg-Salter, figs. 30, 33.

PUBLISHED
Lerner 1975, no. 6.
Pal *Bronzes* 1975, no. 83.
Schroeder 1981, no. 5F.
Klimburg-Salter, pl. 5.

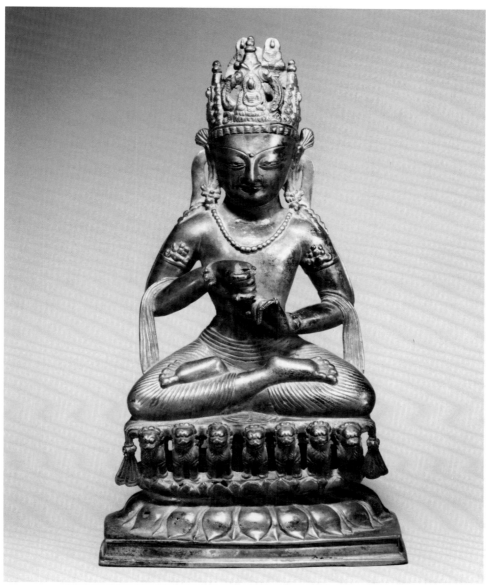

89

89 Seated Transcendental Buddha Vairochana

Pakistan, Gilgit(?), 9th–early 10th century
Bronze inlaid with silver, h. 13 in. (33 cm)
Purchase, Louis V. Bell and Fletcher Funds,
1987
1987.218.7

Vairochana is the presiding deity in the group of the Five Transcendental or Cosmic Buddhas (Tathagatas or Jinas). The concept of this quintet is a later development in Buddhist theology based on the acceptance of a plurality of Buddhas who rule over the cosmic totality of all time and space. Individual Buddhas were associated with the various directions of the universe and conceived of as having specific, separate responsibilities and their own families of deities. The Five Cosmic Buddhas are essential to Esoteric Vajrayana Buddhism and are often depicted in the form of a mandala with Vairochana, the Supreme Buddha, in the center.

Here, the deity sits in the cross-legged yogic, diamond, or adamantine posture of *vajraparyan-kasana*,[1] the right leg over the left with the soles of both feet facing upward, making the *bodhyagrimudra* hand gestures appropriate for the god (see No. 138).

Set in his unusual crown are five Buddhas, and above the double-lotus pedestal are lions—the orthodox vehicle for Vairochana—arranged in a group of seven.

Elements such as the design of the lotus pedestal, the pendant drapery flanking the lions, and the style of the crown relate this sculpture to others from the Swat Valley in northern Pakistan.[2] The physiognomy, proportions of the body, and arrangement of the dhoti, however, are outside the mainstream of Swat Valley art, and it is possible that this Buddha belongs to the Gilgit school, as suggested by Deborah Klimburg-Salter.[3]

ML

1 In my description of seated postures (asanas), I have followed, so far as is practical, the system set forth in D. C. Bhattacharyya, pp. 182–86 and figs. 431–36.
2 Barrett 1962, figs. 12, 13.
3 Klimburg-Salter, pl. 11.

PUBLISHED
Schroeder 1981, nos. 11G, I.
Klimburg-Salter, pl. 11.

90 Lotus-Headed Fertility Goddess

India, ca. 7th century
Stone, 4 1/16 x 4 1/16 in. (10.3 x 10.3 cm)
Lent by Samuel Eilenberg

In Indian art from at least as early as the Mauryan period (the fourth to second century B.C.), fertility goddesses have been a major genre. These voluptuous women embodied the generative power of nature— their mere touch reputedly caused trees to bloom. The lotus flower, which grows out of muddied waters but sits unsullied atop them and daily opens to the rays of the sun, is the quintessential Indian symbol of growth and spiritual transcendence. Depictions of reclining, splayed goddesses whose necks and heads (and sometimes shoulders and arms as well) are replaced by lotus blooms are known from various parts of India from as early as the first century A.D. These images combine in a single metaphor the ideas of both birth and rebirth.[1]

In this sculpture, the goddess wears only anklets and a girdle. By bracing her feet against two stops she spreads her heavy thighs and thrusts down her torso, as in childbirth. Her genitals are prominently revealed. Above her narrow waist and full breasts, her neck and head are transformed into a large lotus set on a floral wreath(?). At her left side is a little figure of a kneeling adorant, above whom a small lotus stem with flower sways toward the larger bloom. A related composition may have existed on the other side, but all that remains is the small head of an animal.

SK

1 For a discussion of the nude, squatting goddess, see Tiwari, pp. 182–219 and pls. I, III–VIII.

90

Northeastern India
Pala Sculpture

The Pala Period

One of the richest and most fascinating chapters in the long history of Indian art concerns the Pala dynasty of eastern India. From the eighth through the twelfth century, the Palas ruled in what are today the states of Bihar and West Bengal, and the recently created nation of Bangladesh. The Palas were the last great royal patrons of Buddhism on Indian soil and, in fact, occupied ancient Magadha, the region in which the historical Buddha, Shakyamuni, lived out his life during the sixth and fifth centuries B.C. Bodhgaya, where the Buddha attained enlightenment, and Rajgir, where he spent many years preaching, are in central Bihar. In addition to Buddhism, Hinduism flourished under Pala rule.

Among the many enlightened accomplishments of the Pala rulers was their endowment and support of great Buddhist monastic universities, where learned faculties taught scientific, artistic, and theological subjects and major libraries were maintained. So important were Buddhist universities such as Nalanda and Vikramashila that they attracted students from all over the Asian world, "exerting," as Wayne Begley has stated, "a profound intellectual and spiritual influence upon the rest of Asia."[1] In the ninth century, for example, a devout Indonesian Buddhist king of Shrivijaya endowed a monastery at Nalanda and arranged for its upkeep,[2] attesting to the international fame of the university.

This rich intellectual climate, coupled with strong interest in Vajrayana or Esoteric Buddhism, prompted the development of an expanded pantheon of deities, resulting in a more elaborate iconographic vocabulary than had existed under the earlier Gupta dynasty. This evolved iconography is clearly seen in the great sculptural variety in surviving Pala icons. During the Pala period, Hinduism also witnessed a transformation, particularly in terms of the increased importance now assigned to female deities. Parvati often accompanies

Shiva on Pala icons, and Vishnu's consorts now flank him with some consistency.

The great flowering of artistic activity under Pala rule is crucial to Indian art but is also notable for the extraordinary influence it had on other regions. Radiating from eastern India, Pala styles and iconography were transmitted across the Bay of Bengal to Burma, Indonesia, and the rest of Southeast Asia and the Far East, in addition to traveling overland north to Tibet and Nepal.

ML

1 Begley 1969, p. 9.
2 S. P. Gupta 1985, p. 150; Diskul, pp. 4, 7.

91 Surya with Attendants

Bangladesh(?), Pala period, ca. 9th century
Bronze, h. 13 5/16 in. (33.9 cm)
Gift of Samuel Eilenberg, 1987
1987.142.334

Surya, the Vedic sun god, stands in a symmetrical, frontal position holding a triple-stemmed, full-blown lotus in each hand. He is dressed in a short, belted tunic and wears boots, only the tops of which are indicated. A long scarf crosses his arms above the elbows and falls, curving, down either side of the deity. The typical decorated armbands, bracelets, earrings, and necklace adorn the figure, and a trilobed tiara covers his hair. Standing to Surya's right, the bearded Pingala, recorder of the sun god, holds a pen and perhaps an inkpot. His attendant to the left, who is holding a staff, is Danda (or Dandi), Surya's youthful general. The inclusion of what appears to be a fire altar at the bottom of the pedestal is most unusual.[1]

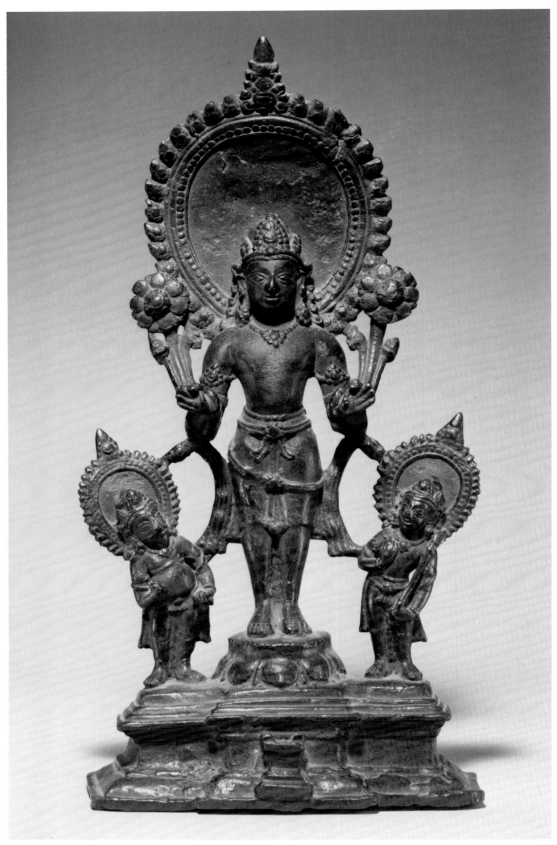

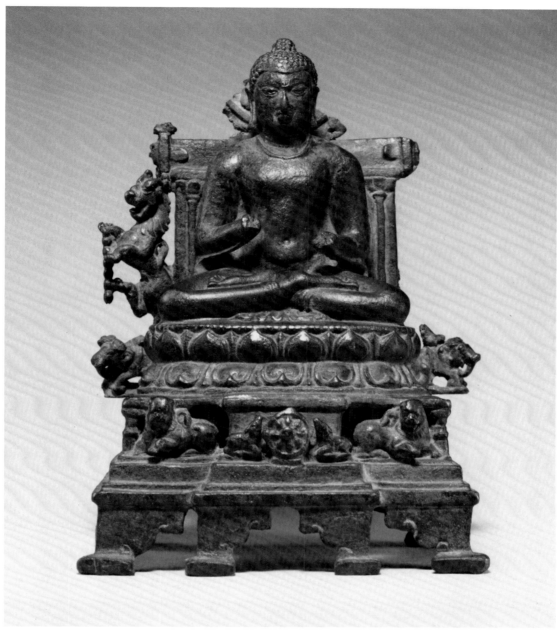

92

A large, prominent halo with an outer perimeter of stylized flames frames Surya's head, and corresponding, smaller versions encircle the heads of his flanking attendants.

ML

1 Similarly shaped fire altars appear on two other Pala-period bronze Suryas, but these have been incorrectly identified as drinking vessels (*patras*) (see Ray, Khandalavala, and Gorakshkar, nos. 206, 207).

92 Seated Buddha Shakyamuni

India, Bihar, Pala period, Nalanda style,
ca. late 9th century
Bronze inlaid with silver, h. 5 ½ in. (14 cm)
Gift of Samuel Eilenberg, 1987
1987.142.337

Despite the missing hands and incomplete throne back and halo, this image of the seated Buddha Shakyamuni is a fine and informative example of

ninth-century Pala styles. The usual elaborate multitiered throne supporting a double-lotus pedestal has the concomitant ninth- to tenth-century Pala-style throne back with a rampant lion on top of a crouching elephant. Somewhat atypical is the pair of deer flanking a wheel of the law set in front of the pedestal. This is a reference to the historical Buddha Shakyamuni's first sermon in the Deer Park at Sarnath and the evidence for the position of the missing hands. They would have formed the *dharmachakra-pravartanamudra*, the gesture of setting the wheel of law into motion. One earlier example from Nalanda

and two tenth-century Buddhas from the Kurkihar hoard[1] preserve the gesture originally made by the Eilenberg Buddha. However, most Pala bronze seated Buddhas make the earth-touching gesture of *bhumis-parshamudra*.

ML

1 Schroeder 1981, nos. 54D, 58D, G.

Ex coll. Ajit Ghosh, Calcutta.

PUBLISHED
Whitechapel, no. 12.

93 Rampant Leogryph

*India, Bihar, Pala period, Kurkihar style,
ca. late 9th century
Bronze, h. 5 ³/₈ in. (13.7 cm)
Gift of Samuel Eilenberg, 1987
1987.142.209*

Just as it is often true that the examination of a small part of a Western painting can be sufficient to allow one to estimate the quality of the whole, so it is with South Asian art. Here, the consummate skill and artistic sensitivity with which this leogryph—a mythological composite creature suggesting a horned lion with the body of a deer or antelope—has been sculpted indicate that the icon of which it was once a part was surely of extraordinary quality.

The leogryph or the lion, usually standing on an elephant, is frequently a component of the throne backs of Pala bronzes from the seventh through tenth century—the preceding sculpture offers one such instance. One particularly fine example, the famous seated Tara found at Kurkihar,[1] provides a clear indication of our leogryph's placement as well as of the quality of its original host icon.

ML

1 Härtel and Auboyer, pl. 75.

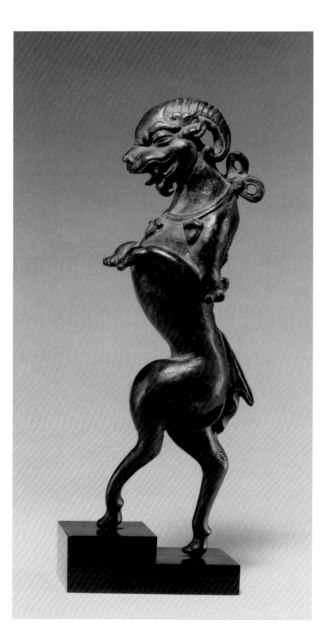

93

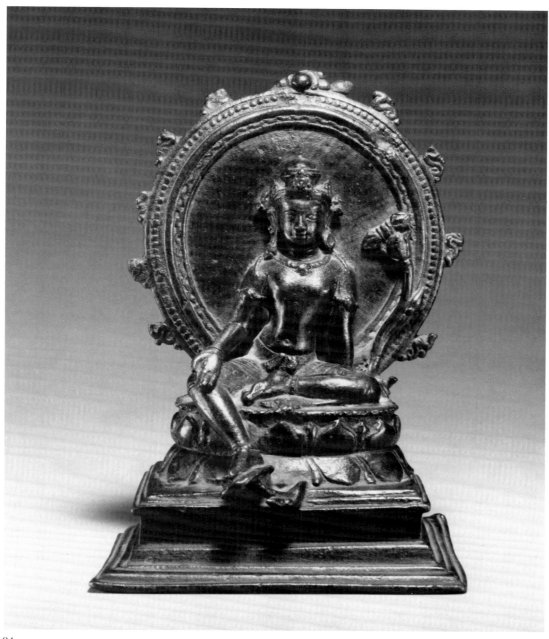

94

94 Seated Vajrapani

Bangladesh, Pala period, late 9th–10th century
Bronze, h. 6 5/16 in. (16 cm)
Gift of Samuel Eilenberg, 1987
1987.142.214

Vajrapani, identifiable through the stylized thunderbolt (*vajra*) on top of the *utpala* (blue lotus), the stalk of which is held in the left hand, sits in the posture of *lalitasana* (royal ease). His lowered right hand makes the boon-bestowing gesture (*varadamudra*). The graceful, relaxed posture of the deity, who is framed by a large round nimbus, is common to many Pala-style bronze figures of the eighth through tenth century. The double-lotus pedestal on the multitiered rectangular base is of a type that appears on other Bangladeshi bronzes,[1] sometimes with four small feet at the corners.

Sculptures of this general sort served as direct prototypes for Indonesian bronzes, and close copies exist, sometimes identified as Shrivijaya style and

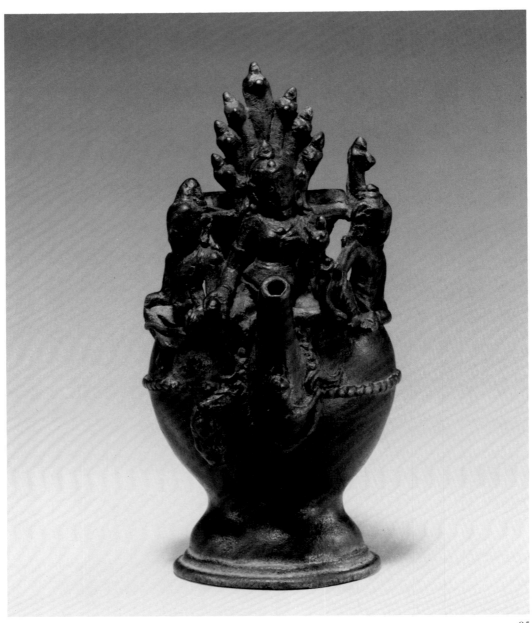

sometimes as Central Javanese style. The copies can be so close to the originals that it is extremely difficult to distinguish the one from the other. This sculpture was found in Java and published as Javanese.

ML

1 D. Mitra 1982, ills. 11, 13, 14, et al.

PUBLISHED
Spink 1978, no. 163.

95 Ritual Ewer with the Snake Goddess, Manasa

India, Bihar(?), Pala period, 10th century
Bronze, h. 5 5/16 in. (13.5 cm)
Gift of Samuel Eilenberg, 1987
1987.142.340

This rare vessel ranks among the finest ritual ewers to have survived from the Pala period. The seated central figure, whose right foot rests on a crouching attendant, is Manasa, the snake goddess associated with the cult

of serpent worship. Her head is framed by a septenary cobra hood, and she holds a snake in her raised left hand. Seated to her right is her consort, Jaratkaru, depicted as a bearded, emaciated ascetic with a *yogapatta* (the band used to support the legs when they are crossed in difficult yogic meditative postures) around his legs, and sitting at her left is her son, Astika. A snake, whose body has been transformed into a beaded pattern, encircles the ewer and the base of the spout.

A very similar example, with the same subject, is in the Nalin collection,[1] and the Los Angeles County Museum of Art has a ritual ewer with a depiction of Gajalakshmi.[2]

ML

1 Casey, pp. 38–39.
2 Pal 1988, pp. 162–63.

PUBLISHED
Whitechapel, no. 29.

96 Standing Crowned and Jeweled Buddha

India, Bihar, Pala period, Kurkihar style,
2nd half of 10th–early 11th century
Bronze inlaid with silver and copper,
h. 11 in. (28 cm)
Gift of Samuel Eilenberg, 1987
1987.142.319

The Buddha is normally depicted wearing simple, undecorated monastic garments. Late in the evolution of Buddhist theology, however, there developed a special form of Buddha wearing an embellished costume with a crown and rich jewelry, which gave rise to the specific type known as the Crowned and Jeweled Buddha. Elsewhere I have discussed some possible explanations for this evolved image,[1] but here it is pertinent to point out that this iconography was particularly popular in northeastern India during the Pala period; the best-known bronze examples are those dating to the tenth and eleventh centuries from the famous hoard of bronzes discovered at Kurkihar in the Gaya district of Bihar. Earlier Crowned and Jeweled Buddhas are known from Kashmir, and the type can be seen as well in the arts of Afghanistan and central Asia. Later, with the dissemination of the Pala styles to Southeast Asia, Indonesian, Cambodian,

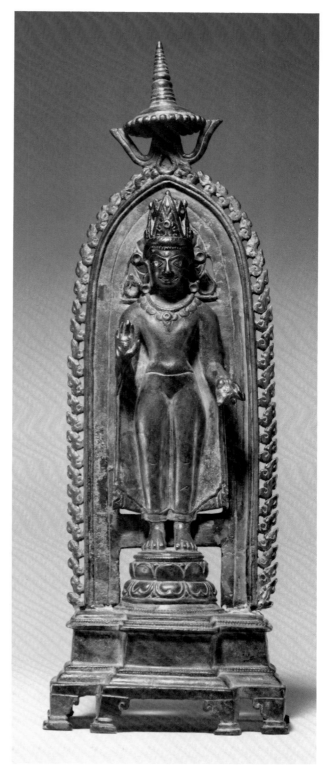

96

Thai, and Burmese versions were made. There are also Tibetan and Nepali examples.

In its modeling, iconography, pedestal, and halo, the Eilenberg sculpture is very similar to some bronzes found at Kurkihar.[2] The fear-allaying gesture (*abhaya-mudra*) displayed by the raised right hand suggests that this is probably the Buddha of the North, Amoghasiddhi, one of the Five Transcendental Buddhas or Tathagatas (see No. 89). Inscribed on the reverse of the pedestal is the standard Buddhist creed.

ML

1 Lerner 1984, pp. 72–74. See also S. L. Huntington 1983, p. 375; J. C. Huntington, pp. 423–24.
2 Schroeder 1981, nos. 64C, G.

PUBLISHED
Whitechapel, no. 14.

97 Marichi, the Goddess of Dawn, with Seven Pigs

India, Bihar(?), Pala period, 11th–12th century
Bronze inlaid with silver, h. 2⅝ in. (6.7 cm)
Gift of Samuel Eilenberg, 1987
1987.142.345

This extraordinary small icon depicting Marichi, the Goddess of Dawn, in the theriomorphic form of a sow, is, so far as I am aware, with one possible exception, unparalleled.[1] Marichi is an important deity in later Buddhist theology who seems to have evolved into an approximate counterpart of the Vedic sun god, Surya. While Surya's chariot is drawn through the heavens by seven horses, however, Marichi's is pulled by seven pigs, who accompany her here. In Esoteric Buddhism, Marichi is considered an emanation and consort of the Supreme Dhyani Buddha, Vairochana, and when she is depicted in

human form, the image of Vairochana sometimes appears in her crown. The particular form of the Eilenberg Marichi does not seem to have been recorded in the iconographic literature dealing with the various aspects of the deity.[2]

The theriomorphic nature of the subject makes dating on the basis of style rather difficult, and one must here rely on the design of the pedestal with its double lotus and beaded registers as a guide to a probable date. A short, faint inscription on one side of the pedestal has not yet been translated.

ML

1 I have been told that a smaller and earlier bronze example exists in an east coast private collection.
2 For a recapitulation of these forms, see Saraswati 1977, pp. XLI–XLVI.

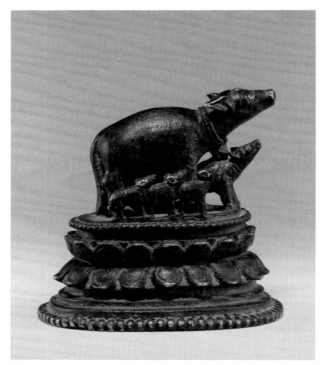

97

Southern India:
Pallava, Chola, and Kerala Sculpture

The Pallava Period

From about the fourth century until the middle or end of the ninth century, the Pallavas ruled over parts of India's southernmost state, Tamilnadu. They were important patrons of Hinduism, leaving as their greatest legacy the seventh- and eighth-century rock-cut caves and temples of Mamallapuram (Mahabalipuram) and the temples at Kanchipuram.

For a long while, scholars had questioned the existence of Pallava metalworking schools and debated whether some small sculpture assigned to the early part of the succeeding Chola period could in fact be of Pallava origin. There is no longer any question that Pallava bronze and copper sculpture has survived, but, in contrast to the very sizable corpus of Chola metal sculpture, they are few indeed. Many of the Pallava metal sculptures are quite small; often they are representations of Vishnu, whose style closely approximates that of larger stone figures.

ML

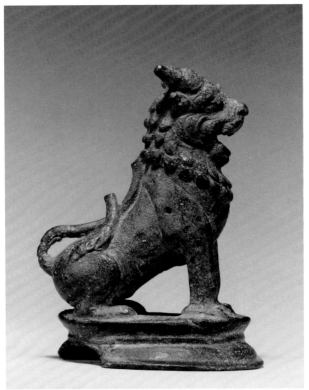

98.1

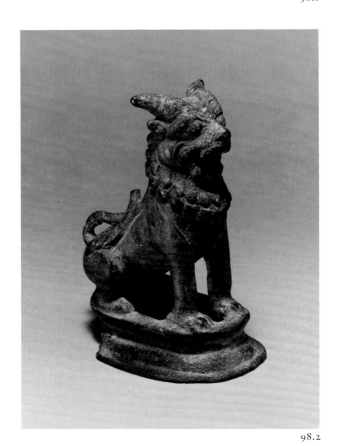

98.2

98 Horned Lion (*Vyala*)

India, Tamilnadu, Pallava period,
ca. 8th century
Bronze, h. 3⅝ in. (9.3 cm)
Gift of Samuel Eilenberg, 1987
1987.142.207

Sculptures of animals are rarely easy to date, and this horned lion (*vyala* or *yali*) is no exception. He seems, however, most reminiscent of the larger stone lions of about the seventh to eighth century that support columns at some of the cave entranceways at Mamallapuram and at other Pallava-period temples at Kanchipuram. I am not familiar with any similar examples but assume they may exist.

ML

Ex coll. Alfred Salmony, New York.

99 Standing Vishnu

India, Tamilnadu, Pallava–early Chola
period(?), 9th century
Copper, h. 5¹³⁄₁₆ in. (14.8 cm)
Gift of Samuel Eilenberg, 1987
1987.142.68

100 Standing Vishnu

India, Tamilnadu, Pallava–early Chola
period(?), 9th century
Copper, h. 4⁵⁄₁₆ in. (11 cm)
Gift of Samuel Eilenberg, 1987
1987.142.67

101 Seated Vishnu

India, Tamilnadu, Pallava–early Chola
period(?), 9th century
Copper, h. 4⅝ in. (11.7 cm)
Gift of Samuel Eilenberg, 1987
1987.142.69

Images of standing four-armed Vishnus are the most common Pallava iconic type in metal and represent the deity in the frontal stance of *samabhanga*, with the weight of the body distributed evenly on both legs. The attributes held by Vishnu are consistent in

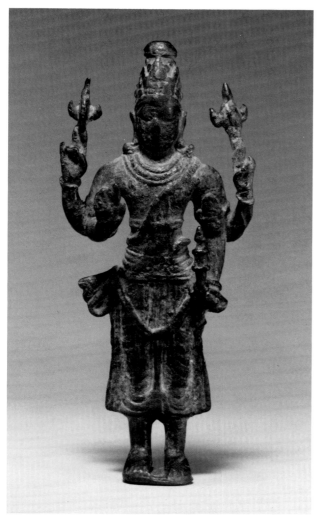

99

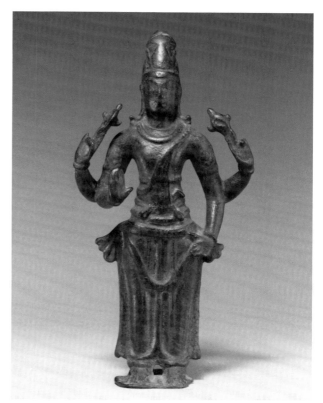

100

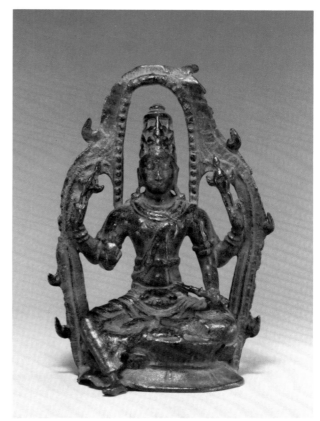

101

their placement and method of representation. In his raised upper left hand he holds a flaming conch (*shankha*), in his upper right, a flaming war-discus (*chakra*) shown in profile. His lowered left hand holds a battle mace (*gada*)—or makes the gesture of holding one—and his lowered right hand is in the fear-allaying gesture of *abhayamudra*. Sometimes a lotus (*padma*) is superimposed over this hand, as in the smaller of our two standing Vishnus (No. 100), or this extended hand may hold a lotus bud or perhaps a citron.

Pallava and, later, Chola Vishnus wear below their waists an elaborate and complex system of subsidiary sashes (*katisutras*) and belts, in addition to the long dhoti or *antariya*. These cross the stomach at different levels; part of the waistband drops in front toward the knees and is knotted at the sides, showing both a loop and the sash end; the long ends of a second sash

fall down the sides of the body. In addition, the sacred thread (*yajnopavita* or *upavita*) is worn diagonally across the chest from the left shoulder, and a band (*udarabandha*) encircles the body above the waist. A rich variety of armbands, bracelets, necklaces, and other jewelry, along with a high miter (*kiritamukuta*), complete Vishnu's rich costume. Close approximations of this mode of dress appear later in the art of Indonesia.

These three rare sculptures suggest the range of stylistic possibility found at the end of the Pallava and the beginning of the Chola periods. The two standing Vishnus probably belong to the first half of the ninth century; the seated example may date to the middle or end of the century and in fact be early Chola rather than late Pallava. Except for relatively minor variations in bodily proportions, the slim and elegant Vishnu seated on a double-lotus pedestal in the relaxed attitude of royal ease (*lalitasana*) closely resembles the standing Vishnus. The costumes are of the same type, and they hold similar attributes (the club of the larger standing Vishnu may have broken off). It is quite rare to find an early sculpture of this sort with halo intact.

Long periods of ritual worship have worn down the surfaces of the figures.

ML

102 Royal Riders on an Elephant

India, Tamilnadu, Chola period, ca. 11th century
Bronze, h. 3 7/16 in. (8.7 cm)
Gift of Samuel Eilenberg, 1987
1987.142.283

Among the many small Indian bronzes of high quality in the Eilenberg collection there are a few of unknown origin that defy precise dating, usually because they are of considerable rarity. Such a sculpture is this elephant with two riders.

Elephants are ubiquitous in the art of India and usually were depicted with considerable naturalism, since they were so well known to the artists. The elephant trappings are normally simple and therefore provide little information that would be helpful in assigning a provenance or date. Here, a blanket with a simple border is strapped to the animal, as is common, and bells hang on either side, in standard fashion.

The figure perched behind the elephant's head wears a necklace, bracelets, earrings, and perhaps an *upavita* (sacred thread) diagonally across his chest. His hair is pulled back behind his head and arranged in a bun. In his right hand he holds what appears to be a branch of a tree. He probably is a royal personage, rather than a mahout. The man behind him, who is also wearing jewelry, holds the fly whisk(?) (*chamara*) of an attendant in his raised right hand. He may be the son of the larger rider. Lively and well fashioned as these figures are, they offer nothing sufficiently distinctive to assist in determining date or provenance.

Indian art provides many examples of elephants with riders; the long friezes of the Lakshmana temple at Khajuraho,[1] for example, could serve as one stylistic source for this sculpture. I believe, however, that it probably comes from a different area. In the Prince of Wales Museum, Bombay, there is a well-known bronze hanging lamp that was discovered in the Jogeshvari Cave near Bombay.[2] This lamp and a similar one found at Dadigama in Sri Lanka[3] provide the closest compositional comparisons, since each has as its main element two figures on an elephant. Neither can be claimed to be stylistically very similar to our bronze—the elephants depicted are heavier, no blankets appear on their backs, and other disparities

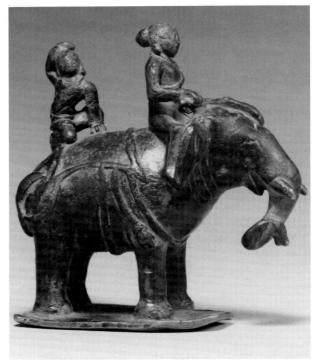

102

occur. Nevertheless, they are the closest objects in bronze known to me and therefore the most appropriate ones with which to begin the search for the origins of the Eilenberg sculpture.

The relationship between the Jogeshvari Cave hanging lamp and the one found at Dadigama has not yet been sorted out. There is no question that it is a close one—in terms not only of the elephants and their riders but also of the figures incorporated into the hanging chains. The Jogeshvari example was formerly assigned to the eighth century[4] but is now thought to date to the twelfth century.[5] If one believes it was made near the place it was found, the lamp is Chalukya, and this shift has advanced it from the early to the later Western Chalukya period. However, it is more likely that both the Jogeshvari and the Dadigama examples were made in southern India. Another smaller sculpture of two royal riders on an elephant, not likely to be part of a lamp, has been dated to the thirteenth century and given the provenance of Tamilnadu.[6] Based on what little information can be obtained from the figural style of the riders on the Eilenberg elephant, our sculpture might be the earliest of all, perhaps belonging to the tenth or eleventh century.

I cannot tell from an examination of the worn surface of our bronze if there originally were attachments to the elephant that would identify it as part of an oil lamp. More likely, if it was part of a lamp, the attachments would have been connected to its surround, as in the Dadigama example. Whether the Eilenberg elephant held a lotus in its curling trunk, as the Dadigama and Jogeshvari beasts do, is impossible to determine, since the front surface of our sculpture's base has been filed, obliterating any traces of a lotus that might have been connected to it.

ML

1 Sivaramamurti, figs. 583–92.
2 Härtel and Auboyer, pl. 194.
3 Lohuizen-de Leeuw 1981, p. 76; Schroeder 1990, no. 119. Another very similar example was found in Sumatra.
4 Härtel and Auboyer, pl. 194.
5 *The Great Tradition*, p. 86.
6 Pal *Elephants* 1981, no. 8.

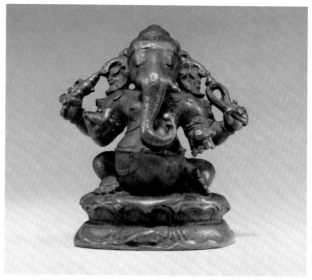

103

103 Seated Four-Armed Ganesha

*India, Tamilnadu, Chola period,
late 12th–13th century
Copper, h. 2⁷⁄₈ in. (7.3 cm)
Gift of Samuel Eilenberg, 1987
1987.142.325*

Ganesha, the elephant-headed Hindu god of auspiciousness, is the son of Shiva's consort, Parvati alone, of Shiva alone, or of the two together, according to different textual sources. He is the deity who controls obstacles—creating them or removing them— and is worshiped before any serious undertaking.

Here, the potbellied Ganesha is seated on a double-lotus pedestal (*vishvapadma*) whose lower part displays the remains of an eroded mongoose, his traditional vehicle. In his four hands he holds his orthodox attributes: the noose (*pasha*) to ensnare evil and wrongdoers in his raised left, a ball of sweets (*modaka*) in his lowered left, his broken right tusk in his right hand, and an elephant goad (*ankusha*) in his raised rear right hand.

This charming miniature representation of Ganesha follows early Chola styles of the tenth and eleventh centuries, in which the seated deity's trunk curves to the left and holds a bit of the sweets,[1] but some details, such as the manner of depiction of the attributes in the upper hands, suggest a date not earlier than the late twelfth or thirteenth century.

ML

1 Barrett 1974, pls. 28, 64, 81A.

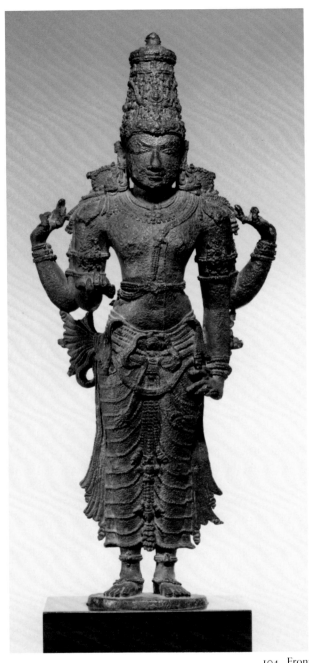
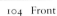

104 Front

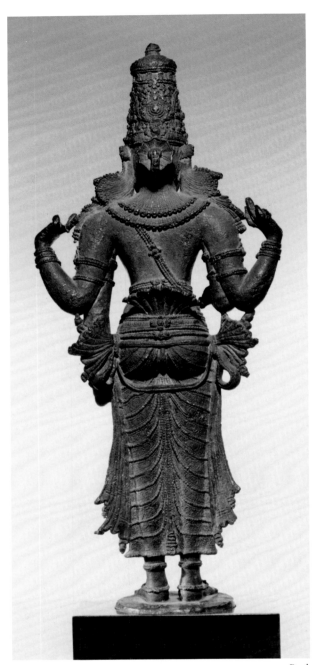

104 Back

104 **Standing Vishnu**

India, Kerala, Chera style,
late 10th–11th century
Bronze, h. 19 ⅜ in. (49.2 cm)
Purchase, Rogers Fund, 1987
1987.218.18

The bronze sculptural styles of the Cheras of Kerala, the state on the southwestern tip of India, developed in ways that were quite different from the celebrated Chola idioms of Tamilnadu in southeastern India. The Kerala (and Karnataka) styles of the twelfth through fourteenth century stressed the formal and iconic nature of the various deities, usually resulting in a more hieratic—that is, frontal and symmetrical—image, with great emphasis on rich and decorative

surface patterning. This latter trait probably reflects the influence of the Hoysalas of Halebid, northern neighbors of the Cheras.

Kerala bronzes of the twelfth century or earlier are exceedingly rare, and large size, impressive quality, and early date make this sculpture one of the most important in the corpus. However, since so few early Kerala bronzes have been identified, one is restricted in material available for comparison. It is nevertheless clear that this Vishnu's stylistic affiliations are with late Pallava and early Chola sculptures rather than with the Hoysala idiom. Vishnu stands in the absolutely rigid posture of *samabhanga* with both knees locked. His lowered left hand makes the gesture of holding, or resting on, a battle mace, and his raised left hand would have held a conch. Missing from his raised right hand is the battle-discus, and he holds a lotus bud in his outstretched right hand. Here, as on some Pallava metal sculpture, the upper hands are connected to the body, creating negative spaces bounded on all sides. In fact, an unusually large number of openings or enclosed spaces appear within this sculpture, as a result of either a specific workshop's metallurgical technology or the sculptor's personal predilection.

The kinds of rich and elaborate jewelry worn and how it is arranged, as well as the specific elements of costume, serve to confirm a relatively early dating for this major sculpture.[1]

ML

1 For a similar treatment of the costume on the lower half of the figure, see the eleventh-century Vishnu in the Nelson-Atkins Museum of Art, Kansas City (Art Institute of Chicago, no. 44).

Ex coll. A. E. Roorda-Dijckmeester, Holland.

PUBLISHED
Roorda, pls. 7, 8.

105 Hilt from a Dance Wand(?)

India, Kerala, ca. 15th century
Bronze, h. 5 9/16 in. (14.1 cm)
Gift of Samuel Eilenberg, 1987
1987.142.284

It has been suggested that this unusual bronze object was the hilt from a dance wand that would have had attached to it a long, flat metal blade of sufficient flexibility for the rapid movements of the dancer to cause it to bend and create sound. I have never seen a cognate example and cannot confirm this identification but, whether part of a dance wand or some sort of weapon, it is surely a fascinating object of considerable aesthetic quality.

The fanciful design of the openwork areas incorporates different types of birds into a finely reticulated scrolling-vine motif. Positioned at key locations are male and female Hindu deities, including what appears to be a depiction of a potbellied Ganesha who has lost his trunk.

ML

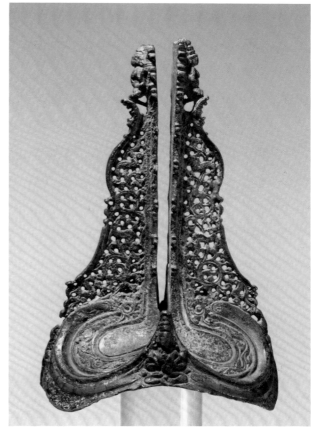

105

Sri Lanka

The Sculpture of Sri Lanka

The conservative nature of the art of the island-nation of Sri Lanka (formerly Ceylon) and the paucity of its dated monuments or individual sculptures make the task of establishing reliable chronological and stylistic sequences very hazardous.[1]

From the beginning, Sri Lanka's geographical position near the southeastern tip of India made her responsive to the cultural influences of her giant neighbor—especially those of Andhra Pradesh and Tamilnadu. During the early periods of Sri Lankan sculptural production, from about the beginning of the first to the fourth century, the close dependence on southern Indian prototypes sometimes makes it difficult to establish provenance on the basis of style alone.

Since Sri Lanka has been, from its early history, primarily a Buddhist nation that for the most part follows Theravada precepts, representations of the Buddha in all media have survived in some profusion. Sri Lankan scholars, unfortunately, have never been able to agree on a uniform system of dating these Buddha images, particularly those of the Anuradhapura period, which lasted from about the time of the introduction of Buddhism into Sri Lanka in the third century B.C. (no sculptures survive from this early date) until the capital was moved from Anuradhapura to Polonnaruva in the eleventh century.

Throughout its long history as Sri Lanka's capital, Anuradhapura endured regular attacks by the Tamils of southern India. After being pillaged by the Pandya armies during the ninth century and the Chola armies in 993, except for some interim transfers, for strategic reasons the Sinhalese capital was moved permanently to Polonnaruva.

ML

1 Ulrich von Schroeder's monumental study, *Buddhist Sculptures of Sri Lanka*, Hong Kong, 1990, has just appeared and will undoubtedly transform our understanding of Sri Lankan sculpture.

106 Seated Buddha

Sri Lanka, Anuradhapura period, ca. 7th century
Bronze with traces of gilt, h. 2 3/16 in. (5.6 cm)
Gift of Samuel Eilenberg, 1987
1987.142.63

This superb small sculpture displaying features of the styles of Andhra Pradesh in southeastern India is a rare, early example in bronze of the Anuradhapura idiom. The Buddha sits in the half-lotus posture

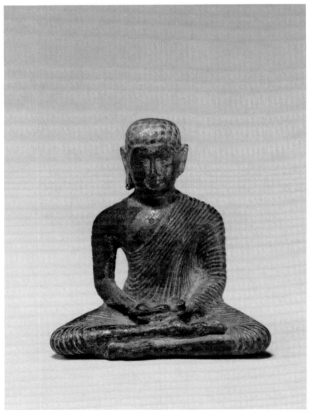

106

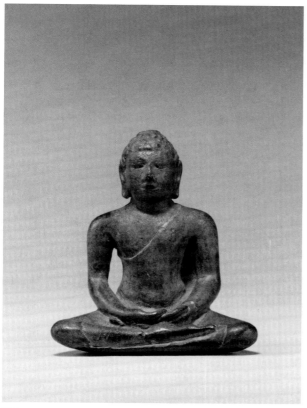

107

107 Seated Buddha

Sri Lanka, Anuradhapura period,
ca. late 7th century
Bronze, h. 2⁷/₁₆ in. (6.2 cm)
Gift of Samuel Eilenberg, 1987
1987.142.64

Our second small Sri Lankan seated Buddha has broad and powerful shoulders, whereas those of the earlier example had a gentle slope; indeed, the general feeling of heavier proportions is sustained throughout —the hands, for example, are larger. No drapery folds appear on the garment, and the *ushnisha* is higher. Instead of the straight, horizontal placement of the crossed legs of the earlier sculpture, there is now a decided sweep, with knees curving upward as they do in a bronze Buddha from Toluvila.[1]

ML

1 Boisselier 1979, pl. 113.

PUBLISHED
Schroeder 1990, no. 45F.

(*satvaparyankasana*), his right leg over his left. His hands are placed in his lap in the attitude of meditation (*samadhimudra* or *dhyanamudra*). The monastic garments are arranged so as to leave the right shoulder bare, and the drapery folds are indicated by precise, regularly spaced incised lines following Andhran precedents. The cranial protuberance (*ushnisha*) is very low, and the *urna*—the round mark between the eyebrows sometimes depicted as a circular wisp of hair—is present. Both are suprahuman markings or physical attributes (*lakshanas*) of the Buddha. It is quite rare for the *urna* to appear on Sinhalese sculpture.

As in some other Anuradhapura figures, the proportions of the legs and the wide angle of the spread knees suggest that the legs are extraordinarily long.[1]

ML

1 For another example, see Lerner 1984, pp. 46–47.

PUBLISHED
Schroeder 1990, nos. 46C, D.

108 Seated Avalokiteshvara

Sri Lanka, Anuradhapura period,
ca. late 7th–1st half of 8th century
Bronze, h. 3⁵/₁₆ in. (8.4 cm)
Gift of Samuel Eilenberg, in memory of
Carneg Kevorkian, 1987
1987.142.65

In front of the high chignon of this deity, set into a round, worn-down medallion, is the faint outline of a seated Buddha, identifying the figure as Avalokiteshvara, the Bodhisattva of Infinite Compassion. Had this emblem been unreadable, one could still make the identification on the basis of the sculpture's very close similarity to another well-known example, formerly in the Coomaraswamy collection and now in the Museum of Fine Arts, Boston.[1] Both sit on the same type of undecorated oblong pedestal, and they are virtually identical in posture and size. Each is seated in the same variant of the attitude of royal ease, with the right leg raised and the foot placed flat on top of the pedestal. The left leg is pendant, the foot resting on a small projecting element, which, in

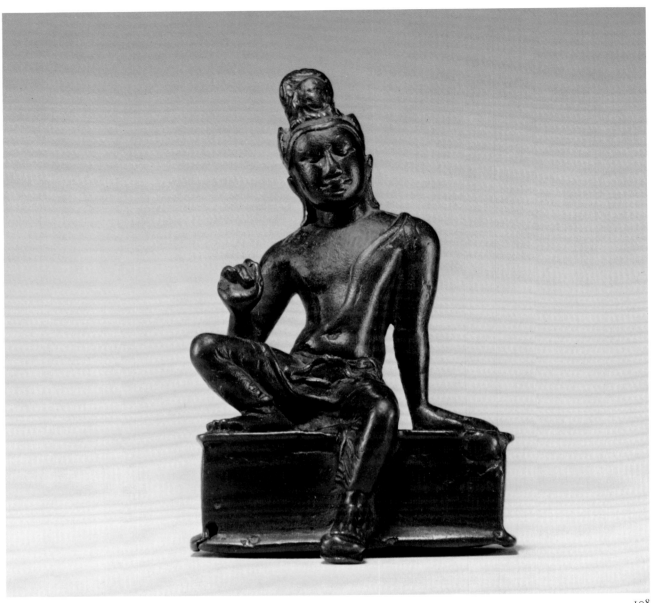

108

the Boston example, is a double-lotus support. Each figure leans backward with the weight of the body steadied by the left arm, and the right hand is in *katakamudra*, the gesture of holding an object. The Eilenberg example, in particular, is modeled with a sensuous fluidity, with volumes gently flowing into each other, resulting in a graceful and elegant body. The style of these sculptures derives from southern Indian Pallava art of the seventh century.

Our bodhisattva is dressed in a long dhoti and has the sacred thread (*upavita* or *yajnopavita*) across his chest. Except for his tiara, he wears none of the rich jewelry usually found on bodhisattvas. This special, unadorned form appears as well elsewhere in Sri Lanka and in Indian rock-cut caves of the Deccan.[2]

ML

1 Coomaraswamy 1914, figs. 172, 173.
2 Dohanian, pp. 34–35.

PUBLISHED
Lerner 1975, no. 11.
Schroeder 1990, nos. 79D, E.

Nepal and Tibet

109 **Linga Cover with Four Faces**

Nepal, 8th–9th century
Copper, h. 18⅜ in. (46.7 cm)
Lent by Samuel Eilenberg

Shiva's phallic emblem, the linga, combines the idea of sexual potency with that of yogic control. The linga is the most sacred icon of Shaivism and the central focus of its ritual activity. Worship of lingas predates Hinduism, which has many myths to explain their origin. In one such myth, Shiva is created to sire a lineage of mortals, a task Brahma cannot fulfill. However, Shiva rejects the idea of releasing his semen and creating imperfect beings. The greatest of ascetics, he tears off his penis, choosing to use his potency internally, and forces his semen up his *chakras* (yogic centers) in order to attain ultimate bliss.[1]

This large copper sculpture is a cover for a stone linga. It is in the form of a *panchamukhalinga*, a linga with five heads of Shiva, one of which is present only in conceptual form. A raised band encircles the tall shaft, and another appears just below the figurative elements. The four manifestations of Shiva that are shown are meant to emerge metaphorically from the interior of the upper portion of the shaft and to be oriented, as is customary, to the cardinal points. They are: Bhairava (south), with asymmetrical earrings and snail-like curls of hair; Nandin (west), with floral earrings and a lion in his crown; Tamreshvara (north), with one floral and one serpent earring; and Mahadeva (east), with no earrings and a piled-up hairstyle that has curls falling around the shoulders. Visible behind the ears of the deities is a third raised band. The fifth manifestation of Shiva, which represents the absolute, is never shown but is conceived of as emerging from the top of the shaft and is oriented to the fifth direction, upward, toward the zenith.

Although the four manifestations portray different aspects of Shiva, their faces are almost identical.

There are two subtle differences: Bhairava, Shiva's angry aspect, has a raised ridge above his nose, perhaps denoting his horrific temperament, and the features on either side of the face of Tamreshvara, who represents Shiva's androgynous nature, do not match—the left side is Shiva's wife, Uma, and the right, Shiva himself (note the differences in the eyes and the earrings, as well as the asymmetry of the crown).[2] Typically, each of the four deities holds the same attributes, a rosary in the left hand (representing death and time) and a water bottle in the right (referring to the elixir of immortality), and the right hand of each is raised in *abhayamudra*, the fear-allaying gesture. These attributes and the mudra symbolize Shiva's assurance to devotees that they will ultimately find spiritual liberation through him.[3]

A number of features point to an early date for this linga cover. The top of the shaft is domed, not flat as is usual after the tenth century. The third eyes of the divinities are horizontal rather than vertical. Bhairava is shown with snail curls instead of a crown and with a pacific rather than an angry face. The attributes are held in a manner uncharacteristic in later times—the rosary hangs over the hand and across the palm instead of between the thumb and index finger, and the water bottle is held around the neck, not cradled in the open palm. Finally, the shoulders and arms of the figures are indicated, whereas in later lingas, the heads and hands of the divinities are disembodied. The few other lingas that combine all of these elements in like fashion are dated by scholars between the fifth and the ninth centuries.[4] It is difficult to date this object precisely, but an assignment to the later part of this continuum, perhaps the eighth or ninth century, appears to be appropriate. This seems likely in particular because the faces of the deities are not as full and their volumes are not as harmonious as in the earlier, Gupta-inspired examples.

SK

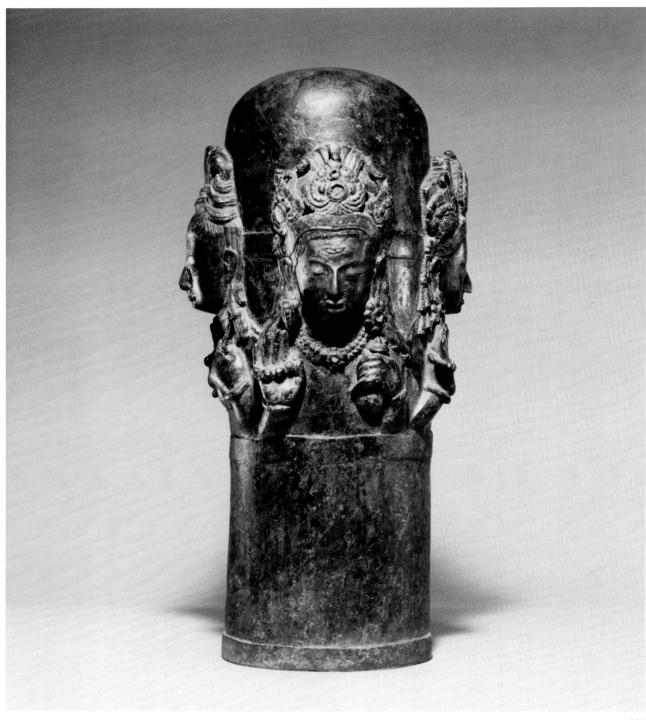

109

1 Kramrisch 1981, p. xv.
2 Save for this one identifying mark, the Bhairava could be Lakulisha, the revered individual who systematized the tenets of the Pashupati sect and is sometimes portrayed on lingas (Slusser, pp. 224–25).
3 Kramrisch 1981, p. 101.
4 For example, the stone linga from Pashupatinath is dated by Pal

to the ninth century (1974, pl. 124); Bangdel, however, dates this to the early fifth century (p. 53). There is another stone linga in the Los Angeles County Museum (M.88.226) dated by Pal to the fifth century (unpublished). A third early stone linga that combines these attributes is in a private collection in the United States (unpublished).

110 Standing Padmapani

Nepal, Licchavi period, 8th–9th century
Copper, h. 4 1/2 in. (11.4 cm)
Gift of Samuel Eilenberg, 1987
1987.142.350

From as early as the Kushan dynasty, the small Himalayan kingdom of Nepal was politically and culturally interrelated with its southern neighbors, the kingdoms of northeastern India. Nepal's artistic traditions evolved directly from those of the Gupta and Pala dynasties of India, each of which ruled the Nepalese for some time. The earliest extant Nepali cast-copper sculptures date to the end of the Licchavi period. The Licchavi kings were members of a tribe of northern Indian origin who intermarried with the Guptas. Political disputes forced them to flee to Nepal, where they became the local rulers.

This attenuated figure of Bodhisattva Padmapani stands in a gentle *tribhanga* (thrice-bent) stance, on a circular double-lotus pedestal. His lowered right hand is held palm outward in *varadamudra*, the gesture denoting the bestowal of boons; his left hand is raised to chest level and holds the stalk of a lotus flower. He wears a dhoti, which is secured by a belt and, characteristically, is tied asymmetrically so that on his left it covers only the thigh and on his right descends to just above the ankle. A long pleated section of the dhoti falls from beneath the belt buckle between the bodhisattva's legs to just below his ankles, to form a zigzag pattern at the hem. A long scarf, with ends streaming off to the figure's left side, is knotted around his hips. He wears a suite of jewelry: bangles, a long *yajnopavita* or *upavita* (sacred Brahmanical thread) slung diagonally across his chest, a double-stranded necklace, and flower-shaped ear pendants. The bodhisattva's hair is smoothed toward the back of his head and pulled up and arranged in looped ropes to form a high chignon. A tiara with a single leaflike triangular form is set before the chignon. Strands of hair are loosened on either side of the bun and fall down onto his shoulders. An ovoid nimbus with pointed top rises from behind the figure's shoulders. It is decorated with a large row of pearling surrounded by a hook motif probably representing flames. The face of the bodhisattva is full and has an unusually small mask.

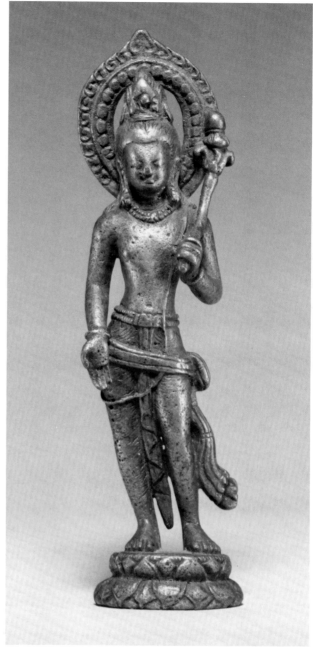

110

Stylistically, this small figure is indebted to the Gupta sculptural tradition. The single-lobed tiara and the large pearling of the nimbus also point to an early date for the image within the corpus of Nepali copper sculpture.

SK

141

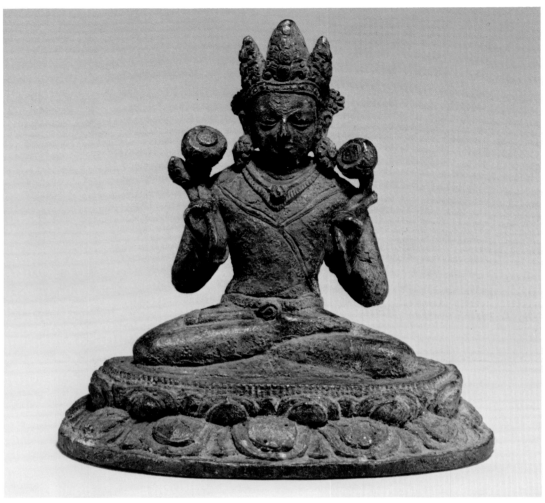

III **Seated Surya**

Nepal, Thakuri dynasty, 9th century
Copper, h. 5 in. (12.7 cm)
Gift of Samuel Eilenberg, 1987
1987.142.353

The sun god Surya is seated in a cross-legged yogic posture on a large ovoid double-lotus pedestal. His hands are raised to chest level, and each holds the stem of a lotus flower that curves up to rest on his shoulder. Each stem bifurcates to bear a bud and an open lotus flower (one of the buds has broken off). The deity wears a vest with lapels and a long dhoti patterned with floral rosettes, triangular sections of which fold over onto the top of the lotus pedestal in front of his legs. The dhoti is cinched at the waist by a belt with a circular boss. Surya wears elaborate jewelry—bangles, a necklace, large earrings in the form of flowers, and a trilobed tiara secured by means of a strap with a fanlike pleat behind each ear. The lobes of the tiara are each decorated with a central motif of piled-up circlets embellished with hook forms on either side. The deity's hair is arranged in a high chignon, most of which is covered by a scarf patterned with small floral rosettes. A shawl, not visible from the front of the sculpture, emerges behind the left shoulder and falls down the back. Surya's beaklike nose, elongated eyes, pursed mouth, and small chin all ultimately derive from Gupta prototypes and are typical of the Nepali idealized physiognomy.

The unusual surface of the metal was probably produced by a fire. The sculpture originally would have been gilt.

SK

PUBLISHED
Schroeder 1981, no. 79C.

112 Linga with Five Faces (*Panchamukhalinga*)

Nepal, Thakuri dynasty, dated 1045
Copper, w. 6⅞ in. (17.5 cm)
Gift of Samuel Eilenberg, 1987
1987.142.314

This *panchamukhalinga* (see No. 109) was cast in one piece together with a large yoni (symbol of the vagina)[1] with a stepped base. Shiva is here manifest four times around the flat-topped shaft of the linga and once, in conceptual form, above it. Each depiction consists of a head, neck, and two hands, and seems to emerge from the shaft. All wear earrings, a necklace of beads, and a tiara, and have hair piled up on top of their heads. A straplike band with incised decoration runs around the perimeter of the linga between the heads, just above the ears. The right hand of each Shiva is raised in *abhayamudra*, the gesture signifying the allaying of fear, and the open left palm cradles a water bottle. The linga appears to emanate from a lotus flower that is molded on top of the yoni. Both yoni and base are unusually large and boldly modeled. There is an inscription in Newari cast into the base, which dates the linga to Samvat 166 (1045) and gives the name of the ruling king as Bhaskaradeva. As very few Nepali bronze objects are dated, this linga has served as an important touchstone for the dating of sculpture from this kingdom.

In *panchamukhalingas*, Shiva is often represented in four of his different aspects, which are usually identifiable by distinctive countenances and attributes. Here, it is difficult to differentiate them, because the attributes shown are identical, the hairstyles are similar, and all of the visages are benign. Only the head opposite the spout of the yoni has two different styles of earrings (one circular, the other in the form of a large flower), a convention that symbolizes Shiva's androgynous nature but does not necessarily serve to identify the particular manifestation of the god as Tamreshvara.

The tops of lingas are anointed in the course of worship, causing the yonis to fill up with liquid, which subsequently drains off through the spouts. During worship, our linga therefore appeared to be emerging from a lotus in a watery setting, a fitting symbol of spiritual transcendence.

SK

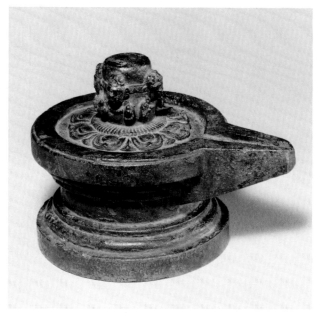

112

1 The linga is always shown with a yoni. In temples it is housed in a small room called a *garbhagriha* (womb chamber). The devotee is therefore presented with an image signifying cosmic sexual embrace.

PUBLISHED
Pal 1971–72, p. 62.
Pal 1974, pl. 32.
Pal *Nepal* 1975, no. 55.
Schroeder 1981, no. 83F.

113 Shiva Seated with Uma (*Umamaheshvara*)

Nepal, Thakuri dynasty, 11th century
Copper, h. 11⅛ in. (28.3 cm)
Purchase, Rogers Fund, 1987
1987.218.1

In this image of dalliance between Shiva as Maheshvara, the Great Lord, and his wife, Uma (Parvati), the ultimate oneness of all things in the cosmos, here represented by the intertwined male and female, is expressed with great tenderness and elegance. The divine couple is seated on a large ovoid double-lotus pedestal, each resting in a variant of *rajalilasana*, the posture of royal ease. The four-armed Shiva's torso is erect and turned slightly to his left. His two right hands hold attributes, a bud and a

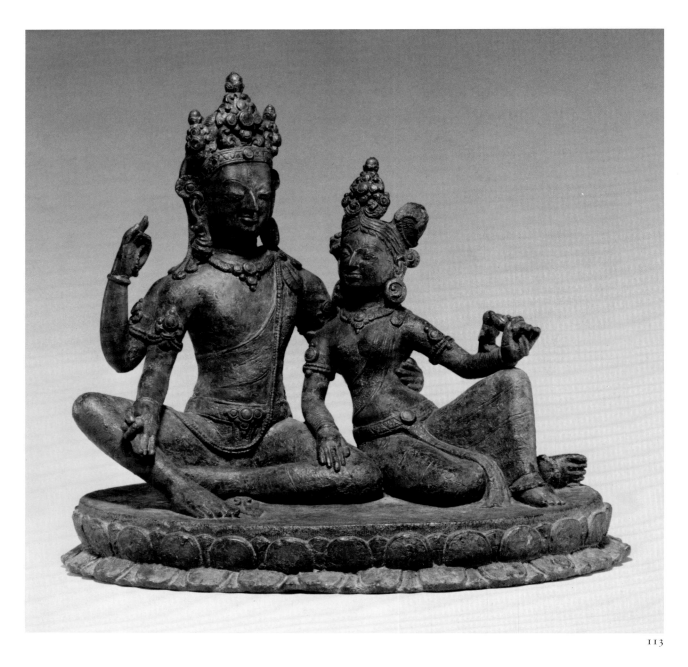

rosary. His upper left hand probably once held a separately cast trident (now lost), and his lower left hand embraces his wife's waist. He wears a patterned dhoti secured by a belt with a jeweled clasp; a large pleated section of the dhoti falls from under the clasp between his legs, and a shawl is slung diagonally across his chest and looped over his left shoulder so that the ends fall down his back. The figure is adorned with elaborate jewelry, including a *yajnopavita* (sacred Brahmanical thread) and a trilobed tiara. Typically, Shiva's right earring is in the form of a snake (*sarpakundala*), and the left is a circular earplug

(*patrakundala*), indicative of his androgynous nature. He has a high chignon made of twisted strands of hair, three of which fall on each side of his head onto his shoulders. Shiva's third eye is incised on his forehead.

His wife is seated to his left. The posture of her lower body is a mirror image of Shiva's own. However, in contrast to his erect upper body, her torso is pulled back in a gently twisting curve by her lover's hand, so that she leans toward him with her right forearm resting on his thigh. Uma's left forearm is placed on her right knee, and in her left hand she holds a lotus

bud. A parrot, a symbol of passion, is perched on her forearm and pecks at the lotus. She is dressed in a manner similar to that of her husband. Her elaborate jewelry consists of anklets, numerous bangles, armlets, a necklace, large circular earplugs, and a single-lobed tiara, which, like Shiva's tiara, is modeled with great vitality. Her hair is arranged above each ear in a high bun dressed with strands of pearls.

This is the largest and perhaps the finest early Nepali cast-copper *Umamaheshvara* known. The physical and emotional inseparability of the divine lovers is manifested through the subtle inter-relationship of their poses as well as in the inward joyfulness conveyed by their exquisitely rendered facial expressions. As in most images with sexual overtones in greater Indian art, the coupling of male and female is here understood as a metaphor for the dissolution of the mirage of duality that veils the true nature of the universe. According to most legends, despite their innumerable years of lovemaking, Shiva and Parvati never produced any offspring. Shiva, the greatest of ascetics, always retained his semen, forcing it up the *chakras* (psychic reservoirs) of his body through the practice of yoga, in order to attain ultimate being. Our sculpture is, therefore, actually an image of spiritual transcendence, not temporal pleasure. It was probably made as the centerpiece of a larger ensemble, the other elements of which are lost. The entire composition originally would have been gilt.

SK

PUBLISHED
Sickman, no. 24.
Schroeder 1981, no. 84A.
Lerner in *Recent Acquisitions*, p. 111.

114 Seated Kumara (Young Karttikeya)

Nepal, Thakuri dynasty, 11th century
Copper, h. 5 ⅜ in. (13.7 cm)
Gift of Samuel Eilenberg, 1987
1987.142.354

Karttikeya, the chief martial god of the Hindu pantheon, is sometimes called Kumara in his youthful, bachelor form. He is depicted here as a potbellied young man cradling Paravani, his peacock *vahana* (vehicle). He sits in a relaxed pose, wearing a long,

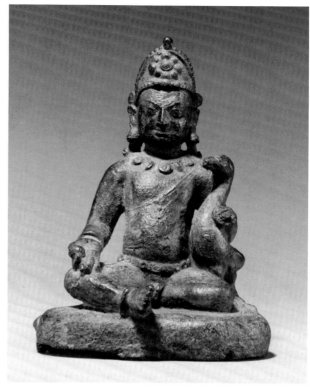

114

patterned dhoti secured by a belt. A long shawl, contoured to his body, is arranged diagonally across his chest. The ends, which descend from his left shoulder, are visible on the reverse of the sculpture. He is bedecked with anklets, bangles, small earrings, a necklace of alternating circlets and tiger claws, and a large miter with a central design of a circular boss surrounded by eight smaller ones. The rim of the miter is decorated on its top and bottom edges with pearling, and each of its ends terminates in a floret. Kumara's hair is pulled up on his head and divided into three parts: The uppermost section is formed into a small bun, and the other two fall down behind his ears on either side of his neck and curl at the shoulders. This hairstyle and the tiger-claw necklace are both youthful attributes.[1] Indian babies are still given tiger claws to teethe on; ultimately they are used as pendants.

SK

1 Lerner in *Notable Acquisitions*, p. 90.

PUBLISHED
Schroeder 1981, no. 84G, as Karttikeya.

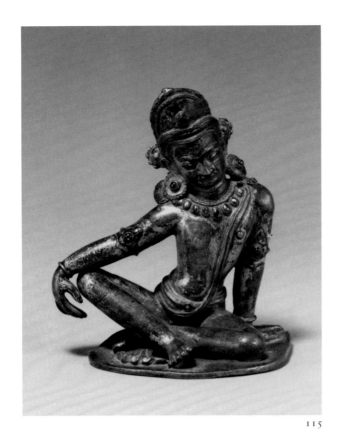

115

115 Seated Indra

Nepal, 12th century
Gilt copper inlaid with precious and semi-precious stones, h. 3⁹/₁₆ in. (9.1 cm)
Gift of Samuel Eilenberg, 1987
1987.142.321

The god Indra is seated in *rajalilasana*, the posture of royal ease, his left arm supporting the weight of his torso, his right draped over his right knee. He wears a short dhoti cinched by a jeweled clasp, a miter with a single jeweled boss, armlets, bangles, a necklace, a *yajnopavita* (sacred Brahmanical thread), and large circular earplugs. His hair is arranged in a large bun behind his right shoulder. The god's eyes are lowered, and his face radiates the same relaxed calm as his body. This statue has no lotus pedestal and probably would originally have been set into a separately cast base.

SK

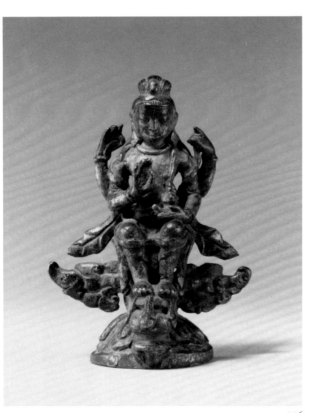

116

116 Seated Four-Armed Shiva

Nepal, Malla period, 12th century
Copper, h. 3¼ in. (8.3 cm)
Gift of Samuel Eilenberg, 1987
1987.142.362

A four-armed Shiva is seated on a tall lotus-pedestal, with his feet resting on top of the vase of immortality. Two lotus stalks grow out of either side of the central stem that supports the lotus on top of which the god is perched. Another, smaller stalk supports the vase. Shiva holds the stem of a lotus in his upper left hand (the flower has broken off) and a waterpot in his lower left palm. His lower right hand is making the gesture signifying the allaying of fear, *abhayamudra*, and in his upper right hand he grasps a rosary. He wears a long dhoti and a scarf wrapped around his upper arms. His hair is piled in a tripartite chignon decorated with a cockade, and he is discreetly adorned with only a necklace, diamond-shaped earrings, a *yajnopavita* (sacred Brahmanical thread), and a single bangle on each wrist. A strap used by ascetics to help maintain difficult postures (*yogapatta*) encircles his knees and signifies, together with the waterpot, rosary, and simple jewelry, that Shiva is being portrayed here as a great ascetic. His tall lotus-seat and the vase that

146

supports his feet would indicate his spiritual accomplishments. Visible on the back of the sculpture are two lugs that emerge from the flanking lotus stems; these probably supported a now-lost *prabha* (aureole).

SK

117 Seated Maitreya

Nepal, Malla period, 1250–1350
Gilt copper inlaid with precious and semi-precious stones, h. 5 ¼ in. (13.3 cm)
Gift of Samuel Eilenberg, 1987
1987.142.358

The stupa crowning this figure's piled-up chignon, the small antelope pelt that falls over his left shoulder, and the waterpot, symbol of an ascetic Brahman, that is set in the center of the lotus flower to his left identify him as the Bodhisattva Maitreya. The bodhisattva is seated in *rajalilasana*, the posture of royal ease, on a single-lotus pedestal, which is decorated at top and bottom with large rows of pearling. His right hand is raised to chest level in *vitarkamudra*, the gesture signifying the exposition of doctrine, and his left rests on the edge of the pedestal, supporting the weight of his torso. A small lotus flower that emerges from beneath the top row of pearling on the pedestal supports the deity's right foot. Two lotus stems crowned with open flowers, one held in the figure's right hand, flank him. Maitreya is naked except for a short, patterned dhoti whose central pleats spill onto the top of the pedestal. A long scarf(?) is draped over the right thigh. He wears elaborate jewelry consisting of anklets, a belt ornament, bangles, armbands, a necklace, earplugs, and a tiara with five lobes, the central and largest of which has a Garuda (the solar anthropomorphic bird-deity) at its base.

By the late twelfth century, the conquest of northern India and the resulting destruction of all the great Buddhist monastic complexes by Muslim forces were

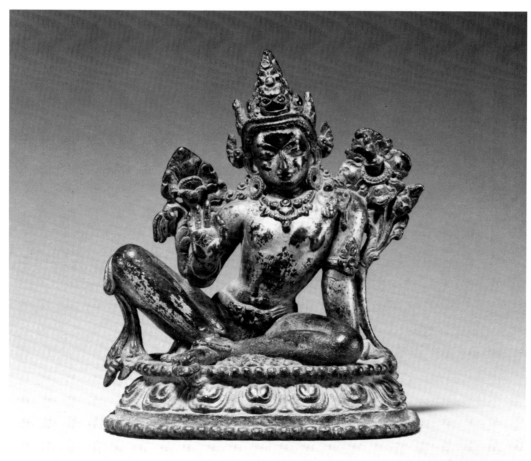

117

complete. This caused the exodus to Nepal of large numbers of Buddhist monks, presumably including artists. In this image, the influence of late Pala bronze sculpture is evident in the body, which is more languid than earlier examples, and in the more curvilinear development of certain details, such as the lotuses and the scarf.

SK

PUBLISHED
Schroeder 1981, no. 93D.

118 A Demon Victim of Durga's Wrath

Nepal, 13th century
Gilt copper, h. 3 ½ in. (8.9 cm)
Gift of Samuel Eilenberg, 1987
1987.142.363

Our small statue was probably originally an attendant figure in an ensemble in which Durga Mahishasura-mardini (Durga as Slayer of the Demon Buffalo) was the central image; most likely it represents another

demon victim of her wrath. A published sculpture of Durga has on either corner of its base two such demons—one wounded by a *chakra* (discus) and the other by a *vajra* (thunderbolt)—who gaze up at the goddess.[1] Our demon is similarly wounded: He seems stunned by the blow of a *chakra* that is wedged into his chest, and he has fallen into a semikneeling position. He is also tearing from around his neck and shoulders a serpent(?) that is presumably about to strangle him. There is a long mace in his lowered right hand. The demon wears a doublet of mail and a short dhoti and is richly bedecked with jewelry that includes a large tiara. Several long scarves are tied around his waist and fall down his sides, in front of, and across his body. The facial features are somewhat avian, both the mouth and nose (although blunted) suggesting a beak. His furrowed brow and bulging eyes are more typical demon attributes.

SK

1 Pal states that the two demons on the base of the pedestal are companions of the Demon Buffalo (*Nepal* 1975, no. 73), but it is more likely that they represent two of the goddess's other conquests, perhaps the demon brothers Sumbha and Nisumbha.

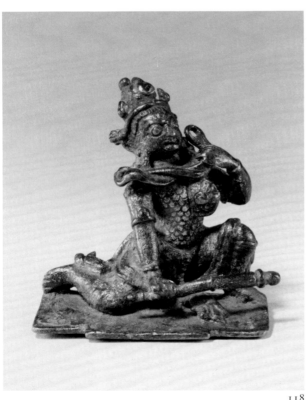

118

119 Standing Female Attendant of Vishnu (Lakshmi)

Nepal, 13th century
Copper inlaid with semiprecious stones,
h. 6 ⅛ in. (15.6 cm)
Gift of Samuel Eilenberg, 1987
1987.142.355

This copper sculpture is extraordinary in its sensitive modeling and feeling of baroque movement. The elaborated ornamentation and exaggerated, mannered pose mark a major stylistic shift from earlier Nepali sculptures (see Nos. 110, 111, 113–16). The figure is identified as a female attendant of Vishnu by the head of Garuda (the bird vehicle of Vishnu) in her crown. She stands in a pronounced *tribhanga* (thrice-bent) posture and in her raised left hand holds a lotus stalk whose open bloom flanked by two buds rests beside her left shoulder. Her right hand is raised before her chest in *anjalimudra* (the gesture of adoration). She is adorned with rich jewelry: anklets, bangles, armlets, necklaces, circular earplugs, and an elaborate tiara

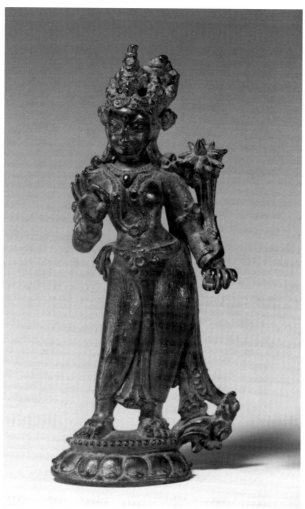

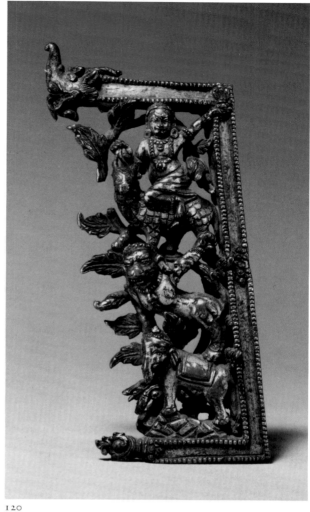

119 120

with three lobes. Her hair is pulled up into a large bun into whose left side two flowers are inserted, and strands terminating in curls fall on each of her shoulders. The goddess is nude except for a long, patterned dhoti secured by a belt with a foliate clasp and a long scarf that cascades behind her arm and down her left side from her left shoulder. A floral spray, which springs from the ovoid lotus base she is standing on, acts as a support for the lower folds of the scarf.

SK

PUBLISHED
Schroeder 1981, no. 90C.

120 Element from a Halo

Nepal, 16th century(?)
Gilt copper, 5 x 2⁷/₁₆ in. (12.7 x 6.2 cm)
Gift of Samuel Eilenberg, 1987
1987.142.361

Of the many early Nepali cast-copper sculptures that survive, the great majority are objects of worship. These were created as parts of larger ensembles that included elaborate mountings, sometimes in the form of throne backs, few of which are still extant. This copper sculpture was a separately cast element that constituted the left side of one such throne back for an image of a Buddhist deity. It is composed of an ensemble of figures and foliage framed by an outward tilting vertical member with perpendicular struts at top and bottom. The lower strut is capped with a

small floral finial, and the upper ends in a head of a *makara* (fantastic aquatic beast). Between the struts, a man, a fabulous beast, and a rampant lion balance on an elephant that stands on a rocky outcropping. Luxuriant foliage, perhaps of a stylized lotus plant, is intertwined with the figures; the elephant holds a small bud in its trunk, and a much larger one appears beside the man.

From as early as the Mauryan period, lions, elephants, and fabulous composite beasts were used in Buddhist art as emblems of royalty and to represent protectors of the faith. Assemblages of figures of the kind seen here, which derive from Indian prototypes, were standard adornment on Nepali throne backs as early as the twelfth century. However, the presence of the *makara* and lotus finials, the rambling lotus stem, and the somewhat pacific animals points to a much later date, perhaps the sixteenth century, for our fragment.

SK

121 Seated Mahashri Tara or Prajnaparamita

Tibet, 13th century
Bronze inlaid with silver, h. 4⅞ in. (12.4 cm)
Gift of Samuel Eilenberg, 1987
1987.142.346

The goddess is seated on a tall lotus pedestal, her pendant right leg resting on a lotus plant, her left foot leaning on her right thigh, and her hands held before her chest in a variant of *dharmachakramudra*, the gesture associated with the Buddha's first exposition of doctrine. She is naked except for a long dhoti secured by a belt and a diaphanous shawl wrapped around her upper arms. Dhoti, shawl, and belt are finely chased with floral or geometric patterns. The deity wears elaborate jewelry, and her hair, which is also chased, is gathered into a large bun behind her left shoulder and dressed atop her head with strands of pearls and crowned by a cockade. Two lotus flowers, both now broken off, must have flanked her head: the stalk of one twists around the crook of her left arm; all that remains of the other is a casting lug behind her right elbow. The left earring is broken in half, and there are two holes in the bottom of the pedestal that do not seem to be original.

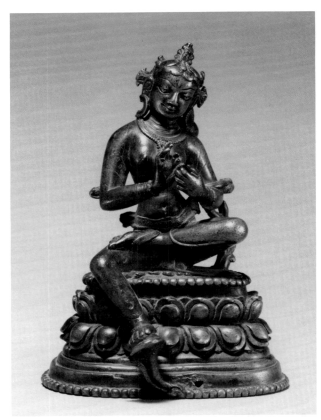

121

Our bronze is closely related to twelfth-century Pala-style sculpture. The form and decoration of the pedestal, with its stamped row of pearling at top and bottom, as well as the detailed chasing of garments and hair, are indicative of a Tibetan origin, as is the somewhat less than successful handling of the complicated posture.[1] This slight awkwardness notwithstanding, the sculpture is aesthetically pleasing, thanks to its great élan and gemlike finish. Her mudra and the remnants of the flanking lotuses identify her either as Prajnaparamita, the incarnation of divine knowledge, or Mahashri Tara, a rare form of the goddess who is associated with the achievement of prosperity and well-being.[2] It would be possible to make the precise identification only if the lotus blossoms were both intact: Mahashri Tara holds two different types of lotus flowers, a blue and a white; Prajnaparamita holds two white lotuses.

SK

1 For a discussion of early Tibetan bronzes, see Huntington and Huntington, pp. 366–88.
2 Ibid., no. 150.

150

Thailand and Cambodia

122 Torso of Standing Four-Armed Durga

Thailand, Surat Thani province(?),
Peninsular style, 6th century
Stone, h. 7⁹⁄₁₆ in. (19.2 cm)
Purchase, Lila Acheson Wallace Gift, 1987
1987.218.20

In surveying early representations of female deities in the Funan-Chenla sculptural repertory of Cambodia and Vietnam, I stated, "The evolution of the develop-ment of the female figure in early Pre-Angkorian sculpture must be charted using frustratingly few examples. From the period of Phnom Da-style A [ca.514–539] to the end of the Sambor style, around the middle of the seventh century—a time span of more than a hundred years—the literature contains fewer than six examples."[1] The Eilenberg collection Durga, executed in the style of southern Thailand's peninsula, is earlier than any of those known examples. Previously published as early seventh century,[2] I believe the sculpture dates to the sixth

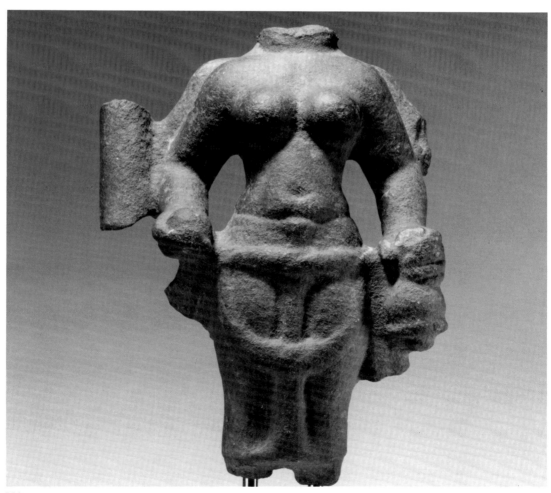

century, making it, so far as I am aware, the earliest known representation of a female deity in the history of Southeast Asian Hindu or Buddhist art.

The style of the Eilenberg Durga derives from the idioms of the Indian state of Andhra Pradesh, more specifically the area around the Krishna River valley. The dhoti covering the lower half of the body is arranged in the typical Andhran Ikshvaku-period fashion, with a thick rolled cloth sash crossing the front of the figure at hip level and a suspended loop dropping down the thighs. The sash is knotted at the hips with the ends falling at the sides of the body.[3] This costume convention appears on the earliest of the Peninsular Thai sculptures.[4]

The identification of the Eilenberg four-armed female deity is not certain. She holds a bell in her lowered left hand and a round object, a lotus bud or possibly a symbol of the earth (*bhu*),[5] in her lowered right. In front of what remains of her rear right arm is part of a thick shaft, probably belonging to a trident. Had the emblems held in the missing hands survived, her identity would not be a problem. From the evidence available in her present condition, it would seem, however, that she is most likely Durga. It is possible that the pedestal upon which she once stood had a buffalo's head, which would definitely identify her as Durga.[6]

ML

1 Felten and Lerner, p. 46.
2 Pal 1978, no. 77.
3 Examples of Andhran figures displaying this convention are the bodhisattva in the Archaeological Museum, Amaravati, and the Vishnu torso from Yelleshvaram, Nalgonda district (Ramachandra, pl. 266; Nigam, pl. XXXII).
4 O'Connor, figs. 1–3.
5 Ibid., p. 30.
6 Boisselier 1955, pl. 24A.

PUBLISHED
Pal 1978, no. 77.

123 Standing Avalokiteshvara

Thailand, Surat Thani province, Peninsular style, ca. early 7th century
Stone, h. 17¾ in. (45.1 cm)
Purchase, Lila Acheson Wallace Gift, 1987
1987.218.16

Among the many superb works of art in the Eilenberg collection, this image of the Bodhisattva of Infinite Compassion, to my eye, is one of the most aesthetically satisfying. It is, additionally, a particularly important sculpture, being one of the earliest representations of Avalokiteshvara found in Thailand.

The figure stands in the frontal *samabhanga* posture with both knees firmly locked, as opposed to the deity's more usual hipshot stance. The general proportions of the body and the way it is modeled are based on northern Indian prototypes of the Gupta period like those found at sites such as Sarnath and Deogarh.[1] It is, however, a slimmer and more elegant figure, approximately a century later in date than these Gupta sculptures. Avalokiteshvara wears a long wraparound skirt (sarong) partially secured by a thin double-strand belt knotted or clasped in front. An antelope skin (*ajina*), barely perceptible in front but clearer on the back, covers his left shoulder.

His hair, which includes a seated Amitabha Buddha, is arranged in the *jatamukuta* fashion, separated into long plaits (*jatas*) piled high on the head and forming loops as it descends. On Gupta sculptures, the piled-up section is not so high and narrow as it appears here[2] and on this figure's closest cognate, a slightly earlier representation of Avalokiteshvara from Peninsular Thailand, now in the National Museum, Bangkok.[3] It is not yet clear if the form of the Eilenberg sculpture's *jatamukuta* developed independently, parallel with the evolution of this kind of hairdo in the sixth- and seventh-century Pre-Angkorian styles of Phnom Da and Sambor,[4] or if it was influenced by those styles. A similar Avalokiteshvara, found in Surat Thani, is now in the National Museum, Bangkok.[5]

ML

1 Williams, pls. 96, 97; Vats, pl. XI.
2 Williams, pls. 96, 171.
3 Krairiksh 1979, no. 2.
4 Dupont, pls. IIA, XIA, XXV.
5 Krairiksh 1980, pp. 114–15.

PUBLISHED
Pal 1978, no. 85.
Chutiwongs, pl. 107.

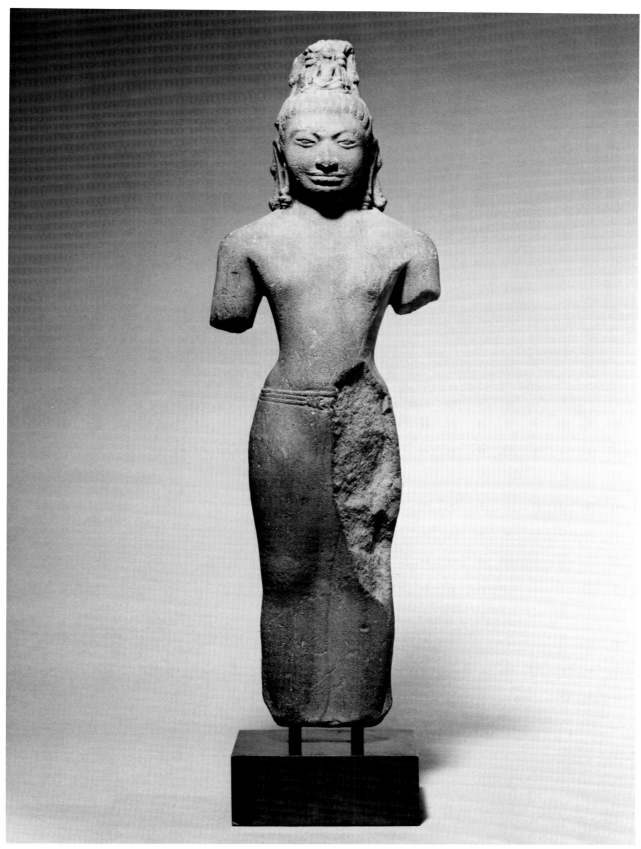

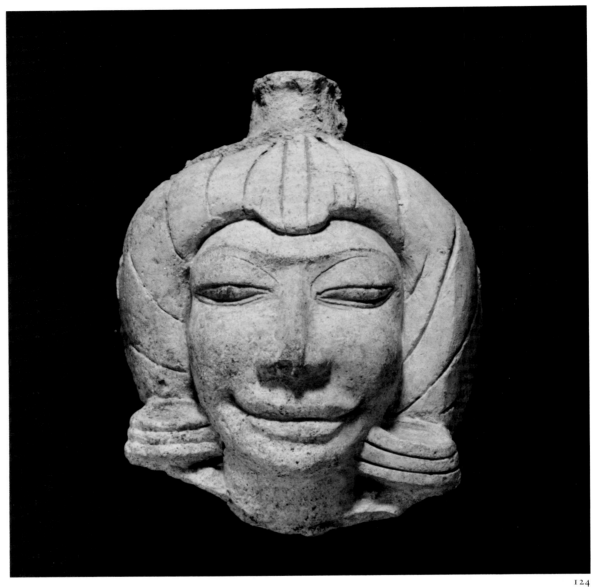

124 Head of a Male Figure

Thailand, Ratchaburi province, Ku Bua,
Mon style, 8th–9th century
Stucco with polychrome, h. 6⅞ in. (17.5 cm)
Gift of Samuel Eilenberg, 1987
1987.142.287

From about the fifth to the tenth century, large parts of central Thailand, southern Thailand—particularly around the head of the Gulf—and lower Burma were populated by the Buddhist Mons. Individual Mon states existed in these areas, but the exact relationship of one to the other is still unclear. Mon artistic

activity was at its height from the seventh to the ninth century, but fine workmanship in their production is evident even later.

Excavations in 1960–61 at the site of Ku Bua, Ratchaburi province, in southwestern Thailand, revealed a remarkable treasure trove of Buddhist sculptures in terracotta and stucco, much of which belonged to narrative friezes that surrounded the bases of large stupas.[1] The terracottas, which were mostly from site nos. 39 and 40, date to the early phase of activity at Ku Bua, about the beginning of the seventh century, and the stuccoes, which came primarily from site no. 10, belong to the later, eighth- to ninth-century phase. Most of the faces of the sculp-

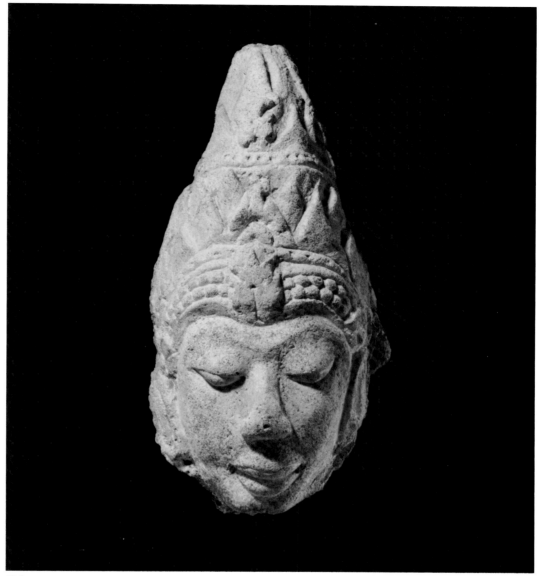

125

tures found at Ku Bua display the distinctive idealized
tures found at Ku Bua display the distinctive idealized physiognomy of the Mon peoples, with wide mouths, high cheekbones, narrow chins, and eyebrows joined in the center. This fine head, which preserves some of its original polychromy, exhibits the typical physiognomy and wears the large round earplugs often found on figures from this site.

ML

1 *Guide to Antiquities*.

PUBLISHED
Reinhardt, no. 7M.

125 Head of a Male Deity

*Thailand, Nakhon Pathom province(?),
Mon style, ca. 9th century
Stucco, h. 10 ½ in. (26.7 cm)
Gift of Samuel Eilenberg, 1987
1987.142.288*

In addition to Ku Bua, many Mon sites have yielded stucco sculptures. These include Kok Mai Den in Nakhon Sawan province in central Thailand and, farther south, in Nakhon Pathom province, the well-known and rich site of Phra Pathom. It is not easy to assign a provenance to an isolated Mon stucco

sculpture on the basis of style alone, but this male head, with its long ovoid face, shows some similarities to a few of the heads from Wat Phra Pathom (or Chula Pathom) now in the Nakhon Pathom National Museum.

The elaborate crown suggests that this head may be that of a bodhisattva, but it could also represent any number of celestial or royal beings. As in the earlier Mon stucco head, the chin is narrow, the cheekbones are high, and the eyebrow ridge is joined over the nose.

ML

PUBLISHED
Reinhardt, pp. 16–17.

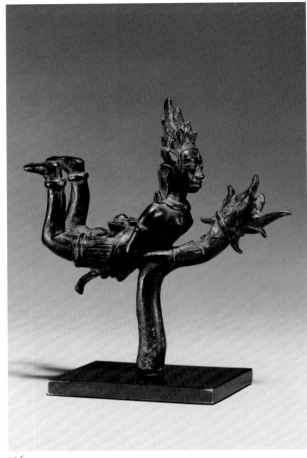

126

126 Finial in the Form of an *Apsaras*

Thailand, Haripunjaya, Mon style,
ca. 12th century
Bronze, h. 4 ¹⁵/₁₆ in. (12.5 cm)
Purchase, Mr. and Mrs. Uzi Zucker Gift and
Rogers Fund, 1987
1987.218.23

Sometime during the eighth century, part of the Mon community began to migrate north and settle around the area of Lamphun (ancient Haripunjaya). Starting about the middle of the tenth century, most of what had been the traditional Mon homeland in Thailand became part of the increasingly powerful and expanding Khmer empire of Cambodia. In Lamphun, however, a Mon kingdom flourished from the eleventh until about the end of the thirteenth century. Some of the later Mon art exhibits a strong overlay of Khmer stylistic influence —this fine and unusual bronze sculpture being a case in point.

The figure probably represents an *apsaras*, a type of minor female celestial deity who occupies the heavens and whose prime purpose is to delight the gods. She wears the short *sampot* usually reserved for males but occasionally found on minor female deities such as the one discussed in entry No. 129. The *sampot* is arranged according to one of the styles of the first half of the twelfth century associated with the Angkor Wat period—a broad decorative flap hangs in front and the part of the garment drawn between the legs terminates in a large quatrefoil element in back. This

flying deity, who holds the stem of a large lotus, was obviously part of a bigger composition. Whether that composition was incorporated in an elaborate halo, a chariot fitting of some sort, or another type of object, I cannot tell.

The virtually identical mate to this sculpture was acquired by the Pan-Asian Collection and was considered to be Cambodian in origin.[1] The physiognomies of both, however, seem to me to be closer to Mon types.

ML

1 Spink 1970, no. 65.

127 Vishnu Resting on the Serpent Shesha (Vishnu *Anantashayin*)

Cambodia, Angkor period, Koh Ker style,
ca. 2nd quarter of 10th century
Stone, 4⅞ x 8%₁₆ in. (12.4 x 21.8 cm)
Promised Gift of Samuel Eilenberg

At the end of each world age, each great time cycle, after the universe has been destroyed, it returns to exist as a cosmic ocean, without form or bounds. Vishnu sleeps on this ocean on the floating serpent, Shesha, also called Ananta (endless), waiting for the appropriate moment for the re-creation of the universe. When Vishnu wakes from his trancelike slumber, there emerges from his navel a lotus upon which sits the four-headed god Brahma, the deity responsible for creating the new universe. Also present at this time is Lakshmi, Vishnu's consort, who gently massages his legs as if to assist in reawakening her lord.

In this superb depiction, Vishnu gracefully reclines on the coiled Shesha, his head framed by the great serpent's five cobralike hoods and his legs resting on Lakshmi's lap. Covering the background, in low relief, are lotuses and incised lines that suggest the cosmic ocean. The psychological impassivity of this scene, at great odds with the dramatic significance of the moment, is most extraordinary. The soft curves of Vishnu's body and arms and Lakshmi's tender ministrations lend to the whole a gentle intimacy, which

Brahma's presence cannot disturb. This emotional effect may be attributable in part to the surprisingly small scale of the object and the scene's sense of isolation, which is conveyed through spatial compression and the reduced number of participants and spectators.

In Cambodian and Thai art, the theme of Vishnu reclining on the serpent Shesha is most often encountered on large architectural lintels.[1] This format allows for an expansion of the composition, permitting more figures to be present and a greater emphasis on decorative elements such as vegetation or the scale patterns covering a very large Shesha. Here, the scene has been reduced to essentials, with the reclining Vishnu occupying almost the complete length of the stone. Having never seen a stone of similar size, I do not know if this is an isolated object for personal devotion or part of a larger program of Hindu subjects composed of a series of like-sized stones.

To judge from the blocklike proportions of Vishnu's face and the costume he wears, this sculpture belongs to the Koh Ker period (921–ca.945) or, at the latest, the Pre-Rup period (947–ca.965). The even wear on Lakshmi's face and left arm, Brahma's face, Vishnu's crown, and some of Shesha's heads, coupled with the polished surface of the back of the stone, strongly suggest that at some time it was used as a whetstone.

ML

1 Marchal, photo 105; and the Thai lintel recently returned to Phnom Rung.

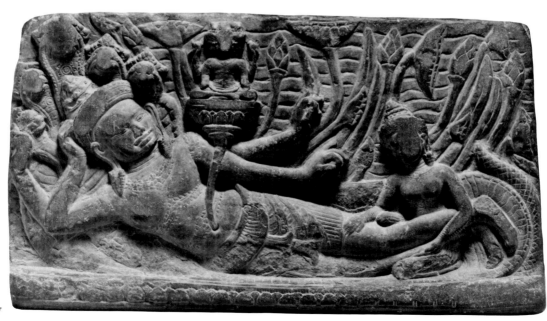

127

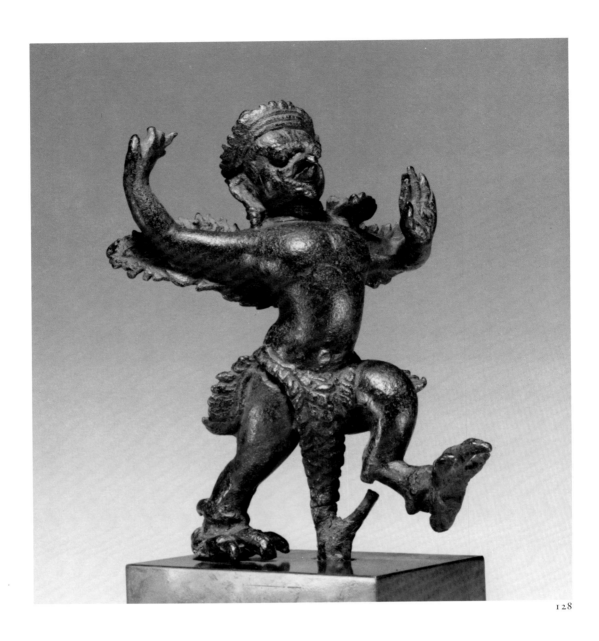

128 Striding Garuda

Cambodia, Angkor period, Pre-Rup style,
ca. 3rd quarter of 10th century
Bronze, h. 5 ¼ in. (13.4 cm)
Purchase, Mr. and Mrs. Nathan Halpern, 1987
1987.218.21

The great solar anthropomorphic bird-deity, Garuda, depicted here in a vigorous stride, is the traditional vehicle for the Hindu god Vishnu. In Khmer art of the Angkor Wat and Angkor Thom periods, during the twelfth and thirteenth centuries, to judge from the many surviving examples, Vishnu standing on Garuda was a particularly popular icon. All that remains here

of Garuda's master is his left foot. The absence of Vishnu's right foot suggests that it was raised and that he too was in a striding stance.

It is usually rather difficult to date isolated Garudas on the basis of style alone, particularly when they wear a garment of feathers, as our example does, depriving us of the evidence that would have been provided by the *sampot*, which is generally arranged in the style of a particular period. Nevertheless, on the basis of the handling of his avian features, bodily proportions, and the design of his crown, I would assign this Garuda to about the middle or the third quarter of the tenth century, and the reign of Rajen-dravarman II (r. 944–68).

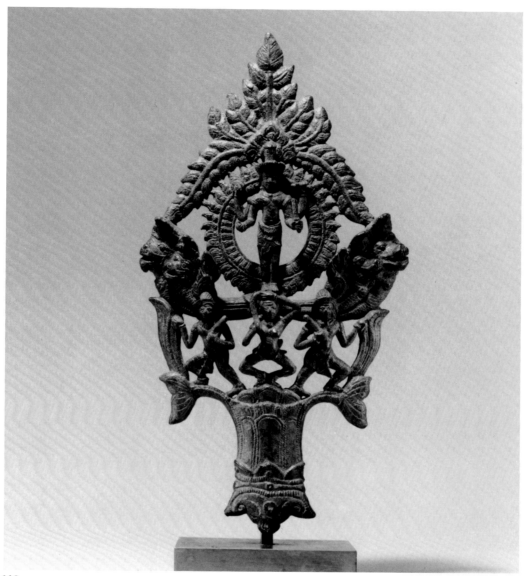

129

There are many Khmer and Thai bronze representations of Garudas supporting Vishnus, but very few are so sculpturesque, lively, and energetic as this powerful example.

ML

Ex coll. Chao Phya Dharmadhikaranadhipati, Thailand.

PUBLISHED
Coedès 1923, pl. XLIII 1.
Spink 1970, no. 50.

129 Finial with Nan Brah Dharani and Standing Vishnu

*Cambodia or Thailand(?), Angkor period,
Bayon style, ca. 1st half of 13th century
Bronze, h. 10⁹/₁₆ in. (26.8 cm)
Promised Gift of Samuel Eilenberg*

This elaborate and visually complex finial is not only an exceedingly rare object—the only similar example known is in The Cleveland Museum of Art[1]—but also a fascinating religious and historical document. Standing beneath the four-armed Vishnu are a female figure and two flanking demonic male figures, each of whom holds a short sword or club. The female is Nan

Brah Dharani (Prah Thorani), the Earth Goddess, who is wringing water from her long hair. Her act is part of the story of Mara's campaign to prevent Siddhartha from becoming the Buddha. To help localize the scene, the upper part of the finial is in the form of the *bodhi* tree under which Siddhartha attained enlightenment. Siddhartha, during his historical lifetime and in previous lives, had performed innumerable meritorious deeds and after each, according to Indian custom, had poured water on the earth in order to document them. When Siddhartha calls on the Earth Goddess to testify to his accumulated acts of merit and therefore his right to become the Buddha, she responds by wringing from her hair an amount of water equivalent to that poured by him in all his lives. The resulting enormous flood washes away Mara and his demonic hosts, represented here by the two warriors moving away from the Earth Goddess and flanked by wavelike elements emerging from the lotuses on which they stride.[2]

The Cleveland and Eilenberg finials have virtually identical compositions and stylistically they are closely related, although the Cleveland example is probably slightly earlier. There is, however, one major difference. While the Cleveland finial has, as it should, a seated Buddha making the appropriate earth-touching gesture (*bhumisparshamudra*) with his lowered right hand, the Eilenberg finial has, most incongruously, a four-armed Vishnu. Since the standing Vishnu holds a *chakra* (war discus) in his raised right hand, a club in his lower left hand, and what is probably a conch in his raised left hand, he cannot be confused with the Buddhist four-armed Lokeshvara. How could the theme of the Earth Goddess wringing her hair have anything to do with a member of the Brahmanical Triad?

I do not know of any canonical justification for combining the specifically Buddhist Nan Brah Dharani with Vishnu or any example of the legend being taken over in service of Hinduism. Only one possibility suggests itself to me, reinforced by the slight variation in figural treatment of the Vishnu: Shortly after this sculpture was created, perhaps during the reign of the Shaivite ruler Jayavarman VIII (r. 1243–95), a period of strong anti-Buddhist sentiment, this icon's original seated Buddha was removed and skillfully replaced with a Vishnu. Although no physical evidence strongly supports this theory, it remains the only reasonable explanation I can find for this Buddhist-Hindu conundrum.

ML

1 Lee, pl. 56.
2 For the story, see Bowie, pp. 130–33; Woodward, p. 76.

Indonesia

The Arts of Indonesia

The Indonesian archipelago is made up of more than thirteen thousand islands, some of which have yielded Hindu and Buddhist sculpture, significant inscriptions on stone and metal, and ancient ruins. By far the most important is the large island of Java, whose central portion in particular is the site of world-famous architectural monuments as well as the source of countless stone and bronze sculptures. Over the years, scholars have been able to propose a broad stylistic sequence set into an incomplete historical framework for Javanese art. However, the problems presented by the arts recovered from certain of the other islands—material that is in some cases earlier than most of what is known from Java—have seemed incapable of solution. The difficulties arise because we know relatively little about the political and historical interrelationships among these islands or about the history of their direct contact with India, China, and other Southeast Asian nations.

Indonesia's location along major trade routes between India and China ensured the introduction to her shores of India's major religions, Hinduism and Buddhism, as well as the steady influx of Indian sculptural styles and artistic traditions. Since these styles emanated from disparate Indian centers at different periods and given the fact that Indonesians sailed to numerous ports in India at various times, the ways they were absorbed into the Indonesian artistic consciousness were decidedly erratic. Thus, an attempt to establish secure chronological and stylistic sequences for Indonesian art is a most formidable task. More about this will follow.

Contacts between India and some of the Indonesian islands are documentable from about the fourth century but must have started considerably earlier. The oldest material remains reflecting Indian contact survive not from Java but from eastern Kalimantan (formerly Borneo), where, at Kutai, seven stone pillars with Sanskrit inscriptions ordered by an Indonesian king, Mulavarman, were found.[1] These are believed to date to about the second half of the fourth century. The style of the script is related to that of the southern Indian Pallava kingdom. Other inscriptions, perhaps a half century later than those at Kutai, which mention a local ruler called Purnavarman and the kingdom of Tarumanagara, were found in western Java.[2] These also include specific references to Brahmanical deities, which may help to affirm comments made by the Chinese Buddhist pilgrim Fa Hsien (Fa Xian), who discovered, when he visited Java in 414, that there were followers of Brahmanism but hardly any Buddhists among the population. In this regard, it is also pertinent that one of the earliest surviving stone sculptures from Indonesia is a Brahmanical deity, a standing four-armed Vishnu, which was found in western Java.[3] This figure, datable on stylistic grounds to about the sixth or early seventh century, is related to earlier, iconographically dissimilar four-armed Vishnus from Peninsular Thailand,[4] which is yet another source of probable prototypes for Indonesian art.

Returning to the subject of eastern Kalimantan and Kutai, we see that material evidence points to the continuation in this area after the fourth century of some kind of important art-producing political unit with a distinctive indigenous style. In a cave at Gunung Kumbeng, northeast of Kutai, a group of both Hindu and Buddhist figures was found[5] (see No. 161), some of which seem to be in an unorthodox local style, and nearby, at Kota Bangun, an important large bronze Buddha of superior quality was discovered.[6] For one of the sculptures from the Kumbeng cave I have suggested a connection with the Shrivijayan empire.[7]

The questions surrounding the great maritime empire of Shrivijaya, which emerged sometime during the seventh century, remain among the most

provocative and crucial associated with the art history of Southeast Asia.[8] Ever since George Coedès's seminal study of 1918 demonstrated the existence of this once-powerful kingdom,[9] scholars have been at odds regarding its geographical parameters and, in particular, the location of its capital. Some placed Shrivijaya in the vicinity of Palembang in the southeastern part of the large island of Sumatra; others have looked to the west coast of Kalimantan,[10] the Malay Peninsula,[11] or Peninsular Thailand.[12] Despite persuasively argued alternate proposals subsequently advanced, scholarly opinion, agreeing with Coedès, now favors Palembang as the most likely location for the original Shrivijayan capital. Later, the capital, of either Shrivijaya or a problematic new kingdom, Malayu, may have been moved farther north to Jambi. Some scholars place Malayu in Malaysia.

Wherever Shrivijaya originated, it is clear that as the kingdom became more powerful, it expanded its territories. Since the empire's prosperity was based on maritime trade, control of seacoasts and shipping lanes, especially the Straits of Malacca, was essential. During the seventh and eighth centuries, when Shrivijaya's importance was at its apex, the kingdom most likely controlled to some degree much of Sumatra, western Java, parts of some of the other Indonesian islands, a portion of the Malay Peninsula that included Kedah, and sections of Peninsular Thailand that included areas in Surat Thani and Nakhon Si Thammarat provinces. Of particular importance here is the probability that the empire extended its influence to the central part of Java at some point during the eighth century. Shrivijayan contacts with China toward the end of the seventh century and during the first half of the eighth century are well documented in the Chinese Annals, which record missions sent to the Chinese court.[13] Shrivijaya remained a major power until about the middle of the eleventh century, and references to it continue into the thirteenth century.

In addition to its commercial and political importance, Shrivijaya was famous as the seat of a now vanished, great Mahayana Buddhist university that favored Esoteric doctrine. This university's reputation was such that it attracted scholars and monks from India, China, and other Asian nations. The Chinese Buddhist pilgrim I Ching (Yi Jing) studied there on three separate occasions during the last three

decades of the seventh century, starting in 671.[14] Other Chinese visitors are also recorded as having been students there.[15] The southern Indian monk Vajrabodhi stopped in Shrivijaya on his way to China from Sri Lanka in 717.[16] Atisha, the renowned Bengali Tantric theologian who had been rector at the university of Vikramashila in Bihar and played a crucial role in the reformation of Tibetan Buddhism in the eleventh century, also studied at Shrivijaya's university. Just as foreign scholars came to Shrivijaya, so Shrivijaya sent monks to study in India, the most notable proof of which is the mid-ninth-century copperplate charter of the Pala ruler Devapala. This document states that, at the request of the Shailendra ruler of Sumatra, Balaputra, the income from five villages is to be set aside for the maintenance of Shrivijayan monks studying at the great monastic university of Nalanda in Bihar.[17] Another charter, dated to 1005, records the establishment of a monastery by the Shailendra king of Shrivijaya at the Buddhist center of Nagapattinam (Negapatam) in Tamilnadu for the benefit of Shrivijayan students.[18]

By the reckoning of some scholars,[19] Shrivijaya from its beginnings was ruled by the Shailendra dynasty, which made its appearance in Sumatra during the seventh century. Many experts, however, have not accepted the association of the Shailendras with the early history of Shrivijaya. Although a number of authorities think the Shailendras were of Indonesian origin, others are confident that they were originally emigrants from the lower Krishna River Valley of Andhra Pradesh in southeastern India[20] who eventually would extend their authority into central Java in the eighth century.

Before one ventures into the murky depths of the history of the relationship between Shrivijaya and Central Java and some of its attendant dynastic problems, the complexities surrounding Shrivijayan sculptural styles must be examined. Since scholars are uncertain about the location of the center of the empire and the extent and nature of its control over the neighboring sociopolitical units, whatever these may have been, it is difficult to propose any system of stylistic parameters for Shrivijayan art from the seventh through the ninth century unless the most probable historical framework is adopted. If one accepts Palembang in southeastern Sumatra as the empire's nerve center and parts of Peninsular Thailand and Malaysia as well as other areas in Indonesia as

extensions of the kingdom, the situation remains complicated but becomes somewhat more manageable. The material that has so far been discovered on the island of Sumatra[21] and the very erratic and extensive distribution of find-spots of what has been called Shrivijayan-style sculpture[22] make it clear that there cannot be a single Shrivijayan style. Instead, one must accept the notion that there are coexisting styles reflecting various prototypes from other cultures —with India clearly predominating—that have been modified to suit the local aesthetic. Stylistic impulses that emanated from southeastern India and Sri Lanka between the fourth and the seventh centuries must have been the earliest of the major components in the Shrivijayan artistic equation.[23] These were followed during the period from the eighth to the tenth century by influences from the northeastern Pala empire. But reflections of the Gupta idiom, the early styles of Orissa, as well as other Indian styles, are also present. And, as one would expect, some of the important early artistic centers of the Southeast Asian mainland make their presences felt. Despite all these donative stylistic ingredients, some of which are also apparent in Central Javanese art, the Shrivijayan styles are often distinctive. In some instances they appear as the dominant stylistic determinants in the already Indianized art of neighboring cultures. A sculpture made in Peninsular Thailand during the first half of the eighth century, for example, might exhibit such hybrid characteristics. It would seem, then, that pending a clearer understanding of stylistic evolutions, such a sculpture might best be categorized using descriptive compounds such as "Shrivijayan style in Peninsular Thailand" in order to make some art-historical sense out of the situation.

The relationship between Shrivijaya and Central Java during the seventh and eighth centuries has defied any precise historical reconstruction. This is partly due to a paucity of dated inscriptions that would provide the kind of information upon which a history could be based, and also to the lack of scholarly unanimity in interpreting the evidence provided by the few pertinent inscriptions that do survive. One crucial stone that is dated 775 and has Sanskrit inscriptions on both its sides was found at Ligor in Nakhon Si Thammarat province, Peninsular Thailand.[24] On one side the king of Shrivijaya is mentioned but his name is not given; the other side refers to a Shailendra king called Vishnu(?).[25] Some scholars believe that the inscriptions refer to different people and are not contemporaneous with each other.[26] Others maintain that they are roughly from the same time but do not refer to the same king,[27] and still others insist that they are not only contemporaneous but are also by the same hand, and that the unnamed Shrivijayan king and the named Shailendra ruler must be the same person.[28]

The earliest dated Central Javanese inscription to have survived—the Canggal inscription of 732— records the name of a King Sanjaya who set up a linga (the phallic emblem of Shiva). This inscription does not give a dynastic name for Sanjaya's lineage. An inscription, dated to 778, that was found between Prambanam and Kalasan mentions the name of the Shailendra king Panangakarana. In the Kedu inscription of 907, Sanjaya is cited as the first king of a line of Shaivite rulers, and his name is immediately followed by that of Panangakarana. Some authorities think Panangakarana was Sanjaya's successor, but others take him to be the first Buddhist ruler of a different dynasty and the same person mentioned on one or both sides of the Ligor inscription of 775.[29] If the latter is true, Panangakarana would be the Shrivijayan king who was the founder of the Shailendra dynasty of Java. Other inscriptions that include names of rulers have survived, but not enough is known to develop a coherent historical record from them. Making these matters more difficult to interpret are the facts that some of the place-names that have come down to us from the records of Chinese travelers who stopped at Shrivijaya and Java have not yet been identified, and the extent of some of the territories mentioned by them also remains unknown.

What seems to emerge from the relatively meager historical evidence is that there may have been at least two major ruling dynasties in Central Java during the eighth century. The first, founded by the Hindu king Sanjaya, was a line that retained Shaivite affiliations and may well have been responsible for the erection of many Hindu temples in Central Java, including the large complex of Lara Jonggrang at Prambanam, whose main temple was dedicated to Shiva. The second, and probably most important, was that of the Shailendras of Shrivijaya, Mahayana Buddhists who adhered to Vajrayana (Esoteric) concepts. It would then seem that at some time during the second half of the eighth century, Panangakarana extended his empire to include parts of Central

Java and established a new Shailendra dynasty there, perhaps about 770.[30] This would not be at odds with the broad picture of artistic activity in Central Java.

The dynasties of the Hindu ruler Sanjaya and the Buddhist Shailendra ruler Panangakarana, if they were indeed separate, must have coexisted peacefully, although the Shailendras probably were dominant. The two dynasties may have been joined through marriage sometime after the first quarter of the ninth century. The daughter of the Shailendra king Sumaratungga married the Shaivite king known as Rakai (titular?) Pikatan.[31] Balaputra, the son of the Shailendra king, fought with his brother-in-law and was defeated and forced to flee to Sumatra. The mid-ninth-century Nalanda charter of Devapala discussed above calls Balaputra the king of Sumatra (Suvarnadvipa). Sometime after the middle of the ninth century, the Shailendras seem to disappear from the Javanese historical record, having ruled in Java from about 770 to about 855. Their continued rule in Shrivijaya, however, is attested to by the Nagapattinam charter of 1005.

Central Java, from approximately the beginning of the second quarter of the eighth century to the beginning of the second quarter of the tenth century, was the site of one of the most ambitious programs of temple construction known. During this period of about two hundred years, in addition to the world-famous monuments Borobudur, built by the Shailendras, and Lara Jonggrang, probably constructed by Sanjaya's line, hundreds of Buddhist and Hindu *chandis* (stone shrines) were erected. Notable among them are Chandi Kalasan, Chandi Sari, Chandi Plaosan, Chandi Sewu, and Chandi Mendut, all of them Buddhist. Also of considerable importance are the eight earlier Hindu *chandis* of the Dieng plateau. Concomitant with this building activity, innumerable sculptures were created, both for the *chandis* and for personal devotion. Among the latter are thousands of small bronze images—some of which are our main concern here, since the most important part of the Eilenberg collection is its superb representation of Javanese bronze sculptures.

In an attempt to advance beyond the imprecise and very broad categories "Hindu-Buddhist period" and "Indo-Javanese period" into which Javanese art of the seventh to the early sixteenth century was once divided, scholars have devised the more focused terms "Central Javanese period" and "Eastern Javanese period," which are based on centers of artistic and political activity. The Central Javanese period began about the late seventh century and ended about 930, when for reasons as yet not certain, but perhaps because of a disastrous volcanic eruption, the court and most of the population moved from the central to the eastern part of the island.[32] The Central Javanese period still confronts us with a long time-span—more than two hundred years—and the task of establishing a sequence for bronze sculpture of this time remains most formidable. To my knowledge, no bronzes of the Central Javanese period have inscriptional dates, and none have been recovered from relic chambers of monuments with fairly secure dates. Scholars, therefore, have had to rely almost exclusively on stylistic evaluations and have often proposed widely divergent interpretations of the evidence.

The problems are compounded by the fact that many easily portable images excavated in Indonesia were actually made elsewhere. Some of these have been established as Indonesian for so long in the standard literature that they have become accepted as local stylistic variants or, even more confusing, as classic models of specific types. Examples of the kinds of problems encountered are presented by the Pala-period Bangladeshi Vajrapani (No. 94) found in Java and published as Central Javanese period and by a southern Indian bronze votive stupa, also discovered in Java, that came from Nagapattinam in Tamilnadu. The stupa had lost its upper part, and a replacement of a shape radically dissimilar to the original had been made for it in Java. This object, which is in the Museum Nasional, Jakarta, has been erroneously accepted into the literature as Javanese[33] and has not been properly identified until now. The museums of Indonesia, particularly the Museum Nasional, have in their collections Indian bronzes of the Pala, Pallava, and early Chola periods, and Sri Lankan and Thai sculpture, all of which are labeled as Indonesian in origin. That this sculpture was found on the various Indonesian islands is not at all surprising, given Indonesia's location along major trade routes and her history of contact with India and other Asian nations.

No clear picture emerges of the first three decades of the tenth century, the period during which the *kraton* (royal court) shifted from central Java to eastern Java, because so little is known of the political activities of that time. Lunsingh Scheurleer describes it as a period of transition "during which a number

of kings seem to have exercised authority simultaneously over Central and East Java."[34]

The Eastern Javanese period is usually divided into three successive dynasties, although there is some divergence of opinion as to when the first began. King Sindok, who ruled from 929 to 947, is usually credited with moving the *kraton* from central to eastern Java about 930.[35] Speculation persists not only about the reasons for this move but also regarding the location of Sindok's capital in eastern Java. During the period from about 930 to about 1050, the center of eastern Javanese political activity may have been located south of Surabaya.[36] One of the descendants of King Sindok, Erlangga, divided his kingdom between his two sons in approximately 1045. One son received the eastern part of the kingdom, Janggala, which is in the area of Surabaya, and the other was given Kadiri, in the region of modern Kediri along the river Brantas. Kadiri became the much more important of the two. The kingdom of Kadiri existed until 1222, when a usurper named Ken Angrok founded a new dynasty and established a short-lived kingdom at Singasari, near modern Malang, which survived only until 1293. The last kingdom of the Eastern Javanese period, Majapahit, had its center at modern Trowulan. This powerful kingdom, where Buddhism and Shaivism both flourished, was destroyed in about 1527, when it was conquered by Muslim troops. By the time Majapahit came to power, the Shrivijayan empire had long been in decline. Majapahit was a worthy successor: With ships sailing out of eastern Javanese seaports, she became the major maritime force in Indonesia and developed extensive commercial relations with China.

On the basis of evidence provided by the bronze sculpture in the Eilenberg collection and elsewhere, it is clear that the shift from central to eastern Java did not precipitate a break in the continuity of stylistic evolution. Nevertheless, other kinds of changes are apparent. During the eleventh century, Esoteric Buddhist images strongly predominated over Hindu ones —in fact, there seem to be few surviving Hindu bronzes from the Eastern Javanese period, even though numerous Hindu images exist in other media. The reasons for this are unknown to me. By the twelfth century, considerably fewer bronze figural icons of any sort were made; instead, one finds bronze hanging lamps, bells, ritual implements, and various kinds of utensils.

Although all of the three kingdoms of the Eastern Javanese period have art styles associated with them, it is sometimes difficult to attach these styles to the small bronze sculptures and objects they produced. In this catalogue, even when an object's find-spot has been reported, as in the case of the halberd head from around Singasari (No. 178), I have followed precedent and simply assigned it to the Eastern Javanese period. The reader should have no difficulty matching the dates I have suggested for these bronzes with the corresponding kingdoms.

For the student of Indonesian bronze sculpture attempting to develop a coherent framework for this material, three important recent exhibition catalogues, each of which approaches the subject from a somewhat different direction, provide a good deal of assistance. The first, the work of the late Johanna van Lohuizen-de Leeuw, classifies the extensive collection of the bronzes in the Linden Museum Stuttgart according to type and iconography, using a pattern of broad dating. She suggests that it is possible that a few of the sculptures might be of Indian origin.[37] The most recent, by Jan Fontein, includes stones, bronzes, and works in other media to present a synoptic overview of the sculpture of Indonesia. For the most part, Fontein groups the figural bronzes according to provenance, type, and suggested dating. When problems of provenance arise, they are discussed appropriately.[38] The intervening publication, the work of Pauline Lunsingh Scheurleer, to my way of thinking, is the most interesting, innovative, and promising approach brought to the subject so far. After presenting the history of earlier methodology, she divides the figural bronzes, all from Dutch collections, into seven categories. She attempts to isolate foreign models from the close Indonesian copies they inspired, to place sculpture in pure Javanese idioms in a stylistic and chronological sequence, and to examine bronzes found on Sumatra and Sulawesi.[39] Despite these three major contributions, it is still extremely difficult to assign dates within a period of a half-century. In my own attempt to propose a provisional stylistic sequence for the sculptures in the Eilenberg collection, I have taken advantage of the work of these three scholars.

As new material is discovered, the rich and complex art history of Indonesia is being modified and revised. This ongoing process reflects the potential for eventually establishing a more secure, better understood system of stylistic sequences than we now have. With

the acquisition of the Eilenberg collection, The Metropolitan Museum of Art has become one of the great repositories of the bronzes of this part of Southeast Asia and an important resource for future research. Since the artistic achievements of Indonesia, particularly of the island of Java, rank so favorably among those of any culture, either of the East or West, the task of presenting these ancient traditions to the public in a coherent fashion is, for us, a new responsibility and a provocative challenge.

ML

1 Lunsingh Scheurleer and Klokke, p. 5; Fontein, p. 25.
2 Lunsingh Scheurleer and Klokke, p. 5.
3 Bernet Kempers 1959, pl. 23.
4 Krairiksh 1980, pls. 1–3.
5 Lerner 1984, pp. 116–17.
6 Bernet Kempers 1959, pl. 97.
7 Lerner 1984, pp. 116–17.
8 For a recapitulation of some of these problems, see Diskul.
9 Coedès 1918, pp. 1–36.
10 Suleiman in Diskul, p. 1.
11 Ibid.
12 Krairiksh 1980, pp. 10–11 and Map 5.
13 Coedès 1968, pp. 83–84.
14 Wolters, pp. 417–18.
15 Ibid., p. 418.
16 Fontein, p. 29.
17 S. P. Gupta *Masterpieces* 1985, p. 150.
18 Aiyers, pp. 213–81.
19 Sarkar, p. 210.
20 Ibid., pp. 207–20.
21 Schnitger; Lunsingh Scheurleer and Klokke, nos. 54–58.
22 For some of these sculptures, see Diskul.
23 The two bronze Lokeshvaras from Mt. Seguntang, if made in Sumatra, stand early in the sequence (Schnitger, pl. VI).
24 Suleiman in Diskul, p. 4.
25 Sarkar, pp. 218–19.
26 Suleiman in Diskul, p. 4.
27 Casparis, p. 56.
28 Sarkar, pp. 218–19.
29 Ibid.
30 Casparis, p. 58.
31 Lunsingh Scheurleer and Klokke, p. 7.
32 Fontein, p. 41. It is possible that the move from central to eastern Java may have been a gradual one (see Lunsingh Scheurleer and Klokke, p. 9).
33 *Rijksmuseum*, no. 29; Thomsen, no. 36. This object is one of a few Indian bronzes found in Southeast Asia I discuss in an article now in preparation.
34 Lunsingh Scheurleer and Klokke, p. 9.
35 Fontein, p. 44.
36 Lunsingh Scheurleer and Klokke, p. 9. For this and the following information regarding the Eastern Javanese kingdoms, I have relied on Lunsingh Scheurleer and Klokke and on Fontein.
37 Lohuizen de Leeuw 1984.
38 Fontein.
39 Lunsingh Scheurleer and Klokke.

130 Standing Maitreya (or Manjushri?)

Indonesia, Shrivijaya style,
late 7th–early 9th century
Bronze, h. 9 ¼ in. (23.5 cm)
Purchase, Pfeiffer Fund, 1987
1987.218.15

The extended dating for this figure, which I had previously assigned to the eighth century,[1] reflects my uncertainty regarding its position in the stylistic sequence of Shrivijaya sculptures and my inability to establish for it a close stylistic relationship to other Southeast Asian schools of sculpture. While I prefer a dating of about the first half of the eighth century, I cannot support this with any confidence. Despite attempts of late to sort out some of the problems surrounding the Shrivijayan styles, we seem no closer to solutions now than before, and the ability to assign certain sculptures to fifty-year periods still remains elusive. This bronze was purported to have been found on the island of Sumatra, where recent archaeological activities around the area of Palembang will perhaps provide new information leading to a clearer understanding of its stylistic and chronological parameters.

This image is identifiable by the emblem of the stupa set in his high headdress as a representation of the messianic Bodhisattva Maitreya, the Buddha-to-be. The stupa is a reference to the belief that, when he descends from the Tushita heaven to become the Buddha of the next great world-age, Maitreya will go to the stupa on Mount Kukkutapada near Bodhgaya, which is associated with Kashyapa, one of his predecessors among the previous Mortal (*Manushi*) Buddhas. At that time, the mountain will miraculously open, and Kashyapa will give the garments of a Buddha to Maitreya.

If the stupa is a standard cognizance of Maitreya, the slim attribute held in this image's raised left hand, a bound manuscript (*pustaka*), is decidedly not. The *pustaka* is normally associated with Manjushri, the Bodhisattva of Infinite Wisdom, as well as with the female deity Prajnaparamita (see No. 84). At times, it is also held by other divinities, including Avalokiteshvara. So far as I know, standard Indian iconographical sources do not prescribe the *pustaka* as one of Maitreya's attributes, nor is it held by Sri Lankan Maitreyas. However, since Maitreya will reconstitute the lost truths and restore proper dogma to the world when he becomes the next Buddha, it

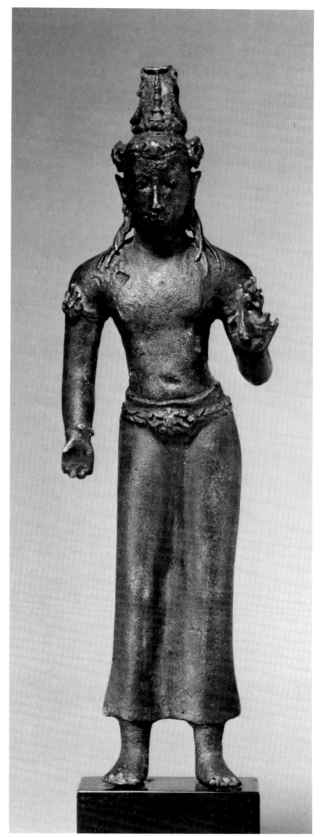

130

would not be inappropriate for him to hold the manuscript symbolizing transcendental knowledge.

There exists at least one eighth-century Shrivijayan bronze Maitreya with a stupa in his hairdo and a manuscript in his raised left hand (it is part of a triad)[2]—suggesting that this iconographic anomaly may have attained some degree of standardization in the Shrivijayan sculptural corpus. The substitution of the manuscript for the iconographically proper cluster of *nagakeshara* flowers held by Indian and Sri Lankan Maitreyas seems to have been a Southeast Asian invention, but when and where this occurred, I cannot say. Perhaps it was a contribution from the monastic university of Shrivijaya.

The high level of aesthetic accomplishment of the sculpture, as well as the provocative iconographic problems it poses, make it an important addition to the Shrivijayan corpus. The bodhisattva stands in a subtle hipshot posture, the weight of the body resting on the rigid left leg and the right slightly bent. Surprisingly elegant because of its attenuated forms— the slender chest, long, subtly modeled legs, elongated face, and the high hairdo—this image nevertheless radiates an aura of restrained power and majesty. Volumes blend into one another in graceful harmony—a characteristic of the finest early sculptures of Southeast Asia.

The deity is dressed in a long skirt (*antariya*) that covers the lower half of the body, and a braided belt with decorative center clasp above the hips. He wears armlets, thin bracelets, and simple earclips attached high on the lobes. The head decorations consist of a trilobed tiara and what appears to be a high, square head covering set on a jeweled ring through which the long locks of hair are drawn and then descend in loops at the sides and back. The absence of a necklace and sacred thread, and the discreet handling of jewelry prompt focus on the pure forms of the body. Maitreya's lowered right hand—missing its fingers—probably made the boon-bestowing gesture of *varadamudra*.

ML

1 Lerner in *Recent Acquisitions*, p. 108.
2 Lerner 1984, no. 41. Recent cleaning of this sculpture has made it clear that Maitreya holds the *pustaka* rather than part of a lost attribute, as I had claimed.

PUBLISHED
Spink 1978, no. 148.
Lerner in *Recent Acquisitions*, p. 108.

131 Surya, God of the Sun

a. Indonesia, Java, Central Javanese period, 9th century or
b. India, Pala period, 9th–early 10th century
Bronze, h. 9¾ in. (24.8 cm)
Gift of Samuel Eilenberg, 1987
1987.142.20

This entry, with two countries of origin suggested for the sculpture, is a somewhat idiosyncratic exercise, but one, I hope, that makes the point. The reader's indulgence, therefore, is requested.

When I published this image of the Vedic sun god, Surya, in 1975, it was dated about ninth century and assigned to Java,[1] where it was found. At that time I claimed, "Javanese representations in metal of . . . Surya are quite rare, and this example is the finest known to me."[2] Some chided me for dating this sculpture too late; no one questioned the provenance. I now believe I may have been wrong regarding the provenance and that the Surya in the Tropenmuseum, Amsterdam, I compared it with,[3] which I took to be Javanese, is of Indian origin.

To my knowledge, nothing similar to this Surya can be found in Java—not in any sculpture in the round, not as part of monuments, and not on the Dieng Plateau as has previously been suggested.[4] This seems to leave only one viable alternative—that it is an Indian figure from the northeastern Pala region, an attribution that the style of the sculpture supports. However, I cannot isolate a particularly close cognate here either, even though quite a few Pala-period metal images of Surya, such as the figure discussed in entry No. 91, exist.[5] Since the present figure displays some unusual features and, so far as I know, there are no Indian examples sufficiently similar to remove any doubts regarding provenance, the origin of this sculpture must remain problematic. Perhaps it is even the product of some other Southeast Asian culture, although which that might be I cannot say.

In Indian art, Surya's costume almost always follows either the northern or southern tradition. In the northern style, which is used here, the deity wears a belted tunic, sometimes trousers, and usually padded boots. This costume is a Kushan-period appropriation from ancient Persia and was worn by Kushan nobility. The tradition of southern India has Surya barefoot and without the tunic. An

udarabandha, the band worn between the waist and chest, almost always appears in the southern tradition and fairly often in the northern one. Sometimes Surya wears a sword and a long scarf.[6] In addition to these elements, as well as jewelry of all sorts and different kinds of crowns, there may be a decorated panel shown on Surya's chest. This panel varies in width from image to image and may be either a separate piece of the costume that continues around the back, as here, or a clearly decorative motif that is part of Surya's tunic. One is not always sure which is intended. This embellishment appears on central and northern Indian sculptures from coast to coast. It seems to have fallen out of favor in the Pala territories, where it appears only rarely.[7]

The briefness of Surya's tunic, which ends just below the hips, is most unusual. A high, peaked miter (*kiritamukuta*) appears in tenth- and eleventh-century Pala sculpture, but its proportions and straight sides differentiate it from our figure's miter. The lotuses that were originally at Surya's shoulders are missing, as are the deity's usual attendants (see No. 91).

Having written this entry, I still cannot bring myself to place the figure with the rest of the Pala material. Some of the features of the costume seem to me to argue strongly for the preservation of an Indonesian provenance. The unusually short tunic with sleeves that come partway down the upper arm, although it is of a different style and cut, appears on another rare Indonesian Surya—one with stylistic affiliations to the Shrivijayan rather than the eastern Indian idiom. This Surya, now in the collection of the Los Angeles County Museum of Art,[8] also wears a high, peaked miter with tapered sides similar to that of the Eilenberg Surya, as does another Indonesian bronze in the collection of the Metropolitan Museum.[9] It is interesting to find that a lower and thicker variant of this kind of miter is worn by an eighth-century Cham bronze standing Vishnu from Vietnam, found in Java, now at the Rijksmuseum, Amsterdam.[10] Our Surya's ear pendants appear to be of a specific Southeast Asian type and not of the sort worn by Indian deities. Finally, there seems to be a confusion regarding the loose anklets (*padasaras*) on our figure's feet. In the art of India, these anklets usually appear only when a deity is barefoot. The Eilenberg Surya wears padded

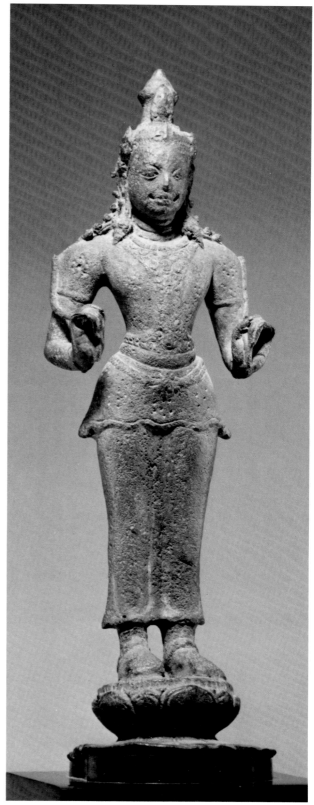

131

169

boots but, most inappropriately, has anklets over these boots. This, it would seem to me, suggests a misunderstanding on the part of the sculptor, who must have combined elements of costume from different foreign models. If one takes all of these factors into account, and pending the discovery of some Indian image displaying these unusual features, this possibly stylistically unique Surya must remain in the Indonesian repertory.

ML

1 Lerner 1975, no. 13.
2 Ibid.
3 Bernet Kempers 1933, fig. 32. The opinion that this sculpture is not Javanese is shared by Lunsingh Scheurleer (Lunsingh Scheurleer and Klokke, p. 67).
4 Sickman, no. 25.
5 For other examples, see Ray, Khandalavala, and Gorakshkar, figs. 28, 205–7, 209, 240.
6 Asher, pls. 41, 49.
7 S. L. Huntington 1984, fig. 148.
8 Brown 1985, p. 125.
9 Acq. no. 65.146. This standing four-armed Vishnu came to the Museum with a Sumatran provenance.
10 Lunsingh Scheurleer and Klokke, no. 8. Although this sculpture is listed as "Java(?), Central Javanese, 7th to 8th centuries," I think a better attribution would be Vietnam, Cham, eighth century.

PUBLISHED
Sickman, no. 25.
Lerner 1975, no. 13.

132 Head of a Male Deity

Indonesia, Java, Central Javanese period, 2nd half of 9th century
Andesite, h. 6⅞ in. (17.5 cm)
Gift of Samuel Eilenberg, 1987
1987.142.285

During the late eighth and ninth centuries, a combination of favorable political, religious, and economic conditions in Central Java fostered an extraordinary surge of architectural activity, akin perhaps to the great cathedral and monastery building that took place in thirteenth-century Europe. The facades of Javanese temples of that period, like those of medieval European buildings, were covered with sculpture in high as well as low relief. This head of a male deity, which is in a style associated with the Prambanam temples (Lara Jonggrang) and other monuments of the second half of the ninth century, is the only Central Javanese stone sculpture in the Eilenberg collection at the Metropolitan Museum; it must, therefore, serve here as the sole representative of that great Javanese tradition of sculptural adornment of temples. This it does most admirably.

The head is well modeled, with finely chiseled features and a sensitive rendering of physiognomy. Its physical presence is enhanced by the somewhat intense expression. The contours of the face are less rounded, and the cheeks not so full as those of the earlier Borobudur style. The representation of the eyebrow ridge as a modulated, continuous line is reminiscent of similar treatments on eighth-century Mon-style Buddhas from Thailand as well as on later Mon-style sculpture (see Nos. 124, 125). The tiara has a raised central lobe flanked by two smaller ones and, at the sides, two high lobes. Tiaras of this type appear also on some of our bronze figures (see Nos. 145, 146). The long, separated locks of hair are pulled back from the forehead and pass through a thick hair-ring; had they survived intact, they would have been piled high on top of the head.

ML

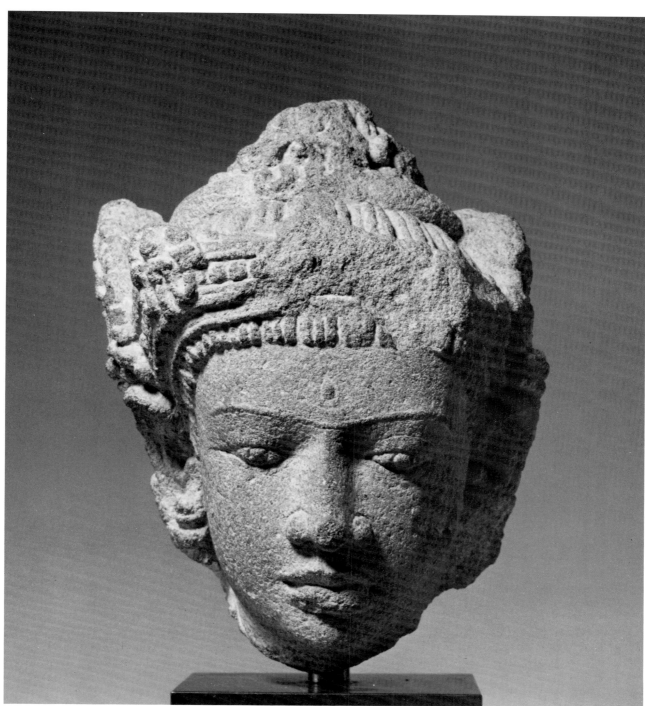

132

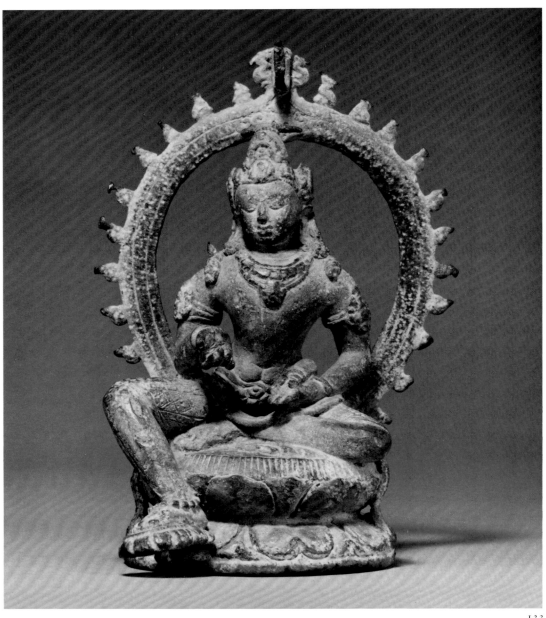

133 Seated Bodhisattva Vajrasattva

Indonesia, Java, Central Javanese period,
2nd half of 8th–early 9th century
Bronze, h. 5 ¹/₁₆ in. (12.8 cm)
Gift of Samuel Eilenberg, 1987
1987.142.169

The iconography of Vajrasattva is both complex and unclear. He can be represented, as here, in the form of a bodhisattva, but also as a Buddha seated cross-legged. In some systems of Vajrayana Buddhist theology, Vajrasattva (or sometimes Vajradhara) is considered to be the Adi Buddha, the highest form of Buddha from whom emanate the Five Transcendental or Dhyani Buddhas (Tathagatas or Jinas) (see No. 89). Vajrasattva as a Buddha is sometimes thought of as the ultimate, sixth Dhyani Buddha, who functions as the priest for the other five.[1]

The attributes assigned to Vajrasattva are the thunderbolt (*vajra*) and the bell (*ghanta*), shown at

times with a *vajra* handle (*vajraghanta*) (see Nos. 165, 167), as here. The *vajra* is also the indestructible diamond, the symbol of adamantine truth or ultimate reality and, therefore, spiritual enlightenment, whereas the bell represents wisdom.[2] They signify as well male (*vajra*) and female (*ghanta*) aspects of the universe, which together symbolize the totality of the cosmos.[3]

Vajrasattva is seated here in the *lalitasana* position of royal ease, his pendant right leg supported by a small lotus, his bent left leg resting on top of the double-lotus pedestal (*vishvapadma*). This pedestal is depicted in a somewhat unusual fashion, with the stamens curving inward and small circles representing the seeds on top of the seedpod. The bodhisattva holds the *vajraghanta* in his left hand and with his extended right makes the gesture of holding the *vajra* or balancing it on his fingertips.

His costume is reminiscent of earlier southern Indian traditions, comprising a decorated dhoti (or *antariya*) and a long sash knotted and looped twice in back, with its ends falling down the sides of the lotus pedestal. He does not wear the sacred thread (*upavita*) but has the usual complement of rich jewelry. He also wears a tiara and the cylindrical miter (*kirita-mukuta*). The most interesting feature of his head covering is its pentad of diminutive seated Buddhas, three of them set into medallions on the tiara (the one in the center is partially effaced), one in front of the miter, and another one (effaced) behind it. While others probably exist, I know of only one iconographically similar Indian sculpture in metal with the five Dhyani Buddhas in the headdress—an eighth-century Kashmiri Vajrasattva.[4] They appear, however, in the headdresses of some slightly later eastern Indian bronze Vajrasattvas seated in the cross-legged position[5] and in an eighth- to ninth-century example from Sri Lanka, which attests to the diffusion of this iconography.[6] Partially surrounding our Vajrasattva's head are the remains of a thin halo. The larger halo behind the bodhisattva, which clearly has been connected to the sculpture for a long while, was not originally intended for it. In terms of proportions and spacing of the stylized flames along its perimeter, the latter halo appears to be of early Chola type and may have been taken from a southern Indian import. Other excavated Javanese bronze sculptures with mismatched pedestals or halos are known.[7]

This Vajrasattva is notable not only for its iconographic importance but also because it is one of the earliest Javanese bronze sculptures in the Eilenberg

collection, probably dating to the second half of the eighth century.

ML

1 Saraswati, p. LV; B. Bhattacharyya, pp. 74–75.
2 B. Bhattacharyya, p. 43.
3 Lohuizen-de Leeuw 1984, p. 18.
4 Pal *Bronzes* 1975, no. 59. The five Buddhas also appear in the crown of the Eilenberg *Seated Vairochana*, No. 89.
5 D. Mitra 1978, photos 54, 58.
6 Schroeder 1990, no. 80E.
7 For example, see Le Bonheur, pp. 165, 169, 171.

134 Seated Four-Armed Ganesha

Indonesia, Java, Central Javanese period,
9th century
Bronze, h. 3 1/8 in. (7.9 cm)
Gift of Samuel Eilenberg, 1987
1987.142.300

The potbellied, elephant-headed Ganesha is the son of Parvati but is sometimes popularly accepted as the first child of both Shiva and Parvati. He is the deity

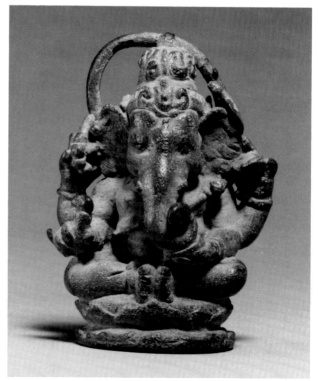

134

who controls obstacles by either creating or removing them; consequently, he is usually invoked prior to a major undertaking. Here, Ganesha sits on a double-lotus pedestal (*vishvapadma*) of such small size that it seems barely capable of supporting his bulk. He is seated in a fashion only rarely encountered in Indian art but standard for Indonesia, with both legs placed symmetrically beneath him and the soles of his feet pressed against each other.

Ganesha holds a series of his orthodox attributes: In his upper right hand is a rosary (*akshamala*), and in the lowered right his broken tusk (even though both tusks are intact); instead of an elephant goad, he has a battle-ax (*parashu*) in his upper left hand, and his curling trunk rests in the bowl of sweets (*modaka-patra*) held by his lowered left hand.

The sacred thread worn diagonally from the left shoulder is in the form of a serpent (*nagayajnopavita*), which is usual for Ganesha. Set in his high hair arrangement separated into individual strands (*jata-mukuta*) are a skull and crescent moon, reaffirming his association with Shiva. His naturalistic, large spread ears emphasize the full volumes of his well-observed head, which is encircled by a simple bent halo.

This unusually small and compact figure is one of the most charming and aesthetically satisfying of the surviving Javanese bronze Ganeshas. It seems to preserve the flavor of southern Indian Ganeshas rather than those of the Pala period.

ML

135 Seated Bodhisattva Vajrapani(?)

Indonesia, Java, Central Javanese period,
ca. mid-9th century
Bronze, h. 2 15/16 in. (7.4 cm)
Gift of Samuel Eilenberg, 1987
1987.142.10

Even though its right leg is gone, this small bronze figure radiates a forceful and energetic presence deriving from the quality of the modeling and the strong facial expression. Its size notwithstanding, the sculpture has a sense of monumentality.

The figure sits in the *lalitasana* manner—the missing leg would have been pendant and probably resting on a small lotus, like the left leg of the Avalokiteshvara of No. 108. The bodhisattva's left hand makes a variant of the expository gesture of *vitarkamudra*, with the middle finger rather than the index finger touching the thumb, and his right may be making the gesture associated with displaying an attribute. There are no indications of a lotus along the deity's left side. Arched, frowning eyebrows establish a look of subtle anger and resoluteness (the *krodha* expression), often associated with Vajrapani, the Thunderbolt Bearer.[1] The costume of the bodhi-sattva is surprisingly sparse, particularly when compared with those of later bronze sculptures.

It is most likely that this deity formed part of a triad, with a Buddha in the center and Avalokiteshvara to the Buddha's right.[2]

ML

1 Lerner 1984, no. 44; Diskul, no. 6.
2 See Bernet Kempers 1959, pls. 58–61; Lunsingh Scheurleer and Klokke, no. 12.

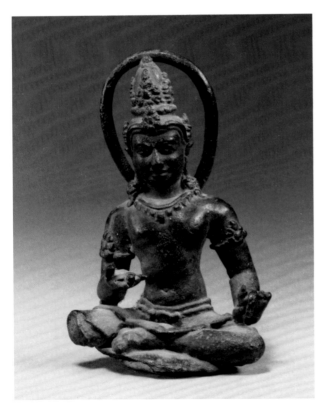

135

136 Standing Padmapani-Lokeshvara

Indonesia, Java, Central Javanese period,
ca. mid-9th century
Bronze, h. 5 1/4 in. (13.4 cm)
Gift of Samuel Eilenberg, 1987
1987.142.303

Padmapani-Lokeshvara is identifiable through the
lotus (*padma*) held in his left hand and the diminutive
seated Dhyani Buddha Amitabha, his spiritual father,
who is set into his high chignon of individual strands
of hair (*jatamukuta*). The deity stands on a double-
lotus pedestal (*vishvapadma*) in the hipshot *dvibhanga*
(twice-bent) posture, the weight of the sturdy body
on the rigid left leg and the right leg bent slightly at
the knee. The lowered right hand makes the boon-
bestowing gesture (*varadamudra*). He wears a long
lower garment (*antariya* or dhoti) secured at the
waist by a belt with a decorative clasp and a sash
wrapped around the hips disposed so that it crosses
the front of the body twice, at two levels, and is then
looped at each hip with the ends hanging down the
sides to just above the knees. This arrangement of the
sash is reminiscent of southern Indian Pallava-period
prototypes of the eighth century. The sacred thread
(*upavita*) takes the form of another sash, worn
diagonally across the chest and looped at the left
shoulder with a large section falling behind the figure.

In the treatment of the physiognomy and the fluidity
of the volumes, this bronze exhibits few of the stylistic
mannerisms of the later Central Javanese and Eastern
Javanese periods. The restrained and subtle jewelry
and garments, such as the simple broad bands of
cloth crossing the hips, are early features and are
aesthetically akin to parallel elements at Chandi
Kalasan, one of the earliest of the Central Javanese
monuments. This sculpture is surely one of the
understated gems of the collection.

ML

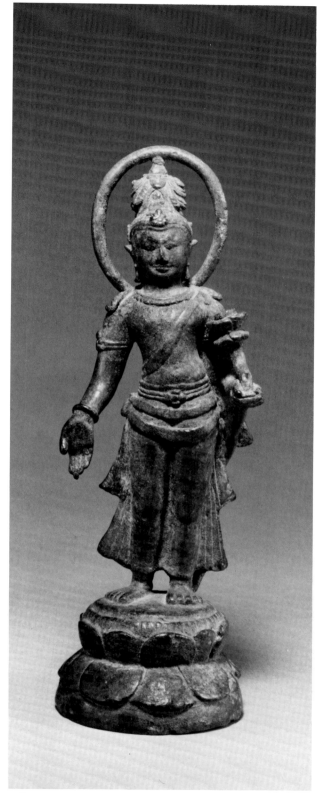

136

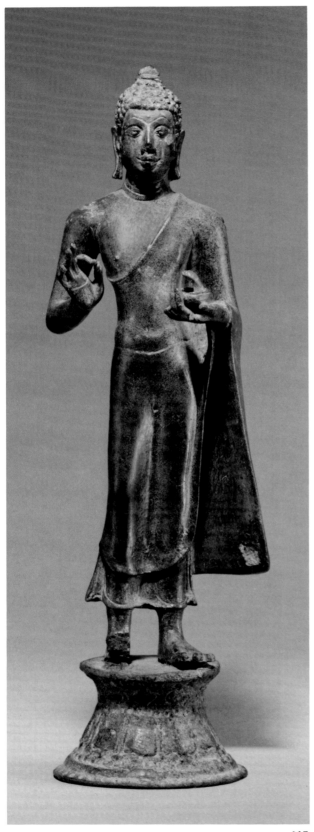

137 Standing Buddha Shakyamuni

Indonesia, Java, Central Javanese period,
9th century
Bronze, h. 7¹¹/₁₆ in. (19.5 cm)
Gift of Samuel Eilenberg, 1987
1987.142.19

Among the highlights of the Eilenberg collection of Javanese bronzes must be included this standing Buddha Shakyamuni holding an alms bowl with a cobra. Serpents figure prominently in the life of the Buddha, and while it may be difficult to isolate the specific episode referred to here, two prime candidates exist: The first, and most probable, occurred at Uruvilva, and the second at Rajagriha.

At Uruvilva, the Buddha disregarded the Hindu ascetic Kashyapa's advice against spending the night in a fire temple housing a venomous serpent king, and through his effulgent glory overcame the creature, which meekly crawled into Shakyamuni's alms bowl. The Buddha later offered the subdued and repentant serpent to Kashyapa, who was so awed he became one of the Buddha's followers. The second episode took place when Shakyamuni left Uruvilva and went to Rajagriha. There, the local king, Bimbisara, asked him to go to a garden to tame a ferocious serpent that was guarding a treasure the serpent had buried in a previous life. Accomplishing this, the Buddha placed the contrite serpent in his alms bowl.[1] Since both of these events are parts of didactic conversion stories, it is not inappropriate for our Buddha to make the teaching or expository gesture of *vitarkamudra* with the long, delicate fingers of his raised right hand.

The arrangement of the garments worn by this Buddha is similar to that found on some Mon examples from Thailand and is ultimately traceable to southern India, as the shape of the unusual pedestal may also be. It is, however, difficult for me to isolate the precedents for the figural style of our Buddha or to insert the sculpture into this catalogue's stylistic sequence for Javanese bronzes, since I cannot cite a close cognate, nor am I aware of the appearance at any of the major or minor monuments of Central Java of figures with similar proportions or physiognomies. The sculpture is iconographically related to a Buddha found at Kota Bangun in Kalimantan (Borneo),[2] but what their chronological and stylistic relationships are, I cannot tell. Unpublished arguments for dating the Eilenberg collection Buddha earlier than the ninth century have not been convincing, and

the stylistic evidence from the problematic Shrivijayan empire provides little assistance. Perhaps our Buddha's unusual sleek elegance and attenuated feet (one is missing) derive from some late eighth- or early ninth-century Mon-style Buddhas from central Thailand. The *urna* is present on the forehead, and the remains of what appears to be a tripartite flame-finial can be seen on the cranial protuberance (*ushnisha*).

ML

1 For the representation of these two episodes in Gandharan art, see Ingholt, pls. 81, 85–89, 92, 163.
2 Bernet Kempers 1959, pl. 97.

PUBLISHED
Lerner 1975, no. 16.
Brown in Pal 1984, no. 58.

138 The Transcendental Buddha Vairochana(?) Seated in Western Fashion

Indonesia, Java, Central Javanese period,
ca. mid-9th century
Bronze, h. 5 1/8 in. (13.1 cm)
Gift of Samuel Eilenberg, 1987
1987.142.14

This beautifully modeled image, one of the finest Javanese bronzes in the Eilenberg collection, perhaps represents the Supreme Transcendental Buddha of the Center, Vairochana, depicted here with an unusually youthful and sensitive face. The Buddha sits in the Western fashion, with both legs pendant (*pralamba-padasana* or *bhadrasana*) and his feet resting on a small double lotus. He is seated on a cushion on top of a tiered pedestal with two rearing horned lions (*yalis* or *vyalas*), forelegs outstretched, springing out from the front corners. Although rampant *vyalas* are not uncommon—appearing, for example, on the throne backs of the large images in Chandi Mendut[1] and as architectural decoration on Chandi Ngawen II,[2] as well as in other contexts—I do not know of another instance where they bound so vigorously.

The Buddha's hands form a variant of *dharma-chakrapravartanamudra*, the gesture of setting the wheel of law into motion, associated earlier in India with Shakyamuni Buddha's first sermon and conse-quently considered to be a preaching mudra,[3] but in Vajrayana Buddhism often given to Vairochana. Most

Central Javanese-period bronze Vairochanas, however, are shown with the right hand grasping the extended index finger of the left hand,[4] the mudra of *bodhyagri* (the wisdom fist), making identification of this Buddha uncertain. *Pralambapadasana* Buddhas on lion thrones (*simhasanas*) making the *dharmachakra-mudra* appear often in India—at Ajanta[5] and slightly later at sites under the influence of Esoteric Buddhist doctrine, Ellora[6] and Aurangabad,[7] for example. The identity of these Buddhas, however, is also decidedly problematic. The best-known *Pralambapadasana* Buddha making the *dharmachakra-mudra* in Central Javanese art is the very large stone Buddha of Chandi Mendut.[8] Basing their arguments on the iconographic program of this temple, some scholars have suggested that the Chandi Mendut Buddha must be Vairochana. On the very rare occasions when Central Javanese stone Buddhas exist in a group, the figure making the *dharmachakra-mudra* is identified as Vairochana.[9] The complication in all this arises because the wheel of the law—sometimes flanked by deer, consistently a reference to Buddha Shakyamuni's first sermon at the Deer Park of Sarnath—appears on the pedestals of some of the *dharmachakra-mudra* Buddhas,[10] including that of Chandi Mendut.

In addition to the Chandi Mendut Buddha, there are a few bronze Buddhas seated in Western fashion with the same mudra as that of the Eilenberg sculpture.[11] All of these have the knees spread wide—considerably farther apart than those of the Eilenberg Buddha. The garments on the lower half of the body of our figure, which are rendered with great precision and clarity, are also arranged in a manner somewhat different from that of the other examples known to me. But whether these bring our Buddha closer to some foreign model or reflect the personal aesthetic of the sculptor, I cannot say.

There is a complexity of artistic intent here that is beautifully realized. The radiating pointed fingers, the abstract decorative pattern of crossing hems and drapery folds, and the dynamic thrust of the rampant *vyalas* are in strong contrast to the gentle, rounded forms of the body and the serene aspect of the Buddha's face. The arrangement of lotus pedestal, feet, and *vyalas*, as well as the projecting hands, establishes a space around the figure that is tangible and profound. The composition is ambitious, and the modeling of the body and disposition of the limbs are subtle.

ML

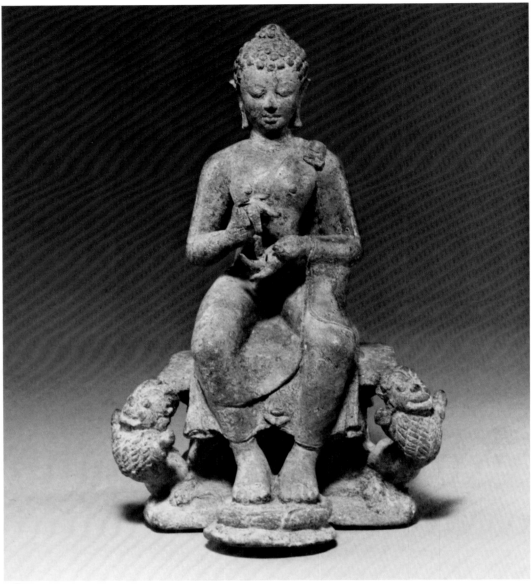

138

1 Bernet Kempers 1959, pls. 58, 60, 61.

2 Fontein, p. 75.

3 For an interesting review of the use of this mudra in early Indian art, see Weiner, pp. 57–62.

4 Lohuizen-de Leeuw 1984, pp. 39–43; Le Bonheur, pp. 125–31.

5 Weiner, pls. 35, 44.

6 Gupte, pls. 1A, 1B, 2A, 3B, 19A.

7 Weiner, pls. 55, 90, 91.

8 Bernet Kempers 1959, pl. 60.

9 Boeles, pp. 195–97 and fig. 2. As Boeles has pointed out, it is possible that the Buddhas he discusses in his text, "Four Stone Images of the Jina Buddha in the Precincts of the Chapel Royal of the Emerald Buddha," are from two different groups.

10 Rijksmuseum, no. 30; Fontein, no. 41.

11 Bernet Kempers 1959, pls. 62, 63; *Guide to National Museum*, p. 91; Pal 1984, no. 158A; Wattanavrangkul, no. 41; Rijksmuseum voor Volkenkunde, Leiden, obj. no. 1403-3060.

PUBLISHED
Brown in Pal 1984, no. 158B.
Lerner in *Recent Acquisitions*, p. 110.

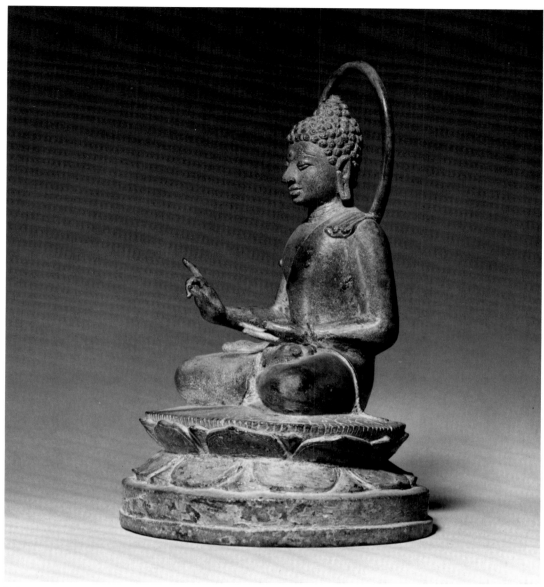

139

139 Seated Transcendental Buddha Vairochana

Indonesia, Java, Central Javanese period,
ca. late 9th century
Bronze, h. 7⅝ in. (19.3 cm)
Gift of Samuel Eilenberg, 1987
1987.142.23

Probably the most famous of the Eilenberg collection's Javanese bronzes is this splendid Buddha seated on a large double-lotus pedestal. The deity sits in the cross-legged yogic, adamantine posture of *vajraparyan-* *kasana*, the right leg over the left, with the soles of both feet facing upward. His robe (*uttarasanga*), like that of the preceding Buddha, is draped to leave the right shoulder bare, but here the portion of the garment that covers the left wrist falls behind the figure. The lower hem of the robe comes all the way down so that the undercloth or skirt (*antaravasaka*) is completely covered. The folds of the small panel of the robe draped on the left shoulder are also arranged in a manner different from that seen on the Buddha of the preceding entry.

The Buddha's raised right hand makes the *vitarka-mudra* (the teaching or expository gesture), and his

left rests on his right foot, approximating the *dhyana-mudra* (meditative gesture). This mudra combination is assigned to two of the Transcendental Buddhas, Vairochana[1] and Samantabhadra.[2] An important bronze triad showing a Buddha seated in Western fashion flanked by Avalokiteshvara and Vajrapani has the Buddha making the same hand gestures as the Eilenberg example.[3] Since these same three deities appear at Chandi Mendut, where, however, the Buddha forms the *dharmachakrapravartanamudra*, and since it is probable that the Chandi Mendut Buddha is Vairochana (see previous entry), it may be that Vairochana can be represented with at least three different mudras and that the Eilenberg Buddha is more likely Vairochana than Samantabhadra. It is apparent that this leads to a very complex and confusing iconographic situation that may never be susceptible to definitive identification.

The importance of the pedestal here, as in many Javanese bronze sculptures, is reflected in the careful attention to precision of modeling and clear articulation of its different parts, as well as to its aesthetic compatibility with the figure it supports. The stamens and seed vessels are depicted, the latter composed in a pattern that appears periodically on top of Javanese lotus pedestals.[4] Along with the small halo encircling the head, two openings at the back of the pedestal indicate that this sculpture was once further enriched by either a large body halo or a throne back.

ML

1 Rijksmuseum, p. 111.
2 Lohuizen-de Leeuw 1984, no. 8.
3 Lunsingh Scheurleer and Klokke, no. 12.
4 For an interpretation of this motif, see Boeles, pp. 193–94.

Ex coll. Gal, Surabaya.

PUBLISHED
Wagner, p. 111.
Rowland 1963, no. 34.
Rawson, ill. 200.
Munsterberg, p. 206.
Lerner 1975, no. 14.
Brown in Pal 1984, no. 157.
Lerner in *Recent Acquisitions*, p. 109.

140 Standing Four-Armed Avalokiteshvara Flanked by Tara and Bhrikuti(?)

*Indonesia, Java, Central Javanese period,
2nd half of 9th–early 10th century
Bronze inlaid with silver, 7 9/16 x 6 7/8 in.
(19.2 x 17.5 cm)
Gift of Samuel Eilenberg, 1987
1987.142.22*

The Avalokiteshvara of this important triad has a small Amitabha in his hairdo, holds a bound manuscript (*pustaka*) in his upper left hand, the stem of a lotus (*padma*) in his lowered left hand, and a rosary (*akshamala*) in his raised right hand, and makes the boon-bestowing gesture of *varadamudra* with his lowered right. As usual, he stands on a double-lotus pedestal—in this case with the seedpod and stamens clearly marked (see No. 139). Similar pedestals support the flanking female deities.

To Avalokiteshvara's right, seated in *satvaparyankasana*, is a Tara wearing crossed belts (*channaviras*) over her chest and holding with her left hand the stem of the open blue lotus (*utpala*). With her right hand she makes the boon-bestowing gesture. Her hair is arranged in a high chignon of individual strands (*jatamukuta*) similar to that of Avalokiteshvara but set with a flower in front. The two-armed female to his left is identical to the Tara except for the *upavita* (sacred thread) worn diagonally across her chest, the stupa in her hairdo, and the closed lotus (*padma*) at her left shoulder. In India, there are many representations of two-armed and multiarmed Avalokiteshvaras flanked by two female deities.[1] When such a triad occurs, Tara is placed to his right and Bhrikuti, sometimes considered a form of Tara, is at his left. Bhrikuti typically has four arms but on occasion is shown with two,[2] and sometimes she has a stupa placed in her hairdo.[3] Although the lotus is not usually considered one of her attributes, some texts do have her carrying a yellow lotus.[4] This evidence strongly suggests that the female deity seated to the left of our Avalokiteshvara should be identified as Bhrikuti.

It is most unfortunate that not many Javanese bronze triads have survived, since they can sometimes provide iconographic clues not easily obtained elsewhere. As Lunsingh Scheurleer has pointed out, "Triads . . . may help to restore the original context of various, now separate bronzes."[5] If my Bhrikuti identification is accurate here, the recently exhibited

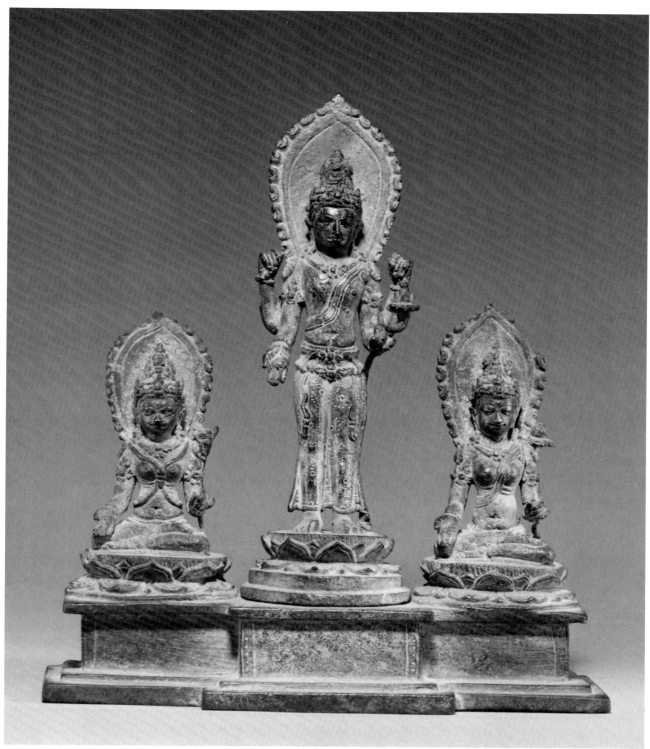

female deity from the Museum Nasional, Jakarta, who has a stupa in her hairdo, her right hand in *varadamudra*, and her left hand lacking the orthodox lotus,[6] probably is also Bhrikuti. Our triad suggests the original context for the silver seated Tara in the next entry.

Avalokiteshvara on his double-lotus pedestal is cast separately, and the eyes of the three figures are inlaid with silver.

ML

1 Ray, Khandalavala, and Gorakshkar, pls. 96, 148AB (in the latter, the position of the females is reversed); Saraswati, ills. 56–61, 66, 67, 71–73.

2 Saraswati, ills. 56, 57.
3 Ibid., ills. 61 and probably 67.
4 B. Bhattacharyya, p. 135. See also the Bhrikuti with a stupa in her hairdo and a lotus at her left shoulder from the extraordinary Sirpur bronze ensemble in the Los Angeles County Museum (Heeramaneck, no. 53).
5 Lunsingh Scheurleer and Klokke, p. 64.
6 Fontein, p. 192.

Ex coll. Resink-Wilkens, Yogyakarta.

PUBLISHED
Stutterheim 1934, pp. 167–97 and fig. 4.

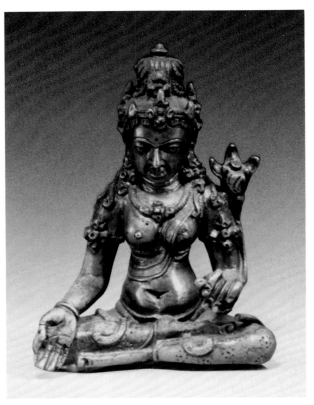

141

141 Seated Tara

Indonesia, Java, Central Javanese period, 2nd half of 9th–early 10th century
Silver, h. 2 ⅜ in. (6 cm)
Gift of Samuel Eilenberg, 1987
1987.142.12

This silver Tara is seated in the *satvaparyankasana* posture, holds the *utpala* in her left hand, and forms the *varadamudra* with her lowered right—like her counterpart in the preceding triad. She too has a flower placed in front of her *jatamukuta* hair arrangement, but the *upavita* instead of the *channavira* is worn diagonally across her chest. The triad of the preceding entry suggests the original context for this figure. The base, double-lotus pedestal, and halo or throne back were probably bronze. The casting is decidedly crisp, like that of many Javanese silver figures.

ML

PUBLISHED
Lerner 1975, no. 15.

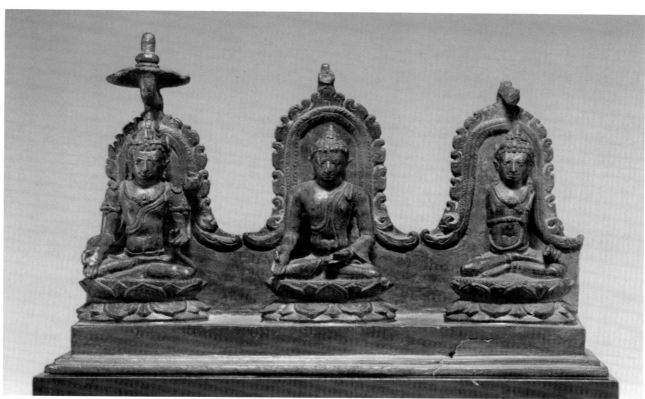

142

142 The Transcendental Buddha Ratnasambhava Flanked by Two Bodhisattvas

Indonesia, Java, Central Javanese period,
late 9th–early 10th century
Bronze, 4 1/2 x 6 15/16 in. (11.5 x 17.6 cm)
Gift of Samuel Eilenberg, 1987
1987.142.156

In the standard grouping of the Five Transcendental Buddhas, the figure whose right hand is in the *varadamudra* is usually considered to be Ratnasambhava, the Buddha of the South. He presides here as the central image of our triad.

To the right of Ratnasambhava sits a bodhisattva making the same mudra as the Buddha and holding in his left hand the stem of the lotus that appears at his left shoulder. The attribute placed on the lotus is unclear; it is probably a bound manuscript (*pustaka*) or perhaps the lower part of a sword (*khadga*). Either one would identify the bodhisattva as Manjushri, since there is no contradictory emblem in the hairdo.

Seated to the left of Ratnasambhava is a second bodhisattva, about whom not much can be said, since both his arms are missing. His left hand still remains, however, and this holds the bottom of a lotus stem, and his costume is slightly different from Manjushri's. He has the *udarabandha* below his chest and a thin, jeweled *upavita* slung diagonally from his left shoulder. His jewelry is also of a different type. Most interesting perhaps is his hairdo, which is not arranged in *jatas* and does not have an image of Amitabha, the conclusive identifier of Avalokiteshvara. Through the process of iconographic extrapolation, one can suggest that this armless bodhisattva is probably Vajrapani. The two bodhisattvas sit in the *satvaparyankasana* posture, the left leg on top of the right, and Ratnasambhava is shown in the more dogmatic, more difficult posture of *vajraparyankasana*.

Originally, there were parasols (*chattras*) above all three deities. The section of the oblong pedestal beneath Vajrapani(?) is restored. A stylistically similar triad, perhaps with the same deities, was in the Mangkoenagoro collection.[1]

ML

1 Stutterheim 1937, fig. 1.

PUBLISHED
Brown in Pal 1984, no. 161.

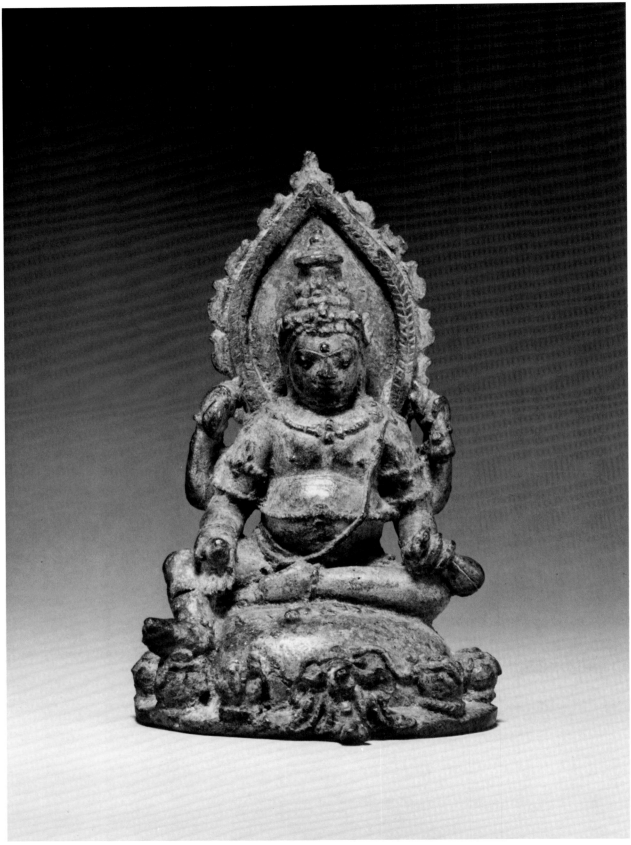

143 Seated Four-Armed Jambhala

Indonesia, Java, Central Javanese period,
2nd half of 9th–early 10th century
Bronze inlaid with silver, h. 4¼ in. (10.9 cm)
Gift of Samuel Eilenberg, 1987
1987.142.301

Jambhala is the Buddhist god of wealth, the equivalent of the Hindu deity Kubera. In Javanese art it is usually not clear which is intended. They are both ancient deities, originally *yakshas* (see No. 9), who preside over the wealth of the earth. Although Javanese representations of four-armed Jambhalas are not uncommon, the most typical form depicts him with two arms, holding a citron (*matulunga* or *jambhara*) and a mongoose (*nakula*) spewing jewels. He is usually shown with small vases of plenty (*purna-ghatas*) overflowing with jewels or loops of pearls; these vases are sometimes tipped over so that their contents spill out.[1] The deity is described as having a potbelly, and some texts assign a yellow-lotus garland to him.[2]

This bronze Jambhala with eyes and *urna* (the round mark on the forehead) in silver sits in the posture of *lalitasana*, his pendant right leg supported by a *purnaghata*. Instead of sitting on the usual double-lotus pedestal, Jambhala is placed on a large sack that contains the wealth he dispenses to his followers; it is tied in front with a long cord and has some of its contents spilling out.[3] Eight small, jewel-filled vases, including the one supporting his right foot, surround the sack, which would originally have stood on a stepped base. In his lowered left hand, the god holds a moneybag; in his lowered right, the citron. The object in his upper left hand seems to be a water vessel; in his upper right hand he has a closed lotus. In addition to the dhoti and the usual complement of jewelry, Jambhala wears a high cylindrical miter (*kiritamukuta*), a jeweled *upavita* suspended from his left shoulder, and the *udarabandha* around his potbelly.

ML

1 Saraswati, pp. LII–LIII; B. Bhattacharyya, pp. 178–80, 237–39.
2 B. Bhattacharyya, p. 238.
3 For other examples of this overflowing sack used as a cushion for Jambhala, see Le Bonheur, pp. 176–77; Lohuizen-de Leeuw 1984, no. 46.

144 Seated Four-Headed and Four-Armed Jambhala(?)

Indonesia, Java, Central Javanese period,
late 9th–early 10th century
Bronze, h. 4¹³⁄₁₆ in. (12.2 cm)
Gift of Samuel Eilenberg, 1987
1987.142.170

The extensive range of iconographic types within the Eilenberg collection of Javanese bronzes makes it one of the most important resources for the study of this genre. Here, what at first appears to be an image of the four-headed, corpulent Hindu god Brahma on closer inspection turns out to be yet another Javanese iconographic rarity, for which I can offer no parallel.

A four-headed and four-armed deity is seated on a double-lotus pedestal, in the *satvaparyankasana* position, the right leg over the left. If he were Brahma, he would be holding a fly whisk in his raised left hand and a water vessel in his lowered left hand, a rosary in his raised right hand, and probably a lotus in the lowered right. Stone sculptures of Brahma are quite rare in Central Javanese art; even rarer are examples in bronze. The few published bronze Brahmas are standing figures,[1] one of which still holds three of the original attributes.[2] A rare bronze seated Brahma is in the Eilenberg collection[3] and holds the normal attributes of fly whisk, water vessel, and rosary; only the stem of the lotus remains in the lowered right hand. In addition, on the front of its pedestal, this sculpture has Brahma's vehicle, the swan or gander (*hamsa*), but there it looks more like a hen.

In Indian sculpture of the Pala period, Brahma is depicted with a large stomach, appropriate to a well-fed Brahman and conforming to textual descriptions in some of the puranas. Javanese representations of Brahma, however, follow the southern Indian Pallava–early Chola idiom of non-corpulent Brahmas. The figure under discussion has a large stomach with a narrow band (*udarabandha*) around it, like the sculpture in the previous entry. The stomach, along with the deity's surviving attributes, prevents it from being identified as Brahma. The most important evidence against this designation is the stylized thunderbolt (*vajra*) in the upper right hand, which, so far as I know, is never held by Brahma. The other attributes are less clear. In his lowered right hand, the deity holds what appears to be the bottom portion of a sword; I cannot decipher the remains of the object in the raised left hand, and nothing survives

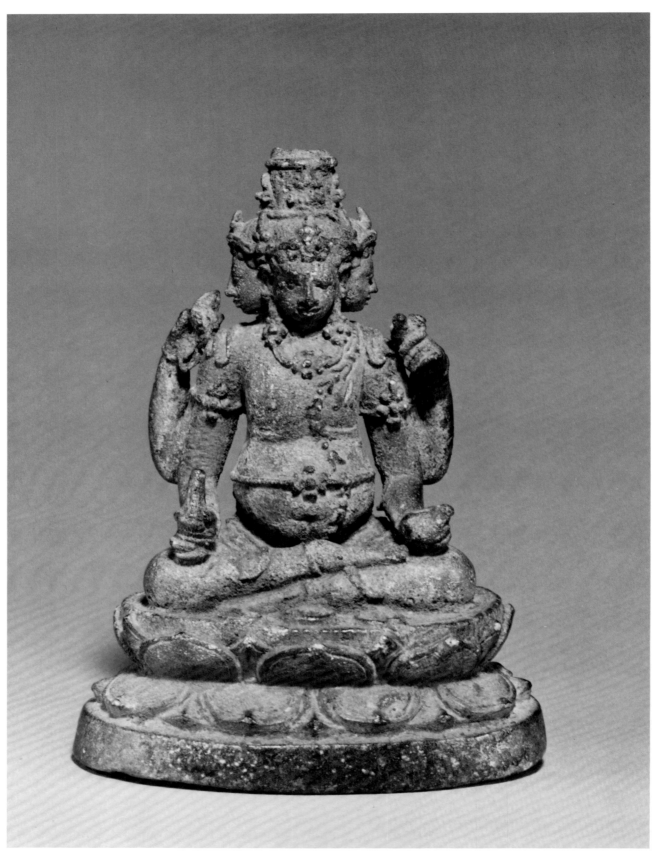

in the lowered left. While Brahma usually is shown with the *jatamukuta* headdress, this deity wears the high cylindrical miter (*kiritamukuta*) hollowed out to accommodate some crowning element and has an *upavita* of stylized lotuses suspended from his left shoulder.

Given the rich and complex iconographic variations within the art of Central Java, it is hazardous to dismiss categorically the possibility that we are dealing here with some unusual form of Brahma. Nevertheless, the evidence clearly indicates that this deity is of Esoteric Buddhist origin and not Hindu.[4] I would exclude atypical forms of the Adi Buddha Vajrasattva, or Vajradhara, of the sort associated with certain three-dimensional Esoteric mandalas (see No. 158) as possible candidates for the god's identity.

A much better solution, having considerably more to recommend it than the preceding ones, would be Jambhala. Esoteric Buddhist texts list a form of Jambhala with three faces and six arms who holds the *vajra* and a sword in two of the right hands.[5] Jambhala is always depicted as potbellied and sometimes wearing a lotus garland,[6] and he is provided with *purnaghatas* (small vessels overflowing with jewels). The three rings on top of the front of our figure's lotus pedestal must have once contained separately cast *purnaghatas*. It would seem, then, that we have here an unrecorded type of Jambhala, or at least a form unknown to me.

ML

1 Lunsingh Scheurleer and Klokke, no. 37; Le Bonheur, pp. 222–23.
2 Lunsingh Scheurleer and Klokke, no. 37. In the collection of the Rijksmuseum voor Volkenkunde, Leiden, there is a bronze standing Brahma holding the fly whisk and rosary in his upper hands and a lotus in his lowered right hand. He makes the *varadamudra* with his lowered left hand (obj. no. 1403-2835).
3 Acq. no. 1987.142.168.
4 The same evidence precluding Brahma as a possible candidate also applies to Bhattara Guru or Agastya (see Fontein, no. 20).
5 B. Bhattacharyya, pp. 238–39. See also Le Bonheur, p. 192, n. 6.
6 B. Bhattacharyya, p. 238. For an interesting eighth-century example of a two-armed, potbellied Jambhala wearing a necklace of lotus blossoms and seated in *lalitasana*, his pendant right leg supported by a *purnaghata*, see Willetts, p. 18. Such Orissan icons surely were one source of Central Javanese style and iconography.

145 Seated Two-Armed Jambhala

Indonesia, Java, Central or Eastern Javanese period, late 9th–1st half of 10th century
Bronze, h. 3 1/2 in. (8.9 cm)
Gift of Samuel Eilenberg, 1987
1987.142.175

Jambhala (or Kubera?) sits in an unorthodox variation of the *lalitasana* posture, his left leg lifted halfway up from the top of the double-lotus pedestal. He holds the *jambhara* (citron) in his lowered right hand and a money pouch—missing its lower part—in his left hand. His right foot rests on a tipped-over *purnaghata*, and there are two smaller *purnaghatas* on the front of the stepped base and one on each of its sides, all overflowing with loops of pearls.

Jambhala does not wear the *upavita* but has the *udarabandha* around his potbelly. The high cylindrical miter is present and, as is common in representations of many deities, two different ear pendants are worn. The very crisp casting is typical of many bronzes of the late Central Javanese style and the Eastern Javanese style.

ML

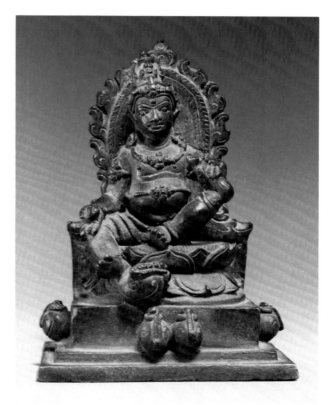

145

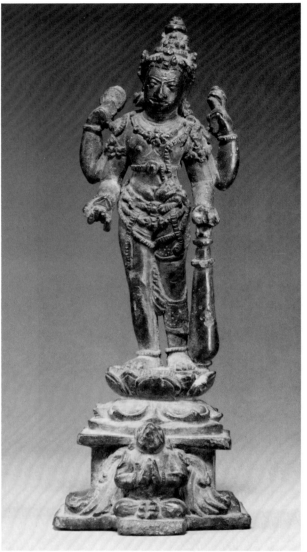

146

hand he has an unidentified attribute that may be restricted to Javanese Vishnus. Here it appears to be a triangular object;[1] elsewhere it is diamond shaped or square.[2]

Vishnu wears the orthodox elaborate array of jewelry, an *upavita* looped behind the *udarabandha*, which works its way in front of and behind other elements of the costume, and a garment with one long section that crosses the left leg beneath the knee.[3] While the arrangement of the garments and belts follows southern Indian traditions, the considerable attention lavished on the details of costuming reflects Indonesian taste, particularly from about the middle of the ninth century onward.

Seated in front of the stepped base that supports the double-lotus pedestal is Vishnu's vehicle, Garuda, with wings spread and hands in the attitude of adoration (*anjalimudra*). A gold standing four-armed Vishnu of slightly earlier date is interesting as a comparison, since it exhibits many similarities.[4]

ML

1 This object also appears in triangular form with another Vishnu (Thomsen, no. 112).
2 Lunsingh Scheurleer and Klokke, no. 26; Fontein, nos. 53, 54.
3 This costume, while not restricted to Vishnu, appears with some consistency on Javanese bronze Vishnus (see Thomsen, no. 112; Lunsingh Scheurleer and Klokke, no. 26; Fontein, no. 53; Le Bonheur, p. 219).
4 Fontein, no. 53. This sculpture is dated in the catalogue "c. 8th–9th century," which seems to me to be too early. I would prefer to date it to the second half of the ninth century. The author's suggestion that "the statue presents a style associated with" the Dieng Plateau is also problematic.

146 Standing Four-Armed Vishnu

Indonesia, Java, Central or Eastern Javanese period, late 9th–1st half of 10th century
Bronze, h. 5 7/16 in. (13.8 cm)
Gift of Samuel Eilenberg, 1987
1987.142.15

Vishnu stands in the somewhat unusual *abhanga* posture, head and body slightly curved in a continuous gentle arch. He holds the conch (*shankha*) in his upper left hand and the war discus (*chakra*) in his raised right, and his lowered left hand rests on top of a large club (*gada*). Instead of the usual lotus held by northeastern Indian Vishnus, in his lowered right

147 Seated Transcendental Buddha Vairochana

Indonesia, Java, Central or Eastern Javanese period, ca. 1st half of 10th century
Bronze, h. 6 1/4 in. (15.9 cm)
Gift of Samuel Eilenberg, 1987
1987.142.21

Carrying tendencies apparent in Indian Pala-period bronze sculptures one step further, the Javanese artists emphasized the physical environment into which their deities were placed. Here, the double-lotus pedestal set on a decorated cushion on top of a large,

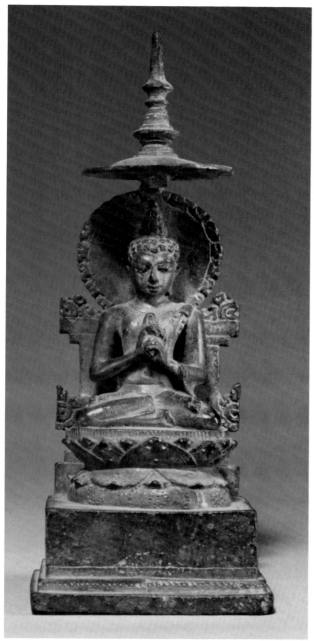

147

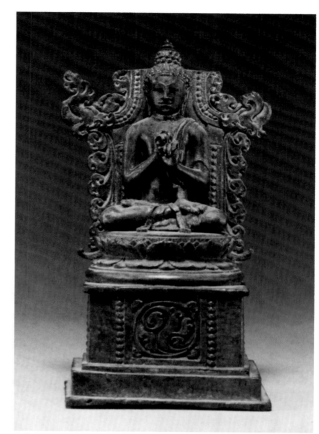

148

148 Seated Transcendental Buddha Vairochana

Indonesia, Java, Eastern Javanese period,
ca. 2nd half of 10th century
Silver (Buddha) and bronze (pedestal and throne
back), h. 3 ¹⁵/₁₆ in. (10 cm)
Gift of Samuel Eilenberg, 1987
1987.142.13

This fine sculpture, in addition to employing two metals, is distinguished by jewel-like precision of treatment of its rich decorative elements. Because of this latter trait, which is embodied in much Javanese metalwork, as well as the generally small size of such sculpture, the Javanese have become known as the great miniaturists of Southeast Asian art.

Vairochana sits in the *vajraparyanka* cross-legged posture on a double lotus, making the *bodhyagri-mudra*. The slimness of the torso is accentuated by his high cranial protuberance (it is not clear if the knob on top is original). Ornamental floral rondels set in a square flanked by rows of beading appear on three

stepped base is combined with a throne back and a parasol (*chattra*) with a tall finial to create a particularly rich visual environment.

Vairochana sits in the adamantine *vajraparyanka* attitude and makes the wisdom fist (*bodhyagrimudra*). His robe is worn in the usual manner, leaving his right shoulder bare, and the cranial protuberance (*ushnisha*) is exceptionally high and pointed.

ML

sides of the pedestal; these probably evolved out of similar floral decoration found at Borobudur[1] and other early sites. The relative importance assigned to pedestal and throne back, in terms of both size and decoration, is an interesting reflection of the aesthetic of the period.

The combination of a silver figure on a bronze pedestal is not uncommon in Javanese sculpture. On occasion, one also finds gold figures with bronze pedestals and throne backs—the Vairochana in the Rijksmuseum, Amsterdam, is one such example.[2]

ML

1 Bernet Kempers 1959, pls. 88, 89.
2 Lunsingh Scheurleer and Klokke, no. 41.

PUBLISHED
Lerner 1975, no. 17.
Brown in Pal 1984, no. 159.

149 Hanging Lamp in the Form of a *Kinnari*

Indonesia, Java, Central Javanese period,
ca. 2nd half of 9th–early 10th century
Bronze, w. 7⁷/₁₆ in. (18.9 cm)
Gift of Samuel Eilenberg, 1987
1987.142.24

Kinnaris and their male counterparts, *kinnaras*, are mythical celestial creatures, half bird, half human.

They are minor demigods who are seen often in Indian art[1] and were quite common in the sculpture of the Pala period, appearing at Nalanda[2] as well as at other sites. They can be found on many Central Javanese temple reliefs[3] and, to judge from surviving Javanese bronze sculpture, were particularly popular during the ninth and tenth centuries. An early jataka tale relating the plight of a *kinnari* separated from her mate for one night is part of the prototypical evidence that led to the establishment of *kinnaras* and *kinnaris*

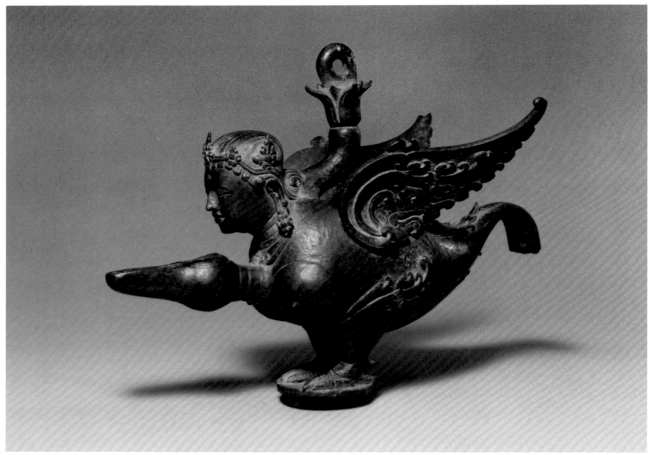

as symbols of marital fidelity.[4] It is said that they die brokenhearted if separated.

The present *kinnari* lamp, the finest example of this specific type known to me, very skillfully combines the human and avian forms. The abstract decorative patterns representing feathers provide a rich visual contrast to the full volumes of the body. This oil lamp would have been suspended from a long chain attached to the ring on the lotus stem emerging from behind the head of the figure. The hollowed body of the *kinnari* serves as the oil reservoir, and the wick would have been placed in the projecting spout. Two pins beneath the talons indicate that originally there was another element at the bottom, perhaps a base in the shape of a perch.[5]

Apropos the popularity of *kinnaris*, *kinnaras*, and Garuda in the art of Java, Fontein has written, "Flying creatures and heavenly beings must have been considered suitable subjects to be represented in oil lamps. The flickering lights enhanced the illusion of movement in such pieces and created lively shadows on the walls of the space in which they were hung."[6]

ML

1 Biswas, pp. 266–69.
2 P. Chandra 1985, no. 64. Despite the absence of wings and talons, these figures should be considered *kinnaras*.
3 For example, see Chihara, Namikawa, and Hikata, panels 111, 112.
4 Biswas, p. 268.
5 For example, see Bernet Kempers 1959, pl. 115.
6 Fontein, p. 248.

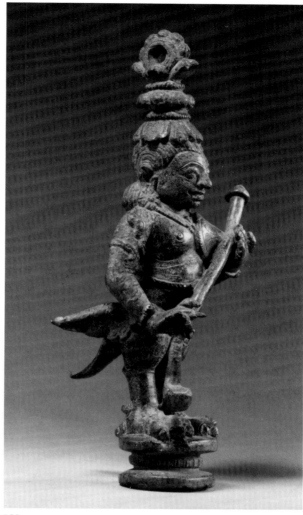

150

150 *Kinnara* Playing the *Vina*

*Indonesia, Java, Central Javanese period,
ca. 1st quarter of 10th century
Bronze, h. 6 1/16 in. (15.4 cm)
Gift of Samuel Eilenberg, 1987
1987.142.16*

This charming figure of a *kinnara* was originally part of the suspension system for a hanging oil lamp (or bell), serving as the intermediary element between the chain and the lamp.[1] The stocky *kinnara*, who has a suspension loop on his head, is shown playing a stick zither (a kind of *vina*)[2] and pressing the resonator against his chest. The refined modeling, the imaginative and skillful combination of human, avian, and purely decorative forms, and the very attractive patina place this sculpture among the best and most inventive of the Central Javanese bronzes in the Eilenberg collection.

Some texts specifically state that *kinnaras* are musical creatures and sometimes assign the *vina* to them.[3] *Kinnaras* playing stringed instruments can be found in the wall paintings at Ajanta[4] and playing the *vina* in later Pala stone sculpture,[5] but I know of only two Indian examples in bronze depicting *kinnaras* playing *vinas*: a Pala-period sculpture now in the Archaeological Museum, Nalanda,[6] and one that appears on the throne back of a pedestal for a Buddha from Kurkihar now in the collection of the Patna Museum.[7] At Borobudur, a particularly

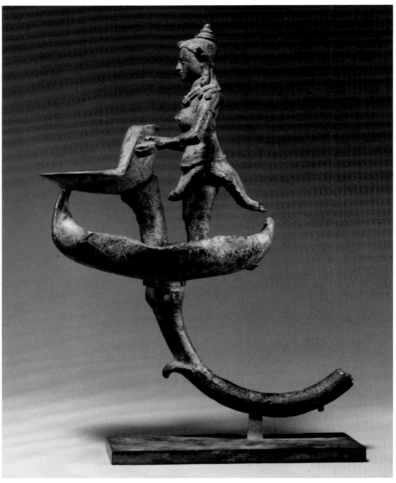

151

appealing depiction of a *kinnara* and a *kinnari* holding hands shows the *kinnara* with a *vina*.[8]

ML

1 Fontein, Soekmono, and Suleiman, pp. 94–95.
2 Sadie, vol. 3, pp. 728–35. I am indebted to J. Kenneth Moore of the Metropolitan Museum's Department of Musical Instruments for this reference.
3 Biswas, pp. 266–67. See Sadie, vol. 3, p. 731, for a specific form of the stick zither called *kinnari vina*.
4 Hendley, fig. 392.
5 Biswas, fig. 574.
6 S. K. Mitra, ill. 123.
7 Shere, ill. 7. For *kinnaras* and *kinnaris* holding other instruments, see ills. 8, 29, 37.
8 Chihara, Namikawa, and Hikata, photo 111.

PUBLISHED
Crucq 1930, opp. p. 165.
Lerner 1975, no. 18.
Lerner in *Recent Acquisitions*, p. 111.

151 Standing *Kinnari* Holding an Oil Receptacle

*Indonesia, Java, Central Javanese period,
ca. 1st quarter of 10th century
Bronze, h. 8 1/16 in. (20.5 cm)
Gift of Samuel Eilenberg, 1987
1987.142.27*

Here, a wingless *kinnari* stands in a large naturalistic lotus leaf, her head tilted to the right and her hands placed at the sides of the back of a receptacle so shallow it must have supported a separate oil container. This rare lamp was originally attached to a bronze shaft,[1] but whether that shaft had additional branches[2] with multiples of this image, one cannot say.

ML

1 See Lunsingh Scheurleer and Klokke, no. 85.
2 See Fontein, no. 79.

192

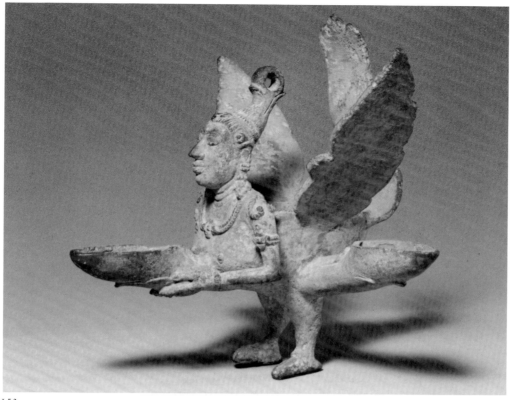

152

152 Hanging Lamp in the Form of a *Kinnari*

Indonesia, Java, Eastern Javanese period,
ca. 2nd half of 10th century
Bronze, w. 6⅜ in. (16.3 cm)
Gift of Samuel Eilenberg, 1987
1987.142.25

Centered in the many projecting elements of this oil
lamp is a long-faced *kinnari* with a suspension loop
on her head and a hollowed body that serves as the
oil reservoir. Her large wings as well as the three oil
spouts point straight out, and her plain tail curves
behind her. No decorative chasing appears on this
kinnari's wings or tail.

Marijke Klokke has written, "Kinnari were a
popular motif in Central Java. In East Java they seem
to have lost their popularity. No representations are
known from the East Javanese Period."[1] If the latter is
true, this *kinnari* oil lamp, which to my eye seems to
belong to the early phase of the Eastern Javanese
styles, is one of the very few from the period—I
assume there must be others—to have survived.

ML

1 Lunsingh Scheurleer and Klokke, p. 131.

153 Finial(?) with a *Kinnari*

Indonesia, Java, Central Javanese period,
ca. 9th century
Bronze, w. 7⅞ in. (20 cm)
Gift of Samuel Eilenberg, 1987
1987.142.33

The purpose of the category of Javanese bronze
objects represented by this sculpture and the two that
follow is unknown. For reasons I cannot understand,
such objects have been described as handles for oil
lamps.[1] All have fanciful openwork tails composed of
long, thin, scrolling, and intertwining members with
curled ends and are very large relative to the figures,
animals, or birds to which they are appended. The
obvious fragility of these tails and the discomfort
they would present the hand make them totally
unsuited to be handles. The bases of the first of our
objects and a similar example in the collection of The
Metropolitan Museum of Art,[2] which have serendipi-
tously survived, conclusively prove that they had a
different purpose, but what that might have been
eludes me. Perhaps they were attached to poles and
carried in procession, but this would not explain the

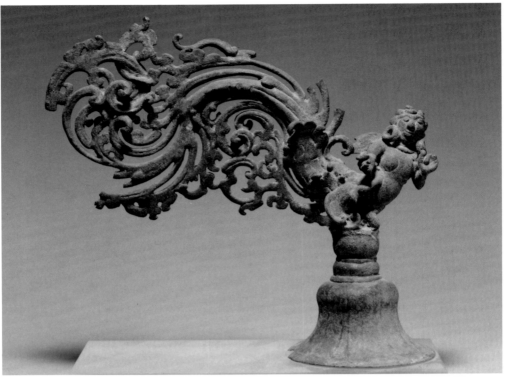

bell-shaped bases with their wide, flared rims incised with petal decoration.

Although these objects were long thought to date to the Eastern Javanese period,[3] there is no stylistic or iconographic evidence to support that assumption. In fact, the vocabulary of forms from which they derive is well represented on the facades of Borobudur and other Central Javanese temples. Most recently, a few have been published as belonging to the Central Javanese period.[4]

The example here depicts a charming, plump *kinnari* with one leg raised, wearing large earrings or earplugs and with her hair arranged in heavy curls. In a different context and without her tail she might very well pass for a sixth-century Indian sculpture of the Gupta period or, at the very least, would not seem out of place stylistically in the corpus of eighth-century Thai sculpture. This, then, suggests to me that the Eilenberg bronze might be an early example of this category of object, which would be most appropriate, since Indian *kinnaris* and *kinnaras* with elaborate, long scrolling tails must have served as its prototype.[5]

ML

1 Rijksmuseum, no. 100; Lohuizen-de Leeuw 1984, nos. 143, 145; Lunsingh Scheurleer and Klokke, nos. 112–14.

2 Acq. no. 1984.491.4.
3 Bernet Kempers 1959, pl. 313; same sculpture in Rijksmuseum, no. 100, as 13th–14th century; Lohuizen-de Leeuw 1984, nos. 143, 145.
4 Lunsingh Scheurleer and Klokke, nos. 112–14.
5 For example, see Pal 1974, pl. 157; Biswas, figs. 568–70; Williams, pl. 240; P. Chandra 1985, no. 64.

154 Finial(?) with Lions and *Makaras*

Indonesia, Java, Central Javanese period, ca. late 9th–1st quarter of 10th century
Bronze, w. 11⅞ in. (30.1 cm)
Gift of Samuel Eilenberg, 1987
1987.142.32

This emblematic finial(?) of unusually complex and intricate composition is the largest and most elaborate example of its kind known to me. An exuberant object, it includes a large horned and winged lion (*vyala*) supporting two *makaras* (composite mythological creatures made up of a kind of snouted, tusked, and horned crocodilelike head and elements from other animals and fish) out of whose mouths

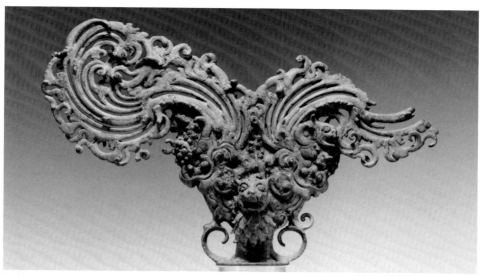

154

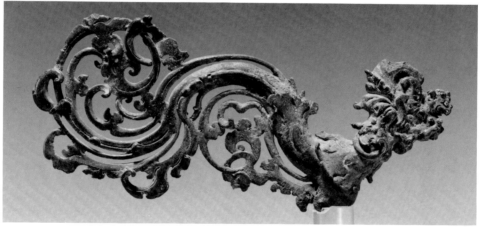

155

spring two more *vyalas*, one of which faces to the rear. Standing on the main lion is a smaller fourth one, pointed in the opposite direction. His tail stands straight up and then curls, and his head and body are shown on the other side of the finial. Growing out of the top of each *makara* head is a huge sweeping mass of long, fanciful, scrolling, stylized feather appendages with curled tips.

The vocabulary of forms employed in this composition, like that of the preceding example, is well preserved on the facades of Central Javanese temples. The *makara*, in particular, with its curled snout, gaping jaws, curving tusks, and horns, is a staple in the repertory of Central Javanese art.

ML

Ex coll. Resink-Wilkens, Yogyakarta.

155 Finial(?) with a *Makara* Spewing Out a Lion

Indonesia, Java, Central Javanese period,
ca. 1st quarter of 10th century
Bronze, w. 7 7/16 in. (18.9 cm)
Gift of Samuel Eilenberg, 1987
1987.142.34

The mythological *makara* spewing out a rearing horned lion is depicted again in this finial. The forms of the long, thin, scrolling appendages that make up the fantastic tail of the creature are more refined and delicate than those of the preceding example. The obvious fragility of this tail militates against any theory that objects of this type could have served as handles.

ML

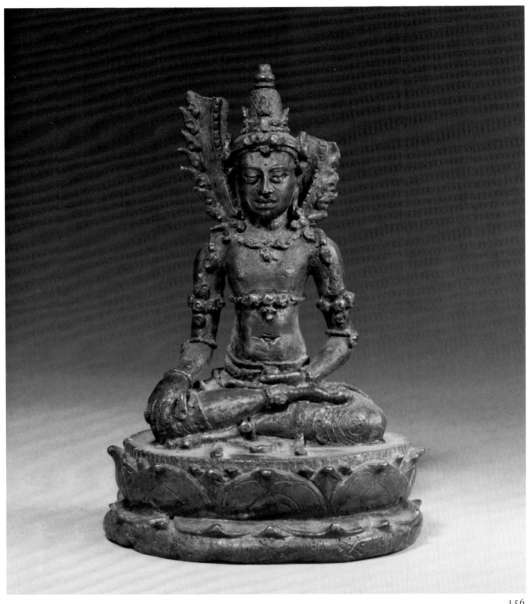

156 Seated Dhyani Buddha Akshobhya(?)

Indonesia, Java, Eastern Javanese period,
2nd half of 10th century
Silver, h. 3 5/8 in. (9.3 cm)
Gift of Samuel Eilenberg, 1987
1987.142.11

This fine sculpture, another of the Eilenberg
collection's rare Javanese images in silver, may
represent the Dhyani Buddha Akshobhya, Lord of the
East. Akshobhya is usually represented, like the figure
here, with his left hand resting in his lap in the

meditative *dhyanamudra* and his right in the earth-
touching gesture of *bhumisparshamudra*. Akshobhya's
orthodox attribute is the *vajra* (thunderbolt), which
is sometimes placed in front of him, on top of his
pedestal. The ambiguous small object in the palm of
this Buddha's left hand confuses what would otherwise
be a straightforward identification. Whether it is
meant to represent a jewel (*ratna*), a miniature bowl,
or a lotus bud is not clear.

Either the *ratna* or the flaming wish-fulfilling jewel
(*chintamani*) is the symbol of the Dhyani Buddha
Ratnasambhava, but this deity's right hand usually
forms the boon-bestowing *varadamudra*. If a bowl is

intended, our figure could be the Healing Buddha Bhaishajyaguru, since this symbol is usually assigned to him. To further complicate matters, Amitabha, in his Amitayus aspect, holds a container, which is sometimes bowl-shaped, with the elixir of immortality (*amrita*). Finally, if the small object is a lotus bud, this attribute is merely a generic symbol of divinity. Although the identification of the Buddha is problematic, the quality of this image, in terms of both casting and aesthetic sensibility, is self-evident.

This Buddha, seated in the *satvaparyankasana* pose, belongs to the Crowned and Jeweled category (see No. 96). The pointed, high conical miter with a knob on top and the handling of the jewelry are what one would expect in the early phase of the Eastern Javanese styles. A double-lotus pedestal whose lower row of petals is decidedly smaller than the upper row appears here. Although pedestals of this style support eighth-century Shrivijayan sculptures,[1] they seem not to appear with Central Javanese-period bronze images but, like the armbands at the elbows of our figure, are typical of the early Eastern Javanese period. The armbands occur on Central Javanese stone sculptures but, so far as I am aware, not on Central Javanese

bronzes.[2] The reasons for this time lag in the appearance of the armbands are unknown to me.

ML

1 Lerner 1984, no. 41.
2 Some of the deities from the Surocolo mandala wear armbands at the elbows. Fontein has dated this group to the early tenth century (p. 223), which seems to me to be too early. Perhaps a dating to the last quarter of the tenth century would be closer to the mark.

157 Seated Esoteric Buddhist Deity

Indonesia, Java, Eastern Javanese period,
ca. mid- or 2nd half of 10th century
Bronze, h .4 ⅛ in. (10.5 cm)
Gift of Samuel Eilenberg, 1987
1987.142.18

Iconographically unusual images such as this four-armed and four-headed deity probably were not individual cult images but rather parts of larger ensembles that formed mandalas of the sort discussed

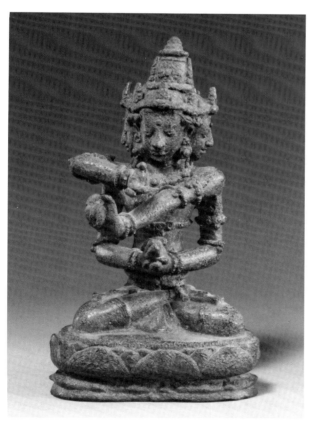

157 Front

157 Side

in the next entry. I have been unable to link any other sculptures to this Esoteric deity on the basis of style, but it is probable that others from the now-dispersed mandala to which it presumably belonged still exist. This supposition makes our fine and rare sculpture particularly important, since it suggests that additional attempts to reconstitute the original group could be rewarding.

In my stylistic sequence of Javanese bronzes, this image belongs to the early phase of the Eastern Javanese period. The conical miter is of Central Javanese type, but the elbow bands, double bracelets, and the proportions of the pedestal's upper and lower registers of lotus petals are all common to the Eastern Javanese idiom. The arrangement of the projecting arms and the emphasis on the angularity of the shoulders reflect Indonesian dance positions.

ML

158a–f Six Sculptures from a *Vajradhatu* Mandala

Indonesia, Java, Nganjuk, Eastern Javanese period, last quarter of 10th–1st half of 11th century
Bronze
Gift of Samuel Eilenberg, 1987

a *Male supporting a* vajra *on the raised middle finger of his right hand, which crosses his chest; the lowered left hand holds the stem of a flower, h. 3 9/16 in. (9 cm)*
1987.142.5

b *Male supporting a double* vajra (vish-vavajra) *or blossom on the raised middle finger of his right hand, which crosses his chest; the lowered left hand holds the stem of a lotus, h. 3 5/8 in. (9.2 cm)*
1987.142.6

c *Male displaying in both hands an object resembling an armor chest-section (cuirass) with openings for arms and head, h. 3 5/8 in. (9.2 cm)*
1987.142.7

d *Male holding two ritual objects in the shape of forearms and hands, h. 3 5/8 in. (9.1 cm)*
1987.142.8

e *Female with a stupa(?) in her headdress, holding a conch in her left hand and a branch(?) in her right hand, h. 3 9/16 in. (9 cm)*
1987.142.9

f *Female with arms missing, h. 4 5/16 in. (11 cm)*
1987.142.61

Undoubtedly, the single most famous group of Javanese bronze sculptures is the Nganjuk hoard. The history of this unusually large find is well known,[1] but a few comments here will be useful. In 1913, farmers from the village of Chandirejo, in the Nganjuk district in Kediri, eastern Java, discovered a large number of bronze sculptures, perhaps as many as ninety.[2] Some of these were soon sold to private collectors, but the bulk of the find was acquired by the Batavian Society, which later became the Museum Nasional, Jakarta.

In 1914, there appeared an article by N. J. Krom on the Nganjuk sculptures then in the possession of the Batavian Society[3] (more were to enter the collection later), and the accompanying illustration of twenty-nine pieces from that group remains even today an exciting and somewhat startling one.[4] Krom separated the figures into five categories based on size and iconographic type. The smallest (for example, our a–e) average 9.1 centimeters in height and do not have halos or bases supporting their double-lotus pedestals. Those of the next size (f), which average 11.1 centimeters, lack bases but have ovoid halos behind their heads. These two groups of small figures constitute the vast majority of the find.

F. D. K. Bosch, realizing that these sculptures constituted a three-dimensional mandala, was able to identify the form specifically as a *Vajradhatu* Mandala (Mandala of the Diamond Matrix or Adamantine Sphere).[5] Later, K. W. Lim further refined this identification by demonstrating that the precise *Vajradhatu* Mandala was based on an Indian commentary written in the reign of the Pala ruler Mahipala, sometime between the last quarter of the tenth and the first half of the eleventh century,[6] thus establishing an approximate time before which these statuettes could not have been made.

Within the Nganjuk hoard, variations in figural proportions and physiognomy are apparent; compare, for example, b with e. For this reason and others, it is

158b

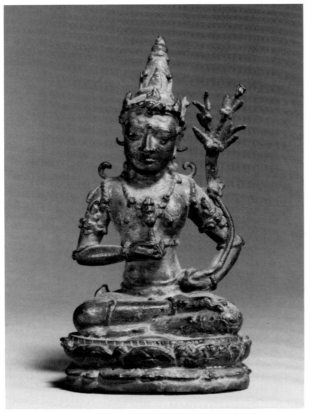

158a

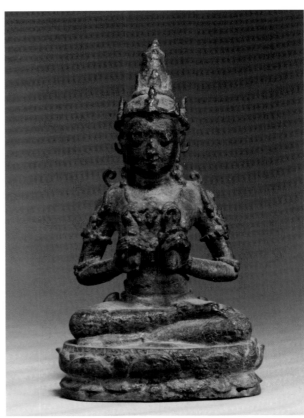

158d

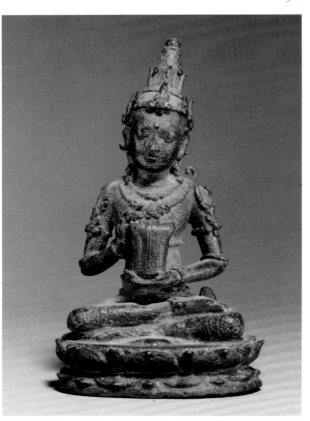

158c

still not certain that they all belonged together. Nevertheless, they form a homogeneous group unified by stylistic common denominators.[7]

The six Nganjuk bronzes in this exhibition all sit in the *satvaparyankasana* posture on double-lotus pedestals (*vishvapadmas*) of the Eastern Javanese-period style similar to those discussed in entry Nos. 156 and 160, with the lower row of petals decidedly smaller than the upper row. In addition to the two locks of hair falling on each shoulder, these figures have a thin ribbon descending from each side of the tiara and curling upward on the shoulder between the two locks (some of these curled ends have broken off). The shorter ends of the same ribbons also curl upward at each ear. The treatment of these ribbon ends and the high, pointed crown surrounded by tall, sharp, projecting, flamelike, or narrow, petal-shaped elements impart a rather spiky flavor to these sculptures. Each of the five smaller figures wears the *udarabandha* and a jeweled belt, and each of two of these five have two different necklaces. All display armbands at the elbows.

The overall quality of the Nganjuk bronzes is quite high. Addressing herself to this point, Lunsingh

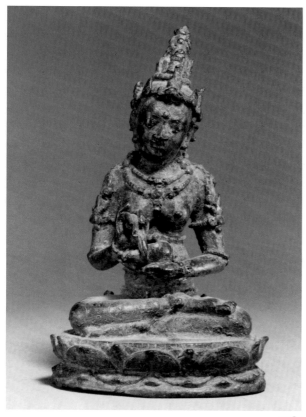

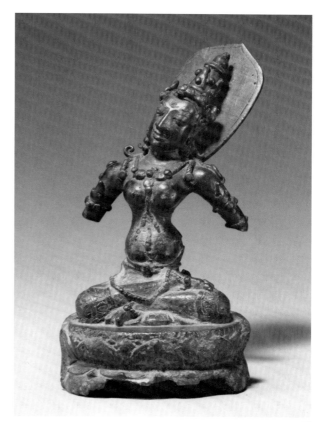

158e

158f

Scheurleer makes this important observation: "The workshop for bronze casting which was entrusted with the manufacture of the prestigious commission of the Nganjuk *mandala* statuettes was apparently already extremely experienced as is shown by the high level of the technique employed and the finish of the products."[8] This goes directly to the problem of the division of the Central and Eastern Javanese periods. Despite the geographical separation of the two centers, it is clear that artists from central Java migrated to and worked in eastern Java, and a continuous stylistic sequence was sustained.

Another comment by Lunsingh Scheurleer is particularly relevant: "The Nganjuk bronzes do not show stylistic influence from North-East Indian sculpture or any other school of sculpture. They are purely Indonesian, or Javanese to be more precise."[9]

ML

1 For a recapitulation of the history of the Nganjuk hoard, see Lunsingh Scheurleer and Klokke, pp. 32–35; Fontein, p. 231.

2 Bosch 1961, p. 121.

3 Krom 1914, pp. 59–72.

4 Ibid., pl. XII. A better reproduction of that photograph is Krom 1923, vol. 3, pl. 109.

5 Bosch 1961, pp. 121–30.

6 Lim, pp. 327–41.

7 For an analysis of the stylistic ingredients of this group, see Lunsingh Scheurleer and Klokke, pp. 33–35.

8 Ibid., p. 32.

9 Ibid., p. 35.

PUBLISHED
Lerner 1975, no. 20 (b, e).

201

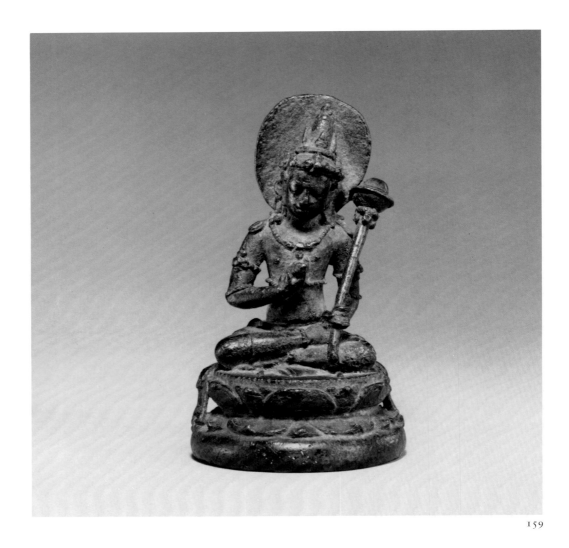

159 Seated Deity from an Esoteric Buddhist Mandala

*Indonesia, Java, Eastern Javanese period,
ca. 3rd quarter of 10th century
Bronze, h. 3 3/8 in. (8.6 cm)
Gift of Samuel Eilenberg, 1987
1987.142.164*

This rare and important sculpture has been taken out of our chronological and stylistic sequence, since the Nganjuk bronzes of the preceding entry are required to establish the context for its evaluation. Stylistically, it is slightly earlier than the Nganjuk hoard and must come from some unknown mandala of the Nganjuk or Surocolo[1] type.

The deity, who holds a *vajra* in his right hand and what may be a rattle on a long shaft in his left, is seated on an Eastern Javanese-style double-lotus pedestal and wears armbands at the elbow. A single loop of hair rests on each shoulder, and appearing behind each ear is the section of cloth attached to the tiara that will evolve into the distinct, curling ribbon-ends of the Nganjuk style. Here, there may have been a slight curl; the tips are now broken off. The *urna* on the forehead of each Nganjuk sculpture does not occur on this figure.

The similarities to the Nganjuk bronzes are apparent, but it is also clear that in terms of physiognomy and restrained use of jewelry, this sculpture is still very close to Central Javanese styles, confirming that there was never a break in Javanese stylistic traditions of the tenth century.

ML

1 Fontein, pp. 223–30. Fontein's dating of the Surocolo group to the early tenth century appears to me to be too early. A dating to the last quarter of the tenth century seems more appropriate to me.

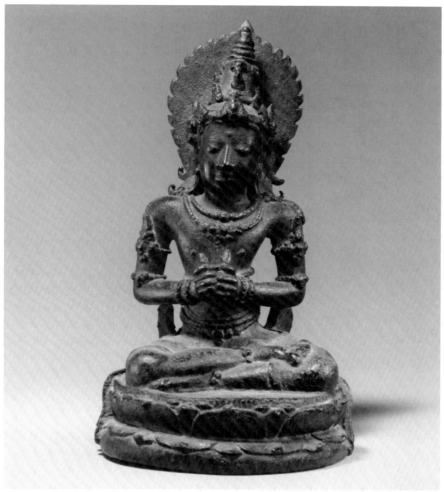

160

160 Seated Esoteric Buddhist Deity

Indonesia, Java, Eastern Javanese period,
ca. 2nd half of 11th century
Bronze with traces of gold lacquer,
h. 6⅝ in. (16.8 cm)
Gift of Samuel Eilenberg, 1987
1987.142.58

This large Vajrayana bodhisattva(?), which exhibits
a continuation of the Nganjuk style, sits in the
satvaparyankasana pose on an Eastern Javanese-style
double-lotus pedestal, whose lower row of petals is
smaller than the upper row. The deity is richly
costumed with two necklaces, double bracelets,
armbands at the elbows, and two jeweled belts below
the waist, along with the other usual jewelry.

The wide, straight shoulders of this well-formed
figure support a large head adorned with a tiara and
a high conical crown. A single long strand of hair
descends to each shoulder, and two sections of
decorative fabric, attached behind either side of the
tiara, their tips curling upward, appear at the side of
each ear. A long sash crossing the thighs is knotted
and looped twice at the back, the ends falling down
the sides of the pedestal. Behind the figure, a shorter
sash is knotted to the long one. The ovoid halo is
serrated to represent flames. The divinity has his
hands joined in front of his chest and holds what
appear to be two lotus buds.

This large Esoteric Buddhist deity probably was
originally part of some three-dimensional mandala.
Based on its relatively large size and high quality, it
clearly is an important Eastern Javanese-style sculp-
ture. At one time it was covered with gold lacquer.

ML

203

161 Head of a Buddhist Deity (Amitabha[?])

Indonesia, Kalimantan (Borneo),
ca. 12th–13th century
Stone, h. 19¼ in. (49 cm)
Purchase, Joseph H. Hazen Foundation, Inc.,
Gift, 1987
1987.218.19

In 1926, there appeared a fascinating report by Bosch concerning a group of Hindu and Buddhist sculptures found in a cave or grotto at Kumbeng, northeast of Kutai, in eastern Kalimantan (formerly Borneo).[1] This is a rather remote area in which important evidence exists of the earliest-known Indian-influenced centers in Indonesia.[2] Elsewhere, I have provided a concise history of the discovery of these very important sculptures.[3]

This head is from one of the figures Bosch illustrated in situ in the cave.[4] The photograph makes clear that the deity is seated on a double-lotus pedestal in the *vajraparyanka* attitude, with legs crossed and both soles turned upward. Behind him is a throne back with an elaborate crossbar with carved *makaras* (see No. 154). (The *makara* on the right is the one preserved here; part of the halo surrounding our head is reconstructed.) The deity wears a jeweled sacred thread (*upavita*) slung from his left shoulder diagonally across the chest, and there seem to be two different necklaces, armbands, and perhaps bracelets. In addition, the figure is adorned with earrings, a trilobed tiara, and a high *mukuta* headdress with elaborate decoration. The hands are placed in the lap in the meditative position of *samadhimudra*, which is usually assigned to the Dhyani Buddha Amitabha. The deity is dressed in the costume of a bodhisattva, and Bosch suggested that the figure might be a representation of Amitabha in the special state of *Sambhogakaya*[5] (Body of Bliss), one of the Three Bodies (*Trikaya*) of Buddhahood propounded by Mahayana Buddhism and accepted as part of Esoteric doctrine. There are

other possible alternatives for the figure's identity, but of greater interest to us here are the date and stylistic context of the sculpture.

In his 1926 article, Bosch recognized that the sculptures in the cave at Kumbeng formed at least two distinct stylistic groups. And while there are some errors in consistency regarding his dating of the earlier-style Hindu sculptures and one early Buddhist sculpture—a seated Vajrapani—and the second, later-style Buddhist group, on the whole, Bosch's evaluation is accurate. It is clear that the sculpture we are dealing with here is from the later Buddhist group. While the first group can be assigned on the basis of style to the early phases of the Central Javanese period, about the eighth or beginning of the ninth century, the second is much more problematic. I have previously assigned one of the sculptures from this later group to about the fourteenth century,[6] which may be too late. However, nothing known to me would permit a dating earlier than the twelfth century, even assuming otherwise-unknown local styles in Borneo. I would think the Eilenberg head must also be assigned to about the twelfth to thirteenth century and that the kind of hair arrangement and head covering represents a continuation of a Shrivijayan or Central Javanese type in which a thick hair-ring set on the head encircles the piled-up, high chignon topped by a knoblike finial.[7]

ML

1 Bosch 1926, pp. 132–46.
2 Lunsingh Scheurleer and Klokke, p. 5. See also Majumdar 1986, vol. 2, pp. 333–38; Majumdar 1955, pp. 35, 75.
3 Lerner 1984, pp. 116–17.
4 Bosch 1926, pls. 30C, 33B.
5 Ibid., pp. 138–39.
6 Lerner 1984, no. 54.
7 Diskul, pl. 9 (Indonesia section), pl. 27 (Thailand section); Fontein, pp. 198, 203.

PUBLISHED
Bosch 1926, pl. 33B.
Bosch 1927, pl. 145.

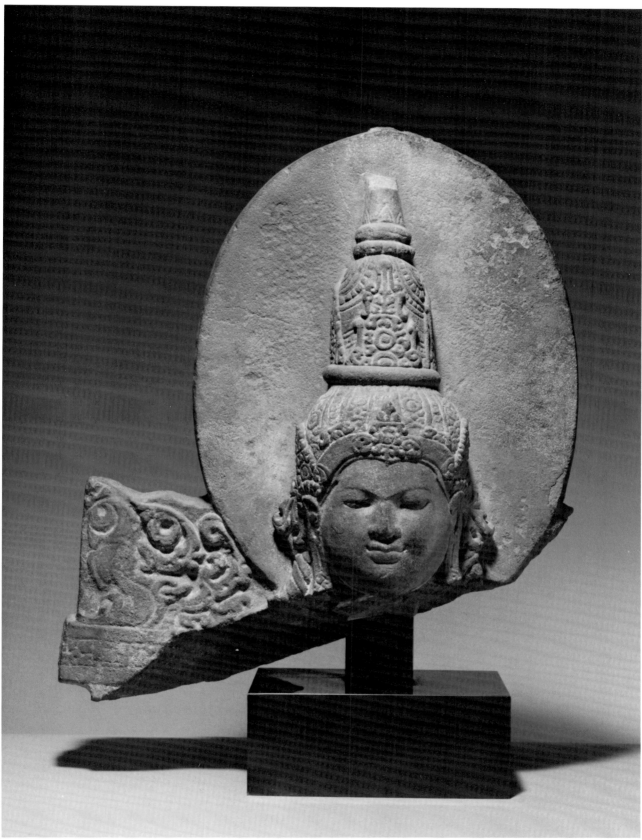

Javanese Ritual Objects

In addition to its wide range of figural sculpture, the Eilenberg collection is notable for the depth of its representation of Javanese bronze ritual objects, objects for domestic use, and objects whose original purposes remain uncertain. The unifying considerations for inclusion in the collection, already seen in the figural bronzes, are refinement of casting, artistic inventiveness, and visual appeal. The appearance of these bells, slit gongs, hanging oil lamps, finials, and other objects demonstrates a singular cultural expression that owes little to outside influences. They are the very specific products of the Indonesian artistic vision.

Since the majority are composed of many decorative elements, the entries for these objects are often short, omitting most descriptive detail. The task of conveying this visual information has been left primarily to the illustrations.

ML

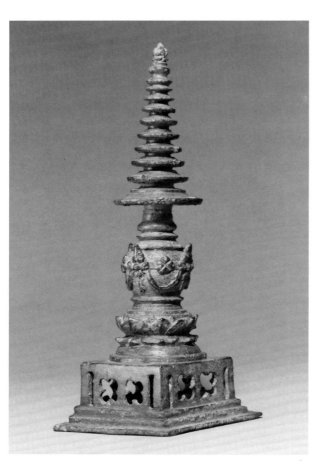

162

206

162 Model of a Stupa

Indonesia, Java, Eastern Javanese period, ca. 2nd half of 10th century
Bronze, h. 5 15/16 in. (15 cm)
Gift of Samuel Eilenberg, 1987
1987.142.195

This architectonic object of unusual design and proportion is supported by a stepped pedestal with openwork decoration of late Central Javanese or early Eastern Javanese type.[1] While it looks somewhat like a sacred-water vessel with an outsized covering in the shape of a multitiered parasol surmounted by a lotus, it is in fact a representation of a stylized stupa.[2]

ML

1 Lunsingh Scheurleer and Klokke, no. 42.
2 Fontein, Soekmono, and Suleiman, no. 84; Stutterheim 1939, opp. p. 138.

163 Ritual Object (Linga[?])

Indonesia, Java, Eastern Javanese period, ca. 11th century
Bronze, h. 8 1/8 in. (20.7 cm)
Gift of Samuel Eilenberg, 1987
1987.142.178

Included among the extensive range of Javanese bronze ritual objects in the Eilenberg collection are some of decidedly enigmatic nature. I know neither the purpose of this mysterious object nor what it represents.

Supported on a double-lotus pedestal whose base is decorated with blossoms in high relief and with smaller rondels is a high, tapered, domical, hollow receptacle(?) of some kind, which is surmounted by a small double lotus missing whatever was set on top. Approximately halfway down the object is a raised band with four large, trifoliate motifs, each with a superimposed jewel or eye. Similar decorative forms are sometimes referred to as the eye of the *kala* monster—a leonine mask associated with time, good fortune, and prosperity—which often appears on lintels in Central Javanese architecture. Smaller foliate

decoration is also incorporated into the design of this band, below which are low-relief festoons.

There are no openings on this object, but it easily lifts off the double-lotus pedestal. An interior tang and a slot in the center of the pedestal into which it fits prove that the two belong together. The nature of the decoration and the treatment of the double lotuses point to an early Eastern Javanese-period dating. It has been suggested to me that this object probably represents a linga, the phallic emblem of Shiva. If that is so, the proportions follow those of the early Peninsular Thai lingas.

ML

164 Tripod Support

Indonesia, Java, Central or Eastern Javanese period, ca. 10th–early 11th century
Bronze, h. 11 5/16 in. (28.7 cm)
Gift of Samuel Eilenberg, 1987
1987.142.257a–d

This unusually large tripod support of rare design[1] probably would have held a small holy-water bowl. If

163

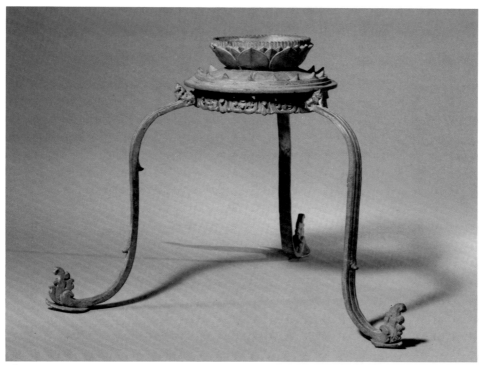

164

so, the discrepancy in size between the bowl and this splendid tripod can be accounted for only if the bowl was made of gold or silver. Three separately cast, long, gracefully curved legs, each with a *makara* at the top and scrolling floral forms at the foot, are set into the recessed skirt, which is decorated with an openwork design of floral festoons. The body is in the shape of a large double lotus with prominent stamens. I do not know of a similar example.

ML

1 For more common tripod supports, see Fontein, Soekmono, and Suleiman, no. 71; Lohuizen-de Leeuw 1984, nos. 88–90; Lunsingh Scheurleer and Klokke, no. 86.

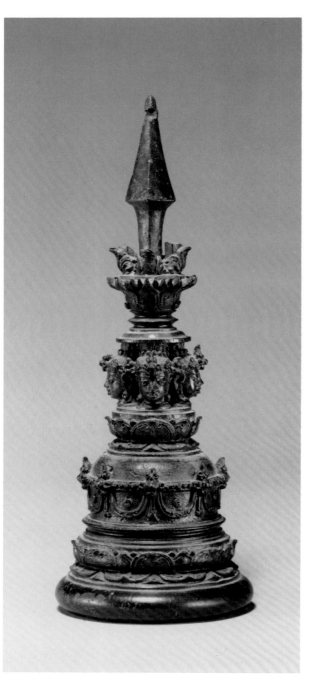

165

165 Handbell

Indonesia, Java, Eastern Javanese period,
2nd half of 10th–11th century
Bronze, h. 5⅞ in. (14.9 cm)
Gift of Samuel Eilenberg, 1987
1987.142.26

To judge from the great number of Javanese bronze bells that have survived and the care lavished on their production, they must have been particularly important to the religious life of that culture. These bells take many forms and incorporate in their design and decoration virtually the whole Javanese decorative vocabulary. That they were used in both Buddhist and Hindu ritual is explicitly clear from some of the iconographic forms of their handles and finials, although the emblems of a number of bells are not sufficiently distinctive to determine religious affiliation. The cosmic symbolism of certain bells, expressed through their shapes and decoration, is well known.[1]

The ringing of the bell invokes and summons the gods, and also calls worshipers to pray. The radiating sound of the bell symbolizes the message of the Buddha going out to the world, and also evokes for Hindus the first primal sound of creation.

Handbells are part of the standard paraphernalia employed by Buddhist priests in various rituals. They are considered sacred objects and their widespread use in countries where Buddhism is practiced has continued to the present. The *vajraghanta*, the bell with a handle in the shape of a *vajra*, is the most sacred of all bells. The *ghanta* is one of the attributes of Brahma, who, along with his other duties, functions as priest for the Hindu gods, and of Vajrasattva, who is sometimes considered the sixth Dhyani Buddha and priest for the other five (see No. 133).

This handle, whose four curving prongs surrounding the main one are missing, is embellished with four

heads representing the Dhyani Buddhas of the four directions. The presence of the Supreme Dhyani Buddha of the Center, Vairochana, is implied by the *vajra* itself. On the most famous *vajraghanta* with Dhyani Buddha heads, now in the Rijksmuseum, Amsterdam, the attributes of the deities are shown on the body of the bell.[2] A slightly earlier bell now in the collection of the Linden-Museum Stuttgart is similar to ours; both depict the petals supporting the *vajra* as the narrow ones of the blue lotus (*utpala*).[3] The casting of the Eilenberg bell, like that of so many Javanese metal objects, is crisp and precise.

ML

1 Lohuizen-de Leeuw 1984, pp. 22–23.
2 Fontein, no. 71. The attributes also appear on the bodies of other bells (for example, see Lohuizen-de Leeuw 1984, nos. 61, 62, 64).
3 Lohuizen-de Leeuw 1984, no. 61.

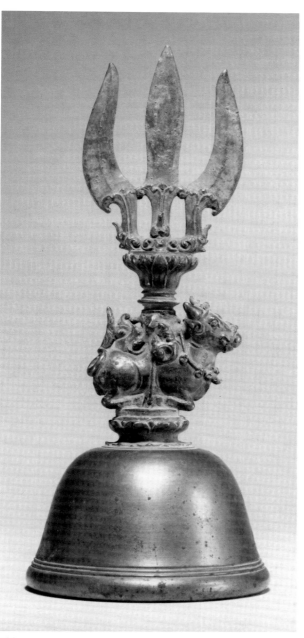

166

166 Handbell

Indonesia, Java, Eastern Javanese period, ca. 11th–12th century
Bronze, h. 8 1/8 in. (20.6 cm)
Gift of Samuel Eilenberg, 1987
1987.142.236

Handbells of the Eastern Javanese period usually have undecorated bodies with simple ring moldings near their bottoms.[1] Their handles, however, can be of rather rich design, as is the case here. On top of this handle, a trident (*trishula*) emerging from scrolling floral forms is set on the narrow petals of an *utpala* similar to the one seen on the *vajraghanta* of entry No. 165. These elements are supported on the back of a bull (*nandin*) embellished with scrolling appendages placed so that they suggest wings. The bull rests on a double-lotus pedestal. Since the *trishula* is one of Shiva's attributes and the bull his mount, this bell may have been used in Shaivite rituals. The precision of modeling and fineness of casting place this *ghanta* among the best of the surviving examples. The style suggests a dating early in the Eastern Javanese period.

ML

1 Lohuizen-de Leeuw 1984, nos. 67–77.

PUBLISHED
Spink 1978, no. 177.

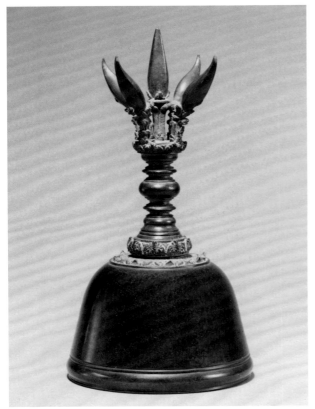

167

167 Handbell

Indonesia, Java, Eastern Javanese period,
ca. 13th–14th century
Bronze, h. 6¹¹/₁₆ in. (16.9 cm)
Gift of Samuel Eilenberg, 1987
1987.142.243

This beautifully cast *vajraghanta* with a five-pronged
vajra finial on its handle represents a continuation of
the type seen in entry No. 165. Consistent with the
bell's date, the prongs curve outward. That the prongs
of the *vajra* represent the five Dhyani Buddhas is
demonstrated by the appearance, in proper sequence,
of their symbols at the base of the outer prongs. The
vishvavajra (double thunderbolt or crossed thunder-
bolts) represents Amoghasiddhi, Buddha of the North;
the *vajra*, Akshobhya, who presides over the east; a
jewel (*ratna*), here set on a *vajra*, stands for Ratna-
sambhava, Lord of the South; and Amitabha, who
reigns over the west, is symbolized by his *padma*
(lotus). Vairochana, the Supreme Dhyani Buddha of
the Center, is the *vajra*'s large, straight prong.

ML

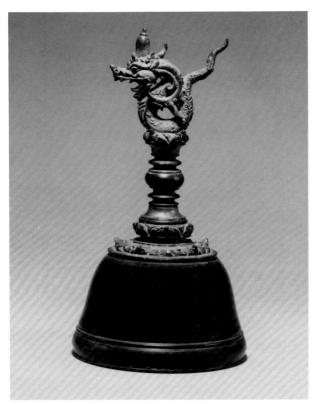

168

168 Handbell

Indonesia, Java, Eastern Javanese period,
ca. 13th–14th century
Bronze, h. 5¹⁵/₁₆ in. (15.1 cm)
Gift of Samuel Eilenberg, 1987
1987.142.242

This *ghanta* has as its finial a small and fierce-looking
naga, whose ubiquitous appearance on ritual objects
testifies to the creature's importance and popularity.
Animistic snake worship is of considerable antiquity,
predating Hinduism and Buddhism both in India
and Southeast Asia. Since the dawn of civilization,
the regenerative aspect of snakes, along with their
other distinctions, has disturbed and captured the
popular imagination of many cultures. *Nagas* figure
prominently in Hindu and Buddhist legend, but it is
their association with water, which is considered
holy, that makes them of primary importance. One
such legendary association, suggested by a motif on
this bell, is often alluded to in Javanese art. Set on the
head of this *naga* (and probably on the heads of those
discussed in Nos. 177 and 178) is a tall, covered water

vessel, sometimes misidentified as representing a jewel. This vessel is one form of a container for *amrita*, the nectar of the gods or nectar of immortality. In ancient Indian literature, one specific duty of the *nagas* is the guarding of the *amrita*. The ferocious *naga* on this bell clearly intends to do that.

ML

169 Handbell

Indonesia, Java, Eastern Javanese period, ca. 13th–14th century
Bronze, h. 6 5/8 in. (16.8 cm)
Gift of Samuel Eilenberg, 1987
1987.142.237

The *ghanta* with a handle surmounted by a seated male figure with arms clasped around his drawn-up knees is not uncommon.[1] Such figures are usually

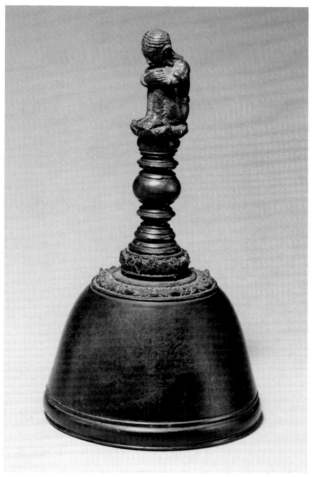

169

identified as ascetics,[2] but since significant variations occur—some are nude, others not; some have demonic faces, others are benign—this may not accurately describe all of them.

The man on this bell has well-observed facial features whose rendering is somewhat portraitlike in its naturalism. His hair is carefully parted in the center and is long in back, and he wears armbands and bracelets and is dressed in a *sampot*. With his chin resting on his hands, our figure appears to be totally absorbed in thought.

ML

1 Lohuizen-de Leeuw 1984, nos. 76, 77; Lunsingh Scheurleer and Klokke, no. 70; Fontein, no. 77.
2 Fontein, no. 77.

Ex colls. S. H. Minkenhof, Holland; Frederick Mayer, New York.

PUBLISHED
Visser, pl. 212.

170 Temple Bell

Indonesia, Java, Eastern Javanese period, ca. 11th–12th century
Bronze, h. 13 3/4 in. (34.9 cm)
Gift of Samuel Eilenberg, 1987
1987.142.182ab

Bronze hanging temple bells of this sort, which do not have clappers but were intended to be struck, are not uncommon in Javanese art. Like this bell, they are usually well cast and splendidly decorated, and are adorned with elaborate animal or human finials. Most of these finials are in the form of rearing mythical lions (*simhas*) with open mouths and raised paws,[1] bulls,[2] *nagas*,[3] or, like the example in entry No. 171, demons. Addorsed monkeys of the type that appear on this bell are quite rare. These seated or crouching monkeys are set on a lotus; each wears elaborate jewelry and holds a flaming orb in its raised hands. The finial rests on the double lotus at the top of the body of the bell.

The central band of the bell is decorated with floral antefixes from which are suspended simple festoons in the shape of lotus petals and floral pendants. Set into the lotus-petal frames are five characters in the Kadiri quadrate script, which have not yet been deciphered, and a winged conch, which also appears on one of our *kentongans* (No. 182), flanked by two

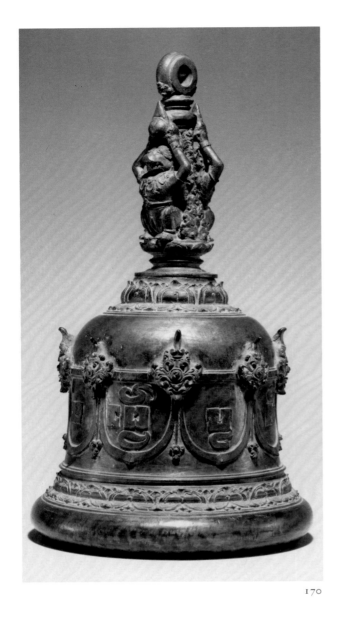

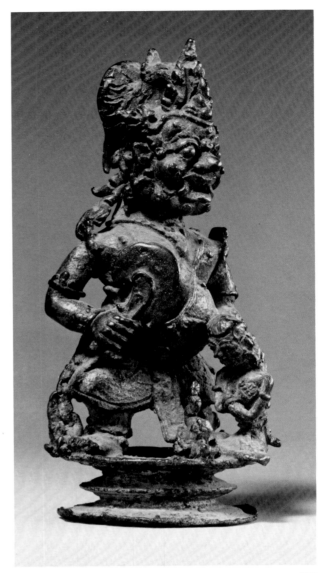

170

171

swirl-like elements. Near the base of the bell is a double-lotus register whose upper row of petals is threaded by a raised band. A heavy torus-molded lip completes the profile and reinforces the resemblance of the bell's shape to that of some stupas represented at Borobudur. It is not certain that the addorsed-monkeys finial is original to this bell.[4]

ML

1 Lohuizen-de Leeuw 1984, nos. 50–53; Lunsingh Scheurleer and Klokke, nos. 72, 73; Fontein, no. 70.
2 Lohuizen-de Leeuw 1984, nos. 48, 49.
3 Fontein, no. 73.
4 An earlier bell, with similar decoration but without the Kadiri quadrate script characters or the conch, suggests the more usual proportional relationship of bell to finial (Rijksmuseum, no. 53).

171 Bell Finial in the Form of a *Rakshasa*

Indonesia, Java, Eastern Javanese period, ca. 2nd half of 12th–early 13th century
Bronze, h. 4¹⁵/₁₆ in. (12.5 cm)
Gift of Samuel Eilenberg, 1987
1987.142.17

This finial from a hanging bell takes the form of an unusually lively and finely modeled *rakshasa*—a demon king or guardian. He is depicted as a short, potbellied, grimacing creature with fangs and large bulbous eyes and a serpent emerging from each armpit. A curved broad chopper is held in his right hand, and his left is placed behind the neck of a

hapless victim with bound hands who is seated in front of him. The hair of the *rakshasa* is pulled back and arranged in a loop to allow for the attachment of the suspension chain.

Ferocious creatures of this sort were popular participants in Javanese mythology and literature and appear often in the art of the Eastern Javanese period. Their association with bells is not uncommon.[1]

ML

1 Another type of demon bell finial, which still preserves its chain, is in the Museum Nasional, Jakarta (Fontein, no. 74. See also Krom 1926, pl. XLVIII).

172 Pellet Bell

Indonesia, Java, Eastern Javanese period, 11th–13th century
Bronze, h. 5 3/16 in. (13.2 cm)
Gift of Samuel Eilenberg, 1987
1987.142.245

The rich repertory of bronze bell types in Javanese art includes pellet bells of various shapes.[1] These contain one or more loose bronze balls, which create the sound.

The large raised frames for the three open slits of this bell taper downward into feet and suggest human forms. Alternating with these slits are three floral swags, each surmounted by a single blossom. At the top of the bell, a double lotus supports a circular knobbed protuberance with an attachment loop.

ML

1 Lohuizen-de Leeuw 1984, nos. 80, 81; Lunsingh Scheurleer and Klokke, nos. 74, 75.

173 Pellet Bell in the Form of a Bear(?)

Indonesia, Java, Eastern Javanese period, ca. 13th–14th century
Bronze, h. 4 1/4 in. (10.8 cm)
Gift of Samuel Eilenberg, 1987
1987.142.298

The last of our bells, again of pellet type, is rendered as a fanciful bearlike quadruped with a suspension loop on his head. The plump, large-eyed creature has

172

173

a long jaw, an open mouth, and a brow embellished with scrolling decorative motifs of the sort that appear in some form or another on virtually all Javanese bronzes. This charming animal epitomizes the strain of playful humor that permeates the Indonesians' cultural consciousness and is so evident in much of their art. Works of this kind provide a delightful counterbalance to the more sober, iconographically orthodox representations of Indonesian Buddhas, bodhisattvas, and Hindu deities.

ML

174 Mirror Handle

Indonesia, Java, Eastern Javanese period, ca. late 11th–12th century
Bronze, h. 5 11/16 in. (14.5 cm)
Gift of Samuel Eilenberg, 1987
1987.142.29

Bronze mirrors of relatively simple design from the Eastern Javanese period are not uncommon. They are almost always solid cast in two sections: a handle and a disc with one highly polished, undecorated surface to serve as the reflector.[1] That hand-held bronze mirrors were also in use during the Central Javanese period is demonstrated by their appearance on reliefs at Borobudur and from an excavated example found near Kalasan.[2] Mirrors from the Central and Eastern

214

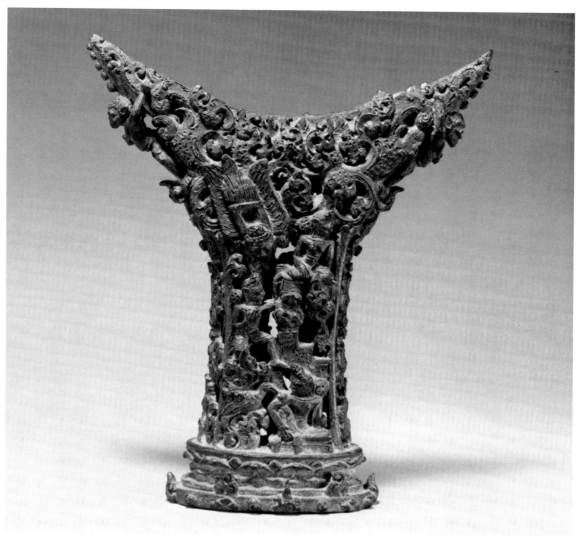

174 Back

Javanese periods must have been used for both domestic and ritual purposes.

Of all the Indonesian mirror handles extant, the one illustrated here has the strongest claim to being the finest surviving example. It is hollow cast and reticulated, incorporating into its rich design animal and human figures set into a stylized landscape composed of scrolling floral and cloud formations. As an example of Javanese bronze casting, it is a technical tour de force: persuasive evidence of an unusually highly developed order of metalworking skills.

The scenes depicted on both sides seem to be taken from the great Hindu epic the *Ramayana*. On one side, Rama is shown slaying the demon Maricha, who, at the insistence of Ravana, Lord of the Demons, had assumed the form of a golden deer in order to lure Rama away from his wife, Sita, thus setting the stage for her abduction by Ravana.[3] Above this scene, Rama is shown conversing with either Sugriva, king of the monkey tribe, or Hanuman, Sugriva's noble counselor, before setting out in his quest to recover Sita.[4]

The identities of the scenes on the other side of the handle are less clear to me. There is a depiction of a seated emaciated female, who should be the grieving Sita in the *ashoka* grove of Ravana's palace in Lanka.[5] Her head is averted from the male figure shown below her—presumably Rama, although no such meeting occurs in the text. Beneath them may be another image of Sita, with less prominent breasts, conversing with a bird. Swooping down from the top of the handle is a large bird with a human head. Since

there seems to be a discrepancy between the episodes represented on this side of the mirror and the text of the *Ramayana*, perhaps a different legend is intended. Another story revolving around an abduction, that of Queen Mrigavati, might be a suitable candidate, and there is some correspondence between our scene and one involving this second abduction on a tenth-century stone relief from eastern Java.[6] Near the top of the two narrower sides of the handle are monkeys with arms raised as if to support the missing mirror disc.

The figural style represented here, along with the type of double-lotus pedestal and the decoration of the base, suggests to me a date no earlier than the eleventh century and no later than the twelfth, with the latter more probable.[7]

<div align="right">ML</div>

1 For a sampling of the range of Eastern Javanese-period mirror types, see Lohuizen-de Leeuw 1984, pls. 108–32.
2 Lunsingh Scheurleer and Klokke, p. 47.
3 The episode concerning Maricha and his ultimate destruction at the hands of Rama appears in chapters 35–44 of the "Aranya Kanda" in the *Ramayana* (Shastri, vol. 2, pp. 73–92).
4 Taken from the first chapters of the "Kishkindha Kanda" in the *Ramayana* (ibid., pp. 170–79).
5 Ibid., p. 373.
6 Fontein, no. 18.
7 The closest stylistic parallel to this mirror, probably dating to the eleventh century, is in the Museum Nasional, Jakarta (Fontein, no. 102).

PUBLISHED
Lerner 1975, no. 19.

175 Holy-Water Vessel

Indonesia, Java, Eastern Javanese period,
11th–12th century
Bronze, diam. 7 5/16 in. (18.6 cm)
Gift of Samuel Eilenberg, 1987
1987.142.193

This container for holy water exemplifies one of the two most common water vessel shapes in the Indonesian repertory, the other being the type illustrated in the following entry. The present vessel originally had a lid of the sort preserved in the collection of the Linden-Museum Stuttgart.[1]

Almost all the surviving water vessels of this category have a very simple band of discreet decoration, sometimes of lotus petals,[2] around the lower part of their bodies. This example, the finest and most elaborate known, has a wide band of nine scrolling cartouches, five of which contain fantastic composite animals; the remaining four are filled with decorative, scrolling floral designs. So far as I know, the only other water container of this shape with a wide decorated band around its body is a slightly later and inferior one in the Museum Nasional, Jakarta.

The dating of these vessels remains problematic. Lohuizen-de Leeuw has suggested they might belong to the Central Javanese period,[3] but Klokke has assigned them to the Eastern Javanese period, with a

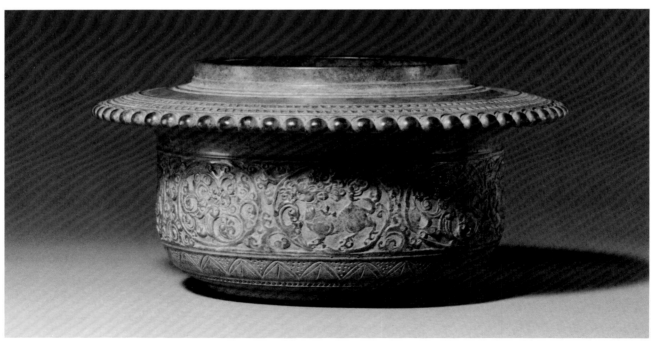

<div align="right">175</div>

dating from the tenth to the sixteenth century.[4] To my eye, the Eilenberg water vessel cannot be later than the twelfth century and may well be earlier. The publication of this vessel, with its unique rich vocabulary of animal and floral designs, will, it is hoped, both prompt and facilitate further research into the problem.

ML

1 Lohuizen-de Leeuw 1984, nos. 87–89.
2 Lunsingh Scheurleer and Klokke, nos. 89, 90; the two sections of the latter may have been joined sometime after it was made. For a plain example, see Lohuizen-de Leeuw 1984, no. 86.
3 Lohuizen-de Leeuw 1984, no. 86.
4 Lunsingh Scheurleer and Klokke, nos. 89, 90.

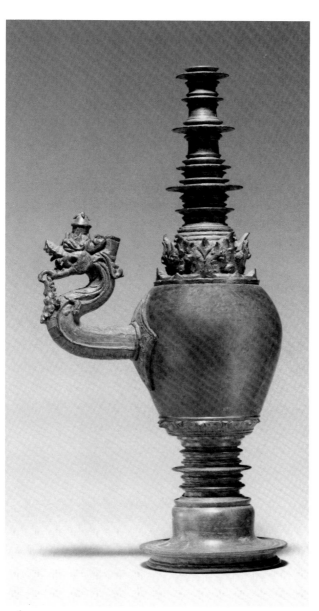

176 Holy-Water Vessel

Indonesia, Java, Eastern Javanese period,
ca. 14th century
Bronze, h. 10⁵/₁₆ in. (26.2 cm)
Gift of Samuel Eilenberg, 1987
1987.142.181

This elongated, footed water vessel, with its high, tapered neck of superimposed rings representing parasols and its projecting spout in the form of a fanciful serpent (*naga*) head with curved neck, is the second of the two common forms of Indonesian holy-water containers referred to in the previous entry. The body, foot, neck, and spout were all cast separately and then joined, as is usual.

As the spouts on these vessels are not used for pouring, there are generally no holes in the *naga*'s mouth. Instead, the container is filled through an opening behind the head, and the liquid is poured from the top. The opening behind the *naga*'s head also serves as an air hole when the vessel is turned over for pouring. For a discussion of the object on the *naga*'s head, see No. 168.

Quite a few examples of this form of water vessel have survived; these differ from one another only slightly in form and decoration.[1] In quality, however, as well as size, significant variations occur.

ML

1 Vessels of this general type are illustrated in Bernet Kempers 1959, pl. 220; Lohuizen-de Leeuw 1984, no. 85; Lunsingh Scheurleer and Klokke, no. 88; Fontein, no. 103.

176

177 *Naga* Spout from a Holy-Water Vessel

Indonesia, Java, Eastern Javanese period,
ca. 13th century
Bronze, h. 4 1/16 in. (10.3 cm)
Gift of Samuel Eilenberg, 1987
1987.142.201

This superb *naga* spout is another example of an
object that reveals the high level of technical pro-
ficiency and refined inventiveness of the artists of the
Eastern Javanese period. It must have belonged to a
water vessel of unusual quality. Bronzes of this sort
tend to confirm the assertion that the extensive range
of artistically impressive metalwork produced on the
island of Java is matched nowhere else in Southeast
Asia. For the object on the *naga*'s head, see No. 168.

ML

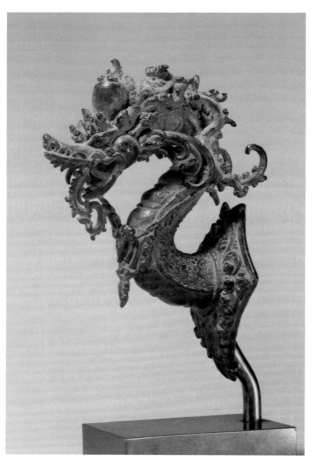

177

178 Halberd Head with *Naga* and Blades

Indonesia, Java, Eastern Javanese period,
ca. 2nd half of 13th century
Copper alloy, h. 17 1/2 in. (44.4 cm)
Promised Gift of Samuel Eilenberg

This fine halberd head is part of a hoard purportedly
found in the area of Singasari, near Malang in eastern
Java. The hoard consisted of eight halberd heads that
vary in complexity of shape and degree of decoration,
a large and elaborate halo for a lost image, and part
of a wooden shaft from one of the halberds. Three of
the halberd heads, as well as the halo, are now in the
Metropolitan's holdings, and the remaining five,
including this one, are promised gifts of Samuel
Eilenberg. Fontein, writing about another halberd
head, suggests that these objects "seem to be emblems
of royalty or nobility" used in secular parades rather
than religious procession.[1] Now that it is together, the
group makes a splendid assemblage, but it must have
been even more stunning originally, when it was
carried.

The present halberd head is in the form of a dragon-
like *naga* with upturned snout and long, scrolling
tongue. He supports a tall blade on his neck and
another on his tail and rests on a double lotus on top
of a ringed shaft. Set on the creature's head is an
enigmatic object with a lotiform stopper, often de-
scribed in the literature as a jewel, but almost certainly
having a different identity (see No. 168). Attached on
either side to the top of the double lotus and the
middle of the *naga*'s body is a winged, one-eyed
kala-monster motif with three claws at its bottom
(see No. 163).

Chinese contacts with Indonesia existed from at
least as early as the Han period (206 B.C.–A.D. 221),
and trade between China and the various Indonesian
kingdoms continued intermittently from that time.
The closest association, however, existed during the
Majapahit period—after Kublai Khan's punitive ex-
pedition to Java in 1292 decisively ended the Singasari
dynasty. The problem of to what precise degree
Chinese prototypes influenced Eastern Javanese dragon
nagas of the second half of the thirteenth century
remains unresolved, but there can be no doubt that
Chinese designs served as partial inspiration, primarily
by way of ceramics exported to Indonesia.

ML

1 Fontein, pp. 266–67.

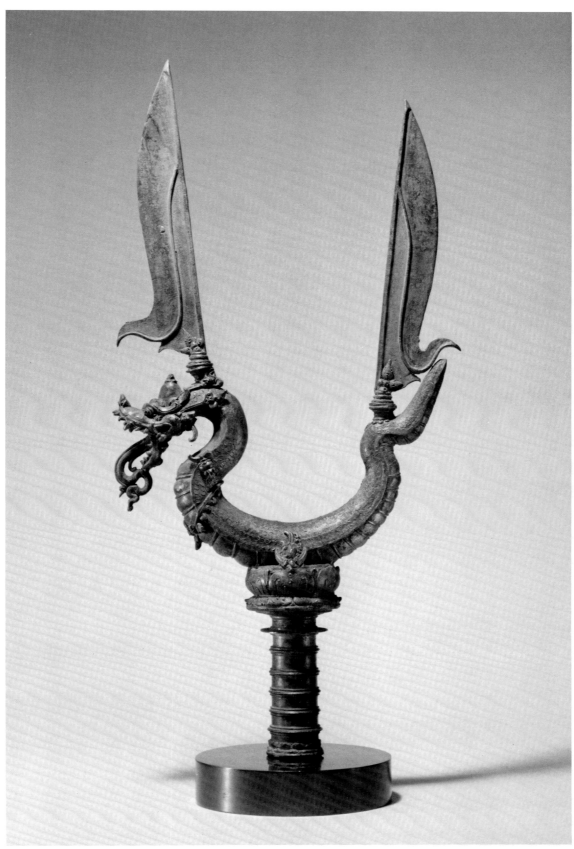

179 Priest's Offering Tray (*Talam*)

Indonesia, Java, Central or Eastern
Javanese period, ca. 10th century
Copper, diam. 22 ⅜ in. (56.8 cm)
Promised Gift of Samuel Eilenberg

Talams (round trays upon which various ritual objects or offerings were placed) are not uncommon. They were made in a variety of sizes and range from elaborately decorated to plain.[1] The Eilenberg collection's holdings of *talams* are particularly distinguished. Included are *talams* from both the Central and Eastern Javanese periods that encompass fine examples of standard types, as well as others that are either unique or extremely rare.

The first of the two *talams* in the exhibition is a rather large example with a flanged rim and one of the most popular of the designs in the repertory at its center—a *purnaghata* (vase of plenty), out of which emerge two scrolling stems with stylized lotus buds. The *purnaghata*, here placed on a lotus-petal support, was encountered earlier in association with Jambhala (Nos. 143–45) and is a common motif symbolizing prosperity that is found on the facades of Javanese temples. The manner in which this *purnaghata* is represented shows an evolution from earlier designs.[2] Here there is an abstracted dissolution of the forms of the pot and an emphasis on the large split seed at its center. The design is embellished with a circular band of interlocked stylized mythical animals, a fish, and a bird. The pointed decoration on the outer perimeter, as Lohuizen-de Leeuw has stated, represents rays of energy or light emanating from the auspicious *purnaghata*.[3] The style of the decoration and the fact that it covers much of the *talam*'s surface suggest a dating at the very end of the Central Javanese period or, perhaps, the beginning of the Eastern Javanese period.

Talams were cast and their designs were not incised but, rather, were transferred from the original wax models.

ML

1 For some of the designs encountered on *talams*, see Lohuizen-de Leeuw 1984, nos. 97–106; Lunsingh Scheurleer and Klokke, nos. 99–101.
2 For examples of earlier designs, see Lohuizen-de Leeuw 1984, nos. 98, 101.
3 Ibid., p. 25.

180 Offering Tray (*Talam*)

Indonesia, Java, Eastern Javanese period,
late 13th–14th century
Copper, diam. 17 ½ in. (44.5 cm)
Promised Gift of Samuel Eilenberg

The decoration on this offering tray, which covers the whole of its flat surface, and the shape of the rim indicate that it is of later date than the preceding *talam*. The unusual, superbly drawn subject matter makes it a particularly outstanding example of the type.

The scene in the center has as its main dramatis personae an elegantly coiffed, richly jeweled, well-dressed woman who is seated in an open pavilion and a parrot that seems to be delivering a message in its beak. In addition, a figure with an animal (bear?) head sits behind the rear right corner of the pavilion, and another figure, whose head is turned up and has the caricatured features of a grotesque demon or jester, sits in back of the parrot. The exact source of this scene is unknown to me, and I cannot tell if it is related to the representation of a seated figure with a bird that appears on one side of the mirror handle in entry No. 174. It may well be a generic reference to birds carrying messages between separated lovers, a well-established theme from ancient Indian literature. In the great Hindu epic the *Mahabharata*, for example, the story is told of the lovers Nala and Damayanti, who employed a golden swan to serve as messenger when they were parted. Representations of the mythical golden swan were replaced in the visual arts by more accessible birds.[1] The use of such a clearly secular theme on this *talam* may have precluded the placement of sacred objects on it.

The style of the drawing of the woman, which emphasizes the angularity of her right shoulder and left elbow, and provides her with a sharp chin and nose and thin arms with long pointed fingers, presages the later so-called *wayang* (shadow-play) style. Open, pillared pavilions, somewhat comparable to the one shown here, are found in the reliefs of the second half of the thirteenth century at Chandi Jago,[2] east of Malang, in eastern Java.

A rich compendium of animals, birds, and insects appears in the tray's outer band. These include a wild boar, a ram, deer of some sort, peacocks, a rooster, a scorpion, and a dragonfly, among others—all drawn more naturalistically than the creatures on the earlier

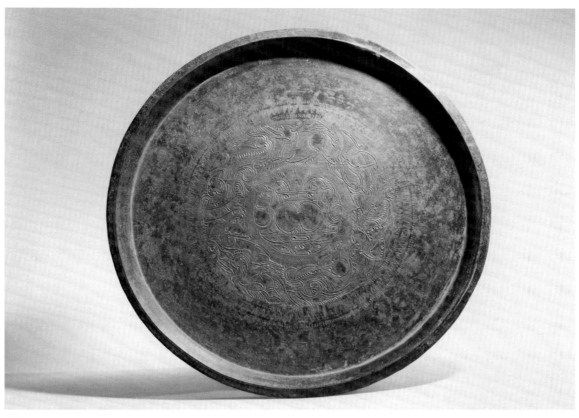

179

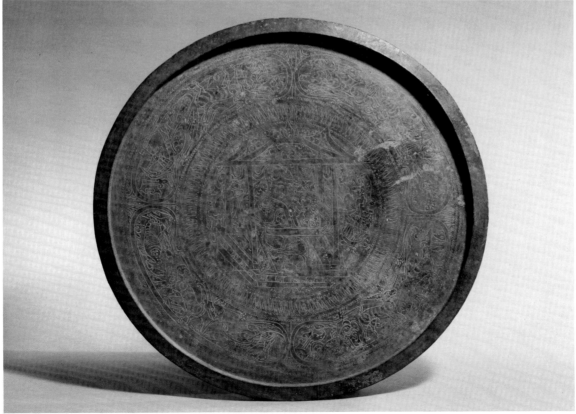

180

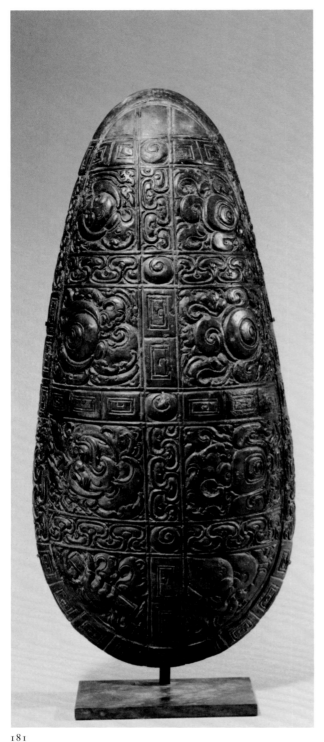

talam. It is useful to compare a closely related offering tray, formerly in the Mangkoenagoro collection,[3] to ours.

ML

1 Goswamy 1975, p. 3, figs. 5A, 20, 53, and pls. 6–9, 33.
2 Brandes, pls. 144–46.
3 Stutterheim 1937, fig. 30.

181 Decorated Lid(?)

Indonesia, Java, Eastern Javanese period, ca. 12th–14th century
Bronze, h. 13 ⅝ in. (34.6 cm)
Gift of Samuel Eilenberg, 1987
1987.142.28

This object, presumably a lid of some sort, is, in my experience, unique. I have never encountered its shape or its decorative elements combined in the same manner on a single object. It is divided into eight decorated compartments embellished with various symbols. In one of the two compartments at the bottom, there is a hand holding a manuscript, and in the other there are two hands holding a lotus bud. A *makara* (see No. 154) appears in the compartment over the one with the manuscript, and next to this is a compartment with a *kala* eye (see Nos. 163, 182) above a knotted ribbon. On top of the compartment with the eye is a similar symbol that is rounded, and above the *makara* is a complete, stylized one-eyed *kala* mask with the teeth or claws of the monster shown beneath the eye. The last two compartments have, respectively, a *kala* eye and a skull. All of these symbols are surrounded by decorative scrolling elements. The broad borders along the rim and separating the compartments include swirl forms, meanders, and a repeated stylized character in the Kadiri quadrate script. What the significance of this pictorial program might be I cannot say, nor can I propose, with any degree of confidence, a close dating for this object.

ML

181

182 Slit Gong (*Kentongan*)

Indonesia, Java, Eastern Javanese period,
ca. 13th century
Bronze, h. 17 ¼ in. (43.8 cm)
Gift of Samuel Eilenberg, 1987
1987.142.31

Musical instruments of all sorts, whether employed
alone, as part of a court or village orchestra, or in
temple ritual, are an important and integral part of
Indonesian culture. The earliest surviving examples,
as one might expect, are of metal. Bronze *kentongans*
of the Eastern Javanese period, as Fontein has pointed
out, are replicas of large wooden slit gongs.[1] Not
many of these early bronze gongs have survived; the
Eilenberg collection includes two, each of which
displays different decor. Both have what appear to
be their original chains with *naga* hooks.

The faceted body of this drum has near one side of
the slit a flaming conch encircled by a ribbon and at
the back a small, mythological rabbitlike creature
holding a dagger—perhaps a reference to the moon.
Above the slit is a stylized one-eyed *kala* motif similar
to those placed above the narrow stairways of Boro-
budur and other temples (see No. 163). The rest of
the decoration is of a sort that appears on other
kentongans.[2]

The fine *naga*-cum-dragon at the top of the slit
gong is quite similar to the *naga* spout discussed in
entry No. 177.

ML

1 Fontein, p. 273.
2 Ibid., no. 100.

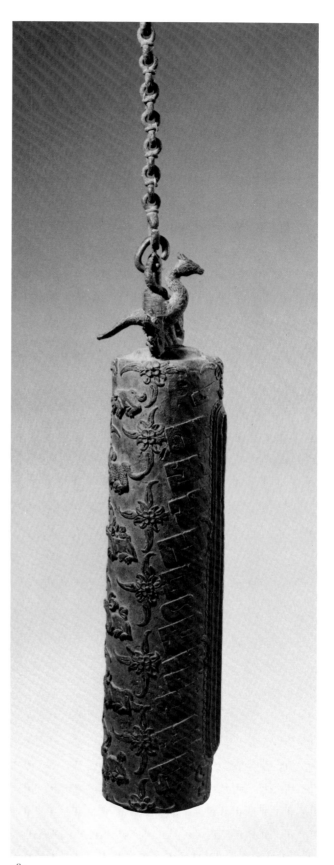

182

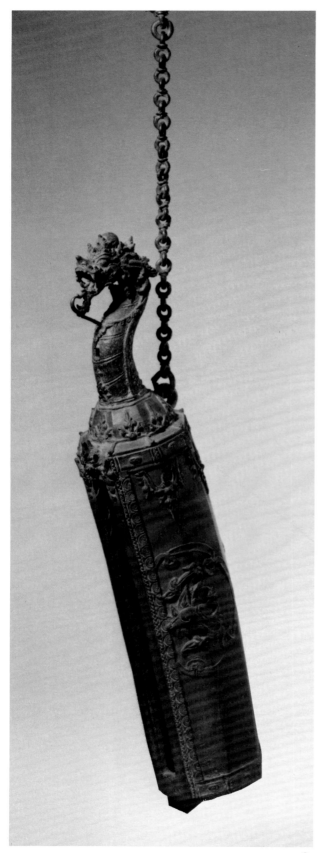

183 Slit Gong (*Kentongan*)

Indonesia, Java, Eastern Javanese period,
ca. 13th century
Bronze, h. 16 in. (40.7 cm)
Gift of Samuel Eilenberg, 1987
1987.142.30

This *kentongan* has at its top a bird with a *naga*
emerging from beneath each wing. On the body of
the instrument are twelve animals, which cannot refer
to the zodiac since some of them are repeated. On
either side of the slit appear rows of oblong char-
acters in the Kadiri quadrate script. The inscriptions
have not been deciphered but might include a date, as
do two other thirteenth-century *kentongans*.[1] Included
in the decor are rows of blossoms, each with four
long, curving leaves.

ML

1 Fontein, p. 275.

184 Hinged Box in the Form of a Tortoise

Indonesia, Java, Eastern Javanese period,
ca. 13th century
Bronze, w. 4⅞ in. (12.5 cm)
Gift of Samuel Eilenberg, 1987
1987.142.165ab

This charming and, to my experience, unique hinged
box is in the shape of a turtle (or tortoise) with a
small Chinese-style serpent-cum-*naga* handle on its
back. While many animals, including turtles in narra-
tive reliefs on the ninth-century facades of Borobudur,
appear in the Indonesian sculptural menagerie, in-
dividual representations of turtles are rare. They do
occur in gold and terracotta, but these are of a date
later than our box and were created for different
purposes.[1] Turtle-shaped vessels are rarely encountered
in the repertory of later Thai, Chinese, or Vietnamese
export ceramics intended for the Indonesian market—
in contrast to containers in the forms of other animals,
such as the frog-shaped vessels that seem to have
been a staple in the export trade.

 This box is made in two parts, which are hinged
under the rather naturalistic head, and has a clasp at
the back. The upper shell of the turtle is decorated
with scrolling vines with pendant blossoms, and its

184

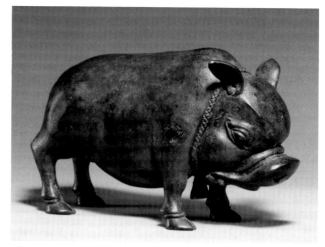

185

outer rim has a wide border embellished with S-shaped motifs alternating with meanders of long, stylized-mask (eyes and nose) design. Part of the shell is reconstructed.

ML

1 Muller, pl. 25; Rijksmuseum, nos. 96, 97. In the collection of The Metropolitan Museum of Art, there is also an elaborate thirteenth-century copper alloy halbert head in the shape of a turtle supporting four tall blades with *nagas* at their base; this was part of the hoard found near Singasari discussed in No. 178 (acq. no. 1986.504.2).

185 Standing Boar

*Indonesia, Java, Eastern Javanese period,
ca. 14th century
Bronze, w. 6¹³/₁₆ in. (17.3 cm)
Gift of Samuel Eilenberg, 1987
1987.142.259*

During the rule of the Eastern Javanese kingdom of Majapahit (fourteenth through early sixteenth century), there developed a fondness for a category of object whose apparent origins usually surprise Westerners—the piggy bank. Many terracotta pigs, naturalistic and usually well sculpted, with slots cut at the top so that they can serve as coin boxes, have been recovered from around Trowulan, the Majapahit capital.[1] Even though swine must have played an important role in the domestic economy, the reasons for the great popularity of this animal shape for coin boxes in eastern Java are unclear. Lohuizen-de Leeuw offers the suggestion that the shape seems "to allude to financial success as well as culinary delights" since "pork and especially sucking-pig [was] considered a great delicacy in ancient Java."[2] A few of these terracotta pigs are unslotted, and their function, like that of this rare example in bronze, remains unknown.

The fierce look of our porcine creature and his projecting tusks suggest he is a wild boar[3] who is sufficiently domesticated to wear a chain with a bell—a common feature of most of the Eastern Javanese terracotta piggy banks. Hollow and cast in two sections (front half and back half), this well-modeled, large-eared boar will be considered charming by some.

ML

1 Muller, pls. 39–41.
2 Lohuizen-de Leeuw 1984, p. 28.
3 "...the word for piggy-bank in Eastern Java is still *tjèlèngan* or wild boar" (Muller, p. 28).

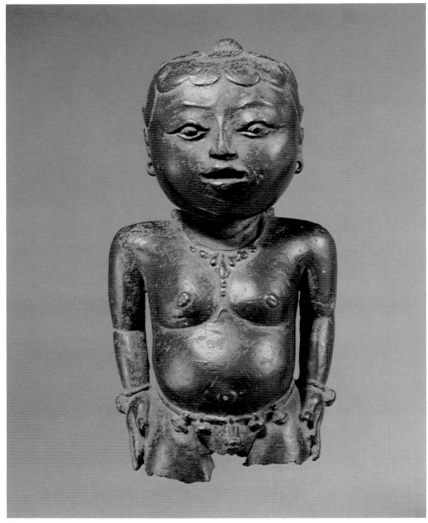

186

186 Image of a Noble Boy

Indonesia, Java, Eastern Javanese period,
14th century
Bronze, h. 5 5/16 in. (13.5 cm)
Gift of Samuel Eilenberg, 1987
1987.142.199

Writing in 1937, the distinguished scholar of Javanese
art W. F. Stutterheim noted that this fragmentary
figure of a boy, with arms pressed against his body
and a concerned look on his face, represents a youthful
inhabitant of the Majapahit court. The cord with
suspended amulets and bells around his waist, his
necklace, and the amulets worn on his wrists suggest
he is of noble birth, perhaps even a prince who died

young. The long lock in the center of his head
survives from the solemn haircutting ceremony under-
gone by young boys, in which all hair other than a
spot in the center of the head is shaved off. That this
ceremony had taken place a while before the boy was
depicted is indicated by the fact that much of the hair
is shown to have grown back. Stutterheim concludes
his discussion by suggesting that this sculpture is
unique and one of the most desirable in the collection
of Sultan Mangkoenagoro.[1]

Since Stutterheim published his comments, a few
other bronzes of similar type have been discovered[2]
and different interpretations of their significance have
been offered. A. J. Bernet Kempers, for example,
writes: "They look more like bronze replicas of
wooden dolls than child portraits. Dolls are some-

187

times used after the birth of a child as its double. They are also used for the magic fulfillment of a woman's desire for a child."[3] A guidebook for the Museum Nasional, Jakarta, says one of these figures may be a manifestation of Krishna.[4]

ML

1 Stutterheim 1937, pp. 25–26.
2 Bernet Kempers 1959, pls. 292, 293.
3 Ibid., p. 95.
4 Short Guide to Museum Nasional, p. 54.

Ex coll. Sultan Mangkoenagoro VII of Surakarta.

PUBLISHED
Stutterheim 1937, figs. 16, 17.

187 Pull Toy of a Cart and Driver

Indonesia, Java, Eastern Javanese period, ca. 15th century
Bronze, w. 10¹¹⁄₁₆ in. (27.2 cm)
Gift of Samuel Eilenberg, 1987
1987.142.261a–c

Bronze and terracotta wheeled objects, probably intended to be children's toys, are found in many cultures—the early art of India, for example, is rich in such material (see No. 14). It is assumed that when made from the more costly bronze, the toys were for children of the upper classes.

Bronze toys with wheels and axles from the Eastern Javanese period usually take the form of horses and

riders or rams and other animals.[1] Representations of carts with drivers are uncommon but probably once existed in some numbers. In this example, the cart, faithfully reproduced from some original, is carefully modeled, but the driver is represented in a curiously cursory fashion. His dress and hairstyle indicate his humble origins, and his long pointed nose and his cap (or pigtail)[2] give him the look of a character from the Javanese shadow-puppet world. The significance of the short object held in his right hand and of the longer one that extends beyond his elbow and is held in his left hand is not clear to me. The charm of the object is as apparent to us today as it must have been to its first user.

ML

1 Fontein, Soekmono, and Suleiman, no. 56; Lohuizen-de Leeuw 1984, nos. 139, 140; Lunsingh Scheurleer and Klokke, nos. 108, 109.
2 There are striations on the right side of the driver's face that might indicate that his long nose and cap are part of a mask. More likely these striations are unintentional.

Bibliography

This list is arranged alphabetically by author. Multiple entries by a single author are organized chronologically.

Agrawala, Prithvi. *Early Indian Bronzes*. Varanasi, 1977.

Agrawala, Vasudeva Sharana. *Indian Art*. Varanasi, 1965.

Aiyers, K. V. Subrahmanya. "The Larger Leiden Plates." *Epigraphica Indica* 22 (1933–34), pp. 213–81.

Allchin, F. R. "A Cruciform Reliquary from Shaikhan Dheri." In *Aspects of Indian Art*, edited by Pratapaditya Pal, pp. 15–26. Leiden, 1972.

Archaeological Survey of India, Annual Report 1906–7. Calcutta, 1909.

The Art Institute of Chicago, *Master Bronzes of India*. Exh. cat., The Art Institute of Chicago (1965).

Asher, Frederick M. *The Art of Eastern India, 300–800.* Minneapolis, 1980.

Ashton, Leigh, ed. *The Art of India and Pakistan*. Exh. cat., Royal Academy of Art (London, 1947–48).

Bailey, H. W. "Two Kharoshti Casket Inscriptions from Avaca." *Journal of the Royal Asiatic Society* 1 (1978), pp. 3–13.

Bangdel, Lain Singh. *The Early Sculptures of Nepal*. New Delhi, 1982.

Barrett, Douglas. "Sculptures of the Shāhi Period." *Oriental Art*, n.s. 3:2 (Summer 1957), pp. 54–59.

Barrett, Douglas. "Bronzes from Northwest India and Western Pakistan." *Lalit Kalā* 11 (April 1962), pp. 35–44.

Barrett, Douglas. *Early Cola Architecture and Sculpture*. London, 1974.

Begley, Wayne. *Pala Art: Buddhist and Hindu Sculpture from Eastern India, ca. 800–1200 A.D.* Exh. cat., The University of Iowa Museum of Art (Iowa City), 1969.

Begley, W. E. *Visnu's Flaming Wheel: The Iconography of the Sudarśana-Cakra*. New York, 1973.

Bernet Kempers, A. J. *The Bronzes of Nalanda and Hindu-Javanese Art*. Leiden, 1933.

Bernet Kempers, A. J. *Ancient Indonesian Art*. Cambridge, Mass., 1959.

Bhattacharyya, Benoytosh. *The Indian Buddhist Iconography*. Calcutta, 1958.

Bhattacharyya, D. C. "On Some Buddhist Āsanas." In *Chhavi–2: Rai Kirshnadasa Felicitation Volume*, edited by Anand Krishna, pp. 182–86. Banares, 1981.

Biswas, T. K. "Kinnara-Kinnarī." In *Chhavi–2: Rai Krishnadasa Felicitation Volume*, edited by Anand Krishna, pp. 266–69. Banaras, 1981.

Bivar, A.D.H. "The Azes Era and the Indravarma Casket." In *South Asian Archaeology 1979*, edited by Herbert Härtel, pp. 369–76. Berlin, 1981.

Bivar, A.D.H. "The 'Vikrama' Era, the Indravarma Casket, and the Coming of the Indo-Scythians, Forerunners of the Afghans." In *Monumentum Georg Morgenstierne I*, Acta Iranica 21, pp. 47–58. Leiden, 1981.

Boeles, J. J. "Four Stone Images of the Jina Buddha in the Precincts of the Chapel Royal of the Emerald Buddha." In *Felicitation Volumes of Southeast Asian Studies Presented to His Highness Prince Dhaninivat Kromamun Bidyalabh Bridhyakorn*, vol. 2, pp. 185–97. Bangkok, 1965.

Boisselier, Jean. *La Statuaire Khmère et son évolution*. Saigon, 1955.

Boisselier, Jean. *Ceylon: Sri Lanka*. Archaeologia Mundi Series. Geneva, 1979.

Le Bonheur, Albert. *La Sculpture Indonésienne au Musée Guimet*. Paris, 1971.

Bosch, F.D.K. "Oudheden in Koetei." In *Oudheidkundig Verslag, Derde en Vierde Kwartaal 1925 (Quarterly Reports of the Archaeological Service of the Dutch East Indies 1925)*, pp. 132–46. 1926.

Bosch, F.D.K. "Oudheden in Koetei." In *Midden-Oost-Borneo Expeditie 1925*, pp. 391–423. Weltevreden, 1927.

Bosch, F.D.K. "Buddhist Data from Balinese Texts." In *Selected Studies in Indonesian Archaeology*, pp. 109–33. The Hague, 1961.

Bowie, Theodore, ed. *The Sculpture of Thailand*. Exh. cat., The Asia Society (New York, 1972).

Brandes, Jan Laurens Andries. *Beschrijving van de ruïne bij de desa Toempang, genaamd Tjandi Djago, in de residentie Pasoeroean.* The Hague, 1904.

Brown, Robert L. "The Śrāvasti Miracles in the Art of India and Dvāravati." *Archives of Asian Art* 37 (1984), pp. 79–95.

Brown, Robert L. "The Art of Southeast Asia." *Arts of Asia* 15:6 (November–December 1985), pp. 114–25.

Carter, Martha L. "Dionysiac Aspects of Kushān Art." *Ars Orientalis* 7 (1968), pp. 121–46.

Casey, Jane Anne, ed. *Medieval Sculpture from Eastern India: Selections from the Nalin Collection.* Livingston, N.J., 1985.

Casparis, J. G. de. "The Dual Nature of Barabuḍur." In *Barabuḍur: History and Significance of a Buddhist Monument,* edited by Luis O. Gómez and Hiram W. Woodward, Jr., pp. 47–83. Berkeley, 1981.

Chandra, Lokesh, and Rani, Sharada, eds. *Mudras in Japan: Symbolic Hand-postures in Japanese Mantrayana or the Esoteric Buddhism of the Shingon Denomination.* New Delhi, 1978.

Chandra, Moti. *Stone Sculpture in the Prince of Wales Museum.* Bombay, 1974.

Chandra, Pramod. "The Cult of Śrī Lakshmī and Four Carved Discs in Bharat Kala Bhavan." In *Chhavi,* edited by Anand Krishna, pp. 139–48. Banaras, 1971.

Chandra, Pramod. *The Sculpture of India 3000 B.C.–1300 A.D.* Exh. cat., National Gallery of Art (Washington, D.C., 1985).

Chihara, Daigoro; Namikawa, Ryo; and Hikata, Ryusho, *Borobudur.* Tokyo, 1971.

Chutiwongs, Nandana. *The Iconography of Avalokiteśvara in Mainland South East Asia.* Leiden, 1984.

Coedès, George. "Le Royaume de Çrīvijaya. *Bulletin de l'école française d'extrême-Orient* 18:6 (1918), pp. 1–36.

Coedès, George. *Bronzes Khmèrs.* Ars Asiatica, vol. 5. Paris, 1923.

Coedès, George. *The Indianized States of Southeast Asia.* Kuala Lumpur, 1968.

Coomaraswamy, Ananda. *Bronzes from Ceylon, Chiefly in the Colombo Museum.* Ceylon, 1914.

Coomaraswamy, Ananda. *Yaksas.* Smithsonian Miscellaneous Collections, vol. 80, no. 6. Baltimore, 1928.

Coomaraswamy, Ananda. "The Parts of a Vīnā." *Journal of the American Oriental Society* 50 (1930), pp. 244–53.

Coomaraswamy, Ananda. *History of Indian and Indonesian Art.* New York, 1965.

Crucq, K. C. "De Loemadjangsche Ruiterbeeldjes en de Paarden op de Reliefs van Jeh Poeloe." *Djåwå* 10:4–5 (October 1930), pp. 164–67.

Czuma, Stanislaw. Kushan Sculpture: Images from Early India. Exh. cat., Cleveland Museum of Art (1985).

Czuma, Stanislaw. "Ivory Sculpture." In *Art and Architecture of Ancient Kashmir,* edited by Pratapaditya Pal, pp. 57–76. Bombay, 1989.

Dalton, O. M. *The Treasure of the Oxus, with Other Examples of Early Oriental Metal-work.* 3d ed. London, 1964.

Das Gupta, Charu Chandra. *Origin and Evolution of Indian Clay Sculpture.* Calcutta, 1961.

Diskul, M. C. Subhadradis, ed. *The Art of Śrīvijaya.* Oxford, 1980.

Dohanian, Diran Kavork. *The Mahāyāna Buddhist Sculpture of Ceylon, Chiefly in the Colombo Museum.* New York, 1977.

Dupont, Pierre. *La Statuaire préangkorienne.* Ascona, 1955.

Fabri, Charles L. "Buddhist Baroque in Kashmir." *Asia* (October 1939), pp. 593–98.

Fabri, Charles L. "Akhnur Terra-cottas." *Marg* 7:2 (March 1955), pp. 53–75.

Faccenna, Domenico. *Sculptures from the Sacred Area of Butkara I.* 2 vols. Rome, 1962–64.

Felten, Wolfgang, and Lerner, Martin. *Thai and Cambodian Sculpture from the 6th to the 14th Centuries.* London, 1989.

Fontein, Jan. *The Sculpture of Indonesia.* Exh. cat., National Gallery of Art (Washington, D.C., 1990).

Fontein, Jan; Soekmono, R.; and Suleiman, Satyawati. *Ancient Indonesian Art of the Central and Eastern Javanese Periods.* Exh. cat., The Asia Society (New York, 1971).

Francfort, Henri-Paul. *Les Palettes du Gandhāra.* Mémoires de la délégation archéologique française en Afghanistan, vol. 23. Paris, 1979.

Fussman, Gérard. "Nouvelles Inscriptions Śaka: Ère d'Eucratide, Ère d'Azès, Ère Vikrama, Ère de Kaniska." *Bulletin de l'école française d'extrême-Orient* 67 (1980), pp. 1–43.

Fussman, Gérard. "Nouvelles Inscriptions Śaka (II)." *Bulletin de l'école française d'extrême-Orient* 73 (1984), pp. 31–46.

Goetz, Hermann. "A Kāshmīrī Lingam of the 10th Century." *Artibus Asiae* 27:3 (1965), pp. 275–79.

Goswami, C. L., trans. *Śrīmad Bhāgavata Mahāpurāna.* Parts 1 and 2. Gorakhpur, 1971.

Goswamy, B. N. *Pahari Paintings of the Nala-Damayanti Theme in the Collection of Dr. Karan Singh.* New Delhi, 1975.

The Great Tradition: Indian Bronze Masterpieces. New Delhi, 1988.

Grünwedel, Albert. *Buddhist Art in India.* Rev. and enl. by James Burgess. London, 1901.

Guide to Antiquities Found at Koo Bua, Ratburi. Bangkok, 1961.

Guide to the National Museum of Ethnology, Leiden. Leiden, 1962.

Gupta, Parmeshwari Lal, ed. *Patna Museum Catalogue of Antiquities.* Patna, 1965.

Gupta, Swarajya Prakash. *The Roots of Indian Art.* New Delhi, 1980.

Gupta, Swarajya Prakash. *Kushana Sculptures from Sanghol, 1st–2nd Century A.D.: A Recent Discovery.* New Delhi, 1985.

Gupta, Swarajya Prakash, ed. *Masterpieces from the National Museum Collection.* New Delhi, 1985.

Gupte, Ramesh Shankar. *The Iconography of the Buddhist Sculptures (Caves) of Ellora.* Aurangabad, 1964.

Hackin, Joseph. *Nouvelles recherches archéologiques à Begram.* Délégation archéologique française en Afghanistan, Mémoires, vol. 11. Paris, 1954.

Hallade, Madeleine. *Gandharan Art of North India and the Graeco-Buddhist Tradition in India, Persia, and Central Asia.* New York, 1968.

Harle, J. C. "On a Disputed Element in the Iconography of Early Mahiṣāsuramardini Images." *Ars Orientalis* 8 (1970), pp. 147–53.

Harle, J. C. "A Gupta Ear-Ring." In *Senarat Paravitana Commemoration Volume*, edited by Leelananda Prematilleke, Karthigesu Indrapala, and J. E. van Lohuizen-de Leeuw, pp. 78–80. Leiden, 1978.

Harper, Prudence Oliver. *The Royal Hunter: Art of the Sasanian Empire.* Exh. cat., The Asia Society (New York, 1978).

Härtel, Herbert. "The Concept of the Kapardin Buddha Type of Mathura." In *South Asian Archaeology 1983*, edited by Janine Schotsmans and Maurizio Taddei, vol. 2, pp. 653–79. Naples, 1985.

Härtel, Herbert, and Auboyer, Jeannine. *Indien und Südostasien.* Propyläen Kunstgeschichte, vol. 16. Berlin, 1971.

Heeramaneck, Alice N. *Masterpieces of Indian Sculpture from the Former Collections of Nasli M. Heeramaneck.* Verona, 1979.

Hendley, Thomas Holbein. *Indian Jewellery.* 2 vols. 1909. Reprint. Delhi, 1984.

Huntington, John C. "Three Essays on Himalayan Metal Images." *Apollo*, n.s. 118 (November 1983), pp. 416–25.

Huntington, Susan L. "Pre-Pāla and Pāla Period Sculptures in the Rockefeller Collection." *Apollo*, n.s. 118 (November 1983), pp. 370–78.

Huntington, Susan L. *The "Pāla-Sena" Schools of Sculpture.* Leiden, 1984.

Huntington, Susan L., and Huntington, John C. *Leaves from the Bodhi Tree: The Art of Pala India (8th–12th Centuries) and Its International Legacy.* Exh. cat., Dayton Art Institute (1989).

Ingholt, Harald. *Gandhāran Art in Pakistan.* New York, 1957.

Joshi, N. P. *Mathura Sculptures.* Mathura, 1966.

Kak, Ram Chandra. *Ancient Monuments of Kashmir.* London, 1933.

Kala, S. C. *Terracottas in the Allahabad Museum.* New Delhi, 1980.

Khandalavala, Karl. "Brahmapuri." *Lalit Kalā* 7 (April 1960), pp. 29–75.

Klimburg-Salter, Deborah E. *The Silk Route and the Diamond Path.* Exh. cat., Frederick S. Wight Art Gallery, University of California (Los Angeles, 1982).

Krairiksh, Piriya. *The Sacred Image: Sculptures from Thailand.* Exh. cat., Museum für Ostasiatische Kunst der Stadt Köln (Cologne, 1979).

Krairiksh, Piriya. *Art in Peninsular Thailand Prior to the Fourteenth Century, A.D.* Exh. cat., National Museum (Bangkok, 1980).

Kramrisch, Stella. *Manifestations of Shiva.* Exh. cat., Philadelphia Museum of Art (1981).

Kramrisch, Stella. *Exploring India's Sacred Art: Selected Writings of Stella Kramrisch*, edited by Barbara Stoler Miller. Philadelphia, 1983.

Krom, N. J. "De bronsvondst van Ngandjoek." In *Rapporten van de Oudheidkundigen Dienst in Nederlandsche-India 1913*, pp. 59–72. Batavia, 1914.

Krom, N. J. *Inleiding tot de Hindoe-Javaansche Kunst.* 3 vols. The Hague, 1923.

Krom, N. J. *L'Art Javanais.* Ars Asiatica, vol. 8. Paris, 1926.

Kurita, I. *Gandharan Art II: The World of the Buddha.* Tokyo, 1990.

Lee, Sherman E. *Ancient Cambodian Sculpture.* Exh. cat., The Asia Society (New York, 1969).

Lerner, Martin. *Bronze Sculptures from Asia*. Exh. cat., The Metropolitan Museum of Art (New York, 1975).

Lerner, Martin. *The Flame and the Lotus: Indian and Southeast Asian Art from the Kronos Collections*. Exh. cat., The Metropolitan Museum of Art (New York, 1984).

Lerner, Martin. "The Contemplative Bodhisattva in Indian Art." In *The Art of Bodhisattva Avalokitesvara—Its Cult-Images and Narrative-Portrayals*. International Symposium on Art Historical Studies 5, pp. 12–16. Osaka, 1987.

Lim, K. W. "Studies in Later Buddhist Iconography." *Bijdragen tot de taal-, land- en volkenkunde* 120 (1964), pp. 327–41.

Lohuizen-de Leeuw, J. E. van. "Gandhara and Mathura: Their Cultural Relationship." In *Aspects of Indian Art*, edited by Pratapaditya Pal, pp. 27–43. Leiden, 1972.

Lohuizen-de Leeuw, J. E. van. *Sri Lanka: Ancient Arts*. Exh. cat., Commonwealth Institute (London, 1981).

Lohuizen-de Leeuw, J. E. van. *Indo-Javanese Metalwork*. Stuttgart, 1984.

Lunsingh Scheurleer, Pauline, and Klokke, Marijke J. *Divine Bronze: Ancient Indonesian Bronzes from A.D. 600 to 1600*. Exh. cat., Rijksmuseum (Amsterdam, 1988).

Majumdar, Ramesh Chandra. *Ancient Indian Colonisation in South-East Asia*. Baroda, 1955.

Majumdar, Ramesh Chandra. *Suvarnadvipa: Ancient Indian Colonies in the Far East*. 2 vols. 1938. Reprint. Delhi, 1986.

Marchal, Henri. *Le Décor et la sculpture Khmers*. Paris, 1951.

Marschak, Boris. *Silberschätz des Orients*. Leipzig, 1986.

Marshall, John. *Taxila*. 3 vols. Cambridge, 1951.

The Metropolitan Museum of Art, *Along the Ancient Silk Routes: Central Asian Art from the West Berlin State Museums*. Exh. cat., The Metropolitan Museum of Art (New York, 1982).

The Metropolitan Museum of Art Annual Report. New York, 1988.

Mitra, Debala. *Bronzes from Achutrajpur, Orissa*. Delhi, 1978.

Mitra, Debala. *Bronzes from Bangladesh: A Study of Buddhist Images from District Chittagong*. Delhi, 1982.

Mitra, Sisir Kumar, ed. *East Indian Bronzes*. Calcutta, 1979.

Morley, Grace. "On Applied Arts of India in Bhavat Kala Bhavan." In *Chhavi Golden Jubilee Volume*, pp. 107–29. Banaras, 1971.

Mukherjee, B. N. "An Interesting Kharoshthi Inscription." *Journal of Ancient Indian History* 11 (1977–78), pp. 93–114.

Muller, H.R.A. *Javanese Terracottas: Terra incognita*. Lochem, 1978.

Munsterberg, Hugo. *Art of India and Southeast Asia*. New York, 1970.

Namikawa, B., and Miyaji, A. *Gandhara Art*. Tokyo, 1984.

Nara National Museum, *Arts of Buddha Sakyamuni*. Exh. cat., Nara National Museum (1984).

Nigam, M. L. *Sculptural Art of Andhra*. Delhi, 1980.

Notable Acquisitions 1975–1979. The Metropolitan Museum of Art, New York, 1979.

O'Connor, Stanley J., Jr. *Hindu Gods of Peninsular Siam*. Ascona, 1972.

Pal, Pratapaditya. "Three Dated Nepali Bronzes and Their Stylistic Significance." *Archives of Asian Art* 25 (1971–72), pp. 58–66.

Pal, Pratapaditya. *The Arts of Nepal: Sculpture*. Leiden, 1974.

Pal, Pratapaditya. *Bronzes of Kashmir*. New York, 1975.

Pal, Pratapaditya. *Nepal, Where the Gods are Young*. Exh. cat., The Asia Society (New York, 1975).

Pal, Pratapaditya. *The Sensuous Immortals: A Selection of Sculptures from the Pan-Asian Collection*. Exh. cat., Los Angeles County Museum of Art (1977).

Pal, Pratapaditya. *The Ideal Image: The Gupta Sculptural Tradition and Its Influence*. Exh. cat., The Asia Society (New York, 1978).

Pal, Pratapaditya. "A Kushān Indra and Some Related Sculptures." *Oriental Art*, n.s. 25:2 (Summer 1979), pp. 212–26.

Pal, Pratapaditya. "An Addorsed Saiva Image from Kashmir and its Cultural Significance." *Art International* 24 (January–February 1981), pp. 6–60.

Pal, Pratapaditya. *Elephants and Ivories in South Asia*. Los Angeles, 1981.

Pal, Pratapaditya. *Light of Asia: Buddha Sakyamuni in Asian Art*. Exh. cat., Los Angeles County Museum of Art (1984).

Pal, Pratapaditya. *Icons of Piety, Images of Whimsy: Asian Terra-cottas from the Walter-Grounds Collection*. Exh. cat., Los Angeles County Museum of Art (1987).

Pal, Pratapaditya. *Indian Sculpture*. Vol. 2. Los Angeles, 1988.

Postel, M. *Ear Ornaments of Ancient India*. Project for Indian Cultural Studies, Publication 2. Bombay, 1989.

Poster, Amy G. *From Indian Earth: 4,000 Years of Terracotta Art*. Exh. cat., The Brooklyn Museum of Art (New York, 1986).

Ramachandra Rao, P. R. *Andhra Sculpture*. Hyderabad, 1984.

Rawson, Philip S. *The Art of Southeast Asia*. New York, 1967.

Ray, Nihan Ranjan; Khandalavala, Karl; and Gorakshkar, Sadashiv. *Eastern Indian Bronzes*. New Delhi, 1986.

Recent Acquisitions: A Selection 1986–87. The Metropolitan Museum of Art, New York, 1987.

Reinhardt, Ad. *Khmer Sculpture*. Exh. cat., The Asia Society (New York, 1961).

Rekha Morris, F. Review of *Les Palettes du Gandhāra*, by Henri-Paul Francfort. *Biblioteca Orientalis* 40:3–4 (May–July 1983), pp. 488–94.

Rijksmuseum, *Borobodur: Kunst en religie in het oude Java*. Exh. cat., Rijksmuseum (Amsterdam, 1977).

Roorda, T. B., ed. *Choix de sculptures des Indes*. The Hague, 1923.

Rosenfield, John. *The Dynastic Arts of the Kushans*. Berkeley, 1967.

Rowan, Diana P. "Reconsideration of an Unusual Ivory Diptych." *Artibus Asiae* 46: 4 (1985), pp. 251–304.

Rowland, Benjamin. *The Evolution of the Buddha Image*. Exh. cat., The Asia Society (New York, 1963).

Rowland, Benjamin. *Art In Afghanistan: Objects from the Kabul Museum*. London, 1971.

Sadie, Stanley, ed. *The New Grove Dictionary of Musical Instruments*. 3 vols. London, 1984.

Sahni, Daya Ram. *Catalogue of the Museum of Archaeology at Sārnāth*. Calcutta, 1914.

Sali, S. A. *Daimabad*. New Delhi, 1986.

Salomon, Richard. "The 'Avaca' Inscription and the Origin of the Vikrama Era." *Journal of the American Oriental Society* 102 (1982), pp. 59–68.

Salomon, Richard, and Schopen, Gregory. "The Indravarman (Avaca) Casket Inscription Reconsidered: Further Evidence for Canonical Passages in Buddhist Inscriptions." *The Journal of the International Association of Buddhist Studies* 7:1 (1984), pp. 107–23.

Saraswati, S. K. *Tantrayāna Art: An Album*. Calcutta, 1977.

Sarkar, Himansu Bhusan. *Cultural Relations Between India and Southeast Asian Countries*. New Delhi, 1985.

Schnitger, Frederic Martin. *The Archaeology of Hindoo Sumatra*. Leiden, 1937.

Schroeder, Ulrich von. *Indo-Tibetan Bronzes*. Hong Kong, 1981.

Schroeder, Ulrich von. *Buddhist Sculptures of Sri Lanka*. Hong Kong, 1990.

Shah, Umakant P. "Rare Jaina Bronzes in Professor Samuel Eilenberg's Collection." In *Dimensions of Indian Art: Pupul Jayakar Seventy*, edited by Lokesh Chandra, Jyotindra Jain, and Agam Prasad, vol. 1, pp. 395–405. Delhi, 1986.

Shastri, Hari Prasad. *The Ramayana of Valmiki*. 3 vols. London, 1969.

Shere, S. A. *Bronze Images in Patna Museum, Patna*. Calcutta, 1961.

A Short Guide to the Museum Nasional Jakarta. 3d ed., rev. and enl. Jakarta, 1972.

Sickman, Laurence. *Masterpieces of Asian Art in American Collections*. Exh. cat., The Asia Society (New York, 1960).

Siudmak, John. "Early Stone and Terracotta Sculpture." In *Art and Architecture of Ancient Kashmir*, edited by Pratapaditya Pal, pp. 41–56. Bombay, 1989.

Sivaramamurti, Calambur. *The Art of India*. New York, 1977.

Slusser, Mary Shepherd. *Nepal Mandala: A Cultural Study of the Kathmandu Valley*. Princeton, 1982.

Spink & Son Ltd., *Indian Influence on Art in South-East Asia*. Exh. cat., Spink & Son Ltd. (London, 1970).

Spink & Son Ltd., *Indian and South East Asian Art*. Exh. cat., Spink & Son Ltd. (London, 1978).

Spooner, D. B. "Excavations at Shāh-Jī-Kī-Dhērī." In *Archaeological Survey of India, Annual Report 1908–9*, pp. 38–59. Calcutta, 1912.

Spooner, D. B. "Excavations at Basarh." In *Archaeological Survey of India, Annual Report 1913–14*, pp. 98–185. Calcutta, 1917.

Stein, Mark Aurel. *Ancient Khotan*. 2 vols. Oxford, 1907.

Stutterheim, W. F. "De Oudheden-Collectie Resink-Wilkens te Jogjakarta." *Djåwå* 14:4–6 (December 1934), pp. 167–97.

Stutterheim, W. F. "De Oudheden-Collectie van Z. H. Mangkoenagoro VII te Soerakarta." *Djåwå* 17:1–2 (January–May 1937), pp. 1–112.

Stutterheim, W. F. "Een Bronzen Stūpa." *Djåwå* 19:1 (January 1939), pp. 138–41.

Suleiman, Satyawati. "The History and Art of Śrīvijaya." In The Art of Śrīvijaya, edited by M. C. Subhadradis Diskul, pp. 1–20. Oxford, 1980.

Taddei, Maurizio. "A Linga-shaped Portable Sanctuary of the Sāhi Period." East and West, n.s. 15:1–2 (January 1964–March 1965), pp. 24–25.

Taddei, Maurizio. "Una placca di terracotta 'Śunga' del Museo Nazionale d'Arte Orientale di Roma." In Arte Orientale in Italia I, pp. 7–24. Rome, 1971.

Thomsen, M., ed. Java and Bali. Exh. cat., Linden-Museum (Stuttgart, 1980).

Tokyo National Museum, Cultural Contacts Between East and West in Antiquity and the Middle Ages from USSR. Exh. cat., Tokyo National Museum (1985).

Tucci, Giuseppi. Indo-Tibetica. 3 vols. New Delhi, 1988.

Vats, Madho Sarup. The Gupta Temple at Deogarh. Memoirs of the Archaeological Survey of India, no. 70. Delhi, 1952.

Visser, Herman F. E. Asiatic Art in Private Collections of Holland and Belgium. New York, 1948.

Vogel, J. Ph. "Excavation at Kasiā." In Archaeological Survey of India, Annual Report 1906–7, pp. 44–67. Calcutta, 1909.

Wagner, Frits A. Indonesia: The Art of an Island Group. New York, 1959.

Wattanavrangkul, S. Outstanding Sculptures of Bhudhist [sic] and Hindu Gods from Private Collections in Thailand. Bangkok, 1975.

Weiner, Sheila L. Ajantā: Its Place in Buddhist Art. Berkeley, 1977.

Whitechapel Art Gallery, Arts of Bengal: The Heritage of Bangladesh and Eastern India. Exh. cat., Whitechapel Art Gallery (London, 1979).

Willetts, William. "An 8th Century Buddhist Monastic Foundation: Excavation at Ratnagiri in the Cuttack District of Orissa." Oriental Art, n.s. 9:1 (Spring 1963), pp. 15–21.

Williams, Joanna. The Art of Gupta India: Empire and Province. Princeton, 1982.

Wolters, O. W. "Śrīvijayan Expansion in the Seventh Century." Artibus Asiae 24:3–4 (1961), pp. 417–24.

Woodward, Hiram W., Jr. "The Bayon-Period Buddha Image in the Kimbell Art Museum." Archives of Asian Art 32 (1979), pp. 72–83.

Zimmer, Heinrich. The Art of Indian Asia: Its Mythology and Transformations. 2 vols. New York, 1955.

Zwalf, W., ed. Buddhism: Art and Faith. Exh. cat., British Museum (London, 1985).

Index

Titles of catalogue entries and page numbers that refer to illustrations are in italics.

S

Samantabhadra Buddha, 180
Sambor style (Cambodia), 151, 152
sampot, 156
Sarnath style, 97, 98–100
 costume, 97
 pedestals, 100
sarong, 152
Sasanian silver dishes, 66, 92
 hunting scenes on, 66, 92, 92 n. 5
Scytho-Parthian period (Gandhara), 60, 62–64
sea monster with rider motif, 62–64
 tritons and, 62, 64; 63
Seated Avalokiteshvara, cat. no. 108, 137–38; 138. Colorplate 29
Seated Bodhisattva Vajrapani(?), cat. no. 135, 174; 174
Seated Bodhisattva Vajrasattva, cat. no. 133, 172–73; 172
Seated Buddha, cat. no. 67, 98–100; 99. Colorplate 22
Seated Buddha, cat. no. 88, 117–18; 117. Colorplate 27
Seated Buddha, cat. no. 106; 136–37; 136
Seated Buddha, cat. no. 107; 137; 137
Seated Buddha Shakyamuni, cat. no. 92, 123–24; 123
Seated Deity from an Esoteric Buddhist Mandala, cat. no. 159, 202; 202
Seated Dhyani Buddha Akshobhya(?), cat. no. 156, 196–97; 196. Colorplate 40
Seated Esoteric Buddhist Deity, cat. no. 157, 197–98; 197
Seated Four-Armed Ganesha, cat. no. 103, 133; 133. Colorplate 28
Seated Four-Armed Ganesha, cat. no. 134, 173–74; 173
Seated Four-Armed Jambhala, cat. no. 143, 185; 184
Seated Four-Armed Shiva, cat. no. 116, 146–147; 146
Seated Four-Headed and Four-Armed Jambhala(?), cat. no. 144, 185–86; 186
Seated Esoteric Buddhist Deity, cat. no. 160, 203; 203

Seated Indra, cat. no. 115, 146; 146
Seated Kumara (Young Karttikeya), cat. no. 114, 145; 145
Seated Mahashri Tara or Prajnaparamita, cat. no. 121, 150; 150
Seated Maitreya, cat. no. 117, 147–48; 147
Seated Prajnaparamita, cat. no. 84, 114–15; 115
Seated Surya, cat. no. 111, 142; 142
Seated Tara, cat. no. 141, 182; 182. Colorplate 37
Seated Transcendental Buddha Vairochana, cat. no. 89, 119–20; 119
Seated Transcendental Buddha Vairochana, cat. no. 139, 179–80; 179. Colorplate 35
Seated Transcendental Buddha Vairochana, cat. no. 147, 188–89; 189
Seated Transcendental Buddha Vairochana, cat. no. 148, 189–90; 189
Seated Two-Armed Jambhala, cat. no. 145, 187; 187
Seated Vajrapani, cat. no. 94, 125–26; 125
Seated Vishnu, cat. no. 101, 130–32; 131
Seated Woman Holding a Mirror(?), cat. no. 28, 67–68; 67
Section of a Portable Linga with Parvati, cat. no. 83, 114; 114
Section of a Portable Linga with Shiva and Parvati, cat. no. 82, 113–14; 113. Colorplate 26
Section of a Portable Shrine with Shiva and Parvati, cat. no. 81, 112–13; 112
Section of a Portable Shrine with Two Scenes from the Life of Buddha, cat. no. 78, 109–10; 110. Colorplate 25
Section of a Portable Shrine with Two Scenes from the Life of Buddha, cat. no. 79, 110–11; 111
Shah, U.P., 100
Shahi dynasty (Pakistan / Afghanistan), 114, 115
 costume, 115
 sculpture, 114
Shailendra dynasty (Indonesia), 162, 163
 King Panangakarana, 163

 King Sanjaya, 163
 King Vishnu, 163
shanka (conch), 96, 131
shawl / scarf styles
 classical, 63–64, 64 n. 3, 67
 Swat Valley style, 65, 65 n. 2
Shiva, Lord, 94, 112–13, 139, 143–44, 146, 209; 112, 113, 146
 attributes, 113, 139, 143–44, 146, 209
 as Bhairava, 139
 four manifestations of, 139, 143
 linga (phallic) emblem of, 94, 113, 139, 143
 as Mahadeva, 113, 139
 as Maheshvara, 143
 as Nandin, 139
 Parvati (Uma) and, 143–45
 as Tamreshvara, 139
Shiva Seated with Uma (Umamaheshvara), cat. no. 113, 143–44; 144. Colorplate 30
Shri Lakshmi (goddess), 82
 shrivatsa symbol of, 82
Shrivijaya empire (Indonesia), 161–64
 Palembang and, 162
 Shailendra dynasty and, 162
Shrivijaya style, 125, 162–63, 167–68
 Indian influence, 161, 163
 Singhalese influence, 163
Shunga period (India), 53–55
 goddesses with weapons in hair, 53–54; 54
 plaques (terracotta), 56
 terracottas, 53, 56–59
Siddhartha, Prince, 84, 160; 84, 85, 110, 111, 159
 birth of, 109
 bodhi tree and, 111–12, 111 n. 1
 fasting, 84–85
 Mara and, 160
silver dishes (Sasanian), 92, 92 n. 5
Singasari hoard, 225
Sirkap (Pakistan), 60, 61, 70
Six Sculptures from a Vajradhatu Mandala, cat. no. 158a–f, 198–201; 199, 200, 201. Colorplate (five of six) 41
Skanda (son of Shiva), 113
Slit Gong (Kentongan), cat. no. 182, 223; 223